A Royal Passion

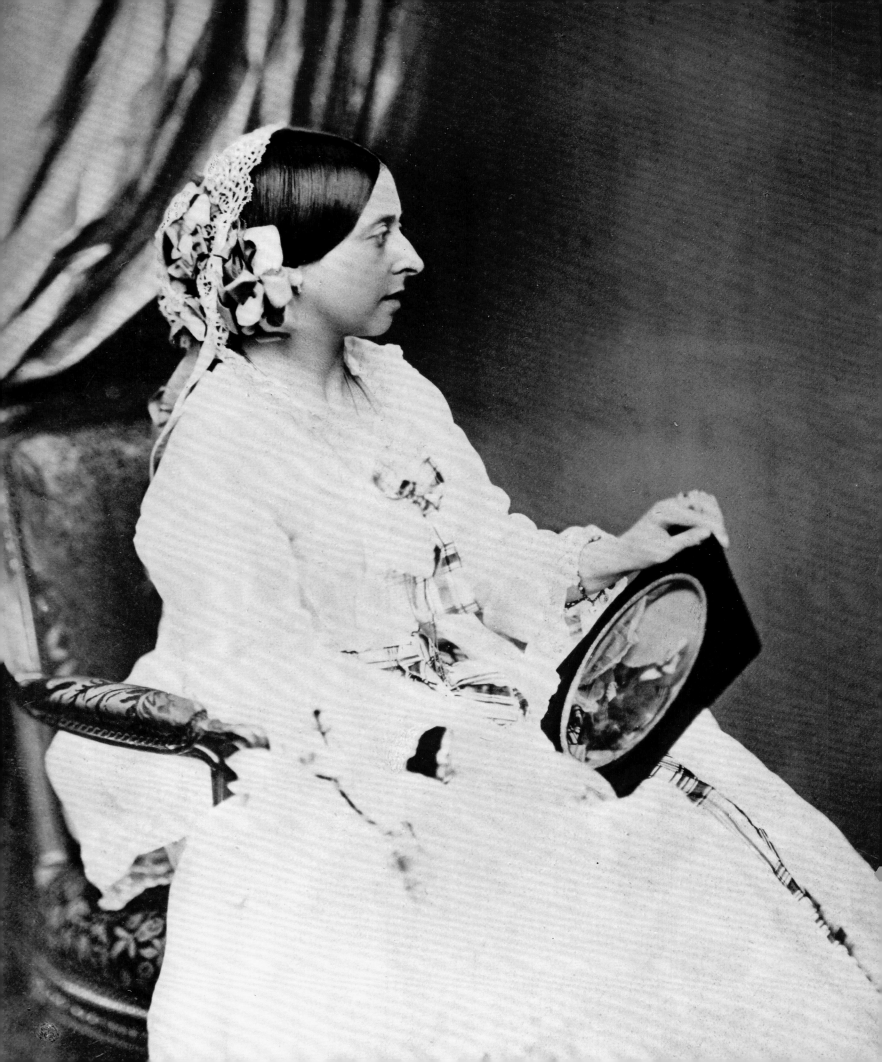

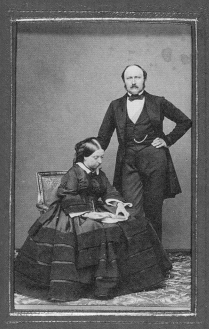 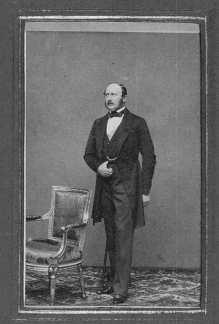 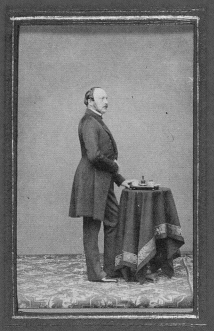 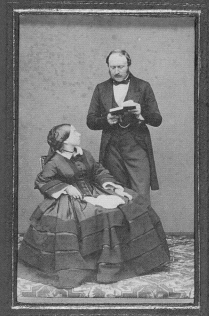

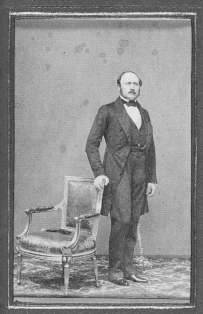 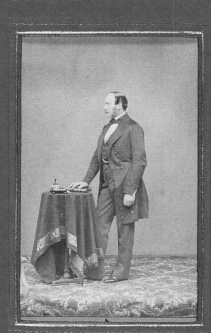 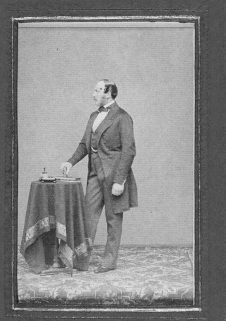 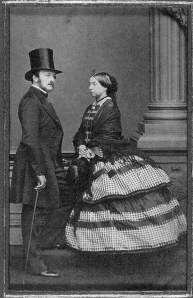

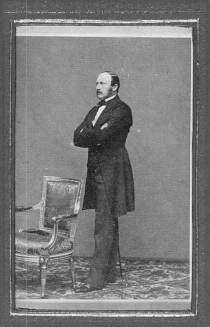 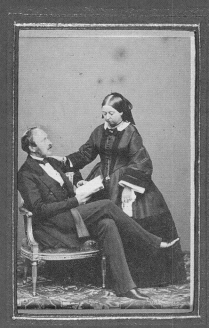 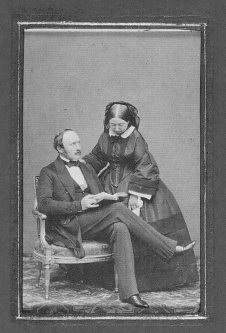 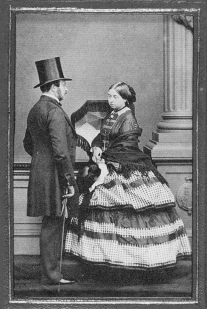

A Royal Passion

Queen Victoria AND PHOTOGRAPHY

ANNE M. LYDEN

THE J. PAUL GETTY MUSEUM, LOS ANGELES

This publication is issued on the occasion of the exhibition *A Royal Passion: Queen Victoria and Photography*, on view at the J. Paul Getty Museum at the Getty Center, Los Angeles, from February 4 to June 8, 2014.

© 2014 J. Paul Getty Trust

Published by the J. Paul Getty Museum, Los Angeles
Getty Publications
1200 Getty Center Drive, Suite 500
Los Angeles, CA 90049–1682
www.getty.edu/publications

Beatrice Hohenegger, *Editor*
Jim Drobka, *Designer*
Amita Molloy, *Production Coordinator*

Printed in Hong Kong

Library of Congress Cataloging-in-Publication Data

A royal passion : Queen Victoria and photography / Anne M. Lyden ; with contributions by Sophie Gordon and Jennifer Green-Lewis.
 pages cm
 Includes index.
 "This publication is issued on the occasion of the exhibition A Royal Passion: Queen Victoria and Photography, on view at the J. Paul Getty Museum at the Getty Center, Los Angeles, from February 4 to June 8, 2014."—Title page verso.
 ISBN 978-1-60606-155-8 (hardcover)
 1. Photography—Great Britain—19th century—History.
2. Great Britain—History—Victoria, 1837–1901. 3. Great Britain—Kings and rulers—Portraits. 4. Victoria, Queen of Great Britain, 1819–1901—Photograph collections. I. Lyden, Anne M., 1972– editor of compilation. II. Gordon, Sophie. III. Green-Lewis, Jennifer. IV. Green-Lewis, Jennifer, author. Invention of photography in the Victorian world.
 TR57.R69 2014
 770.941—dc23

 2013020998

Illustration credits
Every effort has been made to contact the owners and photographers of objects reproduced here whose names do not appear in the captions or in the illustration credits listed below. Anyone having further information concerning copyright holders is asked to contact Getty Publications so this information can be included in future printings.

Front Jacket: Roger Fenton (British, 1819–1869), *Queen Victoria*, 1854 (detail, plate 77)
Back Jacket: Leonida Caldesi (Italian, 1823–1891), *The Royal Family at Osborne*, 1857 (detail, plate 91)
Page ii: Bryan Edward Duppa (British, 1804–1866), *Queen Victoria*, negative, 1854; print, 1889 (detail, plate 78)
Page xii: Reverend Calvert Richard Jones (British, 1804–1877), *Untitled (Two-Part Panorama Study of Margam Hall with Figures)*, ca. 1845 (detail, figure 7)
Page 26: Joseph Nash (British, 1809–1878), *The Great Industrial Exhibition of 1851: Plate 1—The Inauguration*, 1851 (detail, figure 16)
Page 43: William Henry Fox Talbot (British, 1800–1877), *Untitled (Windsor Castle, South Front)*, ca. 1841 (detail, plate 5)
Page 106: Roger Fenton (British, 1819–1869), *Queen Victoria and Prince Albert, Buckingham Palace*, negative, 1854; print, 1889 (detail, figure 27)
Page 128: Unknown photographer, *Daguerreotype Portrait of Queen Victoria and the Princess Royal*, mid-1840s (detail, figure 38)
Page 145: Roger Fenton (British, 1819–1869), *Buckingham Palace*, ca. 1858 (detail, plate 96)

Pls. 1, 3, 4; Figs. 1, 46; Time Line 1840, 1841, 1843, 1844, 1846, 1848, 1850, 1853, 1857: © National Media Museum / SSPL
Pls. 2, 5–10, 13, 14, 17–35, 37–40, 42–44, 46, 48–50, 54–60, 63, 64, 77, 86, 99, 102–4, 106; Figs. 2, 4–8, 10, 13, 17, 18, 21, 47, 52: J. Paul Getty Museum
Pls. 11, 12, 15, 16, 36, 41, 45, 51–53, 61, 62, 65–69, 71–76, 78–81, 85, 87–97, 100, 101, 105, 107–10; Figs. 14, 19, 20, 22–42, 45, 51; Time Line 1897: Royal Collection Trust / © Her Majesty Queen Elizabeth II 2013
Pl. 70: Collection of Charles Isaacs & Carol Nigro
Pls. 47, 82–84, 98; Fig. 3: © Royal Photographic Society / National Media Museum / SSPL
Pl. 111; Figs. 16, 44, 53; Time Line 1838; p. 206: Getty Research Institute
Fig. 11: Photo: NGC
Fig. 12: Tate, London / Art Resource, NY
Fig. 15: Courtesy of the Council of the National Army Museum, London
Fig. 43: Yale Center for British Art, Paul Mellon Collection
Fig. 48: © National Portrait Gallery, London
Figs. 49, 50: By permission of University of Glasgow Library, Special Collections
Time Line 1876: © Trustees of the British Museum

CONTENTS

FOREWORD

IN JANUARY 1839 PHOTOGRAPHY WAS ANNOUNCED TO THE WORLD. A YOUNG QUEEN VICTORIA had been monarch for less than two years, but her initial interest and subsequent embrace of this new medium developed into a passion that continued through her entire reign. As the first British monarch to have her life fully recorded by the camera, Victoria's image became synonymous with an entire age. Now, 175 years later, we take this opportunity to celebrate both the anniversary of photography and the queen's relationship with it, through a collection of images that portray the evolution of the medium and the monarch.

Surrounded as we are today by photographic images, it is difficult to imagine a time when such pictures did not exist. But in the early correspondence between the key progenitors of the medium, their sense of wonderment and excitement at the "miraculous" nature of this new art is palpable. Upon first viewing early samples of William Henry Fox Talbot's photogenic drawings, the queen herself was moved to remark—with typically Victorian understatement—that the images were "curious." The first few years of photography saw an evolving medium that was quickly refined and improved upon, to the point that, by the early 1840s, portraiture was clearly destined to be one of its major applications. In 1842 Queen Victoria's husband, Prince Albert, sat for the first royal portrait in the photographic studio of William Constable in Brighton, England. While the queen made mention of this historic event in her journal, it would appear that she did not sit for the camera on this occasion.

Indeed, it was not until several years later that Victoria presented herself in her first photograph, not as crowned monarch, but as mother to her eldest child, the Princess Royal. Although the photograph itself no longer survives, the image of Victoria as a mother was a lasting one that was repeated many times in photographs from the 1850s onward. Added to the maternal display was that of the loving wife, typically showing Victoria and Albert as the devoted couple that they were. When the prince consort died at the age of forty-two, the queen entered into a period of deep mourning that similarly was captured by the camera. This tragic event coincided with a critical shift within the medium of photography, as the ubiquity of cheap prints led to a rapid commercialization of the medium. The queen unwittingly became part of this phenomenon, her image capable of selling photographs in the millions to an ever-hungrier audience eager to "see" the queen. As the nineteenth century progressed and Britain's reach extended to all corners of the world, the image of Victoria became truly global—the first ever to do so.

From the earliest years of photography, the queen's influence on the success and dissemination of the medium was felt. From patronage of photographers such as Roger Fenton to supporting the newly formed Photographic Society, the royal seal of approval was instrumental in the overall

reception of this new art. Together with Prince Albert, Victoria amassed one of the earliest collections of photography in the world, selections from which are reproduced here alongside a wider representation of photographs from the nineteenth century, providing a cultural and visual context for this royal passion.

Since its inception in 1984, the J. Paul Getty Museum's Department of Photographs has actively collected nineteenth-century material ranging from early daguerreotypes and salted paper prints to popular cartes de visite and stereographs. This publication and the accompanying exhibition feature many of the most important such works from the Getty Museum's permanent collection, shown alongside significant loans from the Royal Collection, United Kingdom, the National Media Museum, Bradford, the Getty Research Institute, and the collection of Charles Isaacs and Carol Nigro, New York. I wish to thank all the lenders for their generosity and especially to acknowledge the permission of Her Majesty The Queen to both lend and reproduce items from the Royal Collection.

The exhibition has been conceived and organized by Anne Lyden, international photography curator at the National Galleries of Scotland, Edinburgh, and former associate curator of photographs at the J. Paul Getty Museum, who also authored two of the essays in this publication. Our thanks and appreciation are due to her and to her two collaborators and fellow authors, Dr. Sophie Gordon and Dr. Jennifer Green-Lewis.

Timothy Potts, *Director*
The J. Paul Getty Museum

Acknowledgments

EMBARKING ON A PROJECT OF THIS MAGNITUDE—PARTICULARLY ONE CONCERNING Queen Victoria—is not a solo task, but one that necessitates the involvement of many individuals and institutions, and I offer my sincerest thanks to all. I gratefully acknowledge the permission of Her Majesty The Queen Elizabeth II to reproduce items from the Royal Collection and to consult documents in the Royal Archives. I also wish to thank my fellow contributors, Dr. Sophie Gordon, senior curator of photographs at the Royal Collection, Windsor, and Dr. Jennifer Green-Lewis, associate professor of English at the George Washington University. Both of them have my deepest gratitude and respect for their engaging essays featured in this book. I am forever indebted to Sophie, who provided not only physical access to the photographs at Windsor Castle but generously shared her wealth of knowledge and insights into the collection itself.

In the Department of Photographs at the J. Paul Getty Museum, I would like to thank Judith Keller, senior curator of photographs, who offered guidance and enthusiastic support to the project's successful completion. My fellow colleagues in the department, past and present, all provided assistance over the course of the last few years, and I thank them all: Lindsay Blumenfeld, Linde Brady, Cheryl Coulter, Virginia Heckert, Karen Hellman, Miriam Katz, Arpad Kovacs, Chelsea Larkin, Amanda Maddox, Paul Martineau, Tami Philion, Marisa Weintraub, and Edie Wu. In addition, I extend my gratitude to the former graduate interns, Vanessa Fleet and Alison Pappas, who contributed greatly to the formation of the time line included in this book.

A nineteenth-century project like this one, which includes fragile material and unique works, can present a particular challenge for paper conservators, and I am indebted to Marc Harnly, head of the Department of Paper Conservation at the Getty Museum, and his colleagues, Ernie Mack and Sarah Freeman, for their expertise and wise counsel. Lynne Kaneshiro and Stephen Heer prepared the Getty objects for inclusion in the accompanying exhibition, always ensuring the highest standards were kept.

I am grateful for the support of Timothy Potts, director of the J. Paul Getty Museum, for his leadership and vision, and Thomas Kren, associate director for collections, who championed the project from the very beginning.

Kara Kirk, publisher, and her expert staff in Getty Publications have my utmost thanks and praise for their work on this book—in particular, Beatrice Hohenegger, editor, whose editorial skills are greatly appreciated, along with her wit, intelligence, and life-coaching talents, but also Jane Bobko, freelance copy editor, and Greg Dobie, freelance proofreader. Jim Drobka designed the book, and his enthusiasm for the project resulted in a very beautiful publication with exquisite details. Amita Molloy, production coordinator, not only saw to it that the book came together as it should and when it should but was a constant advocate of the project and the ideas that unfolded along the way. Thanks are also due to Pam Moffat, photo researcher, who assisted with the request of the figure illustrations for all four essays, and Ruth Lane, whose assistance on the time line came at a critical moment. My warmest thanks are extended to Robert T. Flynn, editor in chief, for his constant and genuine collegiality.

As is the case with a publication and exhibition of this size, many people are involved in the various stages of development, and their contributions are all critical to the overall success of the project. In the Office of the Registrar, Leigh Grissom and Cherie Chen diligently requested images from each of the lenders for reproduction in the publication, while Sally Hibbard and Grace Murakami skillfully managed the loan process to bring all the objects to Los Angeles. In Imaging Services, thanks are due to Gary Hughes, Kevin Murphy, Michael Smith, and Brenda Smith. I would like to offer my sincerest thanks to the following Getty colleagues: Tuyet Bach, Cathy Bell, Erik Bertellotti, Brian Considine, Chris Cook, AnneLise Desmas, Nina Diamond, Maria Gilbert, John Giurini, Elie Glynn, Quincy Houghton, Chris Keledjian, Amber Keller, Michael Lira, Kevin Marshall and his team, Merritt Price, Donna Pungprechawat, Kirsten Schaefer, Karen Schmidt, Ali Sivak, Toby Tannenbaum, Karen Voss, Christina Webb, and Deenie Yudell. I also extend my gratitude to the staff at the Getty Research Institute for assistance in the Special Collections department and for generously agreeing to lend key prints from their holdings. In particular, thanks are offered to David Brafman, Thomas Gaehtgens, Irene Lotspeich Phillips, Marcia Reed, Mary Sackett, Fran Terpak, Stephan Welch, and Kevin Young.

This project also drew on the generosity of several lenders and institutions from the United States and the United Kingdom. I am very grateful to all of them for opening their collections to me and for their willingness to lend artworks. At the Royal Collection, I gratefully acknowledge the support of Jonathan Marsden, director, and the Hon. Lady Roberts, royal librarian and curator of the Print Room. Over the course of my numerous visits to Windsor I was very ably assisted by the following staff members: Tatiana Bissolati, Lisa Heighway, Kathryn Jones, Alessandro Nassini, Louise Pearson, Lauren Porter, Jemima Rellie, Desmond Shawe-Taylor, and Paul Stonell. In addition, I wish to thank Pam Clark and Jill Kelsey at the Royal Archives, Windsor. At the National Media Museum, Bradford, thanks are due to Toni Booth, Paul Goodman, Colin Harding, Brian Liddy, and Philippa Wright. I would also like to thank Charles Isaacs and Carol Nigro, New York, for lending a rare Kilburn daguerreotype from their personal collection.

Early on in my research I had the opportunity to participate in the Royal Collections Studies Course run by the Attingham Trust and wish to express my sincerest thanks to Giles Waterfield, director, and his colleague, Sara Heaton, for their support and encouragement. Over the last few years I have benefited immensely from the knowledge and expertise of many colleagues, collectors, and photographers from around the world, in particular: Martin Barnes of the Victoria and Albert Museum; James Berry of the National Galleries of Scotland; Donald Blumberg; Julian Cox of the Fine Arts Museums of San Francisco; Duncan Forbes of the Fotomuseum Winterthur; Hope Kingsley of the Wilson Centre for Photographs; Hans P. Kraus; Brian May; Alison Morrison Low of the National Museums of Scotland; Alex Novak; Pam Roberts; Sara Stevenson of the University of Glasgow; and Jane and Michael Wilson.

Special thanks are due to Roger Taylor, whose understanding and knowledge of the nineteenth century is unparalleled. I will be forever grateful to him and his wife, Chris, for their generosity of time, support, and expertise.

Lastly, I extend my warmest thanks to the following friends, each of whom participated in the project and supported me in his or her own way: Marie Christie and Ian Crook; Julie Cunningham and Anne Fursey; Elizabeth Escamilla, Carl Lawton, and Zachary Lawton; Anne Louise McCusker; Anne McNeill; Tim McNeil; Dee and Lee McPherson; JoAnn and Raphael Mejia and their family; Beth Morrison; and Vicki Porter. Thanks to my Scottish and American families: Claire and Ramy Booth; Maureen and Pat Lyden; and Mary and Rudy Muniz. I am eternally grateful to Christopher Muniz for his unending and unconditional support throughout the entire project and beyond. And finally, I will be forever delighted by Orla Muniz, whose affection for a queen born 189 years before her often brought a smile to my face.

Anne M. Lyden

THE INVENTION OF PHOTOGRAPHY IN THE VICTORIAN WORLD

JENNIFER GREEN-LEWIS

EARLY DAYS: PHOTOGENIC DRAWING AND THE DAGUERREOTYPE

ON MAY 9, 1839, THE SCIENTIST AND ASTRONOMER SIR JOHN FREDERICK WILLIAM HERSCHEL wrote from Paris to William Henry Fox Talbot, a close friend and longtime scientific correspondent:

> Though much pressed for time I cannot resist writing to you first to say that I have this moment left Daguerre's who was so obliging as to shew us all his Pictures on Silver saved from the fire which burned his house and also one on glass.—It is hardly saying too much to call them miraculous. Certainly they surpass anything I could have conceived as within the bounds of reasonable expectation. The most elaborate engraving falls far short of the richness & delicacy of execution[;] every gradation of light & shade is given with a softness & fidelity which sets all painting at an immeasurable distance.
>
> His *times* also are very short. —In a bright day 3 m suffices for the full effect up to the point where the lights become excessive. In dull or rainy days & in the interior of an apartment (for copying sculptures and pictures) from 5 to 10 m are requisite.[1]

It is understandable that Herschel (1792–1871) was thrilled by his springtime visit to Paris. Louis-Jacques-Mandé Daguerre's discovery had been announced to the public on January 6, 1839, in the newspaper *Gazette de France,* and the story, with its description of his "beautiful designs," received attention from both the British and the American press.[2] However, following the announcement, Daguerre (1787–1851) was involved in protracted negotiations with the French government regarding purchase rights to his process, and for almost eight months, between January and August, there was no explanation forthcoming as to exactly how he had accomplished this feat, or what chemical processes or materials might be involved. Outside France, few people had actually seen a daguerreotype.

After reading about Daguerre's accomplishment in the paper, but as yet having no idea how he had done it or what kind of images had been produced, Herschel spent much of January trying to figure it out for himself. The big question was how one might fix an image on a light-sensitive surface and render it permanent. Within just a few days, the industrious Herschel had come up with an answer: "Tried hyposulphite of soda to arrest action of light by washing away all the chloride of silver or other silvering salt," he wrote in his notebook on January 29, 1839. "Succeeds perfectly."[3]

As he would later learn on his trip to Paris, this process had little in common with Daguerre's. Whereas the Frenchman produced his one-of-a-kind images on sheets of silver-plated copper, Herschel had been experimenting on paper made sensitive to light with silver salts. The paper-based process produced images that were pleasing in part because of their rather misty, impressionistic effects; they lacked the extraordinary clarity and detail of the daguerreotype. Indeed, as Herschel reportedly remarked to François Arago, director of the Paris Observatory and the issuer of his invitation to view Daguerre's work, the paper process "produces nothing but vague, foggy things. There is as much difference between these two products as there is between the moon and the sun."[4]

Herschel's reaction to the markedly different look of the daguerreotype and, in his view, its superior achievement was thus generous as well as ecstatic. His letter to Talbot from Paris continues:

> The beautiful effect of River Scenes *in rain* must be seen to be appreciated. Sculptures are rendered in their most minute details with a beauty quite inconceivable.
>
> In scenes of great detail, every letter in distant inscriptions—every chip in the corner of every stone in every building is reproduced & distinctly recognizable with a strong lens[. A]ll the paving stones in *distant* chaussées are faithfully rendered.
>
> In short if you have a few days at your disposition I cannot command you better than to *Come & See*. Excuse this ebullition.[5]

It's highly likely, however, that Herschel's "ebullition" was *not* excused; in fact, every sentence of this letter must have set its recipient's teeth on edge.

Talbot (1800–1877), too, had been preoccupied with fixing camera images, but for much longer—ever since the summer of 1833, while honeymooning in Italy. In his attempts to sketch the scenery there, Talbot turned to the popular drawing device called the camera lucida. Through the use of lenses, it permitted the optical illusion that the scene surveyed or the object studied was superimposed on the paper before the draftsman. Talbot found it of little help in sketching the landscape, but it reminded him of something he had tried in Italy with a camera obscura some ten years prior, using "transparent tracing paper laid on a pane of glass in the focus of the instrument." The objects on which the apparatus was trained could be seen on the paper and traced with a pencil. It now occurred to Talbot that it might be possible "to cause these natural images to imprint themselves durably, and remain fixed upon the paper!"[6]

Early the following year, at home in England, Talbot set himself to work to find a means of sensitizing paper. This he had accomplished by the end of February 1834, with the use of silver chloride. He washed the paper in a salt solution and then brushed it with silver nitrate (which combined with the salt to form silver chloride). By placing small objects such as leaves or a piece of lace on the now light-sensitized paper outdoors in sunlight, he was able to temporarily produce an image, in negative—what we might now call a photogram and Talbot then called a "copy."

Talbot knew that if after the image was made the paper might be rendered no longer sensitive to light, the image could be permanently fixed and, just as significant, he might be able to reproduce multiple, positive instances of it. His initial attempts at fixing by use of a strong salt solution were not fully successful, however, and these first images, though lasting long enough to be viewed and admired, ultimately tended to fade away. Talbot called them "reversals."

Possibly the earliest mention of Talbot's temporary successes comes in a thank-you note from his sister-in-law Laura Mundy on December 12, 1834:

> Thank you very much for sending me such beautiful shadows, the little drawing I think quite lovely, that & the verses particularly excite my admiration, I had no idea the art could be carried to such perfection—I had grieved over the gradual disappearance of those you gave me in the summer & am delighted to have these to supply their place in my book.[7]

It seems likely that those "beautiful shadows" were photograms, but the "little drawing" was probably the result of Talbot's further experimentation, now with wood boxes, in an effort to capture the image that might be thrown by light through a glass lens onto sensitized paper.

Throughout the spring, and the unusually sunny summer, of 1835, Talbot continued to set up box cameras on the grounds of his country house, Lacock Abbey. One negative from those months—the image size is less than an inch square—is preserved today in Bradford, at the National Media Museum, with a note written by Talbot: "Latticed Window (with the Camera Obscura) August 1835.—When first made, the squares of glass about 200 in number could be counted, with the [*sic*] help of a lens" (fig. 1).[8]

More than two years passed, during which time Talbot did not hurry to make public his process—presumably because he was still unable to satisfactorily resolve the problem of fixing the image. The images from the summer of 1835 ultimately began to fade away; Lacock Abbey's two

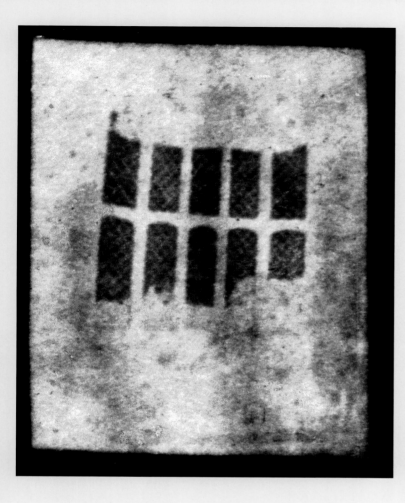

hundred panes of glass, initially so miraculous in their detail, could not be retained. Finally, however, in November 1838, Talbot returned to the topic and began to draft a paper on his findings to present to the Royal Society. And then, just after the New Year in 1839, came the announcement of Daguerre's accomplishment. Lacking details about what, exactly, Daguerre had been able to produce, able to learn only that in some way Daguerre, too, had managed to fix camera images made by light, Talbot felt surprised, affronted, and even cheated out of his role as photographic pioneer.

Talbot didn't want to wait to find out how Daguerre was making *his* images permanent; it was in Talbot's interest to prove that he knew nothing about Daguerre's results and that his discoveries took precedence over them. Talbot, as we know, had not solved the problem of the gradual disappearance of the images that had been so beautifully captured on paper. Nonetheless, galvanized by Daguerre's announcement, he rushed to present some examples of his own process to the Royal Society on January 25, and on January 31 he read a hastily drafted paper to the society explaining exactly how and when he had made his images of "flowers and leaves; a pattern of lace; figures taken from painted glass; a view of Venice copied from an engraving; some images formed by the Solar Microscope...various pictures, representing the architecture of my house in the country; all these made in the summer of 1835."[9] On January 25 he also wrote to Sir John Herschel, who had been following the story with interest, to tell his old friend that he himself had in fact "discovered about five years ago...the possibility of fixing upon paper the image formed by a Camera Obscura; or rather, I should say, causing it to *fix itself*."[10]

It's a little surprising that Talbot, despite a correspondence of many years with Herschel on matters scientific and horticultural, appears not to have previously mentioned to him any of the experiments at Lacock Abbey with cameras. Was his motive competitiveness? Was it a desire to bring his "photogenic drawing" (as he called his process) to more sophisticated and permanent ends before sharing it with the rest of the world? Whatever the reasons for his earlier silence, now that news of Daguerre's invention was being covered by the leading scientific publications of the

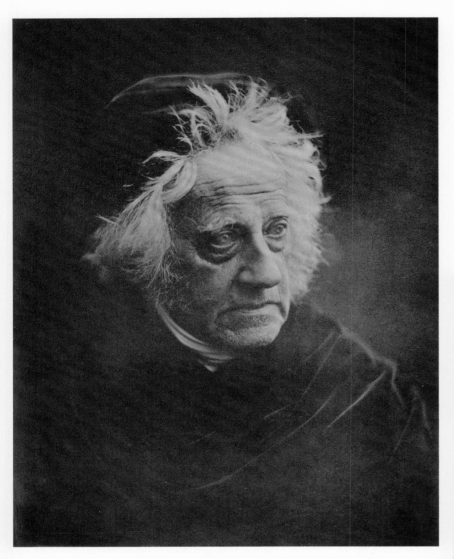

FIGURE 2
Julia Margaret Cameron (British, born India, 1815–1879),
Sir John F. W. Herschel, 1867. Carbon print, 29.8 × 23.2 cm
(11¾ × 9⅛ in.). Los Angeles, J. Paul Getty Museum, 84.XM.349.4

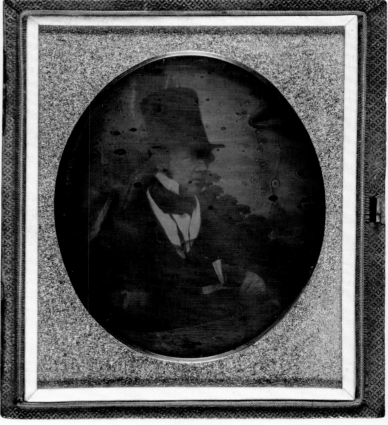

FIGURE 3
Antoine Claudet (French, 1797–1867), *Portrait of William
Henry Fox Talbot*, ca. 1844. Daguerreotype, 9.5 × 8.4 cm
(3¾ × 3⁵⁄₁₆ in.). Bradford, National Media Museum,
2003-5001/2/20882

day, Talbot decided it was time that Herschel should call on him in London to view "specimens of this curious process."[11]

On January 27, however, Herschel wrote back from his country house in Slough to say that he was unable to get to town, owing to "many engagements to say nothing of a rheumatic affliction which confines me a large portion of each day to my bed."[12] Talbot would have to pay a visit to Herschel instead.

Since Herschel's entry in his personal notebook regarding his success with sodium hyposulphite as a fixing agent is dated only two days after that, on January 29, it's hard not to imagine the astronomer (fig. 2) in his dressing gown, feeling under the weather (or possibly not), but nonetheless trying to come up with his own fixer before Talbot (fig. 3) could show up in Slough with his "specimens." In any event, the day after his discovery, on January 30, Herschel wrote again to Talbot, alerting him to his latest findings: "I have myself been thinking since I got your note about this enigma.... If the whole of the unreduced Chloride be *washed out* of *the paper* which may be done *instantaneously* and *to the last atom* by a process I have discovered—leaving the reduced silver still on the paper in the form of a fine Brown or Sepia tint—our picture becomes permanent." Herschel then revised this letter, adding in a postscript to the second version that "on trial the Hyposulphite appears to answer perfectly the end."[13] So it was that on Friday, February 1, 1839, Talbot, carrying his "Camera Obscura pictures"[14] with him, took a day-return ticket on the new train down to Slough.

Herschel's work with "hypo," Talbot discovered, did indeed answer "perfectly the end" and was a vital contribution to the progress of this as yet unnamed art. Moreover, in contrast to Daguerre, who was preoccupied with secrecy, Herschel had no reservations about sharing his discovery of the fixing process. He permitted Talbot to make the findings public, with the result that following their publication by the French Academy of Sciences, hypo was picked up by Daguerre himself.[15] Today, Herschel is also credited with coming up with the umbrella term used to describe the work of both Daguerre and Talbot—*photography*—a word that would be formalized by Talbot a couple of years later in a public letter to the *Literary Gazette*. And in May 1839, just three months after Talbot's visit to Slough, Herschel was one of the few British scientists invited by Arago to go to Paris to see what it was that Daguerre had produced.

It's hard, then, to imagine that when Talbot received Herschel's letter from France he could have been as enthused as his friend was by the evident superiority of the daguerreotype. But one thing, at least, was finally clear to everybody: the two processes, English and French, were very different.

PHOTOGRAPHY AND THE VIEW FROM THE COUNTRY HOUSE

LET'S RETURN FOR A MOMENT TO FEBRUARY 1, 1839, AND THE AFTERNOON OF TALBOT'S VISIT to Slough to show Herschel his "specimens." Although the winter weather was miserable, 1839 was shaping up to be an interesting time for an English gentleman of leisure with solid financial resources. A new and young queen was on the throne; the empire was expanding; change was in the air. Despite the economy's having slowed in recent years, trade and travel had been energized in the late 1830s due in part to new and more time-efficient modes of transportation such as steamboats and the railroad. Interest rates were rising, though soon the government would cut them, leading to increased investment in more profitable private railway futures. There was no sign yet of the overheated market of the mid-1840s that would lead to the collapse of the railway bubble and widespread financial ruin for thousands. Politically as well as financially, it was a time of reform and change—and of dissent regarding those changes and resistance to many of them. The previous year, the Chartist movement had failed in its lobbying effort to extend voting rights to all males and for annual elections to be held for the House of Commons, though those changes were eventually to be made later in the century. Talbot himself was a moderate reformer, largely sympathetic to the Whig party, and had served as a member of Parliament for Chippenham between 1832

and 1835, so if he had picked up a newspaper to read on the train, he might have been interested in following that day's political events.

He certainly had a far greater choice among publications than ever before, as reduced tariffs on stamps and paper continued to lower the production costs of daily publications. We know that he was a regular reader of weeklies such as the *Literary Gazette* and the *Athenaeum*. For daily news coverage, however, he would likely have had a copy of the *Times*, a newspaper that began circulating in 1785 as the *Daily Universal Register*. If he had the paper with him on the ride to Slough, he might well have been following the stories it contained on some of those reforms that had been pushed through earlier in the decade during his tenure in Parliament.

There was plenty of political interest to read about that particular day, including an account of the consequences of the new Poor Law as well as an article about a recent gathering of concerned parties to discuss the state of the current Corn Laws. There was a lengthy piece on the coal trade, with an account of a recent dinner hosted by the Newcastle chamber of commerce, attended by the mayor, several members of Parliament, and various wealthy owners and investors. Talbot might also have been interested in reading about a "curious telegraphic system"[16] tried out the previous week in Paris, or about Queen Victoria's recent private visit to the theater at Drury Lane to see the famous American wild-animal trainer, Mr. Van Amburgh, feed his animals on the stage. In the London law courts, owners of premises in Lower Thames Street were petitioning against extending the Blackwall railway as far as Fenchurch Street, while the *Monthly Chronicle* was bringing a copyright suit against a new magazine, the *Railway Times*, over an article published the month before. Over at the Admiralty, the court was considering the case of the *Aline*, a Russian schooner with a cargo of flax, which had collided in the channel with the *Panther*, a brig with a cargo of oil sailing from Gallipoli to Saint Petersburg.

The financial news that day was good: there was "no fluctuation of any consequence in the funds," and railway shares were stable; news of the failure of some cotton houses in Manchester had apparently not affected the wider market. Cotton prices in Liverpool were "without change . . . mostly steady." In the classifieds, the China Tea Company was reducing its prices, as was the East India Tea Company; coal remained steady, between twenty-nine and thirty shillings a ton. Textiles from the northern mills, as well as imported linens and general haberdashery, were on offer: "Moravian, Trafalgar and French embroidery cottons" along with "knitting and netting cottons, Taylor's Persian thread on reels, netting silks, Berlin patterns and wools."

If Talbot looked at the births and deaths that day, he might not have noticed, as a twenty-first-century reader does, the relative youth of those who had just died, or that the cause of death of the sixteen-year-old daughter of the American consul in London was consumption, a disease that would become familiar to the post-Victorian world largely through the pages of novels that were mostly yet to be written. There is no mention of Dickens in the *Times* that day, though he was well known by 1839 and already feeling decidedly overextended. He had published *Oliver Twist* the year before, and with too many writing commitments on his desk, had decided just that past Monday to resign his editorship at *Bentley's Miscellany* in order to finish up *Nicholas Nickleby* and make some progress with *Barnaby Rudge* (for which he had to beg a six-month extension). Dickens's future literary rival William Thackeray was working as a lowly reviewer for the *Times*, but in that day's book column the focus was not on fiction but on the just-released twelfth volume of the Duke of Wellington's dispatches, allowing the anonymous reviewer (Thackeray?) to indulge in some unabashed hero worship. Wellington (pl. 9) was for many Victorians the embodiment of glorious military history, and he provided a living link between the modern age and what was beginning to feel like the distant past of the Napoleonic Wars. Jane Austen was long dead. The Battle of Waterloo, to be fictionalized later by Thackeray in his best-selling historical novel *Vanity Fair*, already seemed to belong to another age.

Maybe Talbot skipped the book review to look at the society pages: the Duke of Cambridge had gone to Kew Park the day before for a day's shooting; Viscount Melbourne and Lord Hill had held audiences with the queen. Charles Darwin's marriage earlier in the week did not make the news that day, though in 1839 his name probably didn't ring much of a bell for Talbot. Paul Cézanne had

also just been born, though Talbot wouldn't have seen that particular birth announcement in the *Times*, any more than he would have paid attention to the birth later that year of Walter Pater, future aesthete and literary role model for the future Oscar Wilde. In April 1839, just two months away, the world's first commercial electric telegraph line would come into operation. In July, slaves aboard the *Amistad* would rebel and capture the ship. Also in July of that year, the First Anglo-Afghan War would begin, as would, in September, the first Anglo-Chinese Opium War.

Of course, it's possible that Talbot did not read the newspaper at all, but rather looked out the window and experienced the novelty of the train ride. The public railway had been founded in 1825 and only very recently connected London with that part of Buckinghamshire where Herschel lived. The countryside, it seemed, was getting closer to town. One might now make in an hour a journey that had previously taken half a day or more; for the first time, one could, as Talbot did that afternoon, run down to Slough, stay for dinner, and return to London by train the same day. The speed with which it was possible to move through space on land and sea meant that distances were in effect getting smaller. By 1852 the travel time between London and Scotland would lessen so significantly that Queen Victoria could regard the Highlands as a holiday destination and purchase a residence there.

Whereas the reach of empire was expanding, as the many newspaper notices of docking and departing ships attested, it *felt* as though geographical distances were shrinking and the rest of the world was coming closer.

On a grander scale, through refinements in the telescope during the eighteenth century, previously unknown star clusters were being cataloged, and the 1830s (1839 in particular) saw fierce competition among astronomers to calculate with greater precision interstellar distances. Scientific achievement had never seemed more extraordinary or, literally, so far-reaching. At the same time, geological theories concerning the age of the world and the circumstances of its coming into being rendered human beings ever smaller in the history of the cosmos. The vastness of the universe in time and space challenged the religious and philosophical certainties of many nineteenth-century minds.

One who had already made a contribution to the conceptual shrinking of space, by building a new kind of telescope in 1816, was John Herschel. In January 1839, as his letters to Talbot suggest, he was suffering from the dreariness of the English winter weather after having spent the previous five years in South Africa charting the night sky of the Southern Hemisphere. When Herschel returned to England in 1838, he received a baronetcy for his contributions to human knowledge and settled comfortably back into the life of an educated gentleman with scientific interests. When Talbot visited him in Slough that Friday afternoon, Herschel had spent all week in the country, pursuing his experiments there just as Talbot liked to do in his own study at Lacock Abbey in Wiltshire.

It's worth pausing Talbot's train just a little longer to acknowledge the social context in which photography in England came into being. That context—the small world of the leisured and educated classes, with private incomes and comfortable establishments, equipped with studies and libraries in country and town—was considerably less mobile and subject to change than the busy new world documented by the *Times*, a world of commerce, industry, financial speculation, and technological innovation into which many Victorians felt themselves to be moving at alarming speed. Yet the earliest photographs betray little evidence of an unstable or shifting world, all the changes underway in the 1840s notwithstanding. For the first decade of photography's existence, it was what we might call the "view from the country house"—orderly, serene, pleasing—that provided subjects for the camera and gave history its first glimpses of Victorian life.

We don't know what images Herschel shared with Talbot, but we do know that Talbot's included not only those tracings of lace and leaves that had so charmed his sister-in-law but also a number of pictures of his house. These had been made with cameras of varying sizes (his wife referred to these wood boxes as "mousetraps"[17]) and, Talbot warned Herschel, were very different from the life-size "copies," or photograms: "The Camera Obscura pictures which I will shew you are Lilliputian ones," he wrote, "& require a lens to look at them."[18] They were "very perfect but extremely small." It was these pictures that most excited Talbot. Indeed, he had, as he noted in his paper delivered

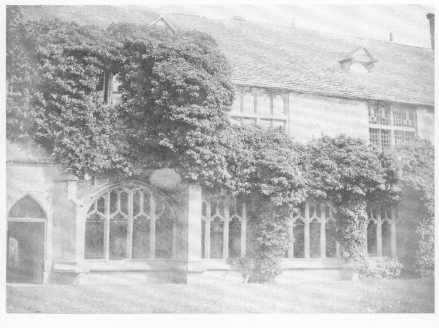

FIGURE 4
William Henry Fox Talbot (British, 1800–1877), *Cloisters of Lacock Abbey*, 1844.
From the book *The Pencil of Nature*. Salted paper print from a paper negative,
16 × 21.4 cm (6⁵⁄₁₆ × 8⁷⁄₁₆ in.). Los Angeles, J. Paul Getty Museum, 84.XZ.571.16

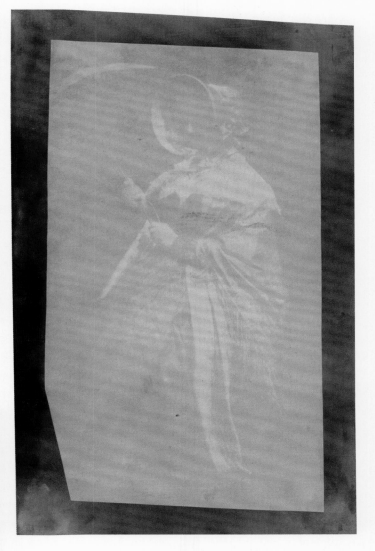

FIGURE 6
William Henry Fox Talbot (British, 1800–1877),
Lady Elisabeth Feilding, August 21, 1841. From the Brewster Album.
Salted paper print from a paper negative, 15.6 × 9.2 cm
(6⅛ × 3⅝ in.). Los Angeles, J. Paul Getty Museum, 84.XZ.574.51

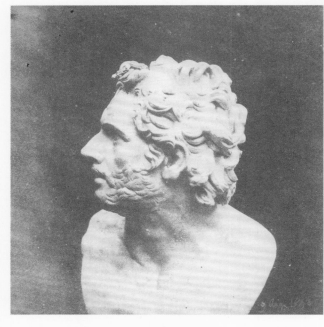

FIGURE 5
William Henry Fox Talbot (British, 1800–1877), *Bust of Patroclus*,
August 9, 1843. From the book *The Pencil of Nature*. Salted paper
print from a paper negative, 14.9 × 11.9 cm (5⅞ × 4¹¹⁄₁₆ in.).
Los Angeles, J. Paul Getty Museum, 84.XM.478.17

earlier that week to the Royal Society, made "a great number of representations of my house in the country," adding the now-famous assertion that "this building I believe to be the first that was ever yet known *to have drawn its own picture*."[19]

The first house to have "drawn its own picture" was not just any house but the thirteenth-century seat of an aristocratic family.[20] Lacock Abbey had, as Talbot said in his paper, "ancient and remarkable architecture" and was "well suited" to photography. Why well suited? For one thing, early photography, as Lady Elizabeth Eastlake was later to note, was very successful at representing old things, rough surfaces, antique textures.[21] But presumably Talbot also thought Lacock Abbey to be suited to photography because it was worth documenting. It represented a piece of English history and was valuable because it embodied continuity with an ancient past. A silent witness and backdrop to many religious and cultural changes of the previous six centuries, Lacock Abbey was significant for the nation's identity, now and in the future.

Talbot later published twenty-four of his images in a limited and pricey series, with a brief account of the history of his discovery. *The Pencil of Nature* (1844–46) suggests some of the subjects the photographer found to be picture worthy: timeworn architecture in Oxford, Paris, and Orléans; the tower and cloisters of Lacock Abbey (fig. 4); and objects Talbot had, as it were, lying around the house: glass, china, a bust of Patroclus (fig. 5), books, and a page from one of those books "containing the statutes of Richard the Second, written in Norman French."[22] These were not just any glass or china, then, and not just any book, either, but rather objects that merited a photograph; they demonstrated historical and family connection. The social world inhabited by Talbot and Herschel, and the material world represented in British photography's earliest images, rested upon the transfer of traditionalist values. Unsurprisingly, photography's first practitioners in Britain—amateurs, enthusiasts, ladies and gentlemen of leisure—chose to photograph objects whose associations were of family, national history, continuity, stability, and transcendence. The world to which those image-objects belong is the world of Lacock Abbey and other grand houses like it, houses from which the view is as curious and as charming, but arguably as unrepresentative of the larger world, as Lilliput.

FROM LACOCK ABBEY TO BUCKINGHAM PALACE

LADY ELISABETH FEILDING (1773–1846; FIG. 6), WAS A WOMAN OF STRONG OPINIONS, and one of them was that her son, Henry Talbot, should become famous for his inventions. Writing to him in February 1839, Lady Elisabeth congratulated Talbot and his wife, Constance, on the recent birth of their new daughter but moved swiftly to the real purpose of her letter: "I was quite surprized at your making the secret of the Photogenic Drawing known, it precludes entirely all chance of your making *your fortune* by selling it as M. Daguerre intended or getting a patent." Of the new arrival, she added in closing that "Horatia [Henry's half sister] proposes her name should be *Iodine* in honor of your discovery."[23]

Despite Lady Elisabeth's irritation at her son's inability, as she saw it, to profit from his scientific pursuits by being slow to publish the results ("If you would only have made it known *one* year ago, it could never have been disputed, or doubted"),[24] Talbot's mother was photography's ardent champion and energetically promoted samples of it among the family and members of her aristocratic circle. News of the accomplishment spread rapidly; everyone she knew, it seemed, was interested both in seeing the "drawings" and in learning how they might be made. Talbot sent her packets of samples for her friends. "People pillage me dreadfully," she wrote in response. "I was obliged to give some of my worst to Julia Sheffield because I really could not spare any more of the best.... Horatia took your Photogenics to Matilda who was exceedingly pleased with your having sent them. H. saw her put them with the others into a small house of carton she has constructed on purpose."[25] "Pray send me some little thing to amuse a sick friend of mine," wrote his cousin Mary Talbot from Dorchester. "She was much pleased when I showed her the little Campanula you sent me some time ago."[26] Christopher Rice Talbot, at home at Margam Hall (fig. 7), in Glamorgan, was also pleased with his "photogenic specimens": "That representing an etching has faded away since

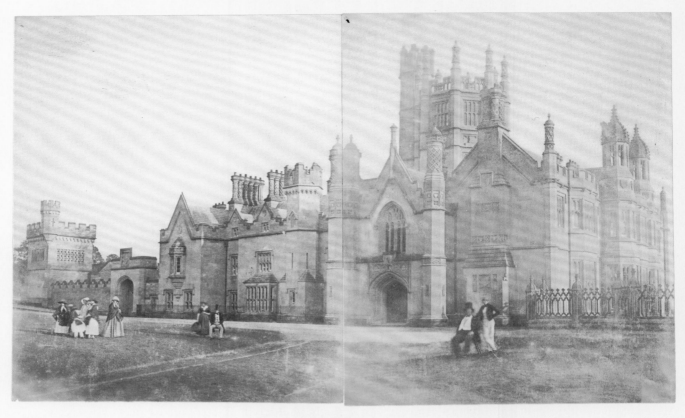

FIGURE 7
Reverend Calvert Richard Jones (British, 1804–1877), *Untitled (Two-Part Panorama Study of Margam Hall with Figures)*, ca. 1845.
Salted paper prints from paper negatives, 22.5 × 37.2 cm (8⅞ × 14⅝ in.). Los Angeles, J. Paul Getty Museum, 89.XM.75

it came, but at first, it was beautiful. Every body here is mad for photogeny."[27] Another cousin, Charlotte Traherne, wrote to Talbot from Penllergare (fig. 8), the Llewelyn family estate in Wales, that she was "charmed with the piece of lace you sent" (presumably a photogram): "It is much too pretty for you to have it again—John Llewelyn has been making some paper according to your process and they are all busy trying little scraps of lace & ribbon[. O]ne succeeded very well this morning before breakfast but the day is clouding over—Mr. Calvert Jones is quite wild about it."[28]

Talbot's discovery was all the rage among the country-house set, with both women and men taking up the new hobby. Even Constance Talbot, whose letters betray little interest in photography, worked anxiously to master the printing process so as to answer her husband's frequent requests from town for more samples of his work. Meanwhile, her mother-in-law, Lady Elisabeth, was determined to get the pictures into the most aristocratic hands, and with family connections it was surprisingly easy for her to accomplish this. Talbot's cousin Theresa Digby was a "Woman of the Bedchamber" at Buckingham Palace, officially Queen Victoria's London residence since her accession to the throne two years earlier. On April 8, 1839, Theresa wrote to tell Talbot that his half sister Caroline had sent her "an attempt at a Photogenic drawing" and that she had duly shown it to the queen, "who was very much interested with it." Naturally, Theresa now wanted Henry to send along something better: "I should like exceedingly for her to see something more worth looking at, and if you could send me one of your own doing I should be very much obliged."[29] Talbot acceded, sending some images to town from Lacock Abbey, which his mother then gave to their footman to deliver ("Wright took your Photogenics to the Palace,"[30] she informed her son). A week later he got this encouraging response from Theresa:

Many thanks for the drawings which I showed to the Queen yesterday evening after dinner, they met with universal admiration from a large party; I am sorry to tell you that the Queen was more struck by the exactness of the similitude of the *ribbon*, than the beauty of the ferns & grasses, the gauze ribbon she said was *very curious*, and she must try to do some herself.[31]

Lady Elisabeth was, of course, inclined to pursue the opening: "I understand the Queen being no Botanist admires *most* the riband you sent her. Therefore I have [a] mind to send you a bit of beautiful Point Lace which I think would have great success—shall I? I wish you would send me some more to lay on my table. Louisa has a vast number of Morning visitors expressly to see them."[32]

By April 1839 the circle of interested persons had expanded to include not only the queen but also European royalty. Lady Elisabeth could hardly contain herself with the news that a "Dr Hamel" from Hamburg had been in touch with her to get some images to send to Russia "for the Emperor's second son, a very scientific young Man. He wishes to lay some before the Czarowitch."[33] And Queen Victoria's interest in Talbot's work continued; indeed, Elizabeth Heyert makes the appealing claim that during the queen's proposal of marriage to Prince Albert on October 15, 1839, "to allay her nervousness, she talked to him first about Daguerre's newly published invention."[34] According to Victoria's diary, in March 1842 her husband posed for his own daguerreotype while the couple was staying in Brighton (see fig. 39).[35] In November 1843, Lady Elisabeth wrote to Talbot that her daughter Caroline, his half sister, now a lady-in-waiting at the palace, had "shewed those little Talbotypes you sent her lately to the Queen Sunday Evg, who was so delighted with them that C. thought herself obliged to offer them, & C. is to stick them into the Album you gave the Q. Her majesty sent for her magnifying glass to inspect them."[36]

Despite Lady Elisabeth's triumph in her son's successes with the palace, she was still inclined to focus on the lost opportunity of, first, securing a fortune through the invention and, second, claiming a place in history for the family name. When she learned, via the *Allgemeine Zeitung*, that a four-foot-long calotype had been made of "one of the most important documents of Modern times, the Treaty of Peace with the Emperor of China," she was incensed. "One copy is ordered for the Queen, to be framed & glazed & hung up at Buckingham Palace," she quoted from the paper in a letter to her son. "Why did not *you* do this for her Majesty?"[37]

PHOTOGRAPHIC PORTRAITURE

FROM THE EXCITED AND VIBRANT CORRESPONDENCE AMONG TALBOT'S FRIENDS AND FAMILY, it would seem that the invention of photography answered a long-felt need, and the potential to record human beings was almost immediately a subject for speculation. Of course, the aristocracy had always had visual access to its family past through the skills of portrait painters. In the spring of 1838, Constance Talbot had in fact been much preoccupied with having the artist and drawing teacher Robert Forster paint the small Talbot girls ("Ela cannot possibly look better or more animated than she does at present—so I think this is a favorable moment for taking her picture").[38] Her brother, as she wrote to her husband in town, "lately had *his* picture painted by Ross the famous Miniature painter."[39] But portraits of any size were pricey. In the same letter, after Forster was hired and at work on the portraits, Constance added, somewhat nervously: "I ought to have told you that Mr. Forster's charge for children's picture is from 2 to 3 guineas each figure."

Aside from Mr. Forster's fee, Constance's greatest concern was for verisimilitude: the portraits, to be successful, must look like their subjects. The degree of success obviously depended upon the skills of the artist. But with the advent of photography, perfect resemblance seemed at last to be within reach in every portrait. As Talbot himself reflected: "What would not be the value to our English Nobility of such a record of their ancestors who lived a century ago? On how small a portion of their family picture galleries can they really rely with confidence!"[40]

A more obvious rhetorical question for the modern reader appears not to have occurred to Talbot. "What would not be the value" to *all* people of a "record of their ancestors"? For while Lacock Abbey, like Buckingham Palace—or, indeed, like Margam Hall, or Penrice, or Penllergare, all great country estates owned by Talbot's extended family—contained its own valuable (if unreliable) records, in the shape of miniatures, sketches, and oil paintings representing generations of family forebears, the vast majority of people had never had access to representations of family likenesses in any form. On the first page of Dickens's *Great Expectations* (1861), Pip tells the reader: "As I never saw my father or my mother, and never saw any likeness of either of them (for their days were long before the days of photographs), my first fancies regarding what they were like, were unreasonably derived from their tombstones."[41] The idea that photography might address the posthumous invisibility of working people was tantalizing; as the *Edinburgh Review* noted in 1843, "where the magic names of kindred and home are inscribed, what a deep interest do the realities of photography excite!"[42]

Yet for all its appeal as an idea, portrait photography did not seem feasible. In 1839 and 1840, photography was expensive and time-consuming, a pleasant occupation only for those with leisure and funds to spare; but the process was also unsuited for making portraits because of the length of time it took to secure an image. Talbot's cameras were set up outdoors for thirty to ninety minutes at a stretch, and the results depended largely on the quality of light, a problem that the British weather did little to resolve (much of Talbot's correspondence makes mention of clouds, overcast skies, and generally unhelpful conditions; Herschel laments that he didn't take up photography while he was in South Africa). Daguerreotypes were similarly slow to produce, requiring fifteen to thirty minutes under good lighting conditions. As much as portraiture seemed the next, highly desirable step in photography's evolution, it was impossible to keep a living subject still long enough to produce an effective likeness.[43]

Desire for portraits, however, inspired experimentation among opticians and chemists in both America and Europe and indeed largely drove the rapid innovations that soon changed both Talbot's and Daguerre's processes. By the end of 1839 a first, early mention of success arrived in a letter from the astronomer and mathematician John William Lubbock (1803–1865) to Talbot, with the unverified news that "Daguerre has done a portrait of himself, said to be excellent."[44] This would still have been impossible for Talbot, but by September 1840, perhaps motivated in part by that report of his rival's progress, he had a significant breakthrough, with a refinement in technique that greatly diminished required exposure times. As Talbot informed readers of the *Literary Gazette*, "a much better picture can now be obtained in a *minute* than by the former process in *an hour*. This increased rapidity is accompanied with an increased sharpness and distinctness in the outlines

of the objects." On both counts, then—time and clarity of focus—Talbot's new calotype process meant that "the art has now reached a point which is likely to make it extensively useful." And, he added, "one of the most important applications of the new process, and most likely to prove generally interesting, is, undoubtedly, the taking of portraits. I made trial of it last October, and found that the experiment readily succeeded. Half a minute appeared to be sufficient in sunshine, and four or five minutes when a person was seated in the shade."[45]

Daguerreotypists were similarly eager to master portraiture. During the same month that Talbot managed to reduce exposure times, Antoine Claudet (1797–1867), a French glassmaker working in London, made progress using chlorine as well as iodine to increase the light sensitivity of the copper plates employed in daguerreotypy.[46] He launched almost immediately into competition with Richard Beard (1802–1888), a coal merchant and inventor, who controlled the daguerreotype patent rights in England (for which he had paid the high sum of eight hundred pounds, an investment that was to pay off extraordinarily well). Beard had already set up a partnership with two Americans, Alexander Woolcott and John Johnson (d. 1871), making use of a new American mirror camera that reduced the time required for a sitting to a more tolerable "one to four minutes."[47] Both Beard and Claudet rapidly opened portrait studios in London—the former in March 1841, and the latter in June the same year—and competition for customers began.

The subject of portraiture immediately surged to the fore of public consciousness. Elizabeth Barrett Browning probably spoke for many with her words to Mary Russell Mitford, who was among the first to have her picture taken:

> I long to have such a memorial of every being dear to me in the world. It is not merely the likeness which is precious in such cases—but the association and the sense of nearness involved in the thing…the fact of the very shadow of the person lying there fixed forever! It is the very sanctification of portraits I think—and it is not at all monstrous in me to say…that I would rather have such a memorial of one I dearly loved, than the noblest artist's work ever produced."[48]

In October 1840 the Edinburgh scientist David Brewster (1781–1868) wrote with gratitude for some "specimens" Talbot had sent him, but confessed, "I long for a Portrait."[49] Talbot at once obliged, and Brewster found that the two "very fine" portraits sent on loan to him as evidence "show what may be expected from the Art."[50]

That "Art" was the appropriate term to describe the calotype seems to have been the consensus among its earliest enthusiasts. Photograms, calotypes, and daguerreotypes were frequently described in the early days as "drawings" or "sketches," with the meaningful point of reference being, obviously, painting. Indeed, some of photography's first admirers seemed initially to believe that the camera had somehow painted the image before them. Certainly it was widely held among Talbot's peers that the aim of photography was to improve upon painting by imitating its accomplishment. Photography's place among the visual arts was later to be contested, but its earliest practitioners remained profoundly interested in its aesthetic power. The Reverend George Butler, Talbot's old headmaster from his school days at Harrow, begged his former pupil to turn his invention to work on "drawings of Forest Trees, the oak, Elm, Beech, &c.," as this would be "the greatest stride towards effective drawing & painting that has been made for a Century."[51] The scientist Sir Charles Wheatstone (1802–1875), the future inventor of the stereoscope, wrote to Talbot: "Your new photograph excited much interest at the Marquis' on Saturday. The artists generally greatly preferred [sic] it to the more elaborately finished Daguerotype [sic] portraits which were also exhibited there. One academician said it was equal in effect to any thing of Sir Joshua's" [Reynolds].[52]

Photography's early status as art, however, or as a practice with artistic potential, was probably due as much to its initial social context as to its aesthetic accomplishment. It was a diversion for the well connected, a pursuit with aristocratic and scientific associations. During the early 1840s those associations were strengthened, no doubt in part by Queen Victoria's interest. Photography was, as the Reverend George Wilson Bridges noted in a letter to Talbot, "certainly an aristocratic

art," and it looked as if it might remain so, since the reverend was hardly alone in finding it "rather expensive."[53] "Lady Blanche Hyems," wrote the humorist Cuthbert Bede,

> assures me that she considers Photography to be *par excellence* the scientific amusement of the higher classes.… For the present at any rate, Photography has the patronage of aristocratic—may we not add, Royal?—amateurs. It has not yet become too common; nor indeed is it likely to become so. The *profanum vulgus* keep aloof from it; it is too expensive a pastime for the commonalty. And, whatever the progress of the invention may do toward cheapening the apparatus required by the Photographer, yet, I am inclined to believe that, at present it is only people with long purses who can afford to take up Calotyping as an amusement. And, more than this, it is only people with plenty of spare time on their hands who can afford to pay attention to it.[54]

For all Bede's satirical tone, he was accurate in his observation that photography remained not just a cumbersome but a pricey hobby—a fact that limited its wider use throughout the 1840s, despite Reverend Bridges's sentiment that it was, of all the arts, "the most astonishing of modern times."[55]

THE WIDENING CIRCLE

AS THE MAKING OF BOTH DAGUERREOTYPES AND CALOTYPES BECAME MORE WIDELY understood and practiced, and as the evolution of both processes led to better results, advertisements in the *Times* and other papers began to offer a variety of competing services (fig. 9), such as "coloured and non-inverted daguerreotype portraits" or "a separate room for ladies, with the attendance of a respectable female." These notices, running daily in the classifieds of major newspapers during the 1840s, were evidence of small refinements in photography, such as hand tinting, that had come into vogue around the same time that the issue of image reversal in daguerreotypes had been resolved. Photography's first professional "operators," aiming at a high-end market, stressed respectability, legality (patent cases regarding the daguerreotype were frequently in the press), speed, and likeness. "The sitting does not exceed half a minute," assured one advertisement, adding that "the portrait is a stamp of the original, and produces in effect a second self."[56]

Prices continued to be high. Claudet, who advertised his services in the *Times* in both kinds of photography, charged from one to four guineas for his daguerreotypes, and one guinea for a calotype portrait the size of half a sheet of letter paper (4¾ × 6½ in., or 12.1 × 16.5 cm)—and seven shillings sixpence for every extra copy. Beard charged two guineas for one daguerreotype sitting (approximately what Constance Talbot in 1838 was expecting to pay for her daughters' painted portraits). Lesser-known photographers were more affordable, though for the most part they could stay in business only if they were able to avoid paying the licensing fees. The price of a quarter-plate daguerreotype (3¼ × 4¼ in., or 8.3 × 10.8 cm) was estimated by the *Edinburgh Review* in 1843 at "five or six shillings."[57] Cases and frames, however, were ornate and expensive, and even the smallest pictures remained out of reach for many working people.[58] The limitations put on British photographers as a result of patents on both the daguerreotype and calotype significantly limited photography's use and kept prices high.

In America, by contrast, there was no patent to contend with. A daguerreotype made in New York was initially not cheap—according to the photographer and historian Bill Jay, the cost of a sixth plate (3¾ × 3¼ in., or 9.5 × 8.3 cm) was about five dollars, which in the 1840s might be a week's wage for the average American worker.[59] However, within just a few years, demand became so high that thousands of picture-making establishments opened across the United States. Prices were pushed down and production soared. Thus while in 1852 there were, according to Elizabeth Eastlake in the *Quarterly Review*, only seven officially listed photographers in the London directory,[60] in New York the previous year, according to the *Scientific American*, there were "127 operators, and thousands upon thousands of pictures … taken every year."[61] Americans were clearly as enthusiastic about photography as their European counterparts. At the Great Exhibition of 1851, three of the five medals awarded for daguerreotypes were won by Americans.[62]

COLOURED and NON-INVERTED DA-
GUERREOTYPE PORTRAITS, by Mr. CLAUDET's IM-
PROVED PROCESS; are taken only at the Royal Adelaide Gallery, or
No. 18, King William-street, Strand. The portraits are coloured by
Mr. M. Mansion, an artist of great skill and taste. A separate room for
ladies, with the attendance of a respectable female. As for the merit
of his productions, Mr. Claudet begs only to submit them to the inspec-
tion of the public.

DAGUERREOTYPE PORTRAITS, with the
last improvements in colouring, continue to be taken very suc-
cessfully at the Gallery, 183, Strand, three doors from Norfolk-street,
by Mr. BRIGHT, under a licence from Mr. Beard, sole patentee.
Paintings and drawings copied, satisfactory ones being guaranteed. The
fidelity, richness of tone, and extreme beauty of the detail in these
pictures, as produced at this establishment, far exceeds the happiest
efforts of the most skilful painter, while the great reduction in prices
places them within the reach of all classes. Sunshine not at all neces-
sary. Hours 10 till 5 o'clock.

COLOURED DAGUERREOTYPE PORTRAITS
(under Beard's patent), so highly praised by the public journals,
are TAKEN daily at Mr. JOSEPH's Establishment, 62, Piccadilly,
corner of Albemarle-street. For the information of those who may not
have studied this most interesting and marvellous art, Mr. J. begs to
state the sitting does not exceed half a minute, thus avoiding the delay
and tedium attending frequent and protracted sittings, and ensuring by
the nature of the process a true and faithful likeness both of face, figure,
dress, expression, &c.; in fact, the portrait is a stamp of the original, and
produces in effect a second self.

PORTRAITS, Landscapes, Copies of Paintings,
&c., by the Agency of Light.—Mr. BEARD's recent improve-
ments in the DAGUERREOTYPE INVENTION have been
honoured with the following, among other notices, by the leading
public journals :—" We witnessed with great gratification the improve-
ments Mr. Beard has lately effected."—Morning Herald. " The por-
traits are now fixed on the plate in all their natural hues of colour."—
Britannia. " They exhibit a degree of boldness and stand out with a
relief greatly desiderated in all the earlier specimens."—The Times.
" The fidelity of the likeness is wonderful and the effect imparted by Mr.
Beard's new process of colouring is extremely beautiful."—Critic. " As
family portraits these miniatures are invaluable."—Church and State
Gazette. Portraits taken daily from 9 till 6, and licences to exercise the
invention in London or the provinces granted by Mr. Beard, 85, King
William-street, city ; 34, Parliament-street ; and the Royal Polytechnic
Institution.

FIGURE 9
Classified advertisements for photographic
services on the front page of the *Times*
(London), May 28, 1846

Despite its enormous popularity, the daguerreotype was to be relatively short-lived. Daguerreo-
types were delicate and easily broken, and more significantly, they could not easily be reproduced.
Although Talbot's calotype process never achieved the remarkable precision of detail permitted by
the daguerreotype, the possibility of reproducing the images secured its longevity. Throughout the
1840s many photographers also enjoyed the aesthetically pleasing depth and gentleness of tone
that seemed to ally the paper process more overtly with artistic practices.

Meanwhile, and presumably following Daguerre's lead, Talbot set about trying to prosecute
any unauthorized calotype practice. At 100 to 150 pounds per year, Talbot's licensing fee was no
small sum, but as the practice of photography expanded, prosecution became impossible for Tal-
bot to pursue, and profits were slim. Lady Elisabeth policed the classifieds, bemoaning the various
ways in which photographic operators were attempting to bypass or circumvent the patenting
restrictions, bringing photography in effect within reach of the middle class. "My Dear Henry," she
wrote on September 15, 1844,

> Have you seen an advertisement which professes to sell at No 98 Cheapside not only pho-
> tographic cameras, but iodine boxes, bromine pans, iodized paper & every chemical prepa-
> ration & apparatus required in Photography, with full instruction given to purchasers, &
> shortly will be published *Plain* directions for obtaining Pictures *on Paper* by the Calotype
> Process. How can they do all this without a licence from you? Claudet I see advertises the
> Talbotype Portraits almost every day in the *Times*.[63]

The problem of patent infringement was soon resolved for all sides. In 1851 the wet collo-
dion process invented by Frederick Scott Archer (1813–1857) came onto the market unhampered
by any licensing fees. Archer's process, in which negatives were developed on glass, produced
sharper images and clearer details than the calotype, and it was cheaper and easier to use than
the daguerreotype. Multiple images could be made from wet collodion negatives. Talbot's initial
efforts later that year to sue a photographer for using the wet collodion process without a calotype
license, based on his conviction that he owned the rights to the negative-positive process, were

unsuccessful, and he must have realized by this point that any financial stake he might once have had in photography's unforeseeable future was evaporating. In 1852, after members of the Royal Society appealed to him on behalf of the many photographers who felt themselves unduly burdened by his licensing fee, Talbot agreed to abandon his claims.

From 1851 until 1880 wet collodion dominated photographic practices everywhere. In Britain, with the expiration of patents, photographic studios opened in almost every town, and prices went down significantly. By 1857 photography was, as Elizabeth Eastlake put it,

> a household word and a household want;…used alike by art and science, by love, business, and justice;…found in the most sumptuous saloon, and in the dingiest attic—in the solitude of the Highland cottage, and in the glare of the London gin-palace—in the pocket of the detective, in the cell of the convict, in the folio of the painter and architect, among the papers and patterns of the millowner and manufacturer, and on the cold brave breast on the battle-field."[64]

From Buckingham Palace to the London gin palace, photography, it seemed, at last belonged to everyone.

PHOTOGRAPHY AND OTHER ARTS

IF THERE IS ONE THING THAT UNITES EARLY AND LATE DISCUSSION OF PHOTOGRAPHY, it is the issue of truthfulness. Most of the first comments on photography were excited responses to its extraordinary accuracy and, at least initially, its perceived inability to lie. The likeness that Constance Talbot sought in the paintings of her children was guaranteed by the camera; it is small wonder that visual artists were quick to make use of photography in drafting their own work (or that they were less quick to acknowledge photography's assistance). The work of the Pre-Raphaelites is a case in point. We know that Dante Gabriel Rossetti (1828–1882) posed Jane Morris for photographs (fig. 10) and used the results in his portrait work (fig. 11); the results are striking. Michael Bartram tells us that "John Everett Millais from the mid-1850s onward, relied more and more on photography for landscape backgrounds and portraits," whereas the lesser known Atkinson Grimshaw "secretly painted over photographs."[65] The artist William Powell Frith (1819–1909) was publicly no fan of the Pre-Raphaelites, but like them he benefited from photographs that helped him draft his paintings. *The Derby Day* (fig. 12), arguably his best-known work, made use of photographs by Robert Howlett (1831–1858) that Frith had commissioned of the grandstand and groups of people (fig. 13). The *Photographic News* reported a couple of years later that "Mr. Samuel Fry has recently been engaged in taking a series of negatives, 25 inches by 18 inches, and 10 inches by 8 inches, of the interior of the Great Western Station, engines, carriages, etc. for Mr. Frith, as aids to the production of his great painting 'Life at a Railway Station.' Such is the value of the photograph in aiding the artist's work, that he wonders now however they did without them!"[66]

It is noteworthy not so much that painters used photography, or even that on occasion they kept the practice quiet, but that the look of photography was the desired effect. In large part because of the obsessive preoccupation with detail, many Victorian paintings seem to promise that through looking the world can be known. The implied viewer of these works has a powerful, godlike eye. Indeed, the relationship realist paintings celebrate between knowledge and vision is in many ways the defining characteristic of the earliest daguerreotypes and speaks to their epistemological as well as aesthetic appeal. Herschel's delight in 1839 at the revelations of a magnifying glass held up to a daguerreotype was a delight in scale but also in a world revealed—a world, in other words, that might be *known*.

The truthfulness of photography, of course, was not always welcome. In a humorous piece of doggerel, Lewis Carroll recorded the difficulties of trying to take a portrait of a family in which beauty was apparently lacking. After numerous failures at making individual portraits, the photographer, "Hiawatha,"

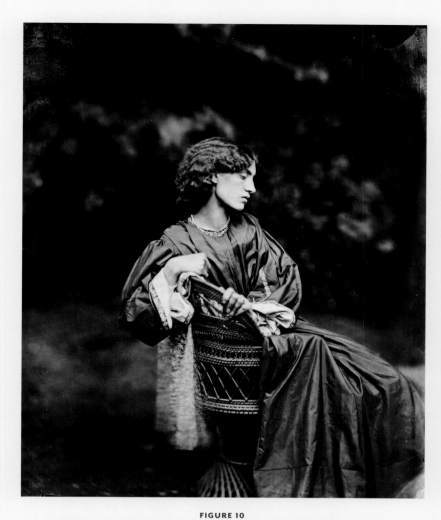

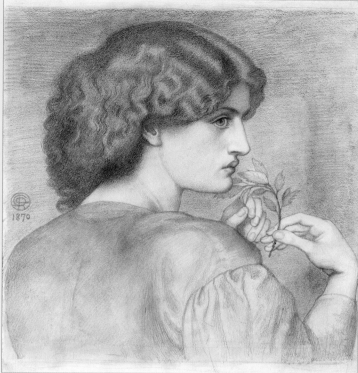

Tumbled all the tribe together,
("Grouped" is not the right expression),
And, as happy chance would have it,
Did at last obtain a picture
Where the faces all succeeded:
Each came out a perfect likeness.

Naturally, nobody is pleased with this result. Carroll continues:

Then they joined and all abused it,
Unrestrainedly abused it,
As the worst and ugliest picture
They could possibly have dreamed of.[67]

As one might expect, the photographer makes a number of appearances in popular fiction of
the age, represented in some cases as an outsider, as a worker of magic or science who is socially
marginalized (though at times, through his association with the arts, within the boundaries of
acceptability). Sir Arthur Conan Doyle was deeply interested in photography's capacity for truth as
well as illusion, and Sherlock Holmes is wise to its potential. Thomas Hardy used photographs in a
number of his novels to indicate the social aspirations of characters who employ them in tasteful
household arrangement, or exchange them with sweethearts and sell them off when love departs.[68]

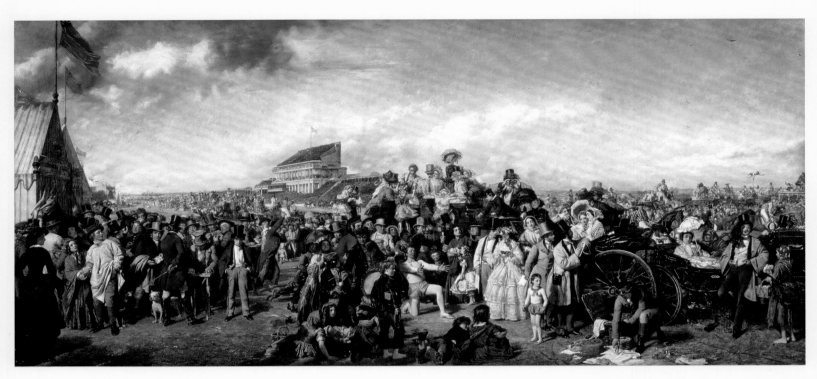

FIGURE 12
William Powell Frith (British, 1819–1909), *The Derby Day*, 1856–58. Oil on canvas,
101.6 × 223.5 cm (40 × 88 in.). Bequeathed by Jacob Bell, 1859. London, Tate Collection, N00615

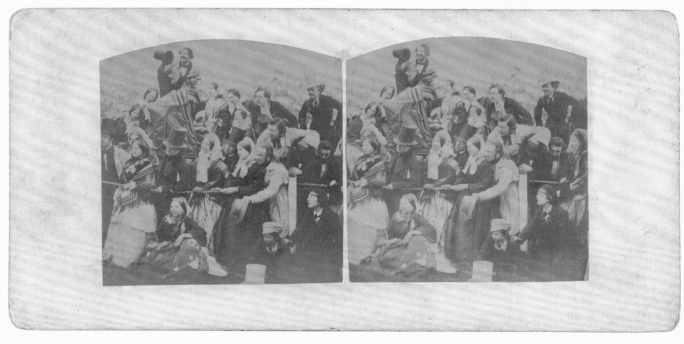

FIGURE 13
Robert Howlett (British, 1831–1858), *Untitled (Study for the Large Painting "Derby Day," by William
Powell Frith)*, 1856. Albumen silver stereograph, 8.6 × 17.5 cm (3⅜ × 6⅞ in.).
Gift of Weston J. and Mary M. Naef. Los Angeles, J. Paul Getty Museum, 84.XC.979.4532

Considerably more subtle, however, but far-reaching in impact, were the stylistic changes in literature that were brought about by the broader visual culture in which photography participated. What we might call the pictorial emphasis of the Victorian novel—its predilection for description; its attention to theater and scene; its sensitivity to point of view and perspective—is arguably a symptom of the omnipresence of image making in Victorian society to which photography contributed. Dickens's fondness for using the present tense in moments of heightened visual attention and pathos anticipates the shift to the present tense that we today undertake without thinking as we show others our own lives in photographs.[69]

Photography's implicitly democratic message also emerges in a variety of ways throughout the literature of the period. Toward the end of George Eliot's *Middlemarch* (1871), for example, the heroine, Dorothea, gets up after a night spent on the floor. Previously consumed with her own romantic distress, in the early morning light she feels a need to put aside self-interest and reach out and connect with the wider world:

> She opened her curtains, and looked out towards the bit of road that lay in view, with fields beyond outside the entrance-gates. On the road there was a man with a bundle on his back and a woman carrying her baby; in the field she could see figures moving—perhaps the shepherd with his dog. Far off in the bending sky was the pearly light; and she felt the largeness of the world and the manifold wakings of men to labour and endurance. She was a part of that involuntary, palpitating life, and could neither look out on it from her luxurious shelter as a mere spectator, nor hide her eyes in selfish complaining.[70]

This is a vitally important moment, not just for Dorothea and the rest of *Middlemarch* but for the history of the novel itself. It marks as deeply significant the simple and invisible act of *thinking*, but it also suggests that the view from the country house—from Lacock Abbey and places like it—might be widening to encompass a broader world. Dorothea does not reach for a camera to record the figures who are outside the entrance gates, but the eye of fiction notes them and forces an acknowledgment by its readers as well as its heroine that the human lot is inevitably bound up with those who walk and work and live beyond the boundary of one's own life. Meanwhile, photography, too, began to demonstrate an increased imaginative sympathy for the lives of the working poor and to force a growing sense of the commonality of human existence. Henry Mayhew's three-volume work of social record, *London Labour and the London Poor* (1851), was copiously illustrated with engravings made from photographs of street merchants, hustlers, and representatives of London's underclass. As much as the work invited the gaze of the armchair tourist who might never set foot in the East End, Mayhew's portraits insisted upon the reader's shared humanity with those at the fringes of society. The sense of a wider world that Dorothea begins to feel in *Middlemarch* speaks, like Mayhew's work, to the implicit *similarities* as much as to the differences among people.

Those similarities suggest one reason—perhaps the main reason—why the Victorians seem more real to us than persons of earlier ages. It's not merely the proximity of our era and theirs; it is also that the Victorians are the first human beings whom we can see through a medium we consider to be both modern and, curiously, our own: the photographic.[71] Unable to discriminate, photography emphasizes that all are a part of "involuntary, palpitating life"; in fact, a portrait photograph really signifies only that one *has* been part of that life. To many Victorians, it was a pity that photography had come too late to capture earlier figures from history. "Could we now see in photogenic light and shadow Demosthenes launching his thunder against Macedon," imagined one dreamer in 1843, "or Brutus at Pompey's statue bending over the bleeding Caesar—or Paul preaching at Athens—or Him whom we must not name, in godlike attitude and celestial beauty, proclaiming good-will to man, with what rapture would we gaze upon impersonations so exciting and divine!"[72]

If it was too late to get a photo of Jesus of Nazareth, other celebrity photographs were very popular. In New York in 1851, Mr. Gavitt's studio at the corner of Broadway and Murray Street offered a wonderful display:

> There is not a single great man in our country without his likeness there, and there are 170 pictures of distinguished Americans now no more, but who were living within the past six years. There was a likeness of the heroic Jackson, taken by an artist three days before the veteran died; Audibon [*sic*], Sir John Herschel, and many other men of note. All our great military and naval characters are to be seen there.[73]

In Britain there was a similar trade in photographs of the royal family and members of the aristocracy. Their portraits could be purchased at studios and became for a while collectible items for both the middle and upper classes. Constance Talbot wrote to her husband in April 1862:

> Could you get us a good Portrait of the Prince varying from the one sent to Ela, for the purpose of adding to your collection of Celebrities—Also a Portrait of the Queen, and as many others of the Royal family as you can meet with that are really good—We would put them into your Carte de visite Album wh. has many blank pages at present.[74]

These "card-portraits," as Oliver Wendell Holmes (1809–1894) called them—small portrait photographs made not just for commercial purposes but also for private exchange—had by 1863 become "the social currency, the sentimental 'Green-backs' of civilization"—and no wonder; as Holmes noted, the small portrait photo "is the cheapest, the most portable, requires no machine to look at it with, can be seen by several persons at the same time,—in short, has all the popular elements. Many care little for the wonders of the world brought before their eyes by the stereoscope; all love to see the faces of their friends."[75]

The practice of putting images into bound volumes and scrapbooks was well established before the advent of photography, and the carte de visite moved easily into the culture of albums, collage, and other mixed-media techniques already popular in Victorian homes. With astonishing rapidity, photography thus became part of the everyday world of all Victorians, a staple of home furnishing and domestic amusement, in evidence on every high street, in shop windows, and in the wider culture of commerce. To some extent, therefore, as it became ordinary, photography became less, rather than more, noticeable. "These miracles are being worked all around us so easily and so cheaply," wrote Holmes, "that most people have ceased to think of them as marvels."[76] Holmes was disappointed by this, since he regarded photography as the greatest invention of the age and one whose limits could not possibly be imagined. Like their British counterparts, however, Holmes's fellow Americans were already taxed with grasping the numerous technological breakthroughs of the day (Holmes's examples of challenges to the modern imagination are the railway, the telegraph, and chloroform). Photography was just one among many astonishing innovations. But Holmes felt that it was photography's *potential* that made it the era's most powerful one; its future was "not so easily, completely, universally recognized in all the immensity of its applications and suggestions."[77]

Although Holmes was right about photography's unimaginable potential—its descendants, the information technologies and social media of the twenty-first century, are arguably restructuring the nature of human relations—in some ways what is most radical and profound about photography was immediately obvious to the Victorians. As Holmes puts it: "Those whom we love no longer leave us in dying, as they did of old." While our eyes "lose the images pictured on them," and even parents "forget the faces of their own children in a separation of a year or two," the "artificial retina…retains their impress." In the era of a newly conceived sense of historical and human oblivion, photography was miraculous: "How these shadows last, and how their originals fade away!"[78] It is hardly surprising that it was precisely this promise of reprieve from mortality that drove much of the marketing of portrait photographs. The prudent Victorian was advised to "secure the shadow 'ere the substance fade" by letting "nature imitate what Nature made."[79]

PHOTOGRAPHY AND THE END OF AN AGE

THE LAST TWO DECADES OF THE VICTORIAN AGE SAW FURTHER REFINEMENTS IN THE photographic process. In 1871 the dry plate process was invented, making photography faster and much less cumbersome. Dry plates, sturdier than wet collodion, could be prepared in advance and were easier to transport. In 1888 George Eastman introduced flexible dry film and the small, hand-held Kodak camera. Not only might photography now be practiced by more people; pictures could also be taken more discreetly. When two brothers in Germany patented a camera designed to be hidden in a hat, *Punch* magazine responded with some verse:

> If they knew what I wear when I walk in
> the street,
> It should be quite a terror to people I meet;
> They would fly when they saw me, and ne'er
> stop to chat,
> For I carry a camera up in my hat.
>
> A Herr Luders, of Görlitz, has patented this,
> And I think the idea is by no means amiss;
> With a hole in my hat for the lens to peep
> through,
> And a dry plate behind, I take portrait or view.[80]

Although outside spy novels the photographic hat has yet to catch on, the newly simplified processes of photography ensured that by the 1880s it was in everyday use in police work and detective surveillance. Meanwhile, down in the Dorset countryside, Hardy was learning the meaning of fame in a photographic age and was disgruntled to find himself the subject of tourist cameras aimed by cyclists over the hedges of his garden at Max Gate. In London, Henry James reflected in his notebooks on the eroding boundary between public and private spheres, a consequence, he felt, of the "devouring publicity" of modern life.[81]

As if to validate those concerns, in 1897 an anonymous "Member of the Royal Household" published a tell-all narrative about Queen Victoria's private life, a work presumably designed to profit from the queen's Diamond Jubilee that year.[82] With a full-length photographic portrait of the queen as its frontispiece, and a preface explaining its method of visualizing Victoria as borrowed from "that of the old masters of the Dutch school," the book promised to help the reader picture the details of Victoria's daily life in all its splendor. Insisting that its realism is assured by the copiousness of its details, the book recalls the appeal of early daguerreotypes: the more that is seen and known, the text implies, the closer the viewer may come to the *real* queen.

But by 1897 the notion of a shared and verifiable reality was noticeably in question, as was the idea that empiricism and the accumulation of visual detail could yield satisfactory answers to questions about the nature of human existence. As fiction by James, Hardy, Wilde, and others was showing, personal identity was no longer necessarily understood in static terms, the sum total of a fixed number of facts. It was susceptible to change, circumstance, perceptual nuance. It altered across time. As the art critic Roger Fry put it in his discussion of Impressionism (1894), "what...we call the same human figure, is not the same inside the studio that it was outside, is not the same at 5 p.m. that it was at 2 p.m. It is in each case only a momentary group of sensations in the perpetual flux, existing in necessary relations to its surroundings and an inseparable part of them."[83] While the single photograph might suggest permanence, over the course of time photography tells a different story. A family album kept throughout many years speaks of mutability; it maps the story of genetic inheritance, making visible time's passage. Holmes's words in 1861 are eerily prescient:

Children grow into beauty and out of it. The first line in the forehead, the first streak in the hair are chronicled without malice, but without extenuation. The footprints of thought, of passion, of purpose are all treasured in these fossilized shadows. Family-traits show themselves in early infancy, die out, and reappear. Flitting moods which have escaped one pencil of sunbeams are caught by another. Each new picture gives us a new aspect of our friend; we find he had not one face, but many.[84]

Each new picture made by a camera arguably helped usher in the time-obsessed age of Modernism, an age that was to be haunted by the multiplicity of the self, a self represented by Cubist painters as having "not one face, but many." Modernist literature of the early twentieth century is preoccupied with the ambiguity of the word and the unreliability of narration; it addresses itself to a generation that will witness the shattering of the idea of objective truth into innumerable past, potential, and simultaneous points of view. In all this, photography will play a part.

The notion that human identity is neither stable, nor unified, nor ultimately knowable is absent, however, from the tell-all book about the queen. The aim of the work, after all, was to "fix" Victoria's image. One of its revelations is how self-conscious the queen was about that image—how much she was aware of "performing" her royal, married, domestic self. "It is quite a weakness of hers," we hear, "to be photographed in every possible condition of her daily life. Sitting in her donkey chair, dangling [sic] the latest new baby, chatting in her private sitting-room among her daughters, working at her writing-table, or breakfasting in the open air . . . the Queen's photographer is always to be sent for and ordered to 'fix the picture.' "[85]

Although Victoria was aware of the value of photography to the public image of a modern monarch, she remained to the end of her life an avid private consumer of photographs, every bit as interested in perusing albums as she had been as a young woman first introduced to photogenic drawings. According to our anonymous source, one of her more notable "fads and fancies" was that she required everything in her possession to be photographed. "Every piece of plate and china, every picture, chair, table, ornament, and articles of even the most trivial description, all pass through the photographer's hands, and are 'taken' from every point of view." The resulting photographs were then arranged in "wonderful bound catalogues," vast volumes that were "many in number, large in bulk, and . . . most expensive." We hear that "Her Majesty is very fond of her catalogues, and few days pass without her sending for one volume or another."[86] It's not entirely clear from this account whether the queen liked her albums because of the objects or the people represented in them. What we *are* told is that she has "a sweet reverence for past happy times" and reveals "a clinging that is touching in its intensity to everything that reflects ever so slightly on the 'days that are no more.' "[87] As the cultural historian Stephen Kern puts it, "Every age . . . has a distinctive sense of the past. This generation looked to it for stability in the face of rapid technological, cultural, and social change."[88] What could be more consoling to the widowed monarch in her last years than these bound volumes of photographs in which nothing more could ever change? What surer place to find stability than in images of the past?

Photography's nostalgic appeal must have been particularly powerful at the close of the nineteenth century—the first century, as Talbot might have put it, to have "drawn its own picture." Through the auspices of photography, Victoria was the first British monarch able to revisit almost all the years of her long reign. In her albums she could view images of her children and their weddings, and of her husband—in life and, later, as a marble effigy. Victoria herself now exists for us in photographs as a young woman, as an elderly matriarch—even on her deathbed. Tucked inside her coffin, unseen by anyone and unbeknown to most, were several photographs that she had previously selected to take with her (fig. 14).[89] Her funeral procession on February 2, 1901, was not just photographed but filmed; one can find it today on YouTube.

Daguerre was long dead by then, as were Talbot and Herschel, but many other photographers were stationed along the route of the funeral procession as it wound slowly through London (fig. 15). With the help of a ladder, one of them even managed to scramble up on top of the Marble Arch, where he perched perilously, braving the bitter cold, the long hours of waiting, and the seemingly endless repetition of Chopin's Funeral March, to get the best picture that he could.[90]

FIGURE 14
Unknown photographer, *Photograph of Victoria on Her Deathbed*, January 1901.
Gelatin silver print, 15.1 × 19.8 cm (5¹⁵⁄₁₆ × 7¹³⁄₁₆ in.). Windsor, The Royal Collection, RCIN 2943926

FIGURE 15
Unknown photographer, *Funeral Procession of Queen Victoria*, February 1901.
Gelatin silver print, 28 × 35.5 cm (11 × 14 in.). London, National Army Museum, NAM 1971-01-35-219

NOTES

1 John Frederick William Herschel to William Henry Fox Talbot, May 9, 1839, in *The Correspondence of William Henry Fox Talbot,* ed. Larry J. Shaaf, De Montfort University, Leicester, http://www.foxtalbot.dmu.ac.uk. The manuscript collections, and the depositories of the collections, in which all of Talbot's letters cited in this essay can be found, are identified on this Web site.

2 H. Gaucheraud, "The Daguerotype [*sic*]," *Gazette de France,* January 6, 1839, reprinted in *Literary Gazette,* January 12, 1839, 26.

3 Quoted in Beaumont Newhall, *The History of Photography,* rev. ed. (New York, 1982), 21.

4 Newhall, *History of Photography* (note 3), 23.

5 Herschel to Talbot, May 9, 1839 (note 1).

6 William Henry Fox Talbot, *The Pencil of Nature* (Project Gutenberg e-book 33447 of Longman, Brown, Green and Longmans, London, 1844 edition), 4.

7 Laura Mundy to Talbot, December 12, 1834, in *Talbot Correspondence* (note 1).

8 Newhall, *History of Photography* (note 3), 20.

9 *Literary Gazette,* February 2, 1839, 74.

10 Talbot to Herschel, January 25, 1839, in *Talbot Correspondence* (note 1).

11 Talbot to Herschel, January 25, 1839 (note 10).

12 Herschel to Talbot, January 27, 1839, in *Talbot Correspondence* (note 1).

13 Herschel to Talbot, January 30, 1839, in *Talbot Correspondence* (note 1).

14 Talbot to Herschel, January 28, 1839, in *Talbot Correspondence* (note 1).

15 Newhall, *History of Photography* (note 3), 21.

16 *Times* (London), February 1, 1839. All quotations and references following are to this day's edition, available online through the digital archive, at http://www.thetimes.co.uk.

17 Constance Talbot to Talbot, September 7, 1835, in *Talbot Correspondence* (note 1).

18 Talbot to Herschel, January 28, 1839 (note 14).

19 William Henry Fox Talbot, "Some Account of the Art of Photogenic Drawing," *London and Edinburgh Philosophical Magazine and Journal of Science* 14 (March 1839), reprinted in Vicki Goldberg, ed., *Photography in Print: Writings from 1816 to the Present* (Albuquerque, 1988), 46.

20 The representation of Lacock Abbey has expanded in kind and reach since Talbot's day to include a number of historical film roles, including bits and pieces of Hogwarts in the *Harry Potter* movies.

21 Lady Elizabeth Eastlake, "Photography," *London Quarterly Review,* April 1857, 442–68.

22 Talbot, *Pencil of Nature* (note 6), 31–32.

23 Elisabeth Feilding to Talbot, February 27, 1839, in *Talbot Correspondence* (note 1). Horatia was not alone in her ideas for the new baby: Harriot Mundy, one of Talbot's sisters-in-law, had just the day before suggested that "the young Lady *must* be called *Photogena* in memory or rather honour of your new discovery!" Harriot Mundy to Talbot, February 26, 1839, in *Talbot Correspondence* (note 1).

24 Elisabeth Feilding to Talbot, February 3, 1839, in *Talbot Correspondence* (note 1).

25 Elisabeth Feilding to Talbot, June 11, 1839, in *Talbot Correspondence* (note 1).

26 Mary Talbot to Talbot, March 18, 1839 (postmarked April 19, 1839), in *Talbot Correspondence* (note 1).

27 Christoper Rice Mansel Talbot to Talbot, March 30, 1839, in *Talbot Correspondence* (note 1).

28 Charlotte Traherne to Talbot, February 28, 1839, in *Talbot Correspondence* (note 1). John Llewelyn was to become a serious amateur photographer, as was the Reverend Calvert Richard Jones.

29 Theresa Digby to Talbot, April 8, 1839, in *Talbot Correspondence* (note 1).

30 Elisabeth Feilding to Talbot, April 13, 1839, in *Talbot Correspondence* (note 1).

31 Theresa Digby to Talbot, April 13, 1839, in *Talbot Correspondence* (note 1).

32 Elisabeth Feilding to Talbot, April 18, 1839, in *Talbot Correspondence* (note 1).

33 Elisabeth Feilding to Talbot, April 30, 1839, in *Talbot Correspondence* (note 1).

34 Elizabeth Heyert, *The Glass-House Years: Victorian Portrait Photography, 1839–1870* (Montclair, N.J., 1979), 78.

35 Helmut Gernsheim, *Victoria R: A Biography* (New York, 1959), 257.

36 Elisabeth Feilding to Talbot, November 14, 1843, in *Talbot Correspondence* (note 1).

37 Elisabeth Feilding to Talbot, January 16, 1843, in *Talbot Correspondence* (note 1). A version of Henry Collen's facsimile of the Treaty between Great Britain and China survives in the Royal Library today, RCIN 1047556.

38 Constance Talbot to Talbot, April 20, 1838, in *Talbot Correspondence* (note 1).

39 Constance Talbot to Talbot, May 7, 1838, in *Talbot Correspondence* (note 1).

40 Talbot, *Pencil of Nature* (note 6), 42.

41 Charles Dickens, *The Complete Works of Charles Dickens: Great Expectations* (New York, 2009), 1.

42 *Edinburgh Review,* January 1843, reprinted in Goldberg, *Photography in Print* (note 19), 65.

43 An obvious exception was the practice of posthumous, or deathbed, portraiture. For an interesting, albeit fictionalized, account of the work of photographing a corpse, see Amy Levy's novel *Romance of a Shop* (1888).

44 Baronet John William Lubbock to Talbot, November 2, 1839, in *Talbot Correspondence* (note 1).

45 *Literary Gazette,* February 13, 1841, 108.

46 Heyert, *Glass-House Years* (note 32), 3.

47 Reported in the *Morning Chronicle,* September 12, 1840, cited in Heyert, *Glass-House Years* (note 32), 3.

48 *Elizabeth Barrett to Miss Mitford,* ed. B Miller (New Haven, 1954), 208–9.

49 David Brewster to Talbot, October 23, 1840, in *Talbot Correspondence* (note 1).

50 David Brewster to Talbot, November 8, 1840, in *Talbot Correspondence* (note 1).

51 George Butler to Talbot, March 25, 1841, in *Talbot Correspondence* (note 1).

52 Charles Wheatstone to Talbot, March 1, 1841, in *Talbot Correspondence* (note 1).

53 George Wilson Bridges to Talbot, February 2, 1847, in *Talbot Correspondence* (note 1).

54 Cuthbert Bede, *Photographic Pleasures Popularly Portrayed with Pen and Pencil* (London, 1855), 54.

55 Bridges to Talbot, February 2, 1847 (note 50).

56 *Times* (London), May 28, 1846, 1.

57 *Edinburgh Review,* January 1843 (note 39), 67.

58 During the 1860s, according to Bill Jay, the average weekly income for an agricultural worker was between eleven and fifteen shillings. Even to a person with some skills working, say, in a photography studio, a daguerreotype might represent more than a week's wages. Bill Jay, "Prices of Photographs: Average Charges for Images in Victorian Photographic Studios 1841–1891," http://www.billjayonphotography.com.

59 Jay, "Prices of Photographs" (note 55).

60 Eastlake, "Photography" (note 21), 443.

61 "Daguerreotype—New Discovery," *Scientific American* 6, no. 19 (January 25, 1851), 145.

62 Newhall, *History of Photography* (note 3), 34.

63 Elisabeth Feilding to Talbot, September 15, 1844, in *Talbot Correspondence* (note 1).

64 Eastlake, "Photography" (note 21), 442.

65 Michael Bartram, *The Pre-Raphaelite Camera: Aspects of Victorian Photography* (Boston, 1985), 7.

66 *Photographic News,* April 26, 1861, "Images of the Industrial Revolution in Britain." www.netnicholls.com /neh2001/pages/aspects7/75frame.htm.

67 Lewis Carroll, "Hiawatha's Photographing," reprinted in Goldberg, *Photography in Print* (note 19), 119–22.

68 See, for example, *Desperate Remedies* (1871), *A Laodicean* (1881), *Jude the Obscure* (1896), and the short story "An Imaginative Woman" (1894).

69 For an extensive discussion of the novel's stylistic response to a newly photographic culture, see Jennifer Green-Lewis, "Victorian Photography and the Novel," in *The Oxford Handbook of Victorian Literature,* ed. Lisa Rodensky (Oxford, 2013), 313–34.

70 George Eliot, *Middlemarch* (New York, 1985), 846.

71 For more discussion of this idea, see Jennifer Green-Lewis, "At Home in the Nineteenth Century: Photography, Nostalgia, and the Will to Authenticity," in *Victorian Afterlife: Contemporary Culture Rewrites the Nineteenth Century,* ed. John Kucich and Dianne Sadoff (Minneapolis, 2000), 29–48.

72 *Edinburgh Review,* January 1843 (note 39), 65.

73 "Daguerreotype—New Discovery" (note 58), 145.

74 Constance Talbot to Talbot, April 25, 1862, in *Talbot Correspondence* (note 1).

75 Oliver Wendell Holmes, "Doings of the Sunbeam," in *Soundings from the Atlantic* (Boston, 1864), 255.

76 Oliver Wendell Holmes, "Sun-Painting and Sun-Sculpture," in *Soundings from the Atlantic* (note 72), 168.

77 Oliver Wendell Holmes, "The Stereoscope and the Stereograph," in *Soundings from the Atlantic* (note 72), 130.

78 Holmes, "Sun-Painting and Sun-Sculpture" (note 73), 170.

79 Newhall, *History of Photography* (note 3), 32.

80 "The Photographic Hat," reprinted in Leonard de Vries, *Victorian Inventions* (London, 1973), 112.

81 Henry James, *Notebook,* 82, quoted in Richard Salmon, *Henry James and the Culture of Publicity* (Cambridge, 1997), 8.

82 *The Private Life of the Queen, by a Member of the Royal Household* (New York, 1898), iii.

83 Roger Fry, "The Philosophy of Impressionism," in *A Roger Fry Reader,* ed. Christopher Reed (Chicago, 1996), 16.

84 Holmes, "Sun-Painting and Sun-Sculpture" (note 73), 169–70.

85 *Private Life* (note 82), 119.

86 *Private Life* (note 82), 119–20.

87 *Private Life* (note 82), 112.

88 Stephen Kern, *The Culture of Time and Space, 1880–1918* (Cambridge, Mass., 2003), 36.

89 Christopher Hibbert, *Queen Victoria: A Personal History* (London, 2000), 498.

90 In the moment at which the queen's coffin passed beneath the arch, the photographer Paul Martin, who was standing at the monument's base, had what is to modern readers a familiar experience: "Off came our hats and click went the shutters of the cameras. I have a faint recollection of seeing a Union Jack which covered the coffin, also the Kaiser on a white horse. My camera saw it all, but I had to wait until it could transfer to me the beauty and the solemnity of the occasion." In other words, Martin missed the procession because he was too busy taking a picture of it. "You naturally like to take as many [pictures] as you can, so that your entire attention is centred on your job and you miss the pageant. Seeing the impressive scene on your dull view-finder of the size of a stamp does not fling you into a state of uncontrolled ecstasy or reverence." It was Martin's colleague who braved the too-short ladder and managed to haul himself up onto the arch. According to Martin, "he obtained quite good results, as being higher up he had a good view." Paul Martin, *Victorian Snapshots* (London, 1939; repr., New York, 1973), 35.

A Young Monarch, a New Art, and the Introduction of the Photographic Exhibition

ANNE M. LYDEN

QUEEN VICTORIA, HAVING ASCENDED TO THE THRONE OF GREAT BRITAIN AND IRELAND at the age of eighteen, was about to turn twenty when the invention of the new medium of photography was announced—first in Paris, then in London—at the beginning of 1839. The queen appears to make no mention of these historic disclosures in her journals of the period, though she was a prolific writer, capable of jotting down several thousand words on all manner of subjects each day.[1] Written accounts by members of her court suggest that by April 1839 she had, at the very least, seen some early work by William Henry Fox Talbot (1800–1877),[2] who vied with Louis-Jacques-Mandé Daguerre (1789–1851) to be acknowledged as the inventor of photography. Certainly there was much to occupy the queen at the time, including whether she should marry. In October 1839, following royal protocol, she proposed to Prince Albert of Saxe-Coburg-Gotha.[3] Photography was still a fledgling art form, and Daguerre's process was extremely slow; Talbot's photogenic drawings were not conducive to portraiture (only in October 1840 would he achieve a portrait through his new process, the calotype). Thus the official portraits made of the affianced royal couple were miniature paintings, by Sir William Ross (pls. 66, 67), not photographic.[4]

Victoria and Albert were married in February 1840, and by the spring the couple were said to have acquired daguerreotypes from the firm of Claudet and Houghton, based in London. According to the firm's advertisement in the *Athenaeum*, the queen and her husband purchased some views of Paris, Rome, and other Continental cities by Antoine Claudet (1797–1867), the first licensed daguerreotypist in England. However, no records of such purchases exist—nor do the photographs.[5] Claudet learned how to make daguerreotypes in 1839 directly from Daguerre. In 1841, after obtaining a license to practice the medium in England, he opened his photographic studio in London, one of only two such enterprises at the time (the other was operated by Richard Beard; see pl. 24). Claudet was a highly skilled portraitist, as evidenced by his photograph of a young man from about 1842 (pl. 8), who is shown half-length, looking straight at the camera, in front of an elaborate painted backdrop. Claudet would, in years to come, make portraits of members of the royal family (pl. 80), but the first royal photographic portrait—of Prince Albert, in 1842 (see fig. 39)—was made by William Constable (1783–1861).

Photography at this point was limited in its application and dissemination; for the royal family to express such an early interest in it—even if not quite as early as previous accounts have suggested—was remarkable. Victoria and Albert's embrace of photography made them instrumental in its evolution and rising popularity during its first thirty years. This interest would prove to be a mutually beneficial one that would shape the history of photography and frame the reign of Queen Victoria. It is arguable that the patronage and attention of the queen and Prince Albert also helped facilitate the introduction of the photographic exhibition in Britain.

Queen Victoria (r. 1837–1901) is still Britain's longest-reigning monarch, but there were moments early in her tenure when it seemed her rule might be cut short. The growing Chartist

movement was a potential threat to her sovereignty. Seeking social and political reform, the Chartists attempted in the 1840s to bring about a more democratic system to replace the monarchical one. Political turmoil and social revolt across Europe, most notably in France, brought about the demise of the established order and the rise of the proletariat. Although Britain—and Victoria—ultimately avoided such violent uprisings, the threat of revolution was real in the spring of 1848, when a series of riots occurred around the country in protest against taxes. On March 6 a large crowd rampaged in Trafalgar Square, tearing down the wood hoardings that still surrounded the unfinished Nelson's Column some four years after Talbot photographed it under construction (pl. 10).[6] One month later, thousands gathered in London for a Chartist meeting. The Duke of Wellington (pl. 9), who had won recognition for his bravery during the Napoleonic Wars earlier in the century, strategically deployed troops around the city to prevent any unrest, and designated that the route of the march end south of the Thames, at Kennington; the royal family was advised to leave London for the safety of Osborne House, their home on the Isle of Wight (pl. 97). Although many of the sought-after reforms were eventually put in place (such as voting rights for most men, a secret ballot, and payment for members of Parliament), the Chartist movement weakened after the 1848 meeting. It was a pivotal moment both in the history of the nation and in that of photography. The serene quality of early photographs, with what Jennifer Green-Lewis in this volume calls their "view from the country house," was shifting alongside the political changes.

Two rare daguerreotypes by William Edward Kilburn (1818–1891) capture the large gathering at Kennington (pls. 11, 12). They are among the earliest photographs of a public meeting and were subsequently acquired by Prince Albert. Although opposed to the violence perpetrated by some of the Chartists, Albert was committed to improving the condition of working people. He was president of the Society for Improving the Condition of the Labouring Classes, and on May 18, 1848, just a month after the demonstration in London, he spoke at the society's annual meeting. The prince acknowledged that some people, "under the blessing of Divine Providence, enjoy station, wealth, and education," but he believed those individuals might use the advantages afforded them to improve the situation of those less well off. He cautioned against "dictatorial interference with labour and employment, which frightens away capital, which destroys liberty of thought and independence of action which must be left to every man if he is to work out his own happiness."[7] This was an extraordinary moment: although it was the prince who delivered the address, he essentially represented the queen, and it appeared that the monarchy was acknowledging a responsibility for the welfare of the people, to the benefit of the nation.

THE GREAT EXHIBITION OF 1851

PRINCE ALBERT BELIEVED THAT SOCIAL REFORM WAS ALSO POSSIBLE THROUGH education and the encouragement of arts and industry. Since 1843 he had been the president of the Society for the Encouragement of Arts, Manufactures and Commerce, often referred to simply as the Society of Arts. The society, which dated back to 1754, was running out of funds, but the prince instigated reforms, and by 1847 finances were much improved, and the society was granted a royal charter. Albert's presidency was lauded by the society's members for its pragmatism and encouragement of the arts: "It is a good sign, that the Prince thus makes his Presidency something of a practical and beneficial reality."[8] By 1849 the Society of Arts was launching plans for an exhibition, similar to the national exhibitions common in France (since 1798) that showcased products of industry, agriculture, and manufacture. At the heart of the endeavor was a desire to promote British designs as superior in the world market, but underlying it was an attempt to cultivate progress and commerce in the wake of the volatile 1840s. Plans were underway by January 1850, and a Royal Commission, with Prince Albert at its head, was established to oversee the development of the ambitious project. Although commissioners included leading politicians and important business figures, the successful opening of the exhibition some fifteen months later was largely due to the work of the executive committee, which included Henry Cole, Lieutenant Colonel J. A. Lloyd, Hugh Lyon Playfair, and Matthew Digby Wyatt. These men had diverse but complementary experiences

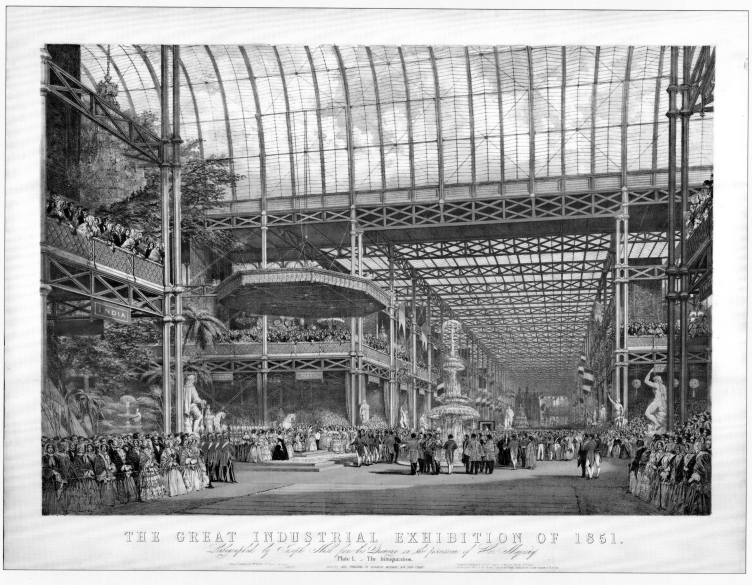

THE GREAT INDUSTRIAL EXHIBITION OF 1851.
Plate I. — The Inauguration.

FIGURE 16

Joseph Nash (British, 1809–1878), *The Great Industrial Exhibition of 1851: Plate 1—The Inauguration*, 1851.
Hand-colored lithograph, 55 × 75.4 cm (21⅝ × 29¹¹⁄₁₆ in.). Los Angeles, Getty Research Institute, 960088

and skills; Cole was a civil servant and inventor, Lloyd invented a device for detecting storms, Play-fair was provost of St. Andrews, and Wyatt was an architect and art historian.

The Great Exhibition of the Works of Industry of All Nations, as it was officially called, opened in London on May 1, 1851, with a crowd of twenty-five thousand onlookers at the ceremony, which was presided over by Queen Victoria and Prince Albert (fig. 16). Six million visitors, over five and a half months, attended the massive display of technological and design wares from forty-four countries and various British colonies and dependencies. The thirteen thousand exhibits were housed in the Crystal Palace (fig. 17), a massive iron-and-glass building designed by the architect Sir Joseph Paxton (1803–1865). Located in the middle of Hyde Park, the building initially drew criticism for its modern design and use of a new material, plate glass. The *Times* enumerated detractors' complaints that

> the glass-roof, being flat, or nearly so, would leak in every direction; that the heat in this monster conservatory would be intense; that the objects of art, manufacture, and commerce which are to be exhibited would not in such a building receive adequate protection; that, generally speaking, these are notorious objections within the knowledge of all builders and architects against the employment of mere glass and metal in our climate upon so mighty a scale as this.[9]

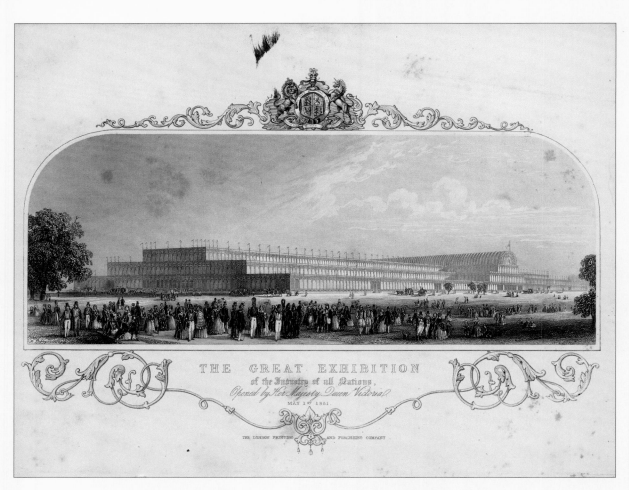

FIGURE 17
H. Bibby (British, n.d.), *The Great Exhibition of the Industry of All Nations, Opened by Her Majesty Queen Victoria*, May 1, 1851.
Frontispiece from the book *Tallis's History and Description of the Crystal Palace*, ed. J. D. Strutt (London, 1851), vol. 1.
Steel engraving, 21 × 27 cm (8¼ × 10⅝ in.). Los Angeles, J. Paul Getty Museum, 84.XB.1184

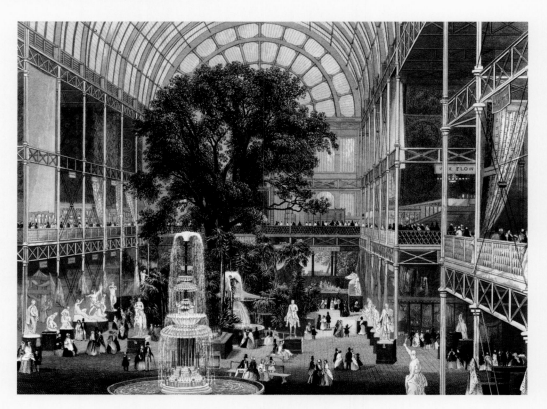

FIGURE 18
W. Lacey (British, n.d.), *The Transept of the Great Exhibition, Looking North*, 1851. From the book *Tallis's History and Description of the Crystal Palace*, ed. J. D. Strutt (London, 1851), vol. 1. Steel engraving based on a daguerreotype by John Jabez Edwin Mayall (1813–1901), 14.8 × 19.6 cm (5¹³⁄₁₆ × 7¹¹⁄₁₆ in.). Los Angeles, J. Paul Getty Museum, 84.XB.1184

However, it was not long before skeptics changed their opinion about the Crystal Palace. A daguerreotype by John Jabez Edwin Mayall (1813–1901) shows the north transept of the building, complete with a large, living elm tree at the center—one of several from the park that were ensconced in this giant greenhouse (pl. 13). Such an image ably illustrates the principles of progress espoused by the exhibition—not even nature can impede the progress of industry and technology. Mayall's daguerreotypes (at least fourteen were commissioned) were the basis of a series of engravings that were widely published (fig. 18). The original photographs were praised in the *Athenaeum* for their veracity: "Nothing is altered, added, or withdrawn for the sake of effect.… They are Nature's own copies of this wondrous scene."[10]

The exhibition was divided into four key categories—Raw Materials, Machinery, Manufactures, and Fine Arts—each of which was in turn divided into thirty classes of objects. Photography was represented in two different classes: Class 10, Philosophical Instruments and Processes, and Class 30, Fine Arts. This assignment to two classes reveals a difficulty in defining photography, which in 1851 was still a relatively young medium. Even so, reports indicated that there were seven hundred photographs on display throughout the building.[11] Among the myriad prints on view was a full-length portrait of the popular actress Jenny Lind, by Kilburn, that had been acquired by Queen Victoria and Prince Albert in 1849 (pl. 15); photographs of Newhaven fisherfolk by David Octavius Hill (1802–1870) and Robert Adamson (1821–1848) (similar to pls. 17, 18); hand-colored daguerreotypes by Claudet (similar to pls. 25, 27); and work by Mayall and Gustave Le Gray (1820–1884). The exhibition also represented the first occasion on which the new wet collodion process of Frederick Scott Archer (1813–1857) was shown (Archer did not exhibit, but Horne and Thornthwaite showed an early example of the process after the exhibition opened). This discovery would have a major impact on the medium during the 1850s, allowing photographers to record greater detail in their images and shortening exposure times. Architectural subjects became more popular, and portraiture was more feasible for sitter and photographer alike (pl. 14). The technical success of the collodion process was owing to the use of plate glass, which was known to be durable and had a smooth, even surface—the same qualities that made the material an appealing component of the Crystal Palace.

For many people, the Great Exhibition provided an opportunity to view a photograph for the first time. The millions of visitors—from both Britain and abroad—had access to all the displays for as little as a shilling.[12] Prince Albert's support of the exhibition was in essence a royal seal of approval. The queen made multiple visits and took great pride in the success of the event, as it reflected well on Prince Albert. Writing in her journal on May 1, 1851, she effused that the opening was "one of the greatest and most glorious days of our lives."[13]

THE PHOTOGRAPHIC SOCIETY

IN DECEMBER 1852, SPURRED BY THE SUCCESS OF THE GREAT EXHIBITION, the Society of Arts mounted the first exhibition in England devoted to photography. Proposed and organized by Joseph Cundall (1818–1895), Roger Fenton (1819–1869), and P. H. Delamotte (1820–1889), the *Exhibition of Recent Specimens of Photography* contained almost four hundred photographs and was dedicated to both the art and science of the medium. When the show was extended a month beyond its original two-week run, it was enlarged to more than eight hundred photographs.[14] The society arranged a national tour of eighty-three prints from the exhibition, and by spring a second tour was arranged. Given the popularity of the first touring exhibition, the second was split into two almost identical shows that traveled to different parts of the country. The exhibitions went to both small towns and large cities, and in addition to offering people a chance to see photographs (as at the Great Exhibition, often for the first time), the tours promoted the society and its aims.

Among the works on view were prints by Talbot; they were intended to offer a concise history of the calotype and formed a retrospective of this important early period in the evolution of photography. In July 1852 Talbot had relinquished his patent and in so doing opened up opportunities for

more people to freely practice photography, in the hope, he said, "that our country should continue to take the lead in this newly discovered branch of the Fine Arts."[15] The *Journal of the Society of Arts* reviewed the exhibition in December, noting, besides the prints by Fenton and Le Gray, the "remarkable collection of positive pictures on glass, the portraits of insane persons, taken by Dr. Diamond" (pls. 19, 20).[16] In addition to being an accomplished amateur photographer, Hugh Welch Diamond (1809–1886) was the chief superintendent of the women's wing of the Surrey County Lunatic Asylum from 1848 to 1858. Diamond's photographs were intended for the patients' medical records and to serve as aids in diagnosis and treatment, but he recognized that the portraits had an appeal beyond the clinical environment. The inclusion of Diamond's photographs in the Society of Arts' first exhibition is indicative of the evolving nature of the medium in the 1850s; the definition of photography was expanding, as photographers explored new categories and applications.

The initial exhibition at the Society of Arts was an enormous success and helped to cement the desire of a number of individuals to establish a formal society for the display and dissemination of photographs. Discussions about forming such a group began in 1852, but it was not until January 1853 that the Photographic Society of London was officially established. Among the society's initial goals was to elevate the status of photography, promoting both the science and the art of the medium, and to encourage more people to become practitioners. The formation and future of the society were praised by the *Journal of the Society of Arts* in January 1853: "It may be confidently expected that the Photographic Society will aid materially that development of the art so auspiciously commenced by the Great Exhibition."[17] Indeed, the official *Reports of the Juries* from the 1851 exhibition had called for more to be done to advance British photography, after both France and America had demonstrated their mastery of the medium.[18]

The members of the Photographic Society made strategic appointments to certain key posts: the painter Sir Charles Eastlake was president; the painter Sir William Newton, the physicist Sir Charles Wheatstone, and the politician Charles Somers Cocks, 3rd Earl Somers, were vice presidents. These men not only possessed knowledge of the arts and sciences; both Eastlake and Somers also had connections to the royal family. Somers had been appointed lord-in-waiting to Queen Victoria in January 1853 and was acquainted with Dr. Ernst Becker (1826–1888), a tutor to the young princes;[19] Eastlake, as secretary to the Royal Commission of Fine Arts, had worked with Prince Albert since 1841.[20] Such proximity to the royal family benefited the fledgling society, and in June 1853 Queen Victoria and Prince Albert became patrons.[21] In January 1854 the Photographic Society held its first exhibition, of 980 photographs, at the Gallery of the Society of British Artists in Pall Mall, London.

New photographic societies were also formed in regional centers outside London, so that by the end of the decade there were estimated to be thirty-one different societies in existence.[22] The popularity of photography among the royal family also grew. The 1850s saw an increase in their photographic activities, both in sitting before the camera and in collecting photographs.[23] Although the photographers patronized by Victoria and Albert were largely amateur practitioners—not commercial enterprises—the majority of them were highly educated or enjoyed a rank or class that was befitting royal association. Victoria and Albert had attended the exhibition of the Photographic Society, and the queen, describing the visit in her journal, wrote:

> It was most interesting and there are 3 rooms full of the most beautiful specimens, some, from France & Germany, & many by amateurs. Mr. Fenton, who belongs to the Society explained everything & there were many beautiful photographs done by him. Prof. Wheatstone, the inventor of the stereoscope, was also there. Some of the landscapes were exquisite & many admirable portraits. A set of photos of the animals at the Zoological Garden by Don Juan, 2nd son of Don Carlos [the king of Spain] are almost the finest of all the specimens.[24]

The zoo photographs were by Count de Montizon (pl. 21), and the queen and Prince Albert acquired forty-three prints for the Royal Collection; they were most likely intended for the education of the royal children. The prints were kept with the natural history collections at the Swiss Cottage Museum at Osborne House.[25] Victoria and Albert's purchases and support of the Photographic Society were not only welcomed by the organization and those members whose work they

FIGURE 19
Roger Fenton (British, 1819–1869), *The "Fairy" Steaming through the Fleet*, March 11, 1854. Albumen silver print,
14.6 × 20.5 cm (5¾ × 8¹⁄₁₆ in.). Windsor, The Royal Collection, RCIN 2906008

procured; their patronage also elevated photography as a medium worthy of the attention of the highest social circles. The interest of the queen and Prince Albert was regularly reported in the press. In 1854 the *Illustrated Magazine of Art* noted that "the proceedings of the Photographic Society…are calculated to have a most beneficial influence upon the progress of this rising branch of art. Its [second] exhibition was opened a short time since, and was honored by a visit from her Majesty and Prince Albert, who are well known to be no means proficient in photography, as in other elegant pursuits."[26]

CONFLICT

THE CRIMEAN WAR BEGAN IN OCTOBER 1853: AFTER THE RUSSIANS OCCUPIED territory controlled by the Ottoman Empire, British ships were ordered to Constantinople to protect British interests and authority in the region. In March 1854, just a few months after the Photographic Society's inaugural exhibition, Britain and France declared war on Russia. On March 11, 1854, the queen and Prince Albert were aboard the royal yacht the *Fairy*, to salute the military ships as they set sail for the war's Baltic theater (fig. 19). The last ship to pass was the HMS *Duke of Wellington*, the flagship of Vice Admiral Sir Charles Napier, which only days before had been photographed in dock by Captain Linnaeus Tripe (pl. 29); Tripe (1822–1902) was a British military officer who apparently became interested in pursuing photography after visiting the Great Exhibition in 1851. The vessel, originally built for the navy in the 1840s as a wood sailing ship, was retrofitted in 1852 to accommodate steam power. When the work was complete, the *Duke of Wellington* was the most powerful warship of her time. Victoria recorded that the vessel "was immensely cheered as she glided along, towering majestically above the blue waters, her figurehead (a very good likeness) being I am sure, a harbinger of glory."[27] Britain had not waged a war on this scale since the Duke of Wellington had fought, and won, the Battle of Waterloo in 1815. Almost forty years later, the military consisted of aging men of rank, and many of the junior officers had never been in battle.

For these young soldiers photography offered the means to record their portrait in full military regalia before heading off to fight. Kilburn's studio, on London's Regent Street, was a popular destination for daguerreotypes, and two of his portraits of soldiers (pls. 30, 31) capture the pristine quality of their uniforms, with shiny brass buttons that were carefully embellished by hand on the photographs. These images, complete with painted backdrops, were in stark contrast to the horrible conditions that awaited the men. The daguerreotype of rosy-cheeked Lieutenant Robert Horsley Cockerell (a son of the architect Charles Robert Cockerell, who designed the Ashmolean Museum at Oxford University) became an eternal image of the nineteen-year-old, whose life would end on September 20, 1854, at the Battle of Alma. Precious and unique objects, typically housed in leather cases, daguerreotypes took on a memorial quality for the family and loved ones of the war dead.

As the war in the Crimea went on, most people in Britain learned about events from the daily reports that appeared in the *Times*, written by William Howard Russell, who sent dispatches directly from the region, or from the *Illustrated London News*, which published woodcut prints based on photographs by James Robertson (1813–1888), who was in Constantinople. In July 1854 the queen acquired two dozen views of Constantinople by Robertson.[28] She was no doubt aware of the ability of photography to provide a visual account of the landscape of a foreign land.

The first coherent body of photographs to document the war was created by Fenton, who in February 1855 traveled to the Crimea on the *Hecla*. Under the auspices of the Duke of Newcastle, secretary of state for war, and Sir Samuel Morton Peto, a railway entrepreneur (both of whom arranged for Fenton's passage), as well as Thomas Agnew (who not only financed the expedition but would sell the resulting prints through his commercial gallery), Fenton produced more than three hundred photographs. Fenton had made a number of portraits of the royal family in 1854 and enjoyed a proximity to the monarch that few photographers were granted at the time.[29] However, it is not clear if he was sent to the region at the behest of the queen, though he did have letters of introduction from Prince Albert, which helped him gain access to all levels of the military hierarchy.[30] Fenton's images documented the landscape of the war and the military personnel, but they did not document the action of the war. Apart from the inherent dangers of the battlefield and the limitations of the medium, there was arguably no need to record the fast action and gore of the war—Russell's graphic dispatches detailed the plight of the soldiers and the appalling conditions for the audience at home. Rather, as the *Journal of the Photographic Society of London* explained, the images by Fenton were visual accompaniments to "all that we have anxiously read about from day to day."[31] Nonetheless, for the most part Fenton's photographs do not jibe with Russell's written account. Although food shortages were common and disease rife in the camps (more men died from illness and injury than in battle), his photograph of the *Cooking House of the 8th Hussars* (pl. 32) almost resembles a leisurely picnic scene. By the time Fenton arrived in the Crimea, the worst had passed, but his correspondence from the region suggests he did witness some bloody scenes, none of which made it into his photographic work.[32]

That the photographs were a commercial enterprise, underwritten by Agnew, may also account for the lack of sensational imagery in Fenton's photographs. For Victorian viewers, these pictures were more prescriptive than descriptive of actual war.[33] Russell's November 14, 1854, dispatch to the *Times* had described the famous scene of the charge of the Light Brigade, where "the plain was strewed with their bodies and the carcasses of horses."[34] Moved by Russell's account, the poet Alfred Tennyson wrote "The Charge of the Light Brigade" (published in December 1854), wherein he described the cavalry riding into "the valley of Death"—evoking "the valley of the shadow of death" of Psalm 23. In Fenton's *Valley of the Shadow of Death* (pl. 33), however, the stark landscape, with an empty road, is strewn with cannonballs, not dead bodies. Fenton's photograph showed not the famous battleground but a stretch of land that was frequently attacked by the Russian Army, and thus named the "valley of the shadow of death" by British soldiers. The Victorian viewer nonetheless made a connection between the photograph and Tennyson's poem, the actual battle, and the lives lost. One contemporary account referred to "'The Valley of the Shadow of Death,' with its terrible suggestions, not merely those awakened in the memory but actually brought materially before the eyes, by the photographic reproduction."[35] In Victorian society, analogy was integral to the

understanding of events and their significance. Those safely ensconced at home used their imagination and drew upon disparate sources such as the newspaper, the Bible, and literature to paint the scene for themselves; Fenton's photographs were a new addition to this established theater of the mind. His photographs were not intended to document the war fully and objectively; rather, they aimed to provide specific frames of reference essential to the overall comprehension of events.

Fenton's Crimean photographs were included in a series of exhibitions that toured Britain in 1855, and although a twenty-first-century audience might view such displays suspiciously, as propaganda, the sentiment of a mid-nineteenth-century audience was more likely hero worship. Admiration of Britain's military heroes had been on the rise since the Napoleonic Wars (Talbot's view of Nelson's Column under construction is evidence of such adulation on a grand scale; see pl. 10) and was to be found in the literature of Sir Walter Scott and the lectures and writings of Thomas Carlyle (pls. 62, 63). Indeed, when Fenton wrote to Agnew from the Crimea, he stated his intention of securing "pictures of the persons & subjects likely to be historically interesting."[36] It took several attempts before Fenton managed a sitting with Lord Raglan, commander in chief of the British Army. Raglan was a veteran of the Napoleonic Wars (he had lost an arm in the Battle of Waterloo), but the Crimea was his first experience leading troops into battle. Although Fenton may have been hoping for a heroic portrait, the sixty-seven-year-old subject is shown seated in a doorway, caught on the threshold between light and dark, looking weary (pl. 34). Raglan was suffering from dysentery and within a month of Fenton's making this portrait, the commander would be dead.

The queen was much affected by the accounts of the war, and her letters and journal entries of the period are full of concern and compassion for the soldiers who were risking their lives. Her desire to recognize their courage resulted in the creation of the Victoria Cross, a medal bestowed on individuals who showed extreme valor.[37] She also kept a private album of portrait photographs of veterans, many of whom had been maimed and lost limbs. A poignant picture of two men convalescing (pl. 36) was annotated by the photographers, Joseph Cundall (1818–1895) and Robert Howlett (1831–1858) of the Photographic Institution, with descriptions of the men's injuries and how they came by them.[38] Each man, Private Jesse Lockhurst of the Thirty-First Regiment (seated) and Thomas O'Brien of the First Royals (reclining), holds the shot that caused his injuries. The queen had visited the soldiers at Brompton Barracks, in Chatham, Kent, on April 16, 1856. She seemed anxious to have a photograph of the wounded men and to fully understand their injuries—and the realities of conflict so powerfully documented by photography.

By the end of the Crimean War, in 1856, attention was turning to India, which since the fall of the Mogul Empire in the 1720s had largely been under the authority of the British East India Company. Many of the army officers and soldiers who had fought in the Crimea traveled eastward, to put down the Sepoy Rebellion (1857–58). Following the British Army to India from the Black Sea was the photographer Felice Beato (1832–1909). The Crimean veterans Colin Campbell (later Lord Clyde) and General Mansfield, whom Beato photographed with Sir Hope Grant (pl. 37), made a name for themselves in India, too. The Indian mutiny began when a group of Indian soldiers rebelled against British rule. The long-drawn-out fight was ultimately won by Britain, but it meant the end of the East India Company, which was dissolved (the Crown—Queen Victoria and her government—took over the running of India and the territories in South and Southeast Asia). Campbell was in command of the relief army sent to help fight the insurgents. By November 1857 he and his regiment, the Ninety-Third Highlanders, and the Fourth Punjab Regiment had fought and killed 2,000 Indians at the Sikandarbagh, a large villa in Lucknow built by the Nawab of Oudh, Wajid Ali Shah. Campbell relied on the help of Hope Grant and Mansfield to secure victory and end the uprising. For the majority of people back in Britain, the battle in India was disturbing, in large part due to what became known as the Cawnpore Massacre. Around 120 British women and children had been caught up in the conflict and were murdered by Indians. The massacre was widely reported in the press, with gruesome accounts of how the women were killed by local butchers wielding their cleavers. The British Army sought retribution and killed as many as 3,000 sepoys in a single day at the Great Gateway of the Kaiserbagh, a palace complex of Wajid Ali Shah's in Lucknow (pl. 38).

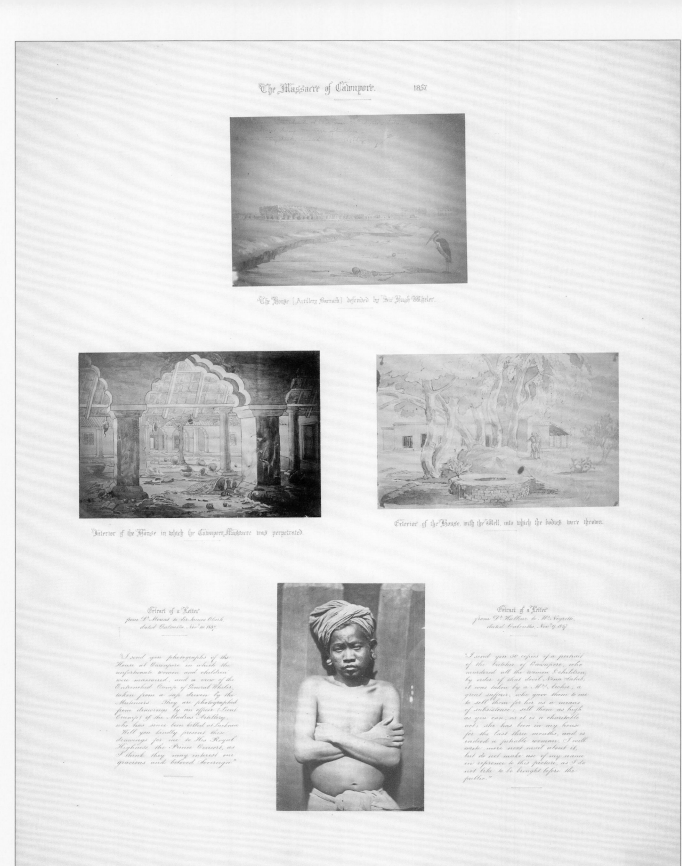

FIGURE 20
Unknown photographer after Lieutenant Crump, Madras Artillery, *Four Photographs of the Massacre at Cawnpore*, 1857. Four photographs and letter/text on large sheet, approximately 73 × 56 cm (28¾ × 22¹⁄₁₆ in.). Windsor, The Royal Collection, RCIN 2942110.a–d

The queen received from a Dr. Morrat a number of photographs of, and written statements about, the uprising, including a group of four photographs, three of which were of drawings by a Lieutenant Crump of the Madras Artillery that documented the house in Cawnpore where the women were held captive as well as a portrait of the "Cawnpore Butcher" by a Mrs. Archer. The original photograph and the photographic copies of drawings and extracts from the accompanying letters were mounted on a large piece of card (fig. 20); they were perhaps intended to perform some didactic function. Prince Albert used a similar presentation for his Raphael Collection,[39] which was intended to aid scholars in their research on the great Italian artist.

Indeed, when twenty-six photographs of the Indian rebellion were on display at the Photographic Society exhibition in London in 1859, the society's journal recognized the importance of the images in teaching the effects of war: "These admirable views give us, in fact, the pictorial romance of this terrible war. They are necessary, as our contemporaries say, to an understanding of the war now, and will be indispensible to its future historians."[40] The images were by Beato, who had arrived in India on February 13, 1858, when the mutiny was almost at an end. Several months had passed since Campbell and his troops had massacred 2,000 sepoys at the Sikandarbagh. This lapse of time did not stop Beato from making a graphic record of the bloodshed, in his photograph *Interior of the Secundra Bagh after the Slaughter of 2,000 Rebels, Lucknow* (pl. 39).[41] Reconstructing the slaughter, he offers the viewer an arrangement of decaying bones scattered over the courtyard, with the ruined palace serving as a scenic backdrop. As Fred Ritchin has pointed out, Beato's war images could present only a sense of before and after, as "contemporary technologies required that the action-packed scenes would be left to the viewers' imagination."[42] Victorian predilections for classification and empirical evidence meant that these photographs became part of a visual language for describing war; they were documents of real places, but they were also tools for the imagination.

ART AND INNOVATION

WHILE IN FAR-OFF LANDS PHOTOGRAPHY WAS BEING USED TO DOCUMENT WAR, in Britain there was an interest in exploring the medium's artistic qualities. There was a new emphasis on the photographer as not a mechanical copier of nature but a creator, whose eye and imagination shaped the image. As the 1850s progressed, with more and more photographic societies, annual exhibitions, and publications, desire grew for another national exhibition, this one showcasing photography alongside painting, drawing, and sculpture. Painting had been omitted from the Great Exhibition of 1851, in part because it was deemed neither fitting nor necessary, given the great volume of paintings and the already numerous exhibition opportunities for painters. However, the display of photographs alongside works of science and industry had not been satisfying to some, who instead longed for photography to be shown in the same space as fine arts. That opportunity came in 1857, in the Exhibition of the Art Treasures of the United Kingdom, a massive display hosted by the city of Manchester. The queen and Prince Albert became patrons of what was advertised as "the LARGEST and most VALUABLE COLLECTION OF WORKS OF ART, ancient and modern, ever collected ... [and that] can never be brought together again." The exhibition ran from May 5 to October 17, attracting over one and a quarter million visitors.[43] Prince Albert presided over the opening alone (the queen was absent due to her confinement after the birth of their last child, Princess Beatrice, in April). His speech at the opening ceremony spoke to the edifying nature of the display: "You have done well not to aim at a mere accumulation of works of art and objects of general interest, but to give your collection, by a scientific and historical arrangement, an educational character."[44] The queen visited the exhibition on June 30 and remarked in her journal on the size of the crowds who lined the streets to greet her and Prince Albert, who was hailed as "the Patron of Art & *promoter* of Peace" (pl. 40).[45]

Once again, the royal seal of approval was critical to the success of the exhibition, which had required facilitating loans of artworks from important collections all over the country in just ten months. The involvement of the royal family as patrons and lenders would have been persuasive in convincing others to lend.[46] The exhibition contained 16,000 objects, among them "1173 ancient pictures, 689 modern, 384 portraits, 969 watercolors, 10,000 objects of art in the general museum,

260 sketches and original drawings, 1475 engravings, 500 miniatures, 597 photographs, and 63 architectural drawings."[47] Paintings included works by Raphael, Dürer, Holbein, Rubens, Van Dyck, and Velázquez. These works were installed floor to ceiling, in a manner that was meant less to enhance visitors' aesthetic experience than to emphasize the abundance of the treasures that filled the barrel-vaulted galleries (fig. 21 and pl. 42). Included in the section devoted to photography were some of the leading names in the field: Francis Bedford, Leonida Caldesi, Antoine Claudet, Joseph Cundall, P. H. Delamotte (who was also responsible for organizing the photography section), Hugh Welch Diamond, Roger Fenton, William Edward Kilburn, Gustave Le Gray, John Dillwyn Llewelyn, John Jabez Edwin Mayall, James and Robert Mudd, William Lake Price, and Oscar Gustave Rejlander. The display was a chance not only to place photography within the fine arts but also to showcase recent technological innovations, such as Le Gray's seascapes, which involved two different negatives (one for the sky and one for the sea), each requiring a different exposure time (pls. 44–46).

Le Gray was not the only photographer to exhibit examples of combination printing. One of the more controversial photographs in the Manchester display was a print by Rejlander, *The Two Ways of Life*, which was made from thirty-two separate negatives (pl. 47). Rejlander, who was born in Sweden but settled in England, specialized in genre scenes of domestic life and supplied artists with photographic studies that they used as a reference tool. In creating photographs for his own use, he excelled at combination printing, using multiple negatives to create an image in a single print. However, it was not the number of negatives involved in the creation of *The Two Ways of Life* so much as the subject matter that caused an outcry. Rejlander depicts two young men at a moral crossroads, where one path leads to debauchery, vice, and turpitude, and the other, to the virtues of labor, fidelity, and knowledge. The photograph appeared so realistic that viewers attributed the partial nudity (of Rejlander's twenty different models) to a real bacchanal rather than the skillful fabrication of the artist. However, the strong moral message of the image was appreciated by others, including Queen Victoria and Prince Albert, who perhaps saw echoes of Raphael's *School of Athens*, which appears to have served as an inspiration for the photograph. At Prince Albert's invitation, Rejlander had gone to Buckingham Palace to show the photograph in April 1857 (before the exhibition), whereupon the prince ordered three copies, apparently to be hung in his dressing rooms at Balmoral, Osborne, and Windsor.

During the 1850s it seemed that technological advancements were happening in almost every field. When Robert Howlett photographed the ship the *Great Eastern* on November 30, 1857, it was the third attempt to launch this iron behemoth, designed by Isambard Kingdom Brunel and at the time the largest vessel in the world (pls. 49, 50). The ship was finally launched in January 1858 and would go on to make numerous transatlantic crossings, often carrying British emigrants to America. The *Great Eastern* photographs were included (with more than a thousand others) in the 1858 display of the Photographic Society at the South Kensington Museum (later the Victoria and Albert Museum). It was the first time photographs were shown in a museum setting. It would seem that photography had arrived. The medium was now capable of recording momentous occasions and achievements, and it provided true likenesses in portraits, disturbing records of wars around the world and national tragedies, and indisputable evidence of engineering feats and innovations.

Also included in the 1858 display was the work of Francis Frith (1822–1898), who had traveled to Egypt in 1856 and 1857. His views of the ancient pharaonic sites were extremely popular and in 1858 appeared in multiple exhibitions in Britain.[48] During the late 1850s and early 1860s photographs of the Holy Land and Egypt were regularly featured in photographic exhibitions. For most Victorians, the Bible had been the sole source of information about this part of the world, but since the advent of photography, these ancient sites and biblical places were recorded with a compelling veracity in photographs. For all the technological innovations of the Victorian world, these views offered a glimpse into a seemingly unchanging landscape, transporting viewers back to the time of Jesus, and before. Such images were often included in religious publications, such as *Palestine in 1860: A Series of Photographic Views*, by the Reverend Robert Buchanan. Buchanan's book contained photographs by John Cramb (act. 1850s–1860s), whose views, such as *Church of the Holy Sepulcher and Christian Street* (pl. 56), were intended for the Bible-reading audience back in Britain.

FIGURE 21
P. H. Delamotte (British, 1820–1889), *View in Central Hall, Art Treasures Exhibition, Manchester*, May 1857.
From *The Photographic Album for the Year 1857*. Albumen silver print, 22.8 × 17.9 cm (9 × 7 1/16 in.).
Los Angeles, J. Paul Getty Museum, 84.XA.871.5.12

A. The Engine house.

B. Part were the beam projected which broke & fell down the Pit Shaft.

C. Machinery over the Shaft.

D. the gangway leading to the Shaft.

E. Pit Heap.

Photographed Jan 30th 1862. and most respectfully forwarded. by W & D. Downey

In 1861, before Albert's premature passing, the prince and the queen decided that their eldest son, Albert Edward, Prince of Wales, should go on a tour of Egypt and the Holy Land. The trip was viewed as an educational experience for the twenty-year-old prince. This four-month excursion was the first time a photographer accompanied a royal tour, and the honor was afforded to Francis Bedford (1815–1894).[49] Having taken up photography in 1853, Bedford was already exhibiting his works in 1854, in the first annual exhibition of the Photographic Society. Bedford's photographs record the adventures of the royal party as they stopped at various sites—his view *Gizeh* (pl. 57) shows the prince and some of his entourage mounted on camels in front of the Great Pyramids—but are also representative of the general Victorian interest in these ancient places. The view *Bethlehem—The Shepherds' Field* (pl. 58) shows the site believed to be where, according to the Gospel of Luke, the Angel Gabriel appeared before the shepherds to announce the birth of Jesus. The audience in 1850s Britain would have viewed this photograph as evidence of the truth of the gospel's words, but the image was also a visual tool for the mind in contemplating the biblical story. In other words, the photographs had the capacity to assist the imagination.

Photography was again a visual aid to Britons' imagination after the Hartley Colliery disaster. More than two hundred men perished on January 16, 1862, after a huge beam blocked the single shaft into the coal mine, trapping the miners underground. The firm W. & D. Downey provided Queen Victoria with photographs documenting the disaster (pl. 51), which remains one of the worst mining accidents in England. The photographs, appropriately bordered in black to denote the loss of life, were accompanied by a hand-written description by the photographers that identified the key areas of the tragic scene (fig. 22); a portrait showed men who had been involved in the unsuccessful rescue effort (pl. 52). The queen, already deep in grief after the sudden death of Prince Albert, in December 1861, contributed to the relief fund established to help the wives and families of the men who had died.

DEATH AND ART

THE EARLY 1860S WERE A DEFINING MOMENT FOR BOTH THE QUEEN AND PHOTOGRAPHY. The two would not part ways, but the role of the queen (now without Prince Albert) in the evolution of photography changed. From the beginning the royal couple had been intellectual contributors to the dialogue on photography as well as passionate patrons and arbiters of taste. The queen had been a regular attendee at photographic exhibitions, but with Albert's passing she retreated from all public engagements. Victoria's sorrow was recorded in photographs that show her in mourning.[50] As the queen's grief deepened, she withdrew even more. It was in many respects the end of an era.

At this time the Photographic Society's authority was diminished. Its annual exhibitions were criticized as boring, and the practice of listing prices alongside artworks in the accompanying catalogue was considered blatant commercialism by many people. Photography *was* now a commercial enterprise, however. The proliferation of inexpensive stereoscopic views and cartes de visite severely undermined the value—both monetary and aesthetic—of the fine-art prints created by photographers such as Fenton and Price. Many saw the democratizing of the medium as a debasing of the art form, and for some photographers of the 1850s the end came when the organizers of the 1862 International Exhibition in London attempted to place photographs in the machinery section. Only after vociferous objections in the leading photographic journals did the exhibition committee reconsider and place photography in a separate hall.

When Victoria and Albert first sat for their portraits in front of a camera in the 1840s, few people had seen a photograph, and even fewer were capable of making photographic images. By the time of Prince Albert's death, just two decades later, photography was an industry that employed thousands, serviced hundreds of thousands, and produced millions of photographs. It was no longer the purview of the elite and royalty; it was available to all. Photography slipped further into the category of the commercial, and it seemed that artistic potential was eschewed in favor of increasing popularity among the masses. People no longer engaged in the imaginative pursuits of the theater of the mind that photography had encouraged in the 1850s; they now preferred more literal representations.

Yet some photographers continued to explore the medium's artistic possibilities. In a letter to Sir John Frederick William Herschel (1792–1871; see fig. 2), the photographer Julia Margaret Cameron (1815–1879) spoke of her desire "to ennoble Photography and to secure for it the character and uses of High Art by combining the real and Ideal and sacrificing nothing of the Truth by all possible devotion to Poetry and beauty."[51] Cameron's work would likely have found favor with the late prince consort. In 1865 a display of Cameron's photographs at Colnaghi's prompted the queen to continue collecting in the medium for which she and her husband had shared a passion. She purchased five prints, among them *Paul and Virginia* and *The Whisper of the Muse* (pls. 59, 60). The subjects of these allegorical works, like many of Cameron's subjects, were drawn from literature, and the story of *Paul and Virginia* held particular meaning for Victoria. The popular French eighteenth-century novel, written by Jacques-Henri Bernardin de Saint-Pierre, featured two children who grow up on the remote island of Mauritius. At the time of the Great Exhibition in 1851, Prince Albert had acquired a marble statue depicting the story's two main characters, by Guillaume Geefs, which he subsequently presented to Victoria.[52] The queen made another purchase of Cameron photographs in 1867, though at this time she seemed to favor the photographer's portraits of important men, such as *G. F. Watts* and *Thomas Carlyle*, rather than the allegorical work (pls. 61–63). Both purchases of Cameron's photographs were made around Christmas, and some are no longer in the Royal Collection, so it is possible that some of the prints were intended as gifts. Victoria continued to collect—notably, a group of twenty-one prints by Rejlander were purchased in 1869, perhaps in honor of her late husband, who favored the artist (pls. 64, 65).[53] Although her engagement with photography in the second half of her reign was less passionate than it had been during the 1840s and 1850s, when Albert was alive, Victoria would eventually return to sitting before the camera for her portrait, and her photographic archive would continue to grow, with new images from her expanding empire and pictures of her children, grandchildren, and great-grandchildren.

1 Prior to her death, Queen Victoria asked her youngest daughter, Princess Beatrice, to transcribe her diaries. After the queen's death, Beatrice not only transcribed but also edited the volumes (and destroyed the originals), so that the journal that exists today is an abridged version. It is thus possible that any early mention of photography was omitted.

2 For the queen's viewing of Talbot's work, see Jennifer Green-Lewis's essay in this volume.

3 It has been alleged that Victoria discussed daguerreotypes with Albert before she proposed; see Helmut Gernsheim, *The Rise of Photography, 1850–1880: The Age of Collodion* (New York, 1988), 20; Helmut and Alison Gernsheim, *Queen Victoria: A Biography in Word and Picture* (London, 1959). There is no evidence to support this story.

4 Ross (1794–1860) began Prince Albert's portrait after the October 15, 1839, engagement. Several sittings took place through early November, before the prince returned to Coburg. Ross then commenced the companion portrait of Queen Victoria.

5 *Athenaeum*, 18 April, 1840, frontispiece.

6 Larry J. Schaaf, *The Photographic Art of William Henry Fox Talbot* (Princeton, N.J., 2000), 194.

7 Unattributed newspaper report on the meeting of the Society for Improving the Condition of the Labouring Classes, May 18, 1848, quoted in Frances Dimond and Roger Taylor, *Crown and Camera: The Royal Family and Photography, 1842–1910*, exh. cat. (New York: Viking, 1987), 29.

8 *Athenaeum*, August 12, 1848, 809.

9 *Times* (London), July 15, 1850, 4.

10 *Athenaeum*, October 4, 1851, 1051.

11 Seven hundred was the number given by Robert Hunt, who was the author of the authorized guide *Hunt's Hand-Book to the Official Catalogues*. See Roger Taylor, *Impressed by Light: British Photographs from Paper Negatives, 1840–1860*, exh. cat. (New York: Metropolitan Museum of Art, 2007), 37.

12 The entrance price varied according to the day of the visit; the most expensive was three guineas.

13 Victoria, Queen of the United Kingdom, Journal, May 1, 1851, Windsor, Royal Archives, VIC/MAIN/QVJ.

14 Roger Taylor, *Photographs Exhibited in Britain, 1839–1865: A Compendium of Photographers and Their Works* (Ottawa, 2002), 18, 38.

15 William Henry Fox Talbot to the Earl of Rosse, July 30, 1852, in *The Correspondence of William Henry Fox Talbot*, ed. Larry J. Shaaf, De Montfort University, Leicester, http://www.foxtalbot.dmu.ac.uk.

16 *Journal of the Society of Arts*, December 31, 1852, 63.

17 *Journal of the Society of Arts*, January 7, 1853, 76.

18 *Reports of the Juries* (London, 1852), 244.

19 For Becker and his role in the royal household, see Sophie Gordon's essay in this volume.

20 Taylor, *Impressed by Light* (note 11), 52.

21 It would not become the Royal Photographic Society until 1894.

22 Taylor, *Impressed by Light* (note 11), 60.

23 For detailed discussions of Victoria's private family photographs and of her photograph collection, see Sophie Gordon's essay and my essay "'As We Are'" in this volume.

24 Victoria, Journal (note 13), January 3, 1854.

25 Jonathan Marsden, ed., *Victoria and Albert: Art and Love*, exh. cat. (London: Royal Collection Publications, 2010), 422.

26 "Photography as a Fine Art," *Illustrated Magazine of Art* 2, no. 61 (1854): 338. There is some confusion in dates here as the first exhibition ran from January 4 through the end of February 1854, and the second, from January through March 1855. See Taylor, *Photographs Exhibited in Britain* (note 14), 40, 44.

27 Dimond and Taylor, *Crown and Camera* (note 7), 81.

28 James Robertson, invoice for five pounds and eight shillings, for twelve photo views of Constantinople, July 10, 1854, and twelve photo views of Constantinople, July 15,

1854, Windsor, Royal Archives, PPTO/PP/QV/PP2/6/4665.

29 See Roger Taylor, "'Mr. Fenton Explained Everything': Queen Victoria and Roger Fenton," in Gordon Baldwin, Malcolm Daniel, and Sarah Greenough, *All the Mighty World: The Photographs of Roger Fenton, 1852–1860*, exh. cat. (New York: Metropolitan Museum of Art, 2004), 75–81.

30 Sarah Greenough, "'A New Starting Point': Roger Fenton's Life," in Baldwin, Daniel, and Greenough, *All the Mighty World* (note 29), 20; Taylor, "'Mr. Fenton Explained Everything'" (note 29), 79.

31 *Journal of the Photographic Society of London*, September 21, 1855, 221.

32 One of Fenton's letters to Agnew, dated April 9, 1855, cautions the dealer to keep the letters private, as it would be "injurious" for Fenton if they were to get into the newspapers. *Roger Fenton's Letters from the Crimea*, De Montfort University, Leicester, http://rogerfenton.dmu.ac.uk.

33 Jennifer Green-Lewis, *Framing the Victorians: Photography and the Culture of Realism* (Ithaca, N.Y., 1996), 139–40.

34 William Howard Russell, "The Charge of the Light Brigade," *Times* (London), November 14, 1854, 7–8.

35 *Journal of the Photographic Society of London* (note 31), 221.

36 Roger Fenton to William Agnew, May 18 and 20, 1855, *Letters from the Crimea* (note 32).

37 The Victoria Cross was inaugurated on June 26, 1857, when the queen awarded medals in a ceremony in Hyde Park. Coincidentally, it was also the day when Prince Albert's new title of prince consort became publicly known. See Victoria, Journal (note 13), June 26, 1857.

38 "Jesse Lockhurst. Grape shot wound in the right eye, destroying right + upper jaw bone wounded in advanced trenches. Aug 16th 1855. Weight of shot 18 1/2 oz. Thomas O'Brien. Grape shot wound in left eye destroying it and fracturing jaw bone weight of shot 6 3.4 oz. at the Redan Sept 8th 1855." Manuscript note from Photographic Institution, April 21, 1856, attached in photographic album, Windsor, Royal Collection, RCIN 2500194.

39 For Prince Albert's Raphael Collection, see Sophie Gordon's essay in this volume.

40 *Journal of the Photographic Society of London*, February 22, 1859, 185.

41 The massacre took place in November 1857, but Beato did not photograph the scene until March or April 1858.

42 Fred Ritchin, "Felice Beato and the Photography of War," in Anne Lacoste, *Felice Beato: A Photographer on the Eastern Road*, exh. cat. (Los Angeles: J. Paul Getty Museum, 2010), 120.

43 *Athenaeum*, April 25, 1857, 519.

44 *Illustrated Times*, May 9, 1859, 291.

45 Victoria, Journal (note 13), June 30, 1857.

46 Frances Dimond, "The Exhibition of Art Treasures of the United Kingdom, 1857," in Dimond and Taylor, *Crown and Camera* (note 7), 41.

47 *Literary Gazette*, January 9, 1858, 39.

48 The 1858 displays began with the Edinburgh exhibition of the Photographic Society of Scotland, followed by the London exhibitions of the Architectural Photographic Association and the Photographic Society of London. Frith's views of Egypt continued to be shown throughout 1862. See Taylor, *Photographs Exhibited in Britain* (note 14), 355–58.

49 See Sophie Gordon, *Cairo to Constantinople: Francis Bedford's Photographs of the Middle East*, exh. cat. (London: Royal Collection Publications, 2013).

50 For photographs of Victoria after the death of Prince Albert, see my essay "'As We Are'" in this volume.

51 Reproduced in Helmet Gernsheim, *Julia Margaret Cameron: Her Life and Photographic Work* (Millerton, N.Y., 1975), 14.

52 Sophie Gordon, *Roger Fenton, Julia Margaret Cameron: Early British Photographs from the Royal Collection*, exh. cat. (London: Royal Collection Publications, 2010), 12.

53 Dimond and Taylor, *Crown and Camera* (note 7), 16.

PLATES | *Part 1*

In the Beginning

In January 1839 two different photographic processes were announced. While Louis-Jacques-Mandé Daguerre's daguerreotype process involved an image formed on a metal plate, and William Henry Fox Talbot's photogenic drawing utilized a paper surface, both fundamentally changed how we see the world, by recording it with an unprecedented veracity. The 1840s were a time of radical political upheaval. However, while revolution spread elsewhere in Europe, the young Queen Victoria ruled Britain from Windsor Castle, as her predecessors had done since the eleventh century.

PLATE 1
WILLIAM HENRY FOX TALBOT
Round Tower, Windsor Castle, ca. 1841

PLATE 2
WILLIAM HENRY FOX TALBOT
Round Tower, Windsor Castle, ca. 1841

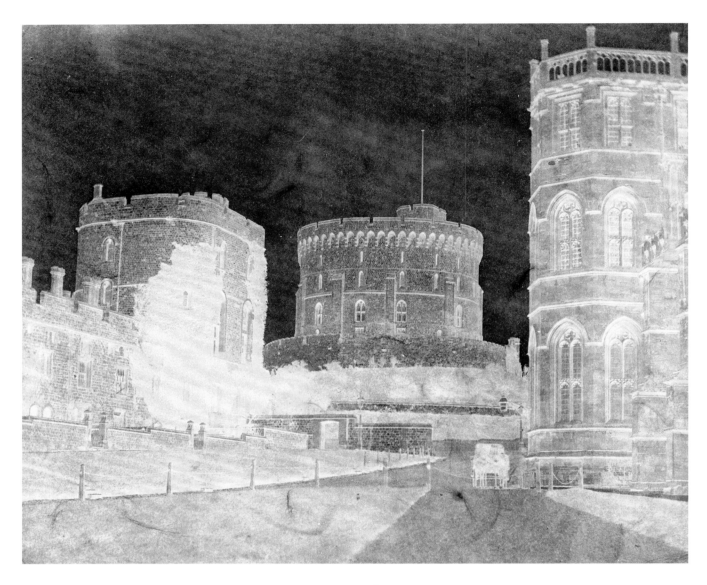

PLATE 3

WILLIAM HENRY FOX TALBOT

View of Round Tower from Lower Ward, Windsor Castle, ca. 1841

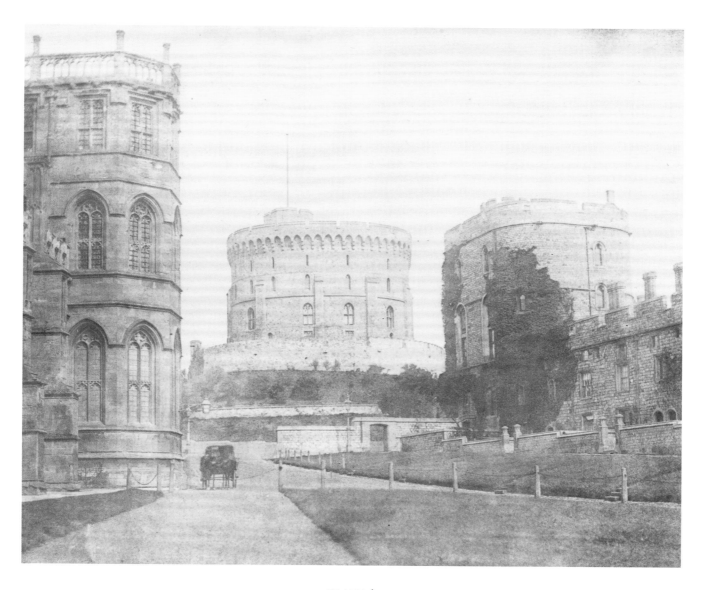

PLATE 4

WILLIAM HENRY FOX TALBOT

View of Round Tower from Lower Ward, Windsor Castle, ca. 1841

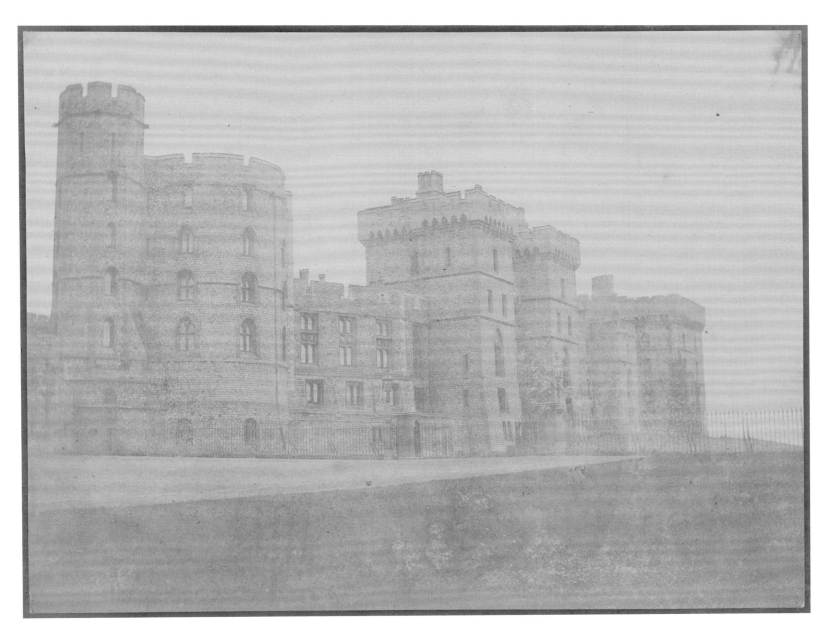

PLATE 5
WILLIAM HENRY FOX TALBOT
Untitled (Windsor Castle, South Front), ca. 1841

PLATE 6
WILLIAM HENRY FOX TALBOT
The Ladder, April 1, 1844

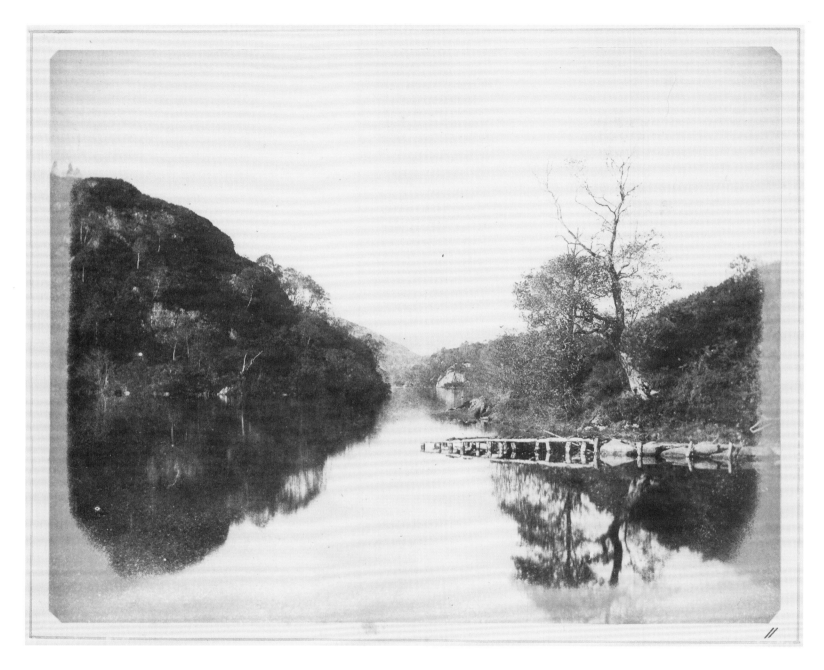

PLATE 7
WILLIAM HENRY FOX TALBOT
Loch Katrine, October 1844

PLATE 8

ANTOINE CLAUDET

Portrait of a Young Man with
Muttonchop Whiskers, ca. 1842

PLATE 9

ANTOINE CLAUDET

Portrait of the Duke of Wellington, May 1, 1844

PLATE 10

WILLIAM HENRY FOX TALBOT

Nelson's Column under Construction in Trafalgar Square, London, April 1844

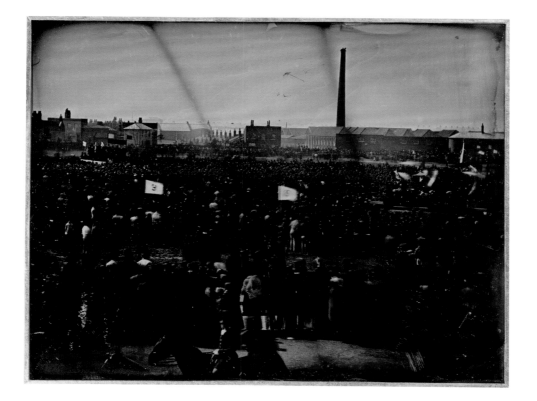

PLATE 11
WILLIAM EDWARD KILBURN
View of the Great Chartist Meeting on Kennington Common, April 10, 1848

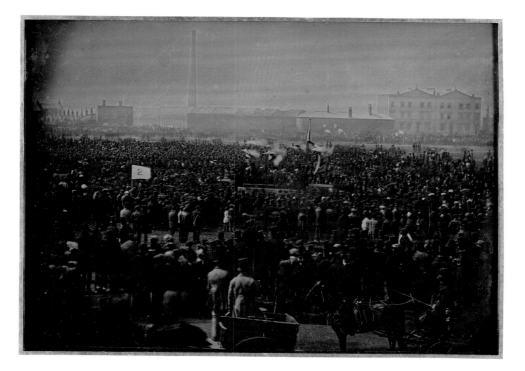

PLATE 12
WILLIAM EDWARD KILBURN
The Chartist Meeting on Kennington Common, April 10, 1848

EXHIBITIONS AND SOCIETIES

The Great Exhibition of the Works of Industry of All Nations opened on May 1, 1851, at the Crystal Palace in London. Of the thirteen thousand exhibits, seven hundred were photographs; this was the first time that many people had seen a photograph. The early 1850s witnessed the rise of the photographic exhibition in Britain and the establishment of photographic societies around the country. These early exhibitions included many of the images shown in the following pages; together they trace the evolution of the two sides of the medium—the technical and the artistic— which were much discussed at the time.

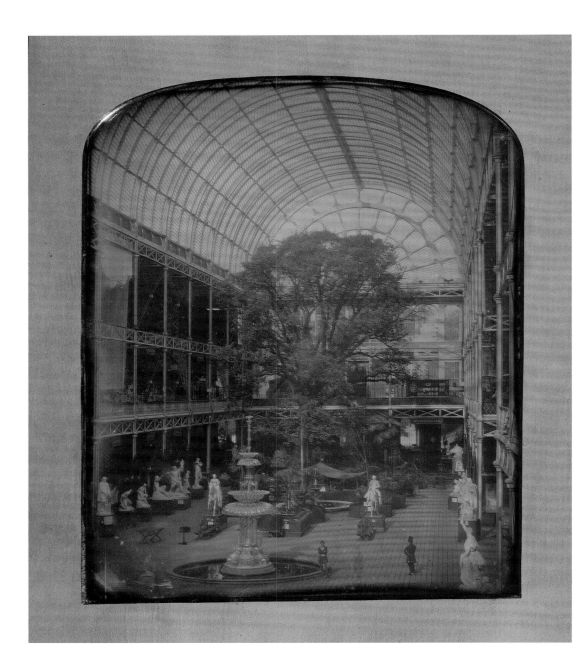

PLATE 13
JOHN JABEZ EDWIN MAYALL
The Crystal Palace at Hyde Park, London, 1851

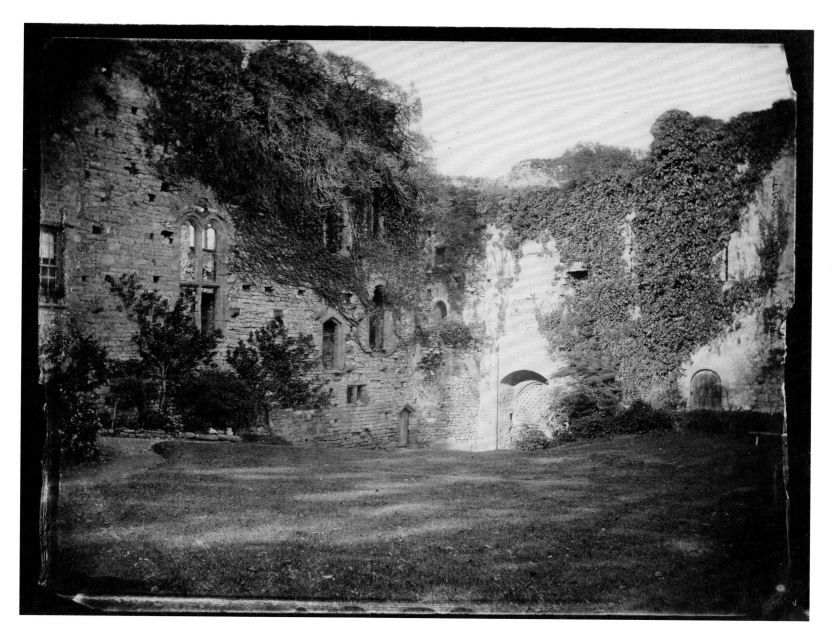

PLATE 14
FREDERICK SCOTT ARCHER
Untitled (Castle, Kenilworth), 1851

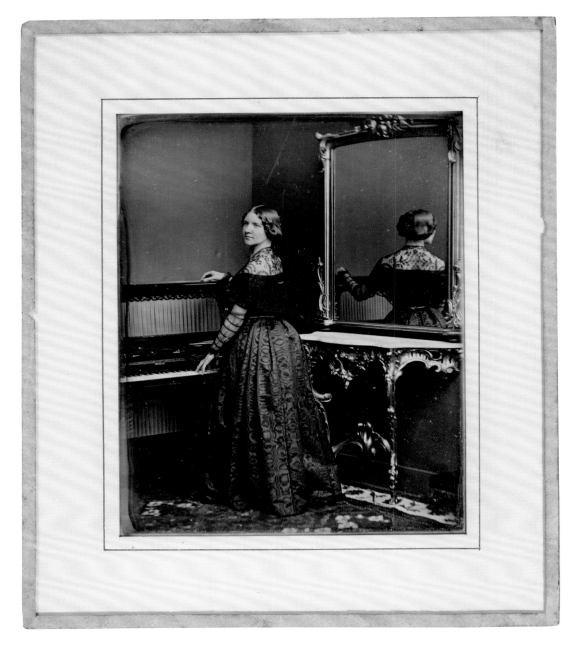

PLATE 15
WILLIAM EDWARD KILBURN
Jenny Lind Standing at a Piano, 1848

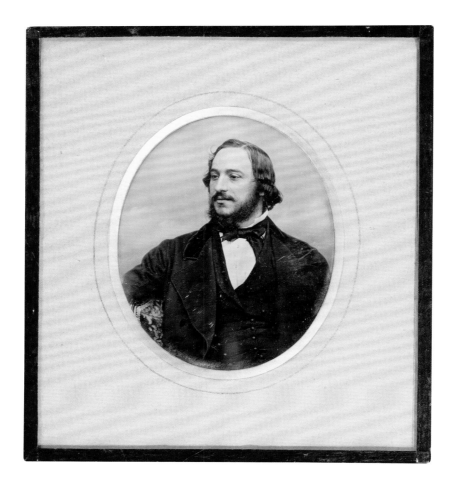

PLATE 16
UNKNOWN PHOTOGRAPHER
Signor Mario, 1851

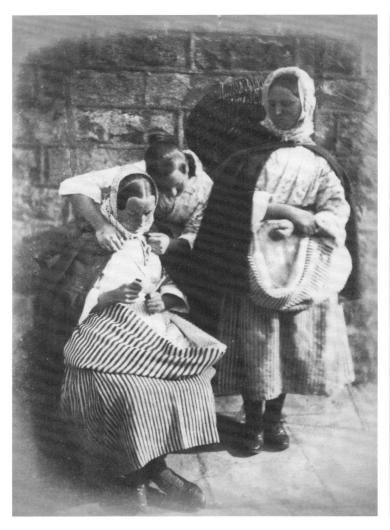

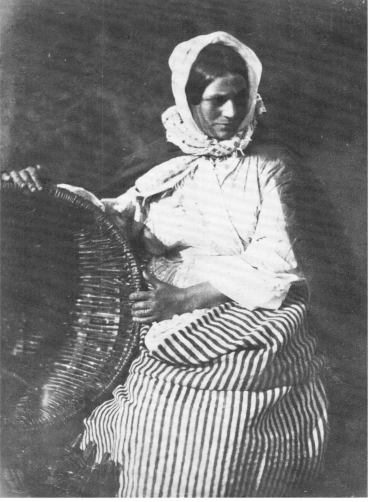

PLATE 17
DAVID OCTAVIUS HILL AND ROBERT ADAMSON
The Letter (Marion Finlay, Margaret Dryburgh Lyall,
and Grace Finlay Ramsay), 1843–47

PLATE 18
DAVID OCTAVIUS HILL AND ROBERT ADAMSON
Untitled (Mrs. Elizabeth [Johnstone] Hall), ca. 1846

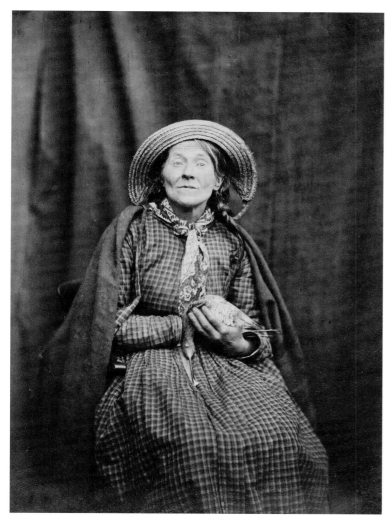

PLATE 19

HUGH WELCH DIAMOND

Untitled (Seated Woman with a Bird), ca. 1855

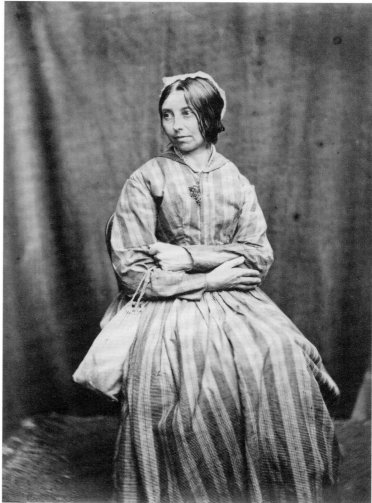

PLATE 20

HUGH WELCH DIAMOND

Untitled (Seated Woman with a Purse), ca. 1855

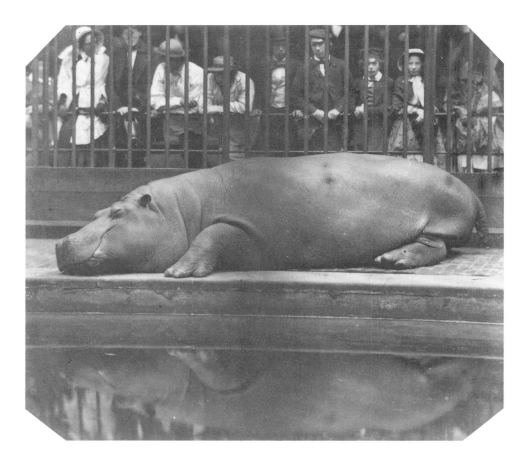

PLATE 21

COUNT DE MONTIZON

The Hippopotamus at the Zoological Gardens, Regent's Park, 1852

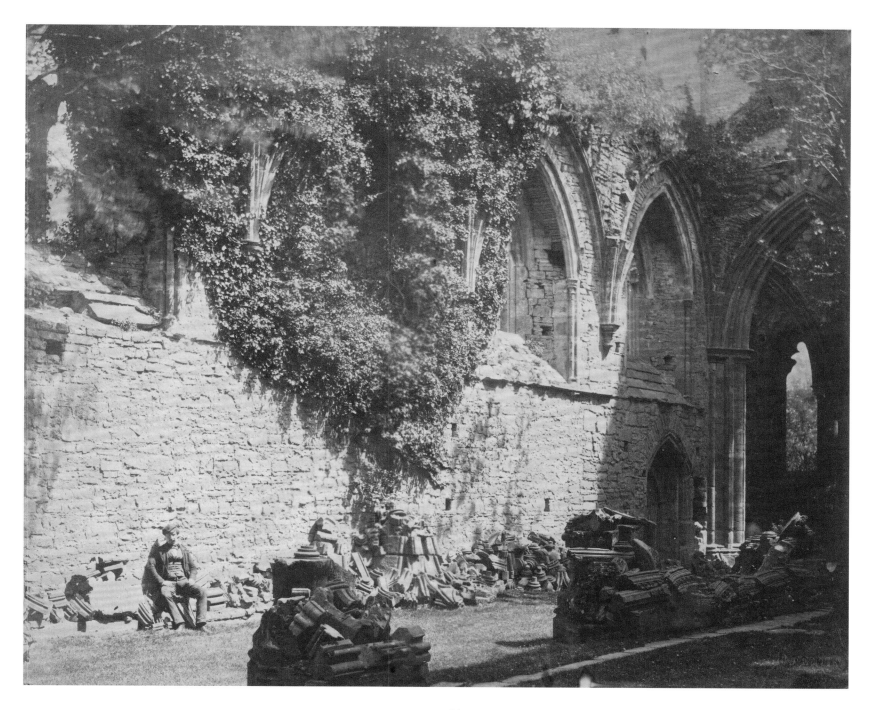

PLATE 22
ROGER FENTON
Untitled (Aisle of Tintern Abbey), 1854

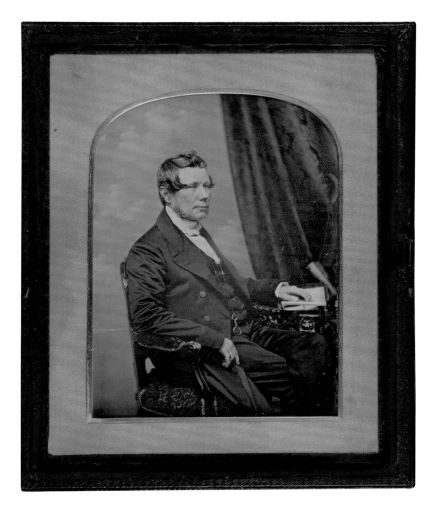

PLATE 24
RICHARD BEARD
Portrait of a Young Man Seated at Table, ca. 1852

PLATE 23
WILLIAM EDWARD KILBURN
Untitled (Portrait of a Seated Man with Graying
Muttonchop Whiskers), 1852–55

PLATE 25
ANTOINE CLAUDET
Portrait of a Girl in Blue Dress, ca. 1854

PLATE 26
WILLIAM CONSTABLE
Self-Portrait with a Recent Invention, ca. 1854

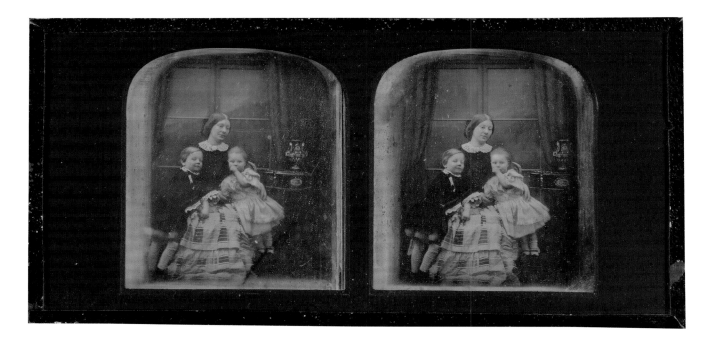

PLATE 27
ANTOINE CLAUDET
Untitled (Mother Posed with Her Young Son and Daughter), ca. 1855

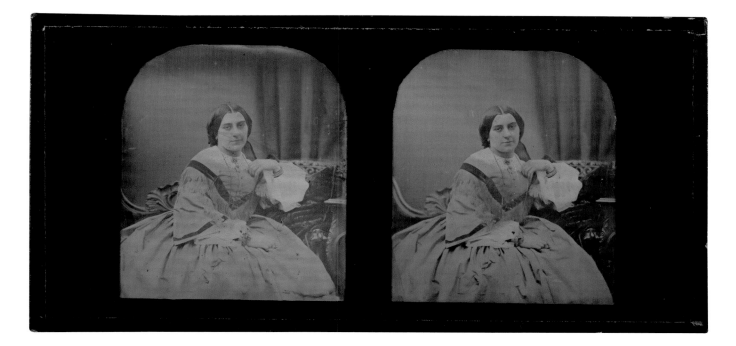

PLATE 28

ANTOINE CLAUDET

Untitled (Portrait of a Middle-Aged Woman), ca. 1855

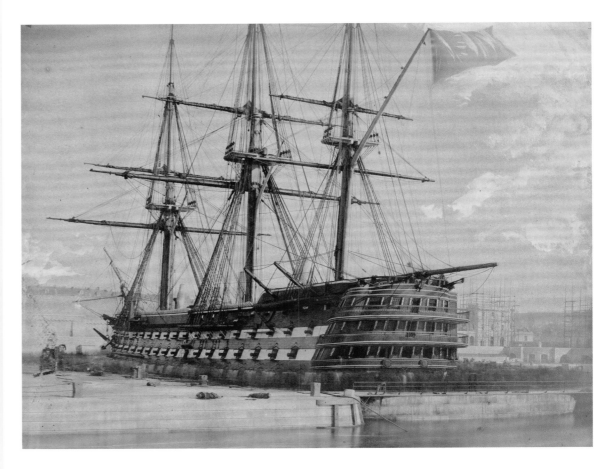

CONFLICT AND THE CAMERA

The 1850s were a period of conflict for Britain: the Crimean War lasted from 1853 to 1856, and the Sepoy Mutiny, in India, from 1857 to 1858. The camera, although unable to record live action, could capture the moments before and after battle. Photographic images revealed both the tedium and the horrors of war in these far-off lands; many of the prints were featured in public exhibitions, whereas other photographs were private mementos.

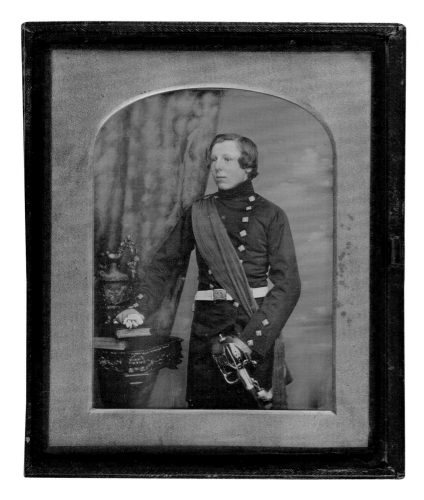

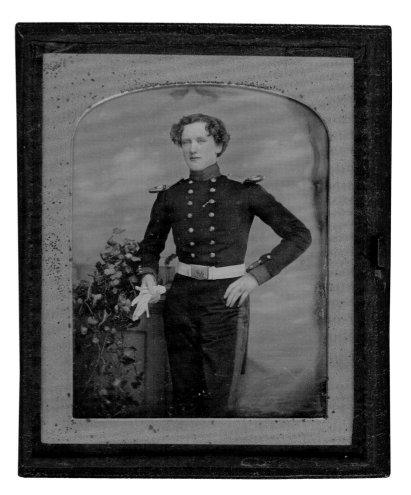

PLATE 30
WILLIAM EDWARD KILBURN
Untitled (Portrait of a Military Man), 1852–55

PLATE 31
WILLIAM EDWARD KILBURN
Portrait of Lt. Robert Horsley Cockerell, ca. 1852

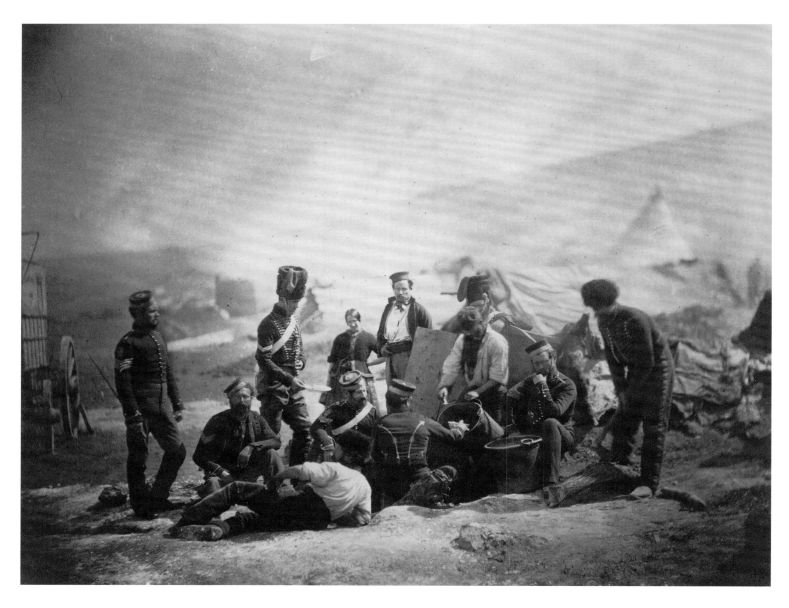

PLATE 32
ROGER FENTON
Cooking House of the 8th Hussars, negative, 1855; print, January 1, 1856

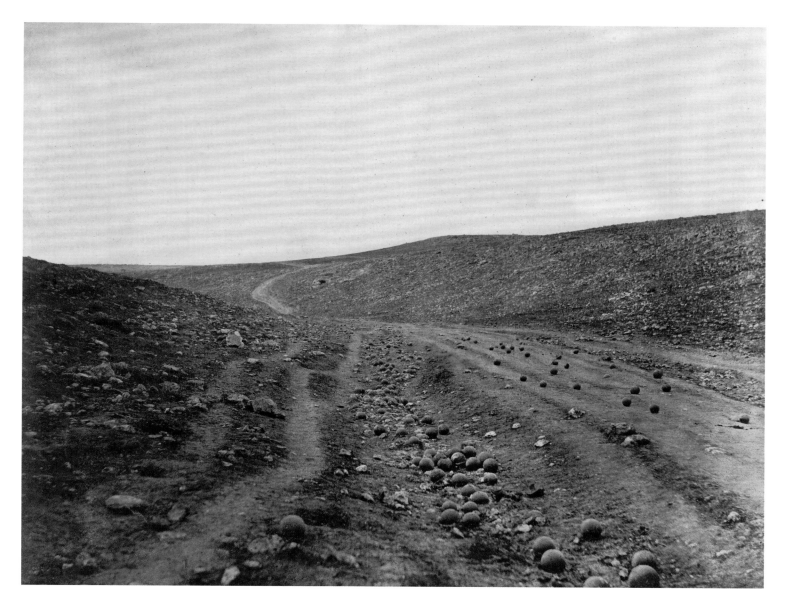

PLATE 33
ROGER FENTON
Valley of the Shadow of Death, April 23, 1855

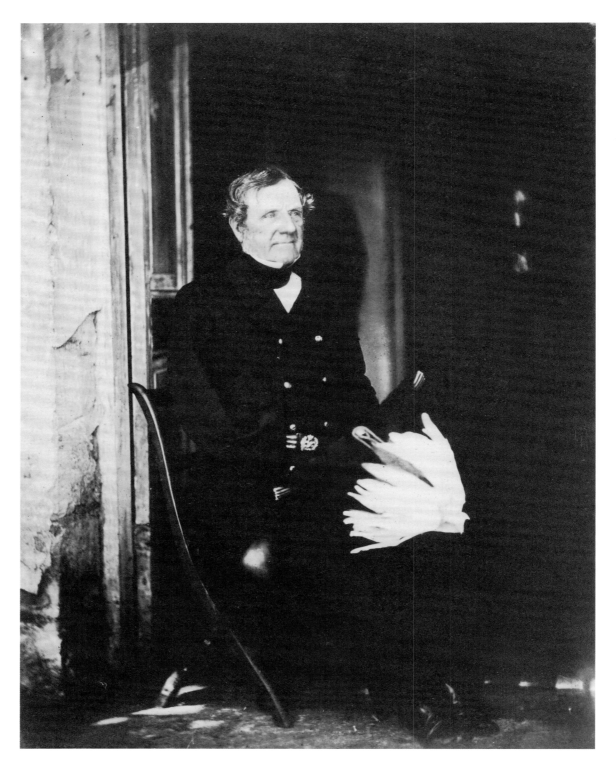

PLATE 34
ROGER FENTON
Field Marshal Lord Raglan, June 4, 1855

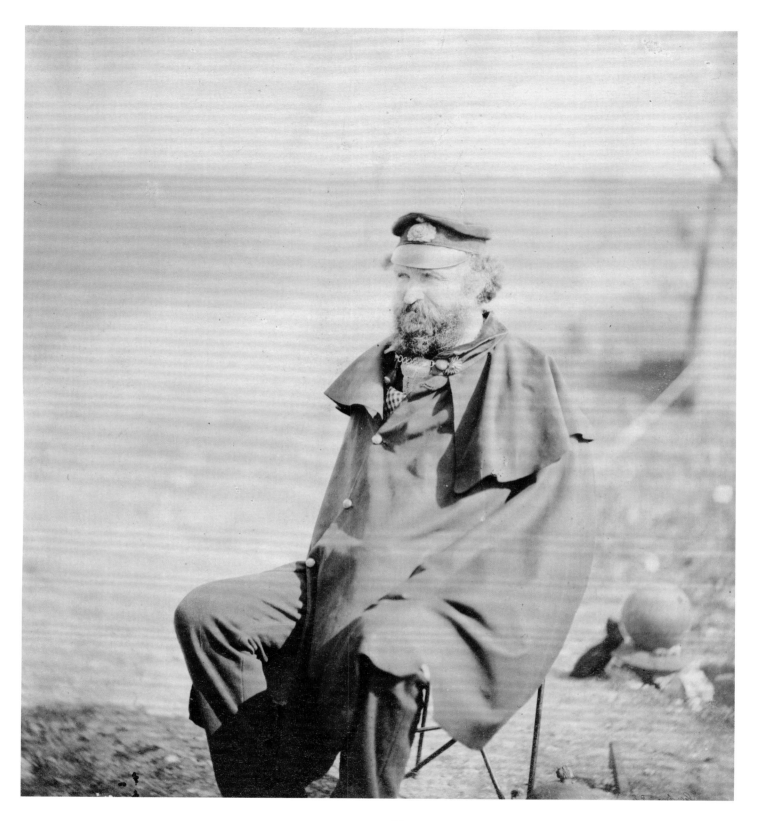

PLATE 35
ROGER FENTON
Col. Gordon, Royal Engineers, 1855

PLATE 36
JOSEPH CUNDALL AND ROBERT HOWLETT
Private Jesse Lockhurst, 31st Regiment, and Thomas O'Brien, 1st Royals, negative, April 16, 1856; print, 1883

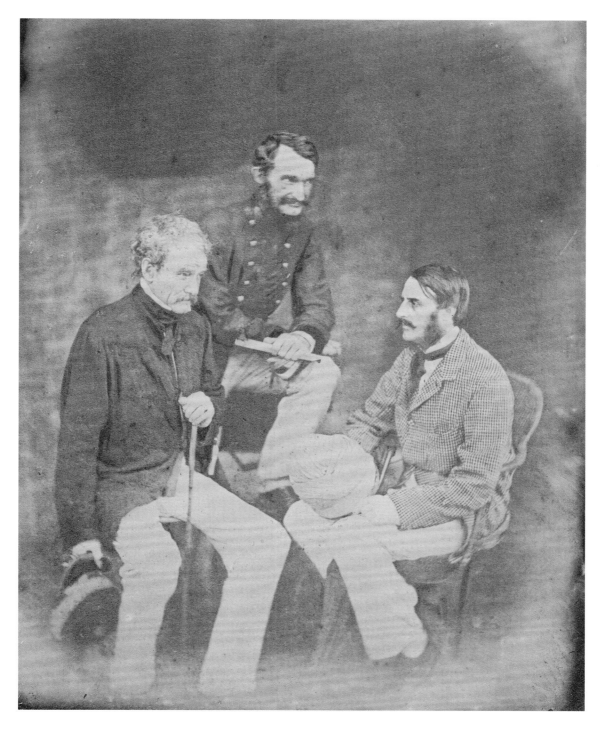

PLATE 37

FELICE BEATO

Untitled (Group Portrait of Lord Clyde, Sir Hope Grant, and General Mansfield), ca. 1858

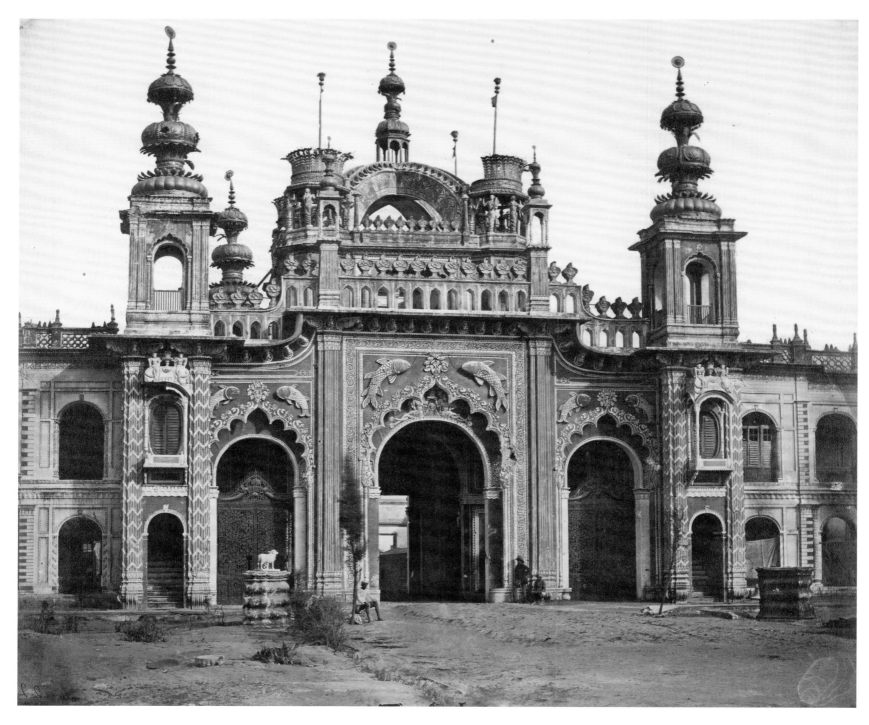

PLATE 38

FELICE BEATO

The Great Gateway of the Kaiserbagh—3,000 Sepoys Killed by the British in One Day in the Courtyard by the Light Division and Brazier's Sikhs, 1858

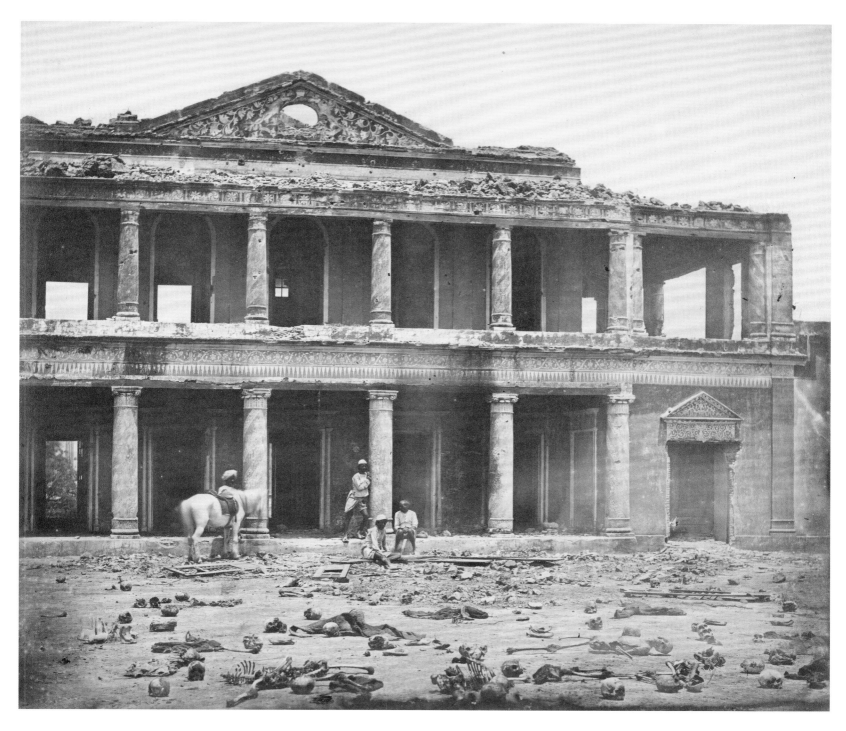

PLATE 39

FELICE BEATO

Interior of the Secundra Bagh after the Slaughter of 2,000 Rebels, Lucknow, 1858

ART AND INNOVATION

Photography proved capable of documenting everything from steamships to biblical landscapes, from royal ceremonies to national tragedies. The medium reached an artistic high point at the Manchester Art Treasures Exhibition of 1857, where photographs were shown alongside paintings and sculpture. The exhibition of the London Photographic Society at the South Kensington Museum (later the Victoria and Albert Museum) in 1858 marked the first time that photographs were displayed in a museum context. Many of the images included in these two exhibitions celebrated the innovations and technological achievements of the day.

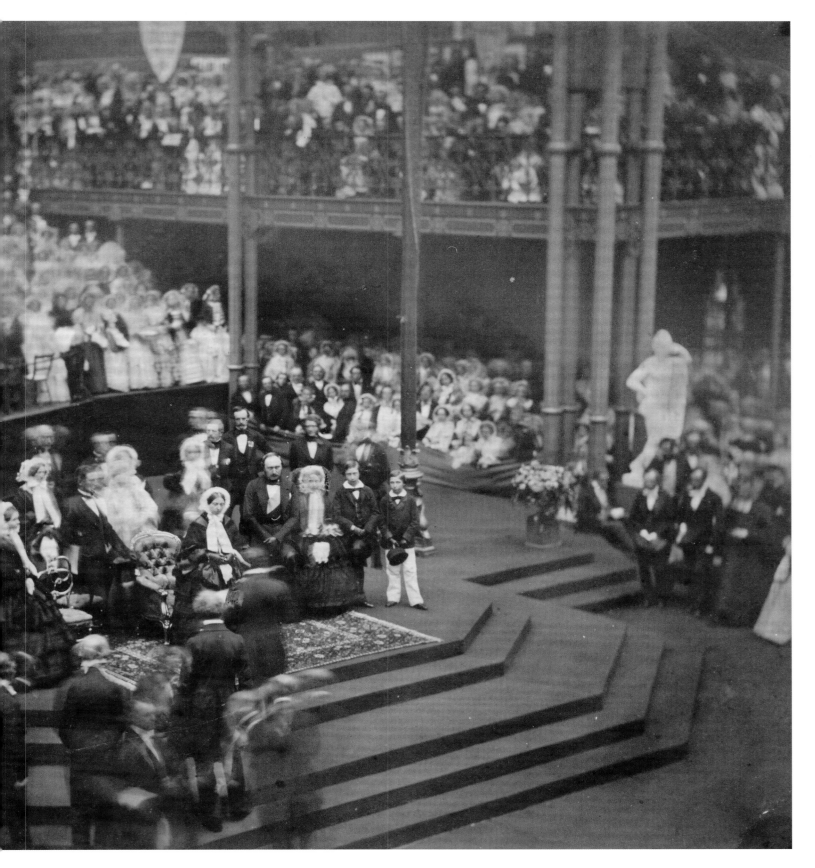

PLATE 40

ALFRED BROTHERS

Her Majesty's Visit to the Manchester Exhibition of Art Treasures of the United Kingdom, 1857

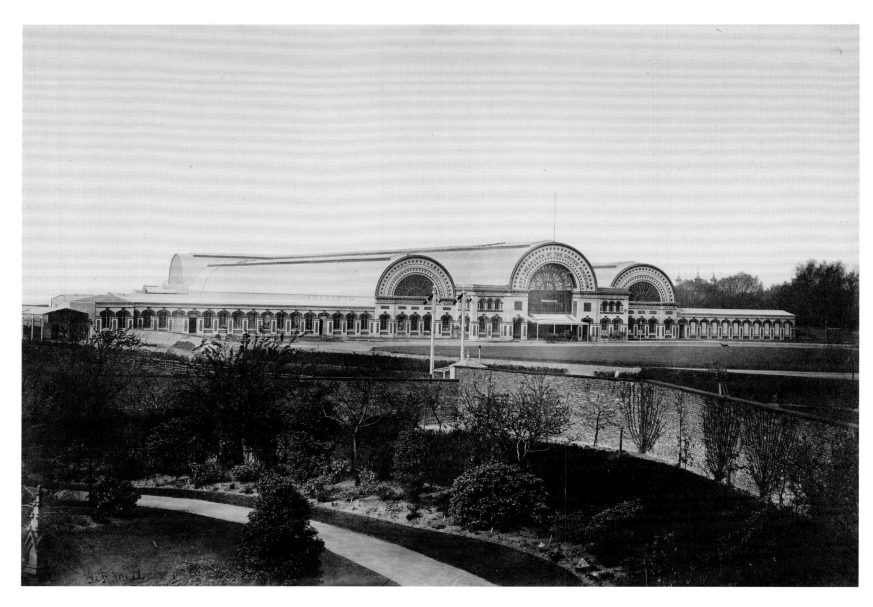

PLATE 41

J. & R. MUDD

Manchester Exhibition of Art Treasures, June 1857

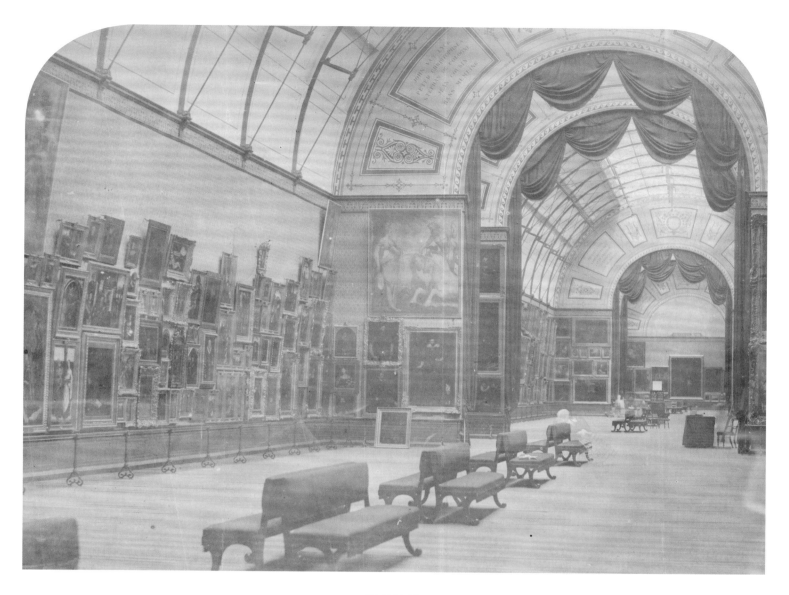

PLATE 42
UNKNOWN PHOTOGRAPHER
Manchester Art Treasures, 1857

PLATE 43

FRANCIS BEDFORD

The Gateway, Canterbury, ca. 1855

PLATE 44
GUSTAVE LE GRAY
The Tugboat, 1857

Plates | 82

PLATE 45
GUSTAVE LE GRAY
The Brig, 1856

PLATE 46

GUSTAVE LE GRAY

The Great Wave, Sète, ca. 1857

PLATE 47
OSCAR GUSTAVE REJLANDER
The Two Ways of Life, 1857

PLATE 48

WILLIAM LAKE PRICE

Don Quixote in His Study, negative, 1856; print, January 1857

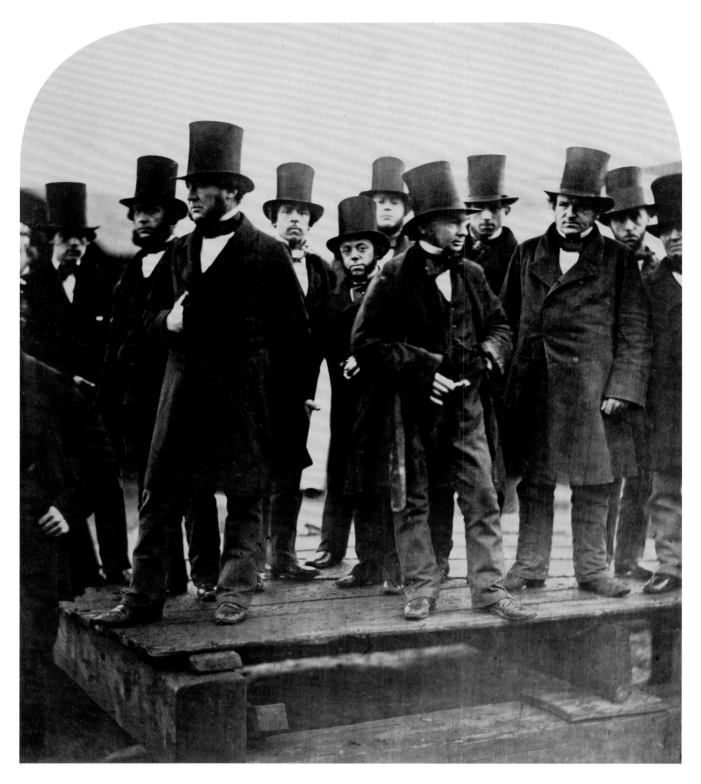

PLATE 49

ROBERT HOWLETT

I. K. Brunel and Others Observing the "Great Eastern" Launch Attempt, November 1857

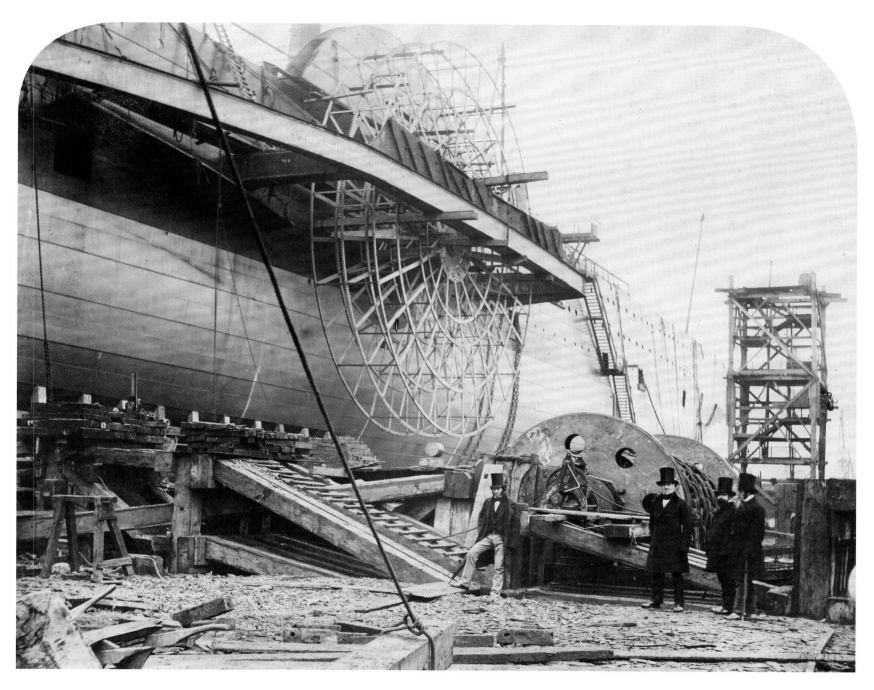

PLATE 50

ROBERT HOWLETT

The Steamship "Great Eastern" Being Built in the Docks at Millwal, November 1857

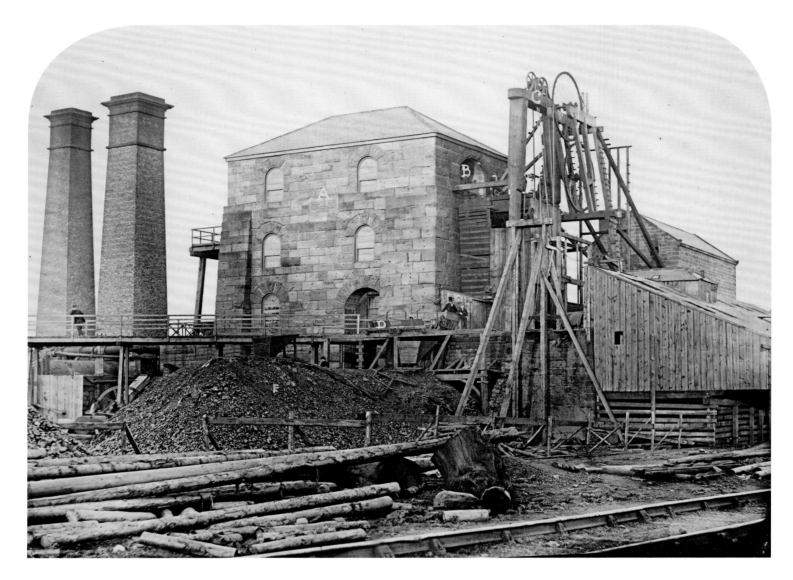

PLATE 51

W. & D. DOWNEY

Hartley Colliery after the Accident, January 30, 1862

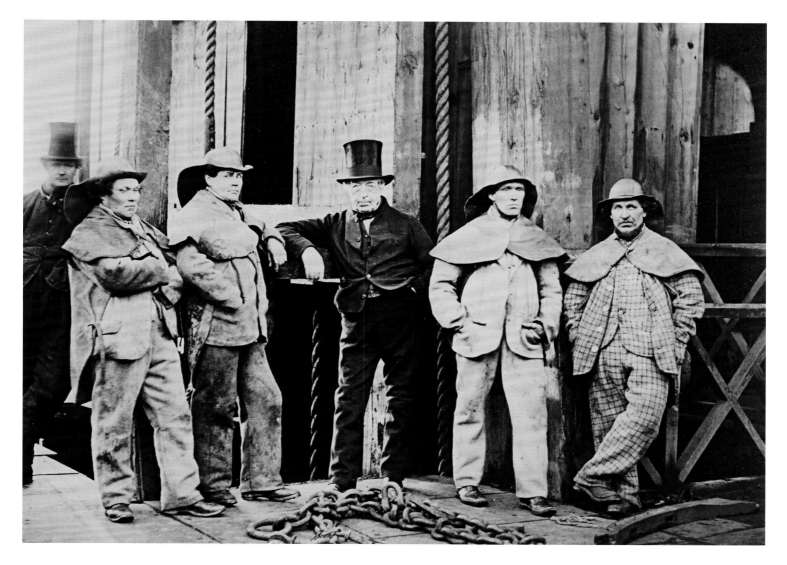

PLATE 52

W. & D. DOWNEY

W. Coulson, Master Sinker, and Four of His Men, Pit Mouth, Hartley Colliery, January 30, 1862

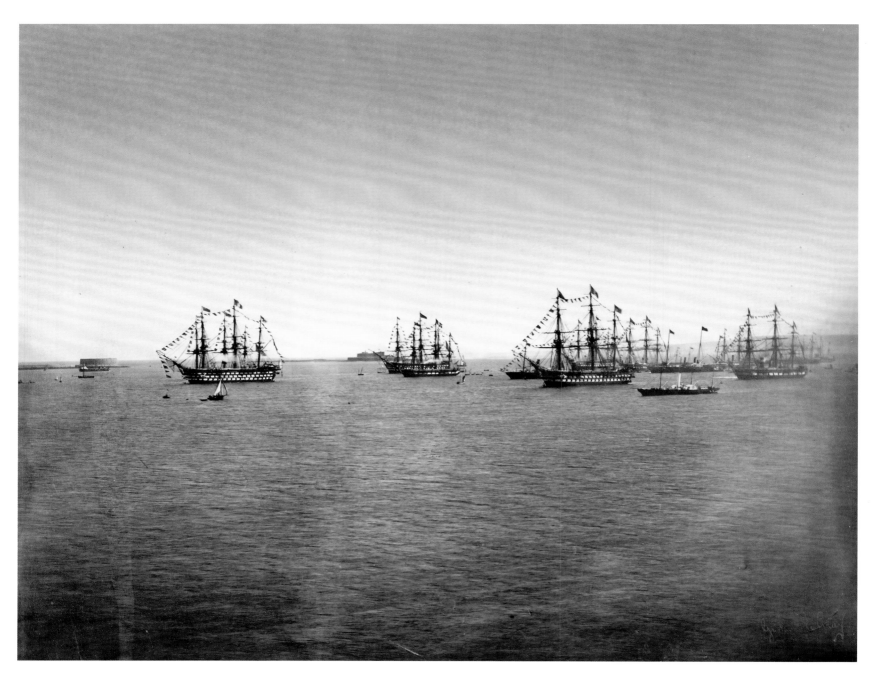

PLATE 53
GUSTAVE LE GRAY
The English Fleet at Cherbourg, 1858

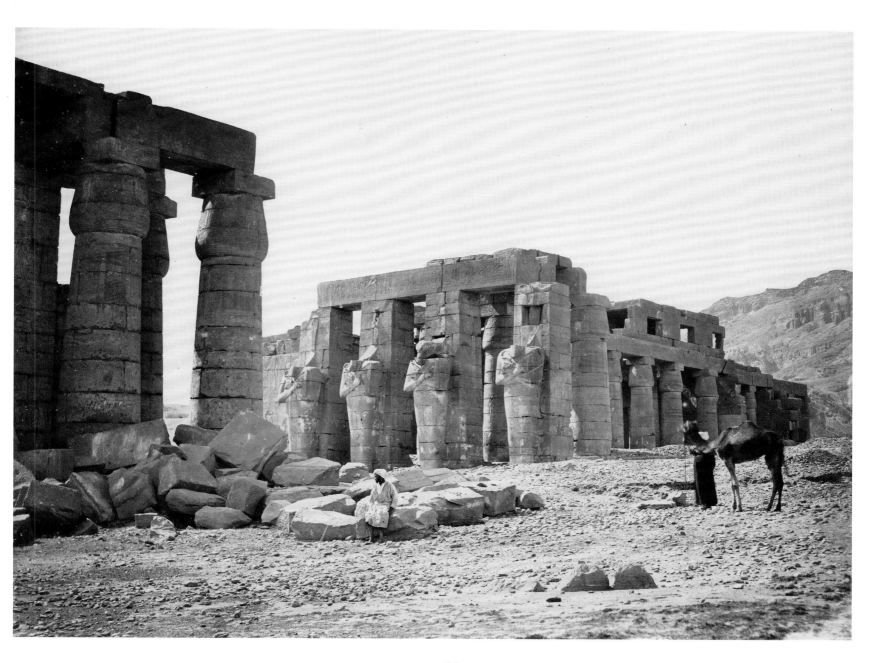

PLATE 54

FRANCIS FRITH

The Ramesseum of El-Kurneh, Thebes, Second View, 1857

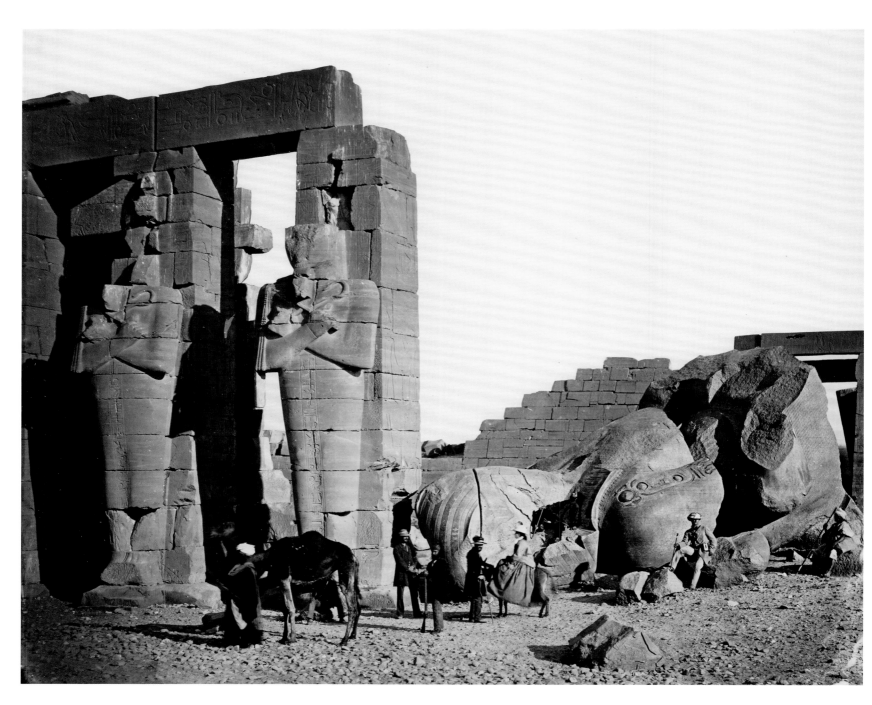

PLATE 55

FRANCIS FRITH

Fallen Colossus from the Ramesseum, Thebes, 1858

PLATE 56

JOHN CRAMB

Church of the Holy Sepulcher and Christian Street, 1860

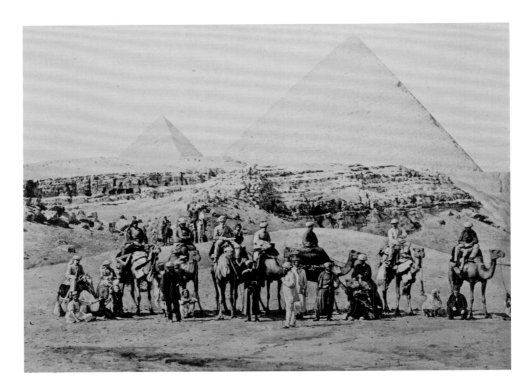

PLATE 57

FRANCIS BEDFORD

Gizeh—The Departure of H.R.H. the Prince of Wales and Suite from the Pyramids,
March 5, 1862

PLATE 58

FRANCIS BEDFORD

Bethlehem—The Shepherds' Field, April 3, 1862

Death and Art

The 1860s were a pivotal decade for both Queen Victoria and photography. As the medium grew in popularity and presence, it became more commercial. Some photographers nonetheless embraced a fine-art approach and found inspiration in literary and biblical subjects. For the queen, the death of Prince Albert, in 1861, was a devastating loss. Without her partner in photographic pursuits, Victoria became disengaged from the medium—with two notable exceptions: she acquired large groups of prints by Julia Margaret Cameron and Oscar Gustave Rejlander.

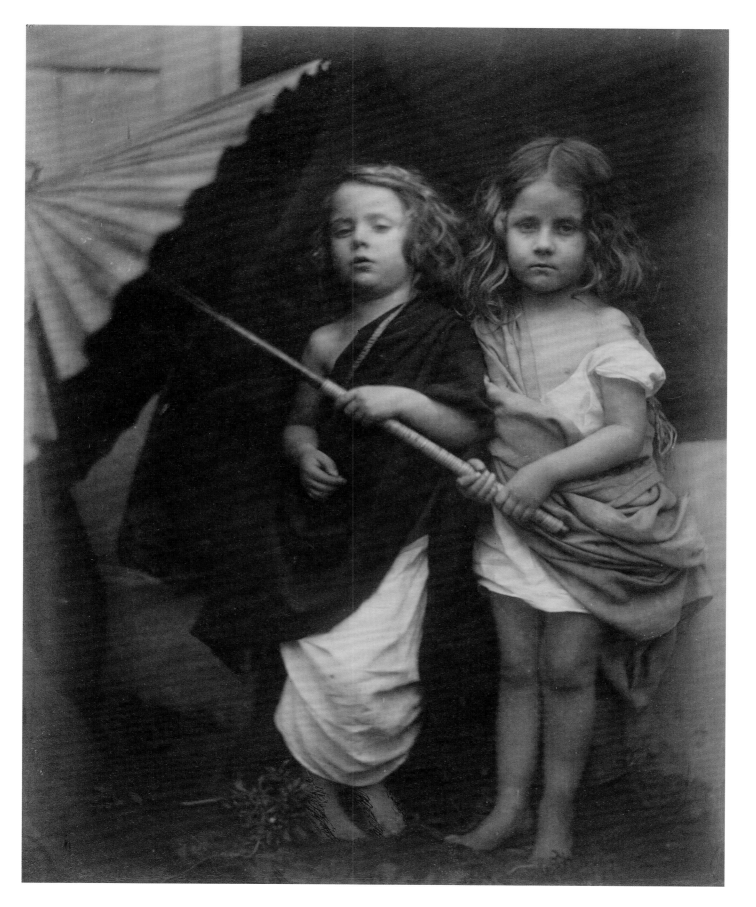

PLATE 59

JULIA MARGARET CAMERON
Untitled (Paul and Virginia), 1864

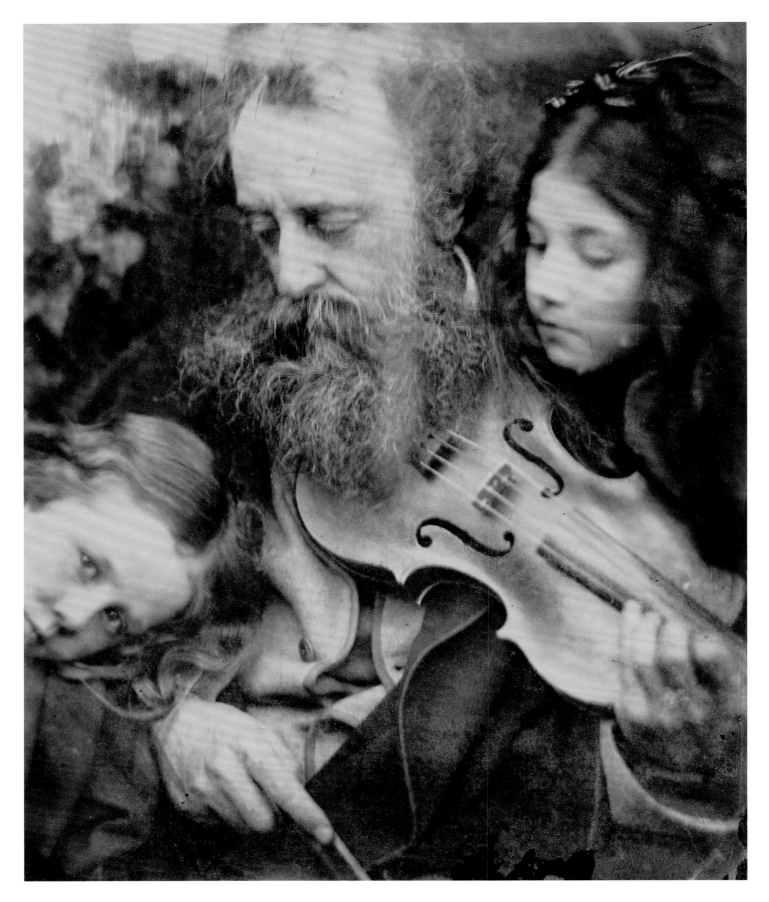

PLATE 60

JULIA MARGARET CAMERON

The Whisper of the Muse / Portrait of G. F. Watts, April 1865

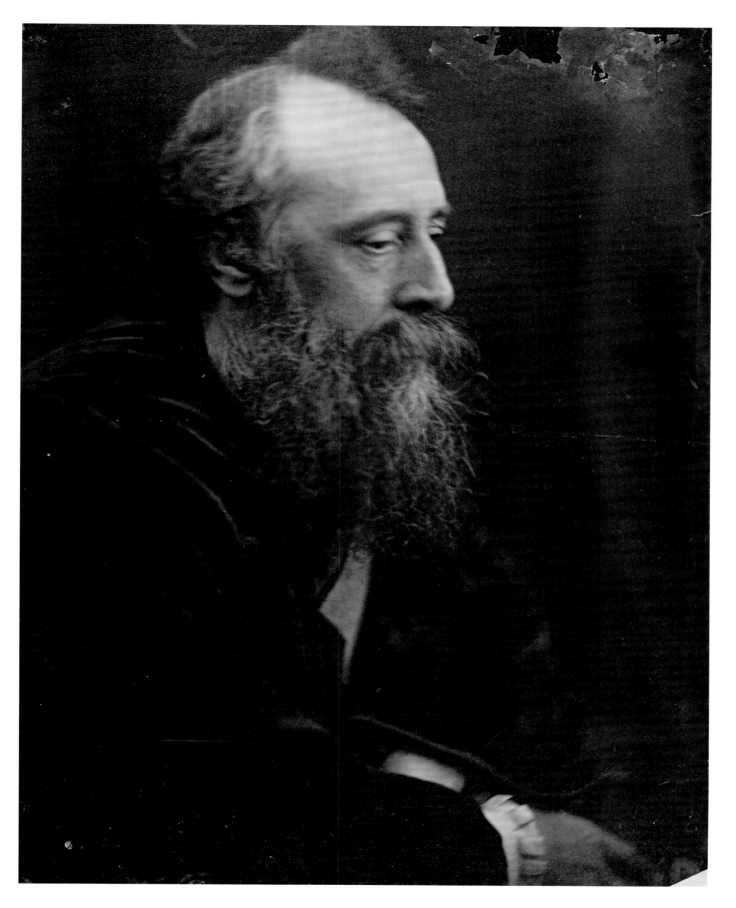

PLATE 61

JULIA MARGARET CAMERON

George Frederic Watts, 1865

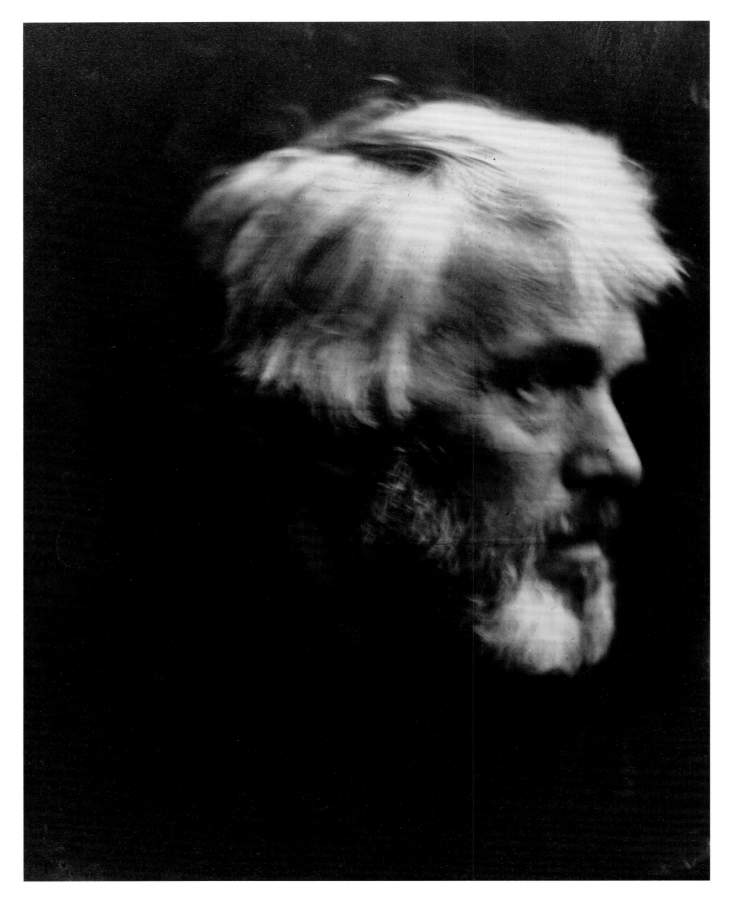

PLATE 62
JULIA MARGARET CAMERON
Thomas Carlyle, 1867

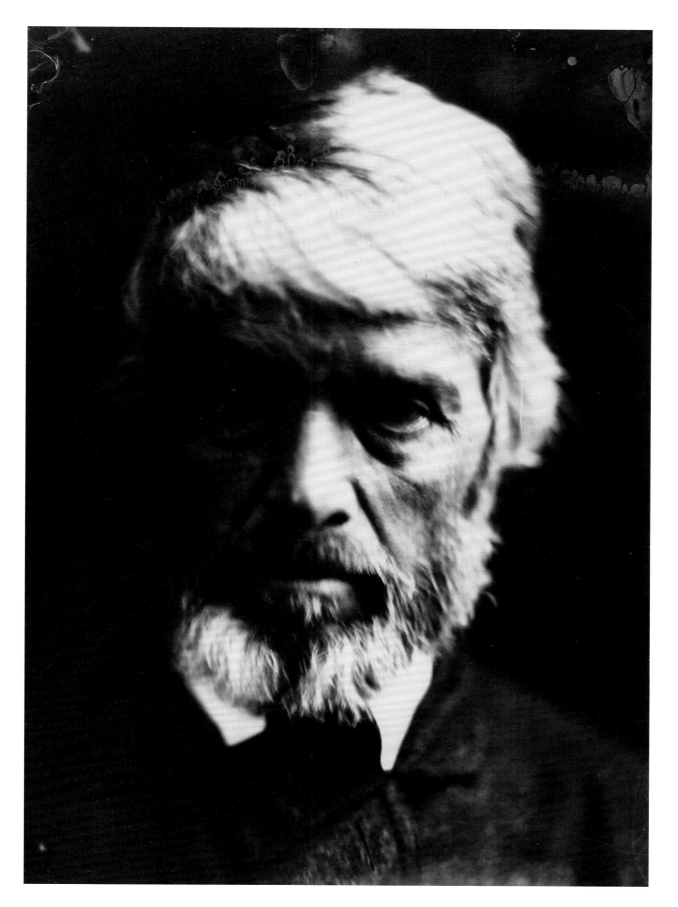

PLATE 63
JULIA MARGARET CAMERON
Thomas Carlyle, 1867

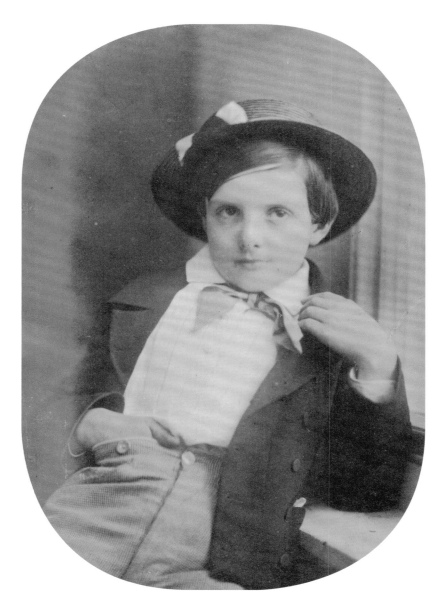

PLATE 64
OSCAR GUSTAVE REJLANDER
Untitled (Portrait of a Young Boy), ca. 1860

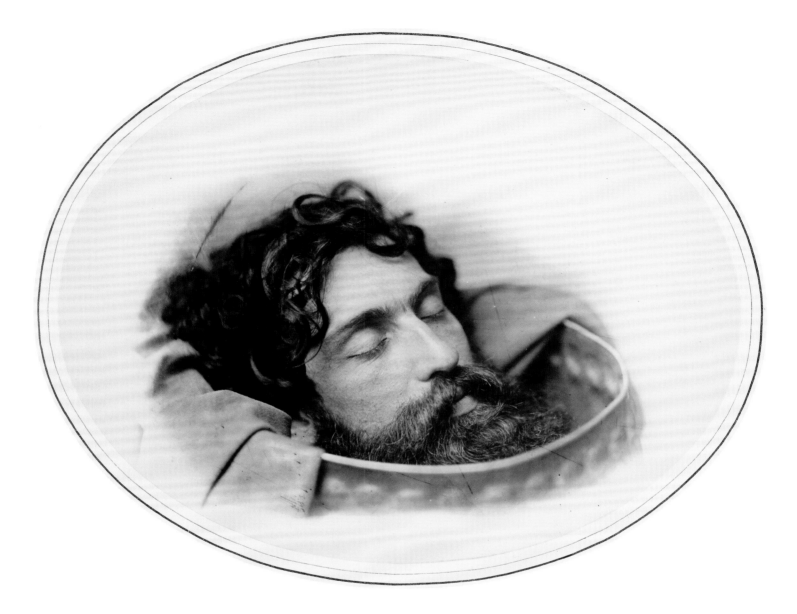

PLATE 65

OSCAR GUSTAVE REJLANDER

Study of the Head of John the Baptist in a Charger, ca. 1855

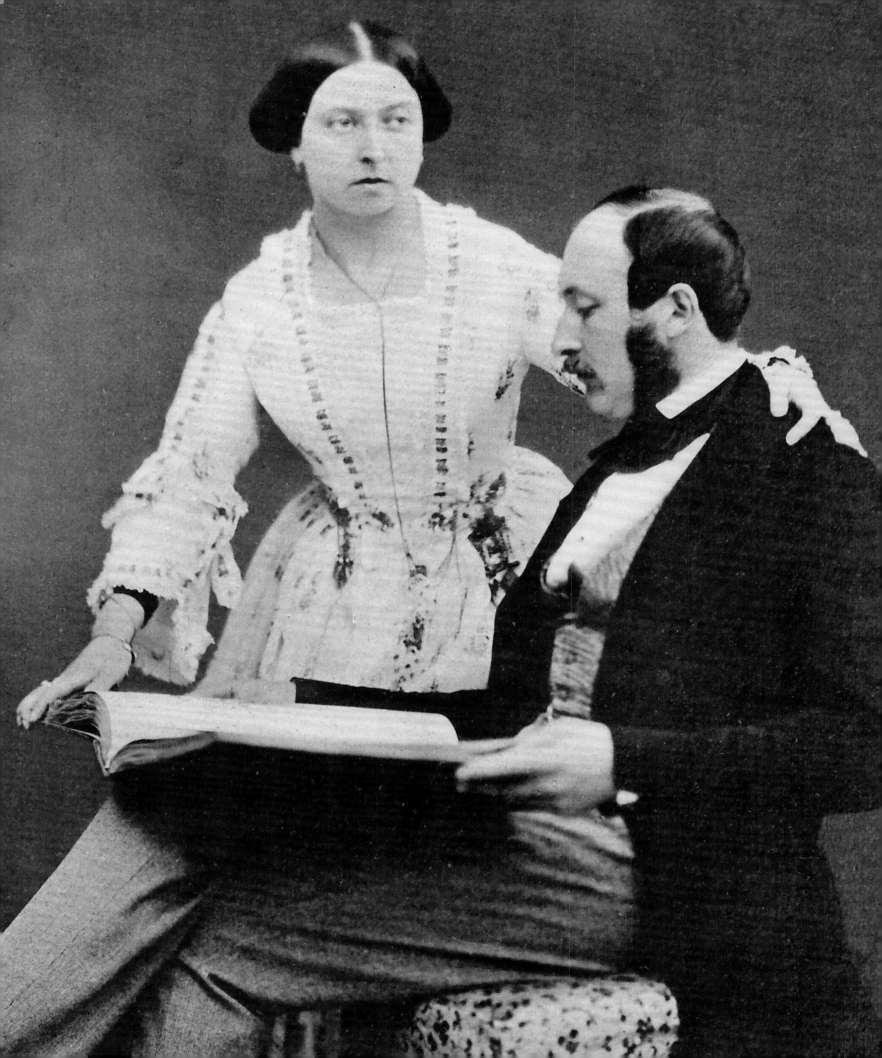

Queen Victoria's Private Photographs

SOPHIE GORDON

WHEN QUEEN VICTORIA DIED IN 1901, HER COLLECTION OF PHOTOGRAPHS, it is estimated, contained well over twenty thousand individual items, and the queen herself had become one of the most photographed people in the world. Today this collection is housed at Windsor Castle and includes a large number of official portraits of the queen and her family, which began to be commissioned or requested more frequently as the decades progressed, as well as photographs acquired as examples of "fine art" and, of course, a large number of personal photographs. This last group is often thought of as a collection of "private" photographs — not necessarily photographs that were hidden, but photographs that were intended for an audience of family and friends only. While the official portraits of the queen-empress were created to be distributed around Great Britain and the British Empire in large numbers, and consequently remain relatively well known, these private photographs can often be found only in the albums and boxes at Windsor organized by the queen and Prince Albert and their nine children. Together these photographs make up a private family archive spanning six decades, from the earliest days of photography, when the royal family cautiously began to work with professional photographers, to the turn of the twentieth century, by which time many members of the royal family owned cameras and took informal snapshots of each other. The photographs suggest an evolving relationship with the medium, as attitudes, expectations, and an understanding of the process and its potential shifted over time.

EARLY PHOTOGRAPHS, 1842–60

THE EARLIEST PHOTOGRAPHS OF THE ROYAL FAMILY WERE NEVER INTENDED TO BE seen by the public. It was only in May 1860 that Queen Victoria eventually gave in to popular expectations and granted permission for photographs of herself and her family by John Jabez Edwin Mayall (1813–1901) to be published and sold. Mayall later submitted an invoice to the queen that described "sundry *cartes de visite* prints from negatives sanctioned for publication."[1] Prior to this date, with a very small handful of exceptions, it would have been impossible for photographs of the royal family to be seen by a member of the public. A notable exception was the display of a photographic portrait of Prince Albert, by William Lake Price (1810–1896), at the Art Treasures exhibition in Manchester in 1857.[2] All the portraits made during the 1840s and 1850s would have been intended solely for the family and their circles of friends and acquaintances. As a consequence, however, many of these early portraits have a curiously informal, sometimes even careless, appearance. Nevertheless, these two decades represent a time of experimentation not only on the part of the photographers but also by Queen Victoria and Prince Albert, as they explored the potential of the camera. In their various photographic sessions, they can be seen adopting a variety of poses, sometimes domestic, sometimes regal; they also explore the different uses to which they can put photography — family record, archival document, or personal statement. As they worked with different photographers during the 1850s — notably Dr. Ernst Becker (1826–1888), Roger Fenton (1819–1869), and William Bambridge (1820–1879) — the royal family became more adept at finding suitable poses and simultaneously became more aware of how they could control their image.

Alongside the first photographic portraits taken "from life," there are in the earliest private albums numerous examples of photographs of paintings and sculptures, and some copies of daguerreotypes. All these media produce unique objects, but when copied as photographs, the objects can be reproduced in multiple copies and consequently shared in different family albums. These copies of artworks appear in the albums alongside original photographic portraits, and little distinction is made between the two. Additionally, in many of the early albums, carbon print copies of the photographs have been pasted over the top of the original albumen prints. Sometimes there will be a handwritten note providing the name of the photographer who made the copy, alongside a date. In the 1850s this was often William Bambridge, the local Windsor-based photographer, who undertook numerous private commissions for the queen. In later years, Queen Victoria employed the firm of Hughes and Mullins, based near Osborne House, on the Isle of Wight, to continue the copying work, focusing as before on both artworks and original photographs. This flexible approach to the status of the photograph—sometimes perceived as an original work of art in its own right, and sometimes more significant for its content—creates a liminal space where the context and the meaning of the object are shifting and often ambiguous.

THE FIRST DAGUERREOTYPES

The daguerreotypes of Prince Albert that were taken in March 1842 probably represent the earliest photographs of a member of the royal family (see fig. 39). The court was then in Brighton, residing at the Royal Pavilion. The photographer William Constable (1783–1861) had opened a studio at 57 Marine Parade, Brighton, in 1841, which he referred to as "the Photographic Institution." Prince Albert visited the studio with two of his cousins from Saxe-Coburg, Princes August and Leopold, on March 5. However, the portraits were not a success, probably because of the lack of light caused by bad weather. Prince Albert returned on March 7, and a number of successful portraits were produced, though only one has survived to the present day. The head-and-shoulders portrait of the prince contains nothing to indicate the royal status of the sitter. He is perhaps indistinguishable from Constable's many other, less significant sitters. Constable delivered the portraits to the queen, and after inspecting them, she wrote in her journal: "Saw the photographs, which are quite good."[3] This surprisingly brief comment marked the beginning of what was to become a complex relationship between the royal family and the camera.

Like the first photograph of Prince Albert, the earliest surviving photograph of Queen Victoria, taken a few years later, chooses not to concentrate on the sitter's royal status; rather, it presents a portrait of a mother accompanied by one of her children (see fig. 38). The portrait is known only through late Victorian copies, made under instructions from the queen. At one point it was believed that the original portrait was a calotype, but it is now known to have been a daguerreotype, thanks to the discovery of a copy that clearly shows the edges of the daguerreotype plate and the name of the plate's maker, Christofle (a French silversmith firm). The photographer's name is still unknown.

The queen is shown as an upper-middle-class woman in a day dress, with her daughter Princess Victoria leaning closely against her. The queen gazes into the distance, as if she is being painted for a more formal portrait, but her daughter stares straight at the camera, making a direct and striking connection with the viewer. In the early photographs, these effects may be only coincidental, but they serve as experiments for the new technology—something that could be done safely, in the knowledge that the images would never be seen beyond the immediate family circle.

Other daguerreotypes were made during the 1840s, though only a handful have survived into modern times. During the mid-1850s a list was made of the queen's daguerreotypes, identifying ninety-two items.[4] Unfortunately, many are no longer part of the Royal Collection: some would have been given away to friends and family; others may have been lost or broken over the years. It is evident, however, that portraits of family and those who worked in the royal household formed the main subject matter for these photographs. Sometimes Queen Victoria asked for those who visited her from abroad to be photographed as well. The list describes two now-lost daguerreotypes in the queen's possession as "2 Arabs (who brought Horses from Mahmud Ali) from life."[5]

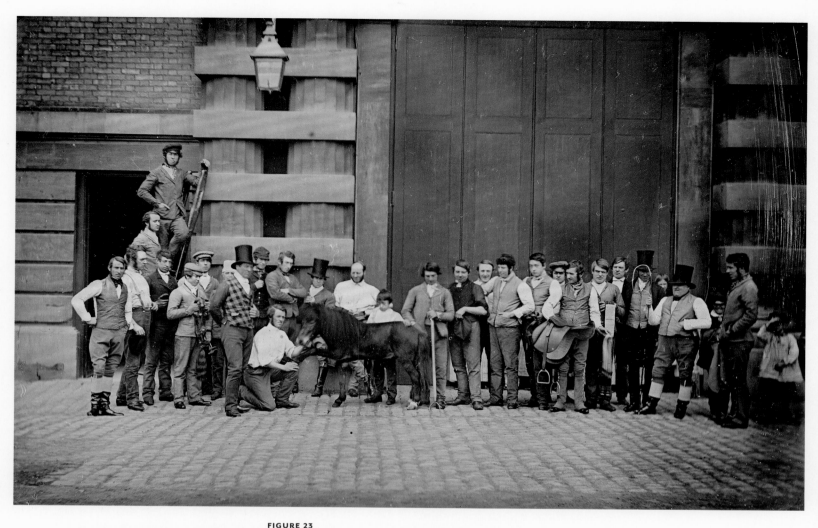

FIGURE 23
Unknown photographer, *Grooms with the Little Pony Webster, Taken at the Mews, Buckingham Palace,*
May 31, 1848. Daguerreotype, 9.1 × 14.3 cm (3⁹⁄₁₆ × 5⅝ in.). Windsor, The Royal Collection, RCIN 2932499

The British daguerreotypist William Kilburn (1818–1891) was asked to attend the queen several times to photograph the family. On one notable occasion he photographed the queen with five of her children. The resulting image of the queen upset her so much that she attempted to scratch out her own face on the daguerreotype plate, leaving the faces of the children still visible (pl. 69). The event was described in her journal: "A Daguerreotype by Mr. Kilburn was taken of me & 5 of the children. The day was splendid for it. Mine was unfortunately horrid, but the children's were pretty."[6]

Also among the daguerreotypes that have survived are studies of the men who worked at the Mews, where the queen's horses and carriages were kept (fig. 23). The queen went to watch the horses being photographed and subsequently recorded the occasion in her journal: "Went to the stables to see the horses dagueriotyped [*sic*], which really was curious, particularly to see how badly the horses placed themselves, when they had to stand still."[7]

Despite this early interest in photography, the queen's collection grew relatively slowly during the 1840s. It took the arrival in 1850 of a young German academic, Dr. Ernst Becker, who was appointed to be Prince Albert's librarian and assistant tutor to the young princes, to engage the queen and Prince Albert with the growing photographic community and encourage them to collect photographs and act as patrons of the new technology.[8]

Becker, who was born in Darmstadt, in the German state of Hesse, came to the royal household in 1850 but almost immediately traveled to Edinburgh to spend some time studying phrenology, the now-discredited discipline of measuring the skull in order to determine character. Becker returned to the queen and Prince Albert in April 1851, intent on introducing science to their household and to the education of the royal children. Becker quickly added chemical experiments, as well as German lessons, to the educational curriculum. He remained with the royal household until 1858, when he left to pursue his scientific career. However, only a few years later, in 1862, he was appointed private secretary to Princess Louis of Hesse, otherwise known as Princess Alice, one of Queen Victoria's daughters whom he had taught previously in Britain. Becker remained in Hesse until his death in 1888.

By March 1852 Becker had started to take a practical interest in photography, almost certainly acting on a request from Prince Albert. The earliest reference to taking photographs is in a letter to his mother dated March 17. He wrote:

> Yesterday and today I occupied myself a great deal with photography. This process has been much improved and simplified in the past six months. The prince wants to learn about it, so as to be able to take pictures of the landscape in Scotland himself, if possible. An experienced practitioner, Capt. Scott, showed us the process, and went through the details very thoroughly, in particular with me. I am now able to make a photograph myself on glass or paper, landscape or portrait, and also to make copies of it by printing.[9]

Captain Scott, responsible for teaching Becker and the prince, is probably Captain Alexander de Courcy Scott, who was in 1853 a founding member of the Photographic Society of London, as was Becker.[10]

Becker continued to practice photography, and references to his work, as well as the many photographs themselves, survive in the Royal Collection. Prince Albert, however, appears not to have pursued photography himself; neither did Queen Victoria. No photographs taken by either of them exist in the collection today, though numerous examples of the queen's drawings and watercolors are carefully preserved. It is far more likely that Becker taught photography to some of the older royal children. Works by Prince Alfred, Duke of Edinburgh (the queen's fourth child and second son), in particular have survived.

Becker's earliest photographs were taken at Balmoral, the queen's Scottish estate. There he photographed the stags that had been shot by the prince and also made portraits of those who were present, including the gillies—the Highland outdoor servants (fig. 24). Queen Victoria was evidently still fascinated by the photographic process, because she made a point of going to watch the occasion: "Went after breakfast to see Dr Becker take a calotype of the stag on the pony & a group of the Highlanders, which have succeeded admirably."[11]

Over the following years, Becker photographed at the queen's and prince's request. In 1853 Becker wrote that "like last year I am taking a lot of photographs again."[12] The queen sat for her portrait three times and also visited Becker in his photographic studio, "in passing," to look at his work. He described how some of his photographs were being framed by the queen and "in the evening they provide a major topic of conversation with the ladies."[13] The queen evidently continued to take a strong interest in photography; when, due to overwork, Becker had to lessen his photographic duties, he commented that the measure "will not please the queen at all."[14]

By 1855 photography appears to have occupied most of Becker's time. He traveled abroad to meet photographers and to make acquisitions for the Royal Collection, he became a member of the Council of the Photographic Society of London, and he continued to take photographs on behalf of the queen and Prince Albert. In a letter from March 1855, Becker described his role:

> Photography takes up more and more of my time, even if not in the practical sense, nevertheless through correspondence about it, and through my position as Council member of the Photographic Society. The great attraction of this art and the importance of its use

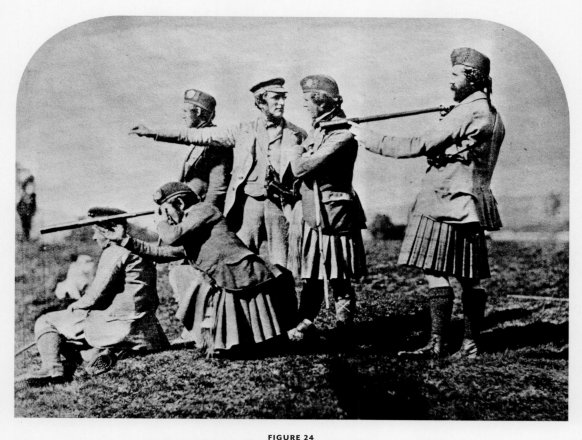

FIGURE 24
Dr. Ernst Becker (German, 1826–1888), *Shooting Party, Balmoral*, 1853.
Albumen silver print, 9.6 × 12.7 cm (3¾ × 5 in.). Windsor, The Royal Collection, RCIN 2160313

make it seem like a wholly new element of the artistic life, indeed of everyday life. It is not only that the magnificent collection formed by the queen and the prince is growing larger every day—they are also constantly making use of photography for all kinds of different purposes, wherever they want to have nothing but a true representation of the progress of the new house at Balmoral, or the wounded soldiers from the Crimea, or a painting by Raphael in Rome.[15]

The queen and Prince Albert's private albums, as well as some of the albums belonging to the royal children, contain many examples of Becker's work. He was called upon to photograph royal life "behind the scenes," at times when it would have been impractical or impossible to commission a professional. Most of Becker's photographic work was fulfilled at either Balmoral or Osborne House, both private residences where the royal family could relax away from the eyes of the public. Becker was uniquely placed to witness a private side to the royal family; he was an outsider, but held the trusted position of tutor to the princes, accompanying the family everywhere, often sitting with them at meals. He recorded a relatively straightforward way of life, albeit undeniably privileged. He photographed the family and the guests of the queen at Osborne, including exiled European royals, the maharaja Duleep Singh (in 1854), and the emperor Napoléon III (in 1855);[16] he photographed the results of Prince Albert's deer stalking in Scotland, as well as the "old house" at Balmoral and the construction of the new one in 1853. His portraits of the royal family, particularly those of the children, are relaxed and informal, suggesting that his relationship with them was close and genuinely affectionate (fig. 25).

FIGURE 25
Roger Fenton (British, 1819–1869), *Prince Alfred, Mr. Becker, and the Prince of Wales*, negative, February 1, 1854; print, 1880s. Carbon print, 21 × 18.5 cm (8¼ × 7⁵⁄₁₆ in.). Windsor, The Royal Collection, RCIN 2900007

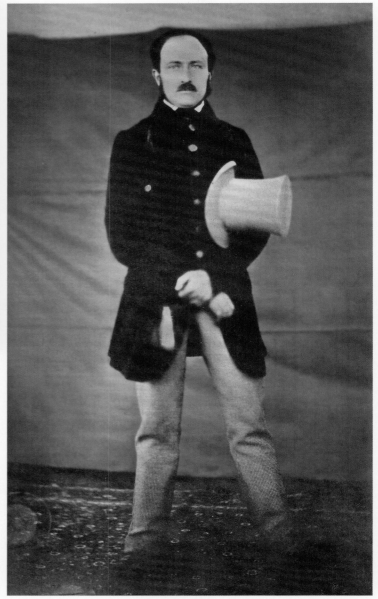

FIGURE 26
Roger Fenton (British, 1819–1869), *Prince Albert, Windsor Castle*, negative, February 8, 1854; print, 1889. Carbon print, 23.1 × 14.6 cm (9⅛ × 5¾ in.). Windsor, The Royal Collection, RCIN 2906508

Apart from taking photographs at the request of Victoria and Albert, Becker played a key role in leading the royal couple into the constantly growing photographic world, where he was able to advise them on appropriate acquisitions for their collection. In hindsight, perhaps his single most important act was to ensure that the queen and Prince Albert were engaged with the newly formed Photographic Society; they agreed to become patrons of the society in June 1853. At the society's annual exhibition in January 1854, Roger Fenton was presented to the queen. He led her around the exhibition and, according to the queen's journal entry, "explained everything."[17]

ROGER FENTON (1819–1869)

In 1854, when he first met Queen Victoria, Fenton was well known in the photographic community. He had become secretary for the Photographic Society and presented talks at some of its earliest meetings. The subject matter of his early work, from Russia in 1852 and Britain in 1853 and 1854, was predominantly landscape or architectural; several examples were acquired by the queen and Prince Albert for their growing collection.

Shortly after meeting Fenton in January 1854, Queen Victoria commissioned him to produce a series of portraits of the royal family over the course of several months during the spring and summer. Fenton traveled to Buckingham Palace and to Windsor Castle to take photographs of the royal children dressed up in costumes as they enacted a series of tableaux—"Les petits Savoyards" in February and "The Four Seasons" in May. In the latter series, the royal children dressed up in costumes to represent the different seasons, in separate photographs, before coming together in a grand tableau to complete the sequence. The photographs re-create the performance that the royal children had put on for their parents to celebrate their wedding anniversary on February 10, 1854. Fenton's photographs show the children standing before a roughly hung backcloth, but they were not considered the finished product. Rather, the photographs were intended for the artist Carl Haag (1820–1915) to overpaint and mount in an album that was given by Prince Albert to the queen on her birthday (pl. 72). The album was beautifully prepared and presented in a crimson velvet portfolio. The queen declared the work "exquisitely done."[18]

Fenton also photographed the queen and Prince Albert, both in formal court dress and in more informal day dress. The portraits are all carefully posed, and the sitters seem less relaxed than they are in Becker's portraits, aware, perhaps, that they are being studied by an outsider. Fenton, however, seems to have encouraged both the queen and Prince Albert to experiment with their own portraits. They are photographed alone as well as together, in compositions that strike differing attitudes. While one image might suggest cozy domesticity (pl. 76), another appears to suggest a strong, independent man of action (fig. 26). Likewise, the queen is shown as regal and elite in her court dress, and also fiercely maternal and protective of her children in the direct portrait with four of her children in which she stares straight into the camera and at the viewer (pl. 71).

Although Fenton may not have truly seen "behind the scenes" in the same way that Becker could, he was responsible for showing the royal couple what could be achieved through photography. They learned how a photographic image could be constructed, even though in 1854 the photographs that Fenton was taking were all still considered private and for the royal family alone.

In 1855 Fenton worked in the Crimea, in Russia, photographing the troops and the landscape associated with the war (pls. 32–35), but the following year he received yet another commission from Queen Victoria. In September 1856 Fenton was asked to make the long journey to Balmoral, where the queen and Prince Albert and five of their children were paying their annual visit.[19] The royal family had moved into the newly constructed castle in the autumn of 1855, and Fenton's visit in 1856 coincided with the demolition of the old castle. He was asked to photograph the new building (the rubble from recent construction can be seen in some of the photographs) as well as take a number of portraits of all five of the royal children present and some of the gillies. Fenton also made some landscape studies of the area around Balmoral.

Much of this work was acquired by the queen. Several of the landscapes ended up in her "Balmoral" albums—which are filled with portraits of the family and their servants, and photographs of the activities they took part in—alongside works by Becker and other photographers.[20]

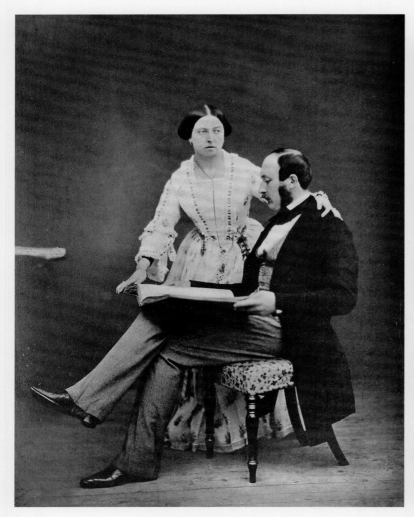

FIGURE 27
Roger Fenton (British, 1819–1869), *Queen Victoria and Prince Albert,*
Buckingham Palace, negative, June 30, 1854; print, 1889.
Carbon print, 18.9 × 14.5 cm (7⁷⁄₁₆ × 5¹¹⁄₁₆ in.).
Windsor, The Royal Collection, RCIN 2906527

FIGURE 28
Roger Fenton (British, 1819–1869), *The Princess Royal and Princess Alice*, 1856.
Hand-painted albumen silver print, 35.4 × 30.4 cm (13¹⁵⁄₁₆ × 11¹⁵⁄₁₆ in.). Windsor,
The Royal Collection, RCIN 2506816

Fenton subsequently exhibited some of this Scottish work at the Photographic Society of Scotland in December 1856 and in the Photographic Society exhibition in London in January 1857. None of the portraits of the royal children were included, however. It is probable that, as part of the commission, Fenton was required to give his negatives for the children's portraits to Queen Victoria. Several of the original glass plates have survived and are in the Royal Collection today. This provision suggests that the queen wished to keep control of these portraits and could do so only by keeping the negatives.

Several copies of the portraits by Fenton were printed, particularly those from the 1854 sittings, and they appear in a number of albums owned by the queen, Prince Albert, and the Prince of Wales. One of them includes a double portrait of Victoria and Albert, in which the queen stands over her husband in what appears to be a reversal of the traditional presentation of a husband-and-wife portrait (fig. 27). A few examples of the photographs were also subsequently hand-colored, framed, and hung on the walls of palace rooms. One of the 1856 portraits of the princess royal and Princess Alice was overpainted and hung in Prince Arthur's sitting room in Windsor Castle (fig. 28).[21] Other examples of Fenton's portraits were included in a photographic inventory of painted photographs (p. 76). A similar painted photograph belonged to the queen's mother, the Duchess of Kent, but following her death in March 1861, it passed to the queen and is recorded in the inventory as "the private property of the Queen." It was hung in the Duchess of Kent's boudoir at Frogmore House for

some years after her death, before the queen gave the photograph to her youngest daughter, Princess Beatrice.[22] The movement of the very few photographs detailed in the inventories is suggestive of how other photographic material may have been passed between members of the family.

The 1856 visit to Balmoral marked the last time that Fenton was employed by the queen. He did complete a series of views of Windsor Castle and the surrounding park area, known as Home Park, in 1860, but this was not in fulfillment of a royal commission. There was no suggestion that Fenton displeased the queen in any way. What is more likely is that the departure of Becker from the royal household in 1858 broke the link between the queen and the Photographic Society, and in particular, the connection with Fenton. The queen was also turning toward another photographer, William Bambridge, who was based locally, in Windsor. He was asked to fulfill various private commissions for the royal family during the 1850s and 1860s.

WILLIAM BAMBRIDGE (1820–1879)

The earliest surviving photographs by Bambridge in the queen's collection date to the summer of 1854. Bambridge submitted an invoice to the queen covering the period from June to December, during which time he photographed the dogs in the royal kennels and a selection of farm animals, in addition to making photographic copies of paintings and prints and mounting photographs in albums.[23] In all, between 1854 and late 1869, Bambridge submitted at least ninety-six invoices to the Privy Purse for photographic activity, more often than not for printing and cataloguing work. The invoices suggest that Bambridge was responsible for the organizing of the queen's photograph collection, which included captioning photographs in albums, printing negatives made by the royal children, particularly Prince Alfred, and undertaking general photographic work to document the royal household and royal animals at Windsor. Bambridge was never a member of the royal household, nor did he receive any formal royal recognition, but he was to all intents and purposes the queen's photographer—so much so that in 1866 the queen's collection of "private negatives" (discussed in more detail below) was entrusted to the care of Bambridge in his own home at 2 Adelaide Place, Windsor.[24]

As a photographer, Bambridge proved to be capable without being brilliant. His work did not have the polish of Fenton's or the relaxed informality of Becker's, but it was sometimes poetic in the choice of subject matter. The photograph of the white stag in the Windsor Great Park successfully captures the nobility of a rare creature associated with mythological tales and religious conversion (fig. 29). The Windsor Great Park was itself associated with legends, particularly concerning Herne the Hunter, whose ghost was said to roam the estate. These stories would certainly have been familiar to the queen and her family, and Bambridge's photograph contributes to an ongoing narrative that connected Windsor with such legends.

Bambridge was also asked to photograph the royal children on numerous occasions. Sometimes these portraits were probably intended to be used as guides for painters such as Franz Xaver Winterhalter and F. W. Keyl; their names appear, alongside those of other artists, in Bambridge's invoices. Some of the portraits also have a makeshift feel to them, as if the photographic session was spontaneous and the best had to be made of an unplanned situation. The portraits of Princess Alice (the queen's third child and second daughter) with Prince Louis of Hesse in December 1860 show the couple standing on what appear to be a pair of doormats (fig. 30). The photographs probably mark the couple's informal engagement; the public announcement was to follow on April 30, 1861. The strangely composed portrait may have been intended to serve as the basis for a painted portrait, in which case the objects surrounding the couple would be irrelevant, but the portraits—four from this particular session—were included in volume five of the queen's series of albums with the title "Portraits of Royal Children." Bambridge contributed many of the earlier portraits to these albums, alongside Fenton, Becker, and others.

Bambridge continued to work for the royal family in various capacities until the 1870s. He contributed extensively to Prince Albert's Raphael Collection, both by taking photographs and printing from negatives (the Raphael Collection is discussed in more detail below). He also accompanied Prince Alfred, Duke of Edinburgh, on the HMS *Galatea* in 1870 on a tour of New Zealand

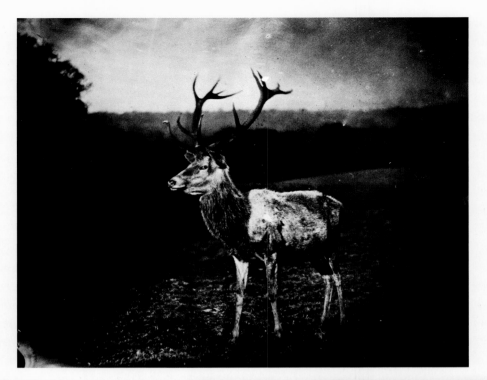

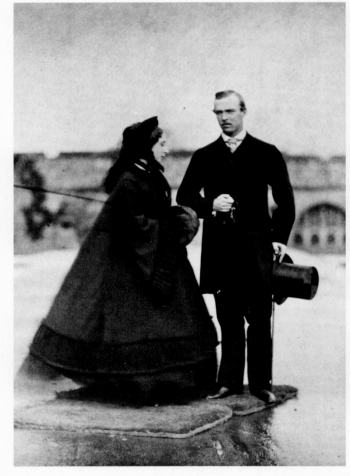

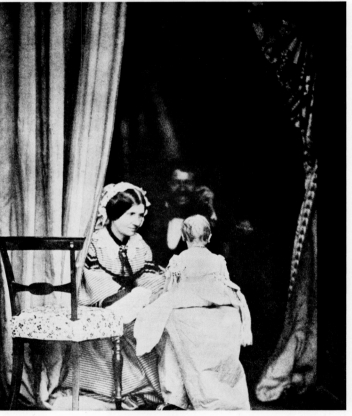

FIGURE 29
William Bambridge (British, 1820–1879),
White Stag in Windsor Park, November 3, 1854.
Albumen silver print, 9.1 × 11.3 cm (3⁹⁄₁₆ × 4⁷⁄₁₆ in.).
Windsor, The Royal Collection, RCIN 2800709

FIGURE 30
William Bambridge (British, 1820–1879), *Princess Alice
and Prince Louis of Hesse*, December 8, 1860. Albumen silver print,
8 × 5.6 cm (3⅛ × 2³⁄₁₆ in.). Windsor, The Royal Collection,
RCIN 2900421

FIGURE 31
Leonida Caldesi (Italian, 1823–1891), *Princess Beatrice
and Mrs. Thurston*, negative, May 1858; print, 1880s.
Carbon print, 11.4 × 9.4 cm (4½ × 3¹¹⁄₁₆ in.).
Windsor, The Royal Collection, RCIN 2900134

and Australia, employed as clerk, librarian, pianist, and photographer, presumably because he had, much earlier in his life, lived in New Zealand for a few years. Bambridge was described as "perhaps the most useful member of His Royal Highness's household."[25] He continued to copy works of art and photographs in the queen's collection and make prints from negatives until 1878, the year before his death. By this time, the queen's "private negatives" had been transferred to the care of another photographer, Cornelius Jabez Hughes (1819–1884).[26]

LEONIDA CALDESI (1823–1891)

The photograph collection of Victoria and Albert continued to grow throughout the 1850s. They collected together and compiled albums together, although while Prince Albert's albums contained mostly landscape, architecture, and genre photographs by the leading British and European photographers of the day, the queen's albums were full of portraits of her family and household and other royal families in Europe and beyond.

Apart from the three principal photographers discussed above, Queen Victoria commissioned a number of photographic firms to undertake work for her. Leonida Caldesi was asked to attend the queen both at Windsor Castle and at Osborne House, where he produced portraits of the queen, several of her children, and some of the dogs in the royal kennels. He is particularly known for the group portrait of Victoria and Albert with all nine of their children on the terrace at Osborne in 1857, a photograph that was subsequently published as an engraving in the *Illustrated London News*.[27] Between 1857 and 1859, Caldesi made numerous portraits of the royal children that ended up in the queen's "Portraits of Royal Children" albums. They include many photographs of the infant Princess Beatrice (born in 1857) with her nurse Mrs. Thurston in 1858. In one of the photographs, a man, perhaps the photographer Caldesi, can be seen trying to engage the princess by shaking a toy in front of her. The photograph shows only the back of the princess but was still regarded as good enough to be included in Queen Victoria's album (fig. 31).

One of Caldesi's most successful and unusual sessions with the royal children took place in 1857, with Prince Arthur (see pl. 85). The poses adopted by the prince copy those of two putti in the *Sistine Madonna*, an early-sixteenth-century painting by Raphael. The same year, the photographer Oscar Gustave Rejlander (1813–1875) had produced a photograph of two young boys modeling the same poses as the putti. A print of the photograph had been acquired by Prince Albert, and it is possible that Caldesi knew the photograph and was inspired by it.

THE DEATH OF PRINCE ALBERT, 1861

TOWARD THE END OF 1861, PRINCE ALBERT CAUGHT TYPHOID FEVER; HE DIED ON December 14 at Windsor Castle. He was only forty-two years old. The death was sudden and unexpected, and it threw the queen into deep grief and lengthy mourning. Two days after the death, on December 16, William Bambridge was asked by the queen to fulfill an intensely private task. Bambridge was called to the castle and asked to photograph the body of the deceased Prince Albert as he was laid out on the bed in the Blue Room. Bambridge made two negatives that show the prince's body, with the face bound and flowers strewn around the bed. The queen later had a print made from each negative, and then the negatives were destroyed, in order that no other prints could be made of this intimate image. The photographs do not appear to be carefully composed, and instead feel almost rushed (fig. 32).[28] Bambridge also made a number of photographs of the Blue Room after the body of the prince had been removed. The queen preserved the Blue Room exactly as it had been at the time of the prince's death, and at the time of the queen's own death, in 1901, it was still largely as it had been forty years previously.

Bambridge's photographs of the Blue Room were passed to the artist William Corden II, who was asked to hand-paint a number of them. (Corden also produced his own watercolor depictions of the room.)[29] By combining the objective recording capabilities of the camera with color and atmosphere provided by the artist, the hand-painted photographs would be regarded as highly accurate and truthful. The queen evidently required as precise a record as possible of her late husband's room.

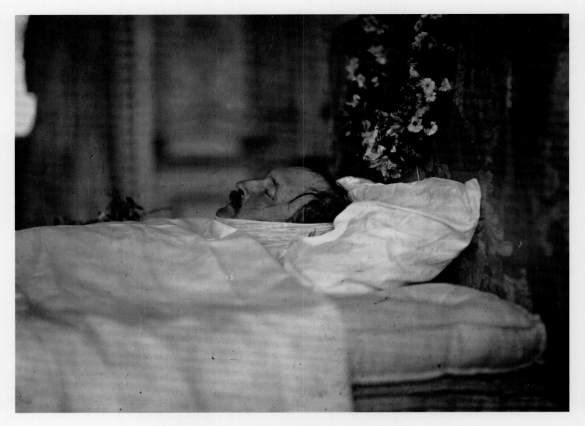

FIGURE 32
William Bambridge (British, 1820–1879), *Prince Albert on His Deathbed*, negative, December 16, 1861; print, ca. 1878. Carbon print, 13.2 × 17.6 cm (5⁵⁄₁₆ × 6¹⁵⁄₁₆ in.). Windsor, The Royal Collection, RCIN 2506826

Soon after the death of the prince, Queen Victoria recalled the times they had spent together compiling prints, drawings, and photographs. They would generally dine alone twice a week and used this time together to look at their growing collection. The queen wrote: "I always kept for those evegs. the placing [of] any new drawings & photographs into the various albums—wh. my beloved Angel always did himself.... Then there were the 'Journey Albums',— 6 in number, begun in 42—into which we placed *all* the prints, woodcuts & photographs we cld. get of all the places we visited, went thro', & events wh. took place—and it was *such* an amusement to collect all these on our journeys. I sent *for all* that cld. be got, wherever we went to.... It was *such* an amusement—such an interest."[30]

In 1862 Bambridge was recalled to the castle to photograph the queen in mourning, seated next to a memorial bust of Prince Albert by the sculptor William Theed (pl. 101). Queen Victoria had herself photographed with her eldest children grouped around the bust of the prince in a variety of poses (the Prince of Wales was not included in these photographs because at the time of the photographic session he was traveling in the Middle East, accompanied by the photographer Francis Bedford). The children were also photographed in various groups without their mother; all five royal princesses, for example, were photographed in mourning alongside the bust of their father.

Queen Victoria made the surprising decision to release one of the "mourning photographs" into the public domain. She gave no reason for this, but her aim was presumably to indicate her intense grief and to share the emotion with a populace she believed to be sympathetic. The gesture, however, drew a considerable amount of criticism in the press.[31] It was felt that a public demonstration of grief on the part of the queen was inappropriate and embarrassing and that such emotions were far better kept private. It was a surprising response, and one that is in marked contrast to what is expected by Britons today from the royal family with respect to public displays of emotion.

COLLECTING AFTER 1861

QUEEN VICTORIA HAD TURNED TO PHOTOGRAPHERS AND ARTISTS TO MARK THE darkest moments of her grief. During the 1860s and beyond, she continued to commission photographers to produce the portraits of herself that were required for public distribution, in addition to working with local photographic firms to carry out documentary work, record her art collection, acquire portraits of her family and household staff, and carry on projects that had been started by Prince Albert. The different series of albums were kept up, many into the 1880s and 1890s, but perhaps the most ambitious project with which the queen continued was Prince Albert's Raphael Collection.

THE RAPHAEL COLLECTION

Prince Albert admired the Renaissance painter Raphael above all other artists, and through the exceptional collection of drawings by Raphael already in the Royal Library, he conceived the idea of acquiring a print of every work by Raphael in existence, in order to form a study collection that would be open to scholars. It was quickly realized that there were many works of which no print existed, however, and therefore the prince's librarians Dr. Becker and, subsequently, Carl Ruland attempted to obtain photographic copies of the works. This involved negotiations with museums, collectors, and photographers across Europe. The works in the Royal Library were also photographed, and those photographs exchanged with collections in order to obtain access to their works. The photographers involved in this project included names such as Stephen Thompson, the Alinari studio in Florence, Adolphe Braun in France, and William Bambridge.

Although by the time of the prince's death the collecting of the prints and photographs had mostly been completed, there was still a considerable amount of printing and organizing to do. The financial records suggest that Bambridge devoted a great deal of time to this throughout the 1860s and 1870s, as the queen was evidently determined to complete her husband's grand undertaking. The culmination of the project was marked by the publication in 1876 of an inventory of the collection by Carl Ruland.[32]

The Raphael Collection was one example of how Prince Albert perceived the potential of photography to perform as an educational tool. Photographs of works of decorative and fine art appear throughout Prince Albert's personal albums, including some of the photographs that had also been incorporated in the four volumes of the *Reports of the Juries*—the luxuriously illustrated record of the Great Exhibition of 1851—which contained 154 photographs by Hugh Owen (1804–1881) and Claude Marie Ferrier (1811–1889). The decision by the exhibition's executive committee to use original photographs pasted into the volumes rather than the more commonly found chromolithographs would undoubtedly have met with the approval of the prince, who had been one of the principal driving forces behind the Great Exhibition.[33] A few years later, in 1855, the prince gave his copy of *Vorbilder für Handwerker* (Models for craftsmen), containing photographs of works of art taken by Ludwig Belitski, to the South Kensington Museum (later the Victoria and Albert Museum).[34] The publication presented the art collection of Baron Alexander von Minutoli as a potential source of education and inspiration for artists, craftsmen, and teachers.

Queen Victoria, while enthusiastic to continue those projects commenced by her husband, notably did not promote any new attempts to use photography for educational purposes. Nor did the queen continue to fulfill the role of a prominent patron of photography, as her husband had done through his visits to the Photographic Society's annual exhibitions and other premises such as the Photographic Institution. The prince, while alive, did much to encourage photography, and it has been suggested that his early death was a "severe blow" to both the Photographic Society and the general status of photography in polite society.[35]

Apart from working on the Raphael Collection, Bambridge spent much of his time copying and printing from negatives belonging to the queen. The negatives were sometimes original negatives by photographers such as Roger Fenton or Thomas Richard Williams (1825–1871), who had fulfilled private commissions for the queen. Sometimes, however, Bambridge was printing up copies of photographs already in the queen's collection. The queen wanted a catalogue of her photograph collection, partly to fulfill a desire to be able to travel with a set of photographs between residences and partly to assuage her anxiety that some of her photographs were fading. The copies made by Bambridge, almost always carbon prints, were usually pasted into the photograph albums over the top of the original salt or albumen silver print. Consequently, today the underlying photographs are often in a far superior condition to those that were not copied, because they have remained protected. The glue used to adhere the copies to the page was pasted only sparingly around the edges of the print and often left almost no marks at all.

The copying and organizing of the collection was taken over from Bambridge by Cornelius Jabez Hughes, based on the Isle of Wight, near Osborne House. Hughes began working for the queen in the 1870s. After he joined forces with Gustav William Henry Mullins (1854–1921) in 1883, the firm of Hughes and Mullins continued to work for the queen until the late 1890s. Hughes started to reorganize the private negatives, renumbering and reprinting them. In 1877 he created the first catalogue, known as "The Catalogue of the Queen's Private Negatives." Three sets of the catalogue were printed over many years; some of the best photographic prints are dated 1891. All the prints in the catalogue are carbon prints, irrespective of the format of the original work.

Today the catalogues serve as valuable documents for the history of the collection. The volumes include copies of original works that can no longer be found in the collection, including a number of early daguerreotypes. The catalogues also show how the queen thought about her photograph collection and what in it was particularly important to her (not everything in the photograph collection was included in the catalogue). Hughes received instructions about the organization and cataloguing through correspondence with the queen's German librarian and secretary, Dr. Hermann Sahl (1832–1896).

The catalogues are organized primarily by subject matter. First are portraits—of Queen Victoria, followed by Prince Albert, then the royal children in order of their age and the Duchess of Kent, the queen's mother. They are succeeded, perhaps surprisingly, by animals—dogs, cows, and other denizens of the royal farms—and finally by royal residences. Next comes a selection of different subjects, notably portraits of Highland troops and soldiers who fought in the Crimean War, and a set of portraits of actors in Shakespearean productions taken by Martin Laroche (1814–1886). (The original hand-painted photographs by Laroche had been a Christmas present to the queen from Prince Albert in 1857.)[36]

The photographs selected for the catalogues were evidently those that had some personal meaning for the queen. It seems fair to infer that she was interested primarily in photographs that showed her family and her home, or photographs that recalled a family connection. For example, the many topographical and architectural works collected by Prince Albert are not included in the catalogues. The queen also cared passionately about the officers and ordinary soldiers who fought for Britain in the wars—an interest that began during the Crimean War and resulted in the commissioning of portraits of the men who received medals from her by the photographic partnership of Cundall and Howlett.

The format of the original photographs also seems to be relatively unimportant. The key issue was the permanence of the copy print—the carbon print process was always used because it would not fade. The queen was primarily interested in the image itself and its preservation; the physical qualities of the original object were not of great consequence.

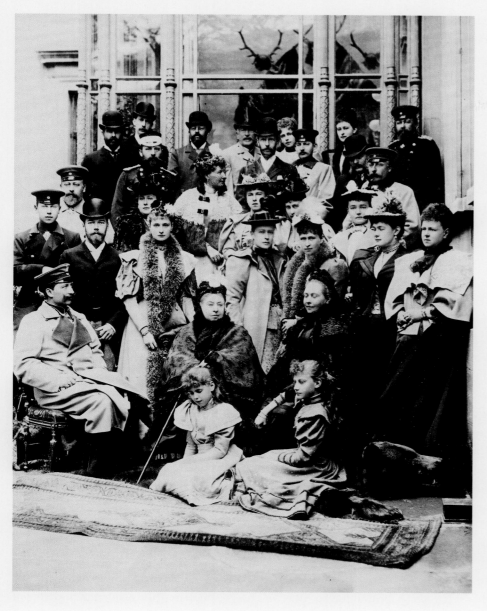

FIGURE 33
E. Uhlenhuth (German, act. 1890s), *Queen Victoria and Her Family, Coburg*, April 21, 1894. Albumen silver print, 19.7 × 15.2 cm (7¾ × 6 in.). Windsor, The Royal Collection, RCIN 2905204

PORTRAIT ALBUMS

Queen Victoria continued to compile the portrait albums that she and Prince Albert had begun together. There were several different series. Perhaps the most coherent and complete is the "Portraits of Royal Children" series, begun in the mid-1840s and kept up in chronological order until the late 1890s, which consists of forty-four volumes. In the 1840s the portraits were of the queen's own children, with portraits by Becker, Fenton, and Thomas Richard Williams. By the 1890s the portraits were of Queen Victoria's grandchildren and great-grandchildren, including as young boys King Edward VIII and King George VI, the present queen's father.

The albums are carefully compiled, with photographs pasted on one side of the page only, and with handwritten captions identifying both the sitters and the photographers below the photographs. Usually a date is included as well. The albums are all bound in the same way, with flaps attached to the back cover that fold over the pages to protect them. The covers are tooled with gilt ruling and lettering. The albums are luxury objects and indicate the importance that the series of photographs had for the queen.

Within the albums, the photographs range from private portraits and copies of daguerreotypes to later portraits released to the public. One photograph, taken in Coburg in 1894, shows the queen seated at the center of a group in which every person present is related to the queen either by birth or marriage (fig. 33). One photograph from the session was released to the public, but many other versions from the sitting remained private. Present is the queen's son, the future King Edward VII;

the new czar of Russia, Nicholas II, with his fiancée, Princess Alexandra of Hesse; the queen's eldest daughter, now the dowager empress of Prussia, and her eldest son, Kaiser Wilhelm II; the Prince and Princess Ferdinand of Romania; and others from Russia and Germany. The photograph is particularly melancholy, as it represents the alliances through marriages, particularly between Britain, Russia, and Germany, that the queen worked hard to put in place and that were subsequently shattered by the outbreak of war in 1914.

The presence in the albums of many more photographs from a sitting than were ever released publicly suggests that the queen was routinely sent all the resulting photographs from a session and that she then selected which ones would be published. A similar procedure is followed with royal photographic portraits today.

Another series, equally carefully compiled, is that of the carte-de-visite portrait albums. Nine volumes titled "Royal Portraits" are followed by five albums titled "Royal Household Portraits" and sixteen successive albums arranged by the nationality of the sitters. The last begin with five albums of "English Portraits," followed by portraits from Austria, Belgium, and so on, covering much of Europe. The final albums in the series contain portraits of artists, writers, and musicians.

Since the largest group of albums is devoted to the queen's extended family and those men and women who worked for the queen, it suggests that she was compiling her albums for emotional reasons. The queen certainly acquired a large number of cartes de visite of people she did not know, but the majority depict either those who worked for her or those who were related to her.

The queen had started collecting cartes de visite in the 1850s. The new format—a photograph measuring approximately 3½ × 2⅜ inches (about 9 by 6 cm) pasted on a small card—was patented by André Adolphe-Eugène Disdéri in 1854 and quickly became extremely popular, especially given its low cost. The cartes could be produced in large numbers. Initially, friends and family circulated their own portraits among themselves; very quickly, however, portraits of well-known figures such as actors, politicians, sportsmen, and, eventually, royalty were produced and collected by the public. The queen engaged with enthusiasm in collecting cartes, asking her ladies-in-waiting to acquire photographs on her behalf from society ladies. These were sent to the queen, who compiled them in her photographic albums and other formats, such as folding portable screens.

Despite the permission given to Mayall in 1860 to release a set of cartes de visite into the public domain (see fig. 46), many of the cartes produced of Queen Victoria and her family were for private consumption only. William Bambridge was commissioned, as was Frances Sally Day (ca. 1816–1892), the first female photographer to work for Queen Victoria. They produced portraits of the royal family that would be sent with letters to relations overseas as well as stored in personal albums belonging to the queen, Prince Albert, and some of the royal children.

The final series of albums that the queen compiled has the title "Photographic Portraits." The albums begin in the 1850s with numerous portraits of the queen and Prince Albert, several commissioned in 1854 from Roger Fenton. The series is continued, through seven albums, into the late 1890s. Other portraits of family members are included, as are portraits of royals from foreign families. The same sitters often appear in the carte-de-visite albums as well, but the "Royal Portraits" series consists of larger photographic prints. Many of the photographic portraits included would have been private commissions from the various royal families depicted, but it was not uncommon for a photograph to be subsequently published in the public domain or used as the basis of a print or illustration in a newspaper, thus blurring the distinction between private and public.

The "Photographic Portraits" albums contain portraits of the British royals' extended family. Through the marriages of her children and grandchildren, Queen Victoria had connections with Denmark, Russia, Prussia and other German states, and Spain. The albums reflect and also consolidate these interrelations. Through the act of acquiring, structuring, and ordering the albums, Queen Victoria is reflecting her own position as the central figure controlling the various dynasties through marriage alliances. One of the portraits in "Photographic Portraits" demonstrates the close ties with the Russian royal family, presenting Alexandra, Princess of Wales, with her sister Dagmar: she took the name Maria Feodorovna when she converted to Orthodoxy and married Grand Duke Alexander, who eventually became Czar Alexander III of Russia (fig. 34).

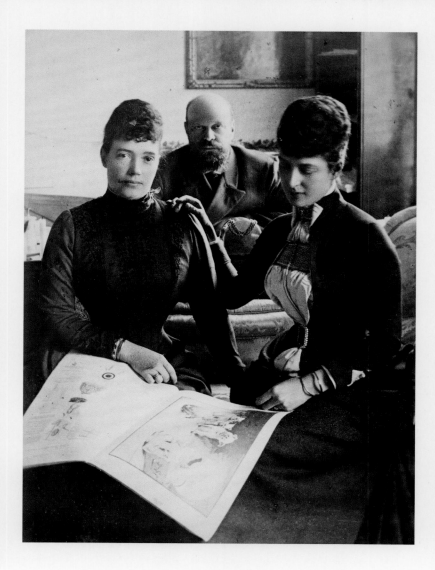

FIGURE 34
James Russell and Sons (British, act. 1850s–1940s),
Czar Alexander III of Russia, Czarina Maria Feodorovna,
and Alexandra, Princess of Wales, early 1890s.
Albumen silver print, 14.1 × 10.5 cm (5⁹⁄₁₆ × 4⅛ in.).
Windsor, The Royal Collection, RCIN 2909332

FAMILY SNAPSHOTS

Toward the end of the nineteenth century the photographic portraits commissioned by the royal family were becoming increasingly formal and stiff. This was partly the fashion at the time but also, perhaps, a response to the more frequent publication of the portraits in illustrated journals and magazines. Technology allowed photographs to be printed as halftone illustrations, which appeared to the eye as true photographs.[37] Sitters increasingly felt the need to present a public image for such portraits. This was assisted by the photographic studios, which would manipulate the negatives of their sitters to remove stray hair, reduce waist sizes, and smooth out wrinkles. Queen Victoria took full advantage of these services in her formal portraits, particularly in the commemorative portraits for her Diamond Jubilee in 1897, when she celebrated sixty years on the throne. Firms such as W. & D. Downey, Hills and Saunders, Hughes and Mullins, Lafayette, and Alexander Bassano fulfilled many of these later commissions.

At the same time, personal use of cameras was increasing within the royal family, creating an alternate set of images running in counterpoint to the publicly presented portraits. The family snapshots show a private side of the royal family, one that was never intended to be seen beyond the immediate family circle. The photographs provide a rare opportunity to see "behind the scenes," showing family members relaxed and happy.

The royal family had been photographing one another from the 1860s, though at this early date the resulting portraits were not substantially different from those being produced by professional photographers. The poses were similar and the backdrops or props were the same. The queen and Prince Albert are known to have taken an interest in the process of photography, but there are no surviving photographs attributed to either of them, which makes it reasonable to assume that they

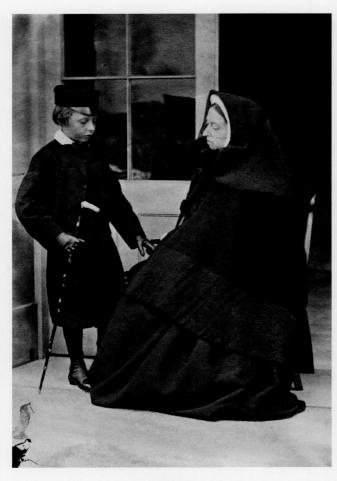

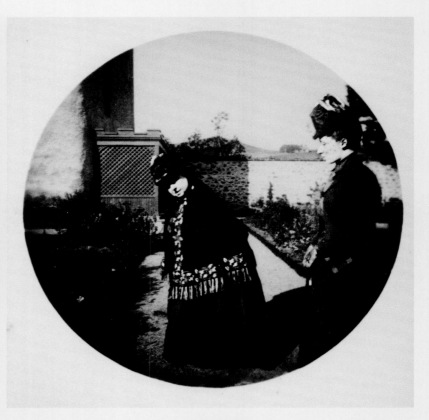

did not practice photography to any great extent. Works by some of the royal children survive, however. In particular, Prince Alfred, Duke of Edinburgh, took numerous photographs of his brothers and sisters and of members of the royal household. He also photographed his mother in March 1862, at the same time that Bambridge created the mourning portraits of the queen with the bust of Prince Albert. It seems likely that Bambridge was guiding the prince, and Bambridge certainly made the prints from the negatives for the prince afterward (fig. 35).

Alexandra, Princess of Wales, already an accomplished artist, probably took up photography in the mid-1880s. The earliest surviving photographs by her, taken with a No. 1 Kodak camera, are found in an album dating from 1889–90.[38] The Princess of Wales used her camera on every possible occasion, photographing family and friends and travels abroad. At roughly the same time, her daughter Princess Victoria was also starting to take photographs. Her earliest surviving work dates from 1887–88. Other members of the royal family who are known to have taken photographs include Princess Louise (daughter of the Prince and Princess of Wales), Princess Beatrice (Queen Victoria's youngest daughter), and the Duchess of York (who later became Queen Mary, married to King George V). There are several photographs in which they are seen holding or using cameras, and examples of their work were exhibited in a Kodak exhibition in London in 1897.[39]

The snapshots taken by the Princess of Wales, her daughter Princess Victoria, and the other royals provide a rare record of Queen Victoria in her final years, at a time when she was being photographed less and less. The queen did not travel to the extent that her extended family did, but she moved between the different royal residences where family and friends were entertained. These events would be photographed by family members, and the snapshots survive today in private albums.

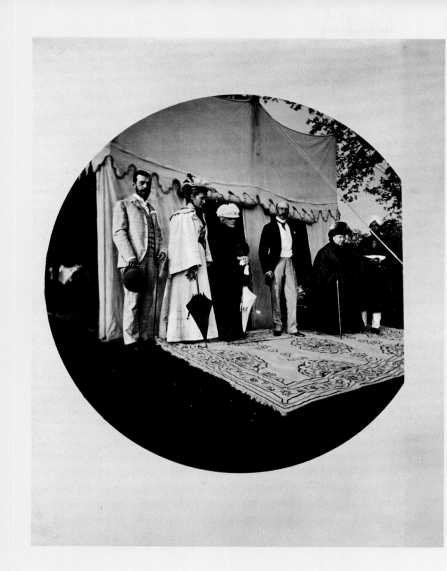

FIGURE 37
Princess Louise Margaret, Duchess of Connaught
(British, born Prussia, 1860–1917), *Group at Bagshot, Windsor Park,*
with Czarevitch Nicholas Alexandrovich; His Fiancée, Princess
Alexandra of Hesse; Marie, Princess Leiningen; Arthur, Duke of
Connaught; Queen Victoria; and Indian Servant, June 1894.
Gelatin silver print, 8.5 × 8.5 cm (3⅜ × 3⅜ in.).
Windsor, The Royal Collection, RCIN 2801672

The Princess of Wales's photographs include a number of portraits of Queen Victoria apparently in almost a playful mood—not something that is often associated with the elderly monarch. One of the photographs shows the queen wrapped up in her hat and cloak, gazing into the camera, while her granddaughter Princess Louise of Fife stands to the side (fig. 36). It was taken in Scotland in October 1890. A second photograph, taken at the same time, focuses more closely on the queen, showing her leaning forward on her walking stick. It is a surprising photograph, because the queen appears to be oblivious to being photographed. It is rare to see such a photograph, which contrasts dramatically with the formal portraits in which the queen is presented as a sovereign and empress. The photograph of Queen Victoria and Princess Louise was subsequently used by the Princess of Wales, with many other photographs, to decorate a china tea service, made in Cauldon Ware by the firm of Brown-Westhead, Moore & Co.

Family members also photographed more formal occasions. In June 1894 the soon-to-be Russian czar Nicholas II traveled to Britain to meet Queen Victoria and to visit his fiancée, Princess Alexandra of Hesse. It was the first time that Queen Victoria was to meet Nicholas, even though he was already engaged to her granddaughter. During his time in Britain, a visit was made to Bagshot Park, the home of Prince Arthur, the Duke of Connaught (Queen Victoria's seventh child and third son). Outside a tent put up in the grounds for entertainment, the Duke's wife, Princess Louise Margaret, took a photograph of a group that included Queen Victoria with her son Prince Arthur and the engaged couple. The informality of the photograph is evident, as only the czarevitch looks at the camera, and the grouping is such that Queen Victoria appears to be the least important person in the photograph (fig. 37).

Far fewer photographs were taken of the queen toward the end of her life. After her death, on January 22, 1901, at Osborne House, Queen Victoria was photographed once more, just as her husband, Prince Albert, had been photographed after his death almost forty years earlier. One photograph was subsequently printed, showing the queen swathed in almost bridal white fabric, holding a wood cross, surrounded by flowers, with a painting of Prince Albert above the bed and another to the side (see fig. 14). The photographer remains unknown, but it is possible that the image was taken by the artist Sir Hubert von Herkomer (1849–1914), who was asked to produce a painting of the queen on her deathbed. It is known that Herkomer took photographs to use in the preparation of his portraits. Very few copies of the photograph exist, and many of those that do survive are often found to be later copies. A print exists in the Royal Collection, as does the watercolor produced by Herkomer. Today the latter hangs at Osborne House, outside the room in which the queen died.[40]

The private photographs of Queen Victoria, when considered together, perhaps provide a picture of the monarch different from the one generally associated with the queen. While we are used to thinking of her as an elderly, grumpy woman, we can see through her photographs that she was passionately engaged with her family and her relations throughout her life. She was interested in those who worked for her, whether directly, in the royal household, or indirectly, in the British Army, for example. Throughout her life the queen maintained her fascination with humankind and its diversity.

We can also see how important photographs were to the queen. At the time of Queen Victoria's death, every royal residence contained photographic albums in the library, framed photographs on the walls, and smaller framed photographs on desks and mantelpieces. Certainly the photographs were used to fulfill a necessary function, projecting a public image of the queen, but they served a more intimate purpose too, linking the queen directly with those men and women about whom she cared. The queen's relationship with photography was emotional rather than intellectual, perhaps the opposite of the relationship experienced by Prince Albert. This is only to be expected, though, from a woman whose passion for life is evident throughout her private journals.

The queen saw photography as a means to an end, as a way of creating and sustaining relationships with people and places. The photographs themselves were not necessarily seen as fixed physical objects, nor did they need to be; rather, they were treated as fluid and changeable images that could be printed in different sizes and different formats and appear in different locations, all at the same time. In light of the very similar way that digital images are reproduced and republished today, it seems a remarkably modern way to think about photography.

NOTES

1 Windsor, Royal Archives, PPTO/PP/QV/PP2/71/5146.

2 For the Manchester exhibition, see Anne M. Lyden's essay "A Young Monarch, a New Art, and the Introduction of the Photographic Exhibition" in this volume.

3 Victoria, Queen of the United Kingdom, Journal, March 7, 1842, Windsor, Royal Archives, VIC/MAIN/QV. According to the ledger of Prince Albert's private expenses, he paid six pounds and thirteen shillings for the photographs. The entry is dated May 24, 1842. Royal Archives, PPTO/PP/PAPC/PAPCACC/LED/1842/19.

4 List of daguerreotypes belonging to Her Majesty, Windsor, Royal Archives, VIC/ADDC04/2.

5 In the Royal Archives records from the 1840s and 1850s, a distinction is often drawn between a photograph "from life" and a photograph that is a copy of a painting or drawing. "Mahmud Ali" is almost certainly Muhammad Ali, the ruler of Egypt between 1805 and 1848.

6 Victoria, Journal (note 3), January 17, 1852.

7 Victoria, Journal (note 3), May 31, 1848.

8 "A Dr Becker is to be engaged on trial, to be with Bertie." Victoria, Journal (note 3), November 23, 1850.

9 Ernst Becker to his mother, March 17, 1852, Windsor, Royal Archives, VIC/Add.U/105/47 (English translation from German original). The volume in Windsor is a typewritten transcription of the German originals, which are in the Hessisches Staatsarchiv, Darmstadt. All the letters in the volume are from Becker to his mother.

10 *Journal of the Photographic Society* 1, no. 1 (March 3, 1853): 5.

11 Victoria, Journal (note 3), September 28, 1852.

12 Becker to his mother, October 9, 1853, Windsor, Royal Archives, VIC/Add.U/105/67 (English translation from German original).

13 Becker to his mother, October 9, 1853 (note 9).

14 Becker to his mother, January 27, 1854, Windsor, Royal Archives, VIC/Add.U/105/76 (English translation from German original).

15 Becker to his mother, March 15, 1855, Windsor, Royal Archives, VIC/Add.U/105/86 (English translation from German original).

16 Becker subsequently described meeting Duleep Singh, who asked Becker to explain the photographic process to him. Becker, letter to his mother, September 8, 1854, Windsor, Royal Archives, VIC/Add.U/105/83.

17 Victoria, Journal (note 3), January 3, 1854.

18 Victoria, Journal (note 3), May 24, 1854.

19 The queen was at Balmoral from August 30 until October 14. She was accompanied by her husband and the princess royal, Prince Alfred, and Princesses Alice, Helena, and Louise.

20 Fenton submitted an invoice to the queen in 1857 listing "8 Negatives taken at Balmoral at £5 5s [each]" and eight "large photographs, Scotch." Windsor, Royal Archives, PPTO/PP/QV/PP2/22/7526.

21 The portrait is inventory number 904 in Richard Redgrave, "Catalogue of Pictures the Property of Her Majesty Now at Windsor Castle," 1859–75, Windsor, Royal Collection, RCIN 2906481. Redgrave (1804–1888) was surveyor of the queen's pictures from 1857 to 1880. The painted photograph was later transferred to Osborne House, where it remained on display until the late twentieth century, when it was returned to the main photograph collection at Windsor Castle.

22 Redgrave, "Catalogue of Pictures" (note 16), inv. no. 1442.

23 Invoice for fifty-one pounds and three shillings, Christmas 1854, Windsor, Royal Archives, PPTO/PP/QV/PP2/8/5080.

24 Invoice for sixty-eight pounds, two shillings, and twopence, June 1866, Windsor, Royal Archives, PPTO/PP/QV/PP2/103/10844.

25 Lieutenant A. B. Haig to Queen Victoria, August 27, 1870, Windsor, Royal Archives, VIC/MAIN/S/27/54.

26 Helen Gray and Megan Gent, "The Rehousing of Queen Victoria's Private Negatives," in *Care of Photographic, Moving Image and Sound Collections: Conference Papers, York, 20–24 July 1998* (Leigh, UK, 1999), 130.

27 *Illustrated London News*, June 4, 1857, 540.

28 There has been over the years a great deal of speculation as to the existence or otherwise of a postmortem photograph of Prince Albert. This has usually focused on the image of Prince Albert that was framed and positioned above Queen Victoria's bed and that is often visible in photographs of the queen's bedroom. This image is not a photograph; rather, it is the painting that still hangs above the queen's bed in Osborne House today.

29 See Jonathan Marsden, ed., *Victoria and Albert: Art and Love*, exh. cat. (London: Royal Collection Publications, 2010), 436.

30 Victoria, Queen of the United Kingdom, "Albert" journal, 1862, Windsor, Royal Archives, VIC/MAIN/Z/491/20–21. This volume of Queen Victoria's recollections of her late husband also contains a number of photographs pasted in by the queen, including three cartes de visite of Prince Albert and photographs of Christmas decorations and presents in 1860, the prince's last Christmas.

31 John Plunkett, *Queen Victoria: First Media Monarch* (Oxford, 2003), 180.

32 Carl Ruland, *The Works of Raphael Santi da Urbino as Represented in the Raphael Collection in the Royal Library at Windsor Castle, formed by H.R.H. the Prince Consort, 1853–1861, and Completed by Her Majesty Queen Victoria* (London, 1876).

33 For a discussion of the Great Exhibition of 1851 and Prince Albert's role, see Lyden, "Young Monarch" (note 2).

34 *Vorbilder für Handwerker und Fabrikanten aus den Sammlungen des Minutolischen Instituts* (Liegnitz, 1855), 3 vols. The Minutolisches Institut, in Liegnitz (today Legnica, Poland), was responsible for the publication. See London, Victoria and Albert Museum, no. 36:077.

35 Roger Taylor, *Impressed by Light: British Photographs from Paper Negatives, 1840–1860*, exh. cat. (New York: Metropolitan Museum of Art, 2007), 140–41.

36 Invoice for 126 pounds, December 1857, Windsor, Royal Archives, PPTO/PP/QV/PP2/25/8128.

37 Halftone printing appeared in the early 1870s, but the use of halftone blocks in magazines and journals became popular and frequent only in the 1890s. A halftone print uses tiny dots of varying size in a single color to create the appearance of a continuous image. The human eye and brain do not see the individual dots but, rather, blend the dots together into a smooth and gradual toned image.

38 For a full account of the Princess of Wales as an artist and photographer, see Frances Dimond, *Developing the Picture: Queen Alexandra and the Art of Photography* (London, 2004).

39 Dimond, *Developing the Picture* (note 33), 77.

40 Windsor, Royal Collection, RCIN 450066.

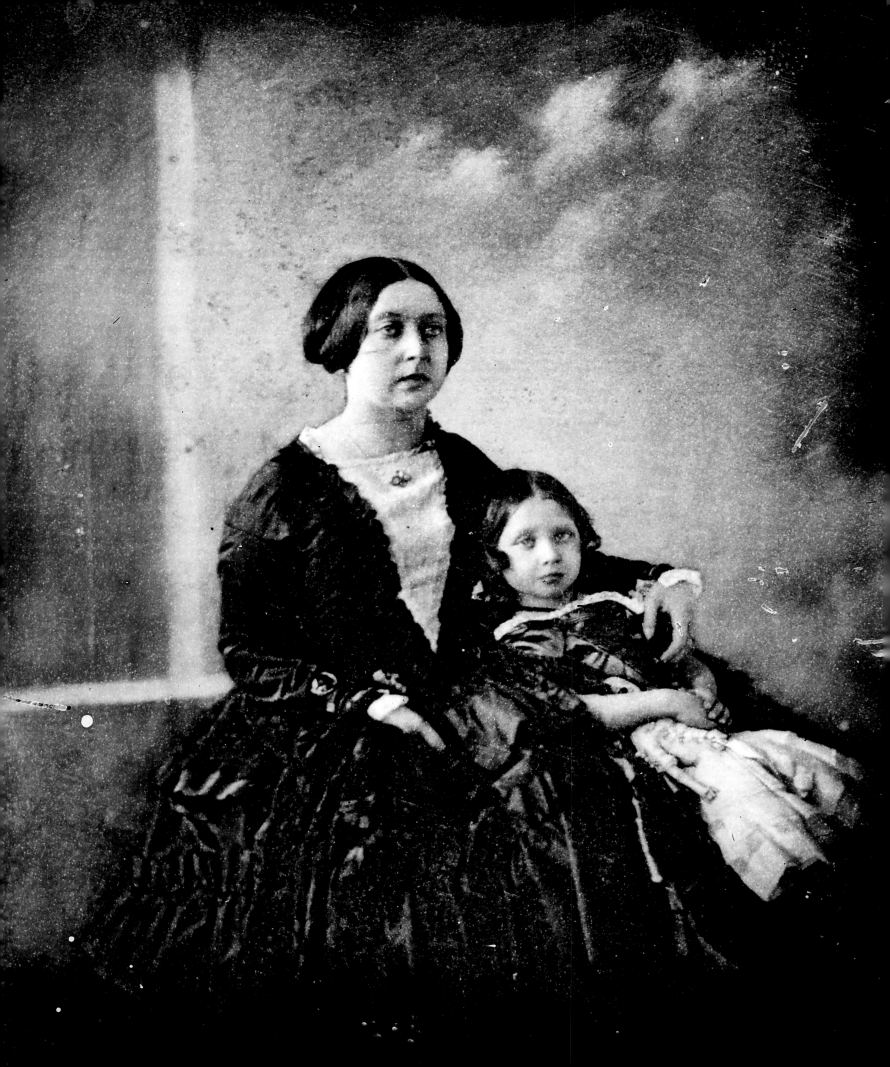

"As We Are": Exploring the Royal We in Photographs of Queen Victoria

ANNE M. LYDEN

QUEEN VICTORIA WAS THE FIRST BRITISH MONARCH TO HAVE HER LIFE fully recorded by the camera. During Victoria's reign her subjects had for the first time an immediate account of what their queen looked like and of the varying roles she occupied: ruler, wife, mother, widow, and empress. As the queen's long reign continued into the late nineteenth century, photographs of her proliferated around the world, in all corners of the British Empire. And her image continues to resonate today. Although the empire on which the sun never set is gone, Victoria's photographic image is still a global one. The image readily called up (and often parodied) is that of the stout figure wearing the tiny crown. As identifiable as Queen Victoria is to viewers today, however, this was not always the case. As the medium of photography evolved over the years, so did Victoria's photographic image: she was a camera-shy young mother before she became an internationally recognizable sovereign.

The earliest known photograph of Queen Victoria appears to date from the mid-1840s. This daguerreotype portrait has not survived, but a copy negative and later print in the Royal Collection testify to its existence.[1] Previously believed to be the work of Henry Collen (1800–1879), the queen's painter of miniatures, but now attributed to a still unknown daguerreotypist, the image shows the queen with her eldest daughter, the princess royal, who appears to be around four or five years old (fig. 38).[2] There is no elaborate backdrop, no props (other than the child's toy), and no hint of royal status. The scene is an intimate one; the queen has her arm tenderly around Princess Victoria, who in turn is holding on to a doll. Indeed, if one did not recognize the queen, this image could easily be mistaken for an ordinary portrait of a mother and child. Yet it is noteworthy that the earliest known photographic image of the queen portrays her as a mother. Although there are numerous examples of Prince Albert sitting before the camera in the 1840s, none from this period show him as a father figure—that is to say, unlike the queen, he is never photographed with any of his children. In another contrast, whereas little evidence survives regarding Victoria's first photographic experience, there is a considerable amount of documentation, including entries in the queen's journal and coverage in the press, regarding Albert's engagement with photography.

Victoria wrote in her journal that Albert first sat for his portrait when he visited the studio of William Constable (1783–1861) on March 5, 1842, when the court was in residence at the Royal Pavilion in Brighton. The weather proved inclement and the session was not successful, so the prince returned two days later, on March 7, when the first photographs of British royalty were recorded.[3] The murkiness of these small daguerreotypes reveals the primitive nature of the new art, which the Frenchman Louis-Jacques-Mandé Daguerre (1789–1851) had announced just a few years prior (fig. 39). While the queen may have enjoyed viewing the portraits of her beloved husband, she did not accompany him when, later in the month, he visited the studio of Richard Beard (1802–1888), a photographer who operated the first portrait studio in London. According to the *Times,* Prince

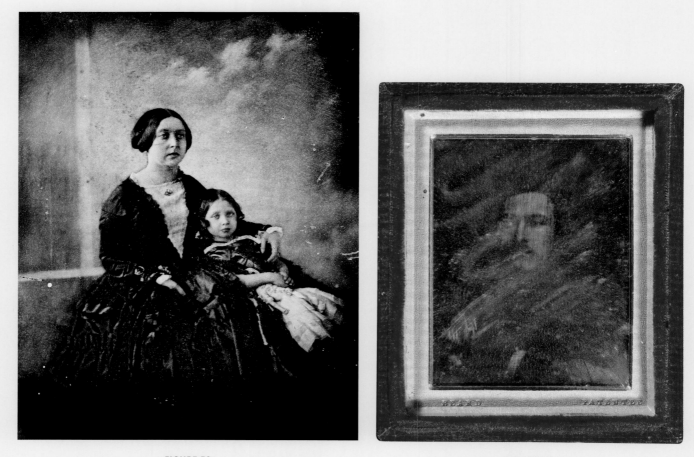

FIGURE 38
Unknown photographer, *Daguerreotype Portrait of
Queen Victoria and the Princess Royal*, mid-1840s.
Later carbon print, 15.2 × 12.7 cm (6 × 5 in.).
Windsor, The Royal Collection, RCIN 2506821

FIGURE 39
William Constable (British, 1783–1861), *Portrait of
Prince Albert*, 1842. Daguerreotype, 8.7 × 6.3 cm (3⁷⁄₁₆ × 2½ in.).
Windsor, The Royal Collection, RCIN 2932488

Albert sat for six portraits (two "full face," two "profiles," and two "whole lengths").[4] Albert sat for his portrait again in 1848, this time with the photographer William Edward Kilburn (1818–1891), but it would be another four years before the queen did the same (pls. 68–70).

The absence of images of the queen in the early years of photography is curious. Perhaps, like her first daguerreotype portrait, the evidence of sittings has been lost; or perhaps it was Victoria's decision to absent herself.[5] Between 1840 and 1850 she was pregnant with six of her nine children, and it is possible that in her continual state of pregnancy she did not wish to sit before the camera. While attitudes toward pregnancy today make room for ubiquitous images, from photographs to medical scans, that document each milestone of the gestational period (even the fetus in utero), there is little photographic evidence that Victoria was inclined to have her condition recorded by the camera.[6] It was not unthinkable for women to appear in public when pregnant; as the scholar Judith Schneid Lewis has commented, "at no time...does there seem to have been any social taboo against appearing visibly pregnant in public, contrary to popular myth....Aristocratic women remained relatively free of restraint, even during their ninth month of pregnancy."[7] Nonetheless, Victoria was the queen and came under more public scrutiny than most women, and she was often the target of gossip and rumors about her many pregnancies.[8] Years later, in letters to her eldest daughter, the queen acknowledged that she was unhappy being pregnant throughout the first two years of her marriage and did not like appearing in public when she was pregnant, believing that people stared at her.[9] Victoria may have experienced some degree of postpartum depression after the birth of the Prince of Wales, in 1841, just one year after the princess royal was born. An account by Prince Albert's secretary from December 26, 1842, reveals that despite the Christmas

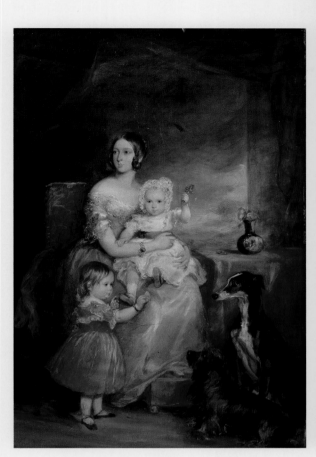

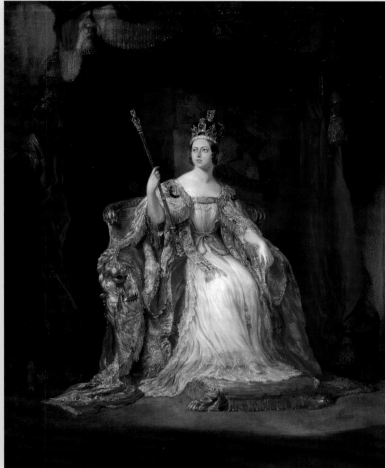

FIGURE 40
Sir Francis Grant (Scottish, 1803–1878), *Queen Victoria with Victoria, Princess Royal, and Albert Edward, Prince of Wales,* 1842. Oil on canvas, 44.7 × 30.7 cm (17⅝ × 12¹/₁₆ in.). London, The Royal Collection, RCIN 406944

FIGURE 41
Sir George Hayter (British, 1792–1871), *Queen Victoria,* 1840. Oil on canvas, 270.7 × 185.5 cm (106⁹/₁₆ × 73¹/₁₆ in.). London, The Royal Collection, RCIN 405185

holiday, usually a time of cheer in the royal household, the queen was unwell, "being again troubled with lowness.... I should say that her Majesty interests herself less and less about politics."[10]

For Christmas that year, Victoria presented Albert with a painting by Sir Francis Grant (1803–1878), *Queen Victoria with Victoria, Princess Royal, and Albert Edward, Prince of Wales* (fig. 40). The queen's apparent unhappy disposition is at odds with the contented mother depicted in the work. Victoria commissioned Grant to paint her portrait with her two children (both of whom were under the age of two at the time), and it is likely that she dictated the particulars of the painting, as she presumably wanted to present her husband with an attractive view of herself as his wife.[11] The piece celebrates the young Victoria, shown in a pretty white dress and surrounded by her children and dogs, as a happy, even glamorous mother. Even if, by her own account, Victoria was "miserable" at this time, it is not surprising that she would want to put forward an ideal version of herself. It had been evident from the beginning of her reign that she had a clear sense of how she should appear in portraits.

The first painting in which Victoria is officially represented as queen is David Wilkie's *First Council of Queen Victoria* (ca. 1837–38; Windsor, Royal Collection, RCIN 404710). Although the queen had commissioned the work, she strongly disliked it—both the painting as a whole and the likeness of her. Shown wearing a white dress (when in fact she would then have been wearing the dark clothes of official mourning for King William IV), the queen is presented as a young, innocent girl, surrounded by her council of considerably older men. At the time, the painting was criticized for its informality, which may in part be due to Wilkie's being primarily a genre painter; it is also possible that the painting reflected the already growing interest in and portrayal of the queen in

popular media. Wilkie (1795–1841) was the principal painter for the court, as he had been for Victoria's predecessors George IV and William IV, and in that capacity he also executed her coronation portrait. This staid portrait did not find favor with the queen, either, and she insisted that a copy of another painting be used in its place at the British embassy in Paris.[12] Victoria preferred the lighter palette and more fluid handling of Sir George Hayter (1792–1871), whose portrait showed the queen in full regalia, bathed in light (fig. 41). The painting may seem traditional in its representation of the monarch, but it was unusual for the queen to be shown wearing her coronation robes and crown and holding the scepter. Indeed, not since Paul van Somer (ca. 1576–1621) executed his portrait of James I more than two hundred years earlier had a painting shown the British monarch this way. According to the conventions of state portraiture, the sovereign was typically depicted in state robes, with crown, scepter, and orb off to the side.[13] Furthermore, in Hayter's portrait the queen is shown seated—another marked departure from tradition. These innovations were clearly pleasing to Victoria, who consistently favored Hayter's work.

Photography did not easily lend itself to such idealizing; the camera could not record what did not exist, and it certainly did not flatter the way the painter's brush could. While the now-lost daguerreotype portrait of Victoria demonstrates the maternal qualities of the queen, it has none of the touches of glamour, in either dress or background, of Grant's painting and appears overall to be a rather modest, if true, representation. That the camera captured a faithful likeness may have required an adjustment by the queen, who on January 17, 1852, sat for her portrait with several of her children on the grounds of Buckingham Palace. Upon viewing the finished image by Kilburn (fig. 42), the queen was disappointed in her own appearance (her eyes were inadvertently closed). Writing in her journal that day, she described her dismay over the portrait: "Mine was unfortunately horrid, but the children's were pretty."[14] Indeed, she disliked the portrait so much that apparently she scratched the surface of the daguerreotype to obliterate her face (pl. 69). Nonetheless, this medium continued to attract the monarch; just two days later she repeated the exercise, posing with her children in almost the same arrangement as during the previous session, but this time she elected to sit in profile, with the rim of her bonnet obscuring her face, presumably forestalling any risk of an unflattering likeness (pl. 70).

The photographs from the 1840s and 1850s fall within the private domain; they did not circulate beyond the royal household. Yet these images suggest a curiosity about photography on Victoria's part, and as more photographs accumulated, they indicated how she saw herself. Her willingness to engage in the photographic sessions meant she was complicit in the production of the work, and thus in the overall look of the image—*her* image. Although the photographs of family life were private, other, nonphotographic images of the royal family proliferated in popular culture. In woodcut prints and colored lithographs, and in the recently established illustrated press, images of Victoria as a mother were everywhere (figs. 43, 44). The ubiquity of such images reflected the desire, even the need, of the nation to view her in this way. A female monarch was unsettling to many people, who feared female rule would upset the nineteenth century's established gender roles. Portraying Victoria as a loving wife and mother satisfied these concerns.[15]

Apart from the exaggerated image of Victoria as mother to the nation, she was, of course, a real mother to her actual children. The private photographs demonstrate that by 1854 Victoria was more comfortable in front of the camera when domestic scenes were recorded. A photograph from February of that year by Roger Fenton (1819–1869) is disarming in its informality, from the casual attire of the queen to the grouping of the children around her; it offers an intimate glimpse into her family life and responsibilities (pl. 71). Victoria is shown with four of her children: the Prince of Wales (aged twelve), at the far left, standing next to his sister the princess royal (aged thirteen); Prince Alfred (aged nine), standing on the right; and Princess Alice (aged ten), on her mother's lap. The queen is wrapped in a tartan shawl, and the scissors and key visible on the chain suspended from her chatelaine suggest practicality and quotidian household rituals, though such instruments were no doubt useful when it came to royal dispatch boxes and correspondence. The informality extends to the scenery; the backdrop appears to be a simple tarpaulin that was, however crudely, meant to convey an interior, or at least disguise the outdoor setting of Buckingham Palace.

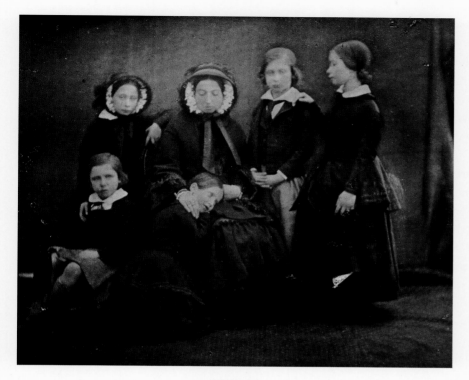

FIGURE 42
William Edward Kilburn (British, 1818–1891), *Daguerreotype of Queen Victoria,*
the Princess Royal, the Prince of Wales, Princess Alice, Princess Helena, and Prince Alfred,
January 17, 1852. Later carbon print, 8.1 × 9.8 cm (3³⁄₁₆ × 3⅞ in.).
Windsor, The Royal Collection, RCIN 2931319C

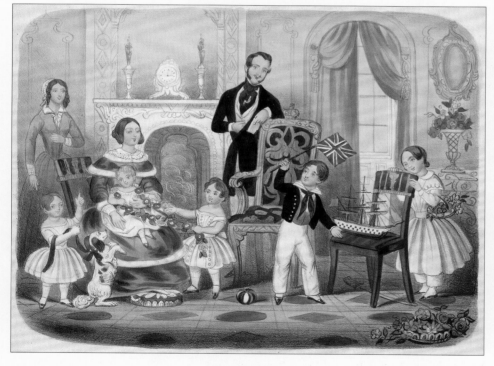

FIGURE 43
The Royal Family in the Nursery, 1845. Hand-colored lithograph, 22.5 × 28.5 cm
(8⅞ × 11¼ in.). New Haven, Yale Center for British Art, Paul Mellon Collection,
GV 1119 V33 1845+ Oversize

FIGURE 44
Bradbury and Evans, *There's No Place Like Home!*
1845. From *Punch* 9 (1845): 109. Lithograph,
27.6 × 21 cm (10⅞ × 8¼ in.). Los Angeles, Getty Research
Institute, 85-S836, vol. 9

The queen, of course, could command the presence of a photographer at her home and had no need to visit a commercial studio (though she did on occasion). Her journal entries often mention going into the garden (of whichever of her homes she happened to be residing in at the time) and having her picture taken by the photographer who had been summoned to do so. Most of the photographic sessions took place on the grounds of the royal palaces, usually in the gardens or greenhouses, or on the terraces.

All the family gathered on the terrace at Osborne, Victoria and Albert's home on the Isle of Wight, on May 24, 1854, for a photograph (pl. 90) by Dr. Ernst Becker (1826–1888). The occasion was the queen's thirty-fifth birthday, and present that day were her husband, children, mother, the Duchess of Kent, and two of the family dogs—Dandie and Deckel. A few days later Victoria sent the photograph to her uncle King Leopold I of Belgium, describing it as "a little photograph of *our family group* including dear Mama" and adding, "it has such truth about it & represents us *as we are*."[16] Victoria was in regular correspondence with her uncle, a close family member who was no doubt familiar with how they *were*—both in appearance and in health; by stressing the verisimilitude of the image, the queen acknowledged what distinguished photographic representations of her from other images: an undeniable truth.

The public did not see the queen and her family *as they were*, however. Instead, during the 1840s and 1850s the queen's public image was still derived from official paintings. In 1847 an exhibition by one of the queen's favorite artists, Franz Xaver Winterhalter (1805–1873), drew around one hundred thousand visitors to St. James's Palace to see paintings of the royal family.[17] Among the highlights of the show was Winterhalter's portrait *The Royal Family in 1846* (fig. 45), which was an exercise in skillfully combining the private and public life of the queen. Dressed formally (though not in robes of state), with her crown, Victoria is seated next to Prince Albert and surrounded by five of their children. The painting unambiguously presents the queen as monarch, wife, and mother. It also demonstrates the royal succession (the queen has her arm around the Prince of Wales, the heir to the throne) and largely follows a tradition that began with Henry VII.[18] Like many popular paintings of the queen, this portrait was made into an engraving, by Samuel Cousins (1801–1887), in 1850 and circulated widely.

Technological advances in printing, together with the rise of the illustrated press, brought pictures of the monarch to the public; they both satisfied an increasing demand for such visual information and strengthened the bond between the people and their queen. Since her accession to the throne, the queen had embraced a more informal approach to the monarchy than her predecessors had. She spent on her coronation a third of the lavish amount expended by George IV on his (£70,000 as opposed to £240,000), and this caused her to be seen as having a common touch.[19] Stripping away much of the pomp and ceremony, she had been eager to be seen by her people in the coronation procession from Buckingham Palace to Westminster Abbey—an event that was memorialized in souvenir prints and panoramas (see p. 206). The excitement, anticipation, and expectations of the public had been so great that the popular press coined the term "Reginamania."[20]

The mania had not been limited to paintings and printed material; the monarch was represented in tableaux in theaters and at Madame Tussaud's (as early as 1839), not to mention the large-scale dioramas in public parks or the songs of London street patterers.[21] Images of Victoria were everywhere, but there was no way of knowing which likeness—the idealized painted portraits of Victoria as a beautiful young woman, with an emphasis on her femininity, or the woodblock prints and engravings (which did not faithfully depict her, either)—was truly that of the queen. Artistic license in each painted portrait, and the differences in the same portrait when it was reproduced in different print media, made for a multitude of queens. Contemporary writers addressed the consequences of such a plethora of images, calling for the creation of a patron, or master, portrait as a way to ensure the veracity of the queen's image. In 1838, a couple of years before the queen's marriage to Prince Albert, a humorous article for *Bentley's Miscellany* by Richard Hengist-Horne had cited the queen's multiple identities as a potential impediment to her attracting a suitable prince as a husband: "And with these treasonable portraits,—each foreign prince [will die] over a different queen, and no foreign prince [will fall] in love with the real one, because there is no Patron Portrait!"[22]

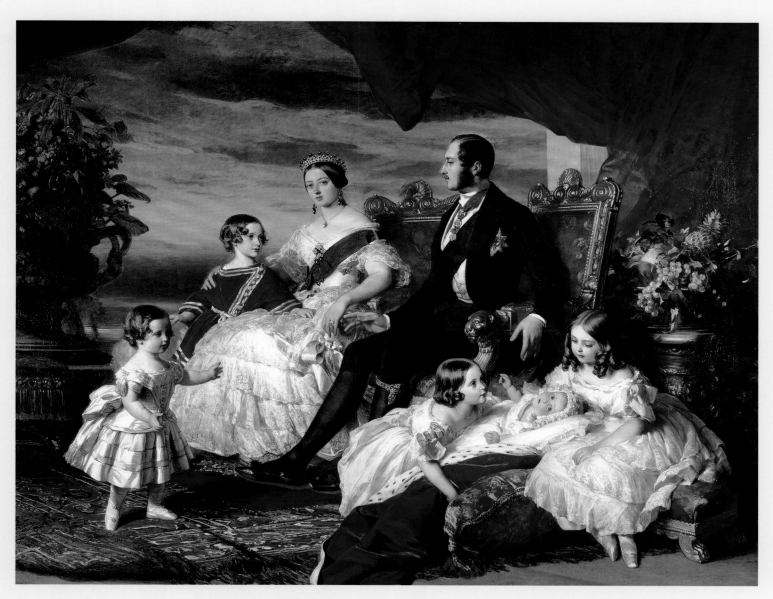

FIGURE 45
Franz Xaver Winterhalter (German, 1805–1873), *The Royal Family in 1846*, 1846. Oil on canvas,
250.5 × 317.3 cm (98⅝ × 124¹⁵⁄₁₆ in.). London, The Royal Collection, RCIN 405413

Photography had the means to provide such authentication, but the limitations of the medium early on—the singularity of the daguerreotype, and the expense and time involved in creating a number of prints derived from a negative—were obstacles to widespread dissemination of a photograph of the queen. Mass distribution of photographs would not be possible before the introduction of the carte de visite in the late 1850s. However, engravings could be made after photographs, and in 1859 Colnaghi's distributed a print based on a photograph by Leonida Caldesi (1823–1891), of the firm Caldesi & Montecchi (act. 1857–67). Although published as an engraving, this was the first photographic image of the queen to be publicly distributed. Perhaps not surprisingly, it was a family portrait.

Caldesi's portrait included for the first time all nine royal children, even Princess Beatrice, who was just six weeks old. Several views were made, but the most moving among them is the image of Victoria looking down at her youngest daughter's face (pl. 91). It is unlikely that the sitting was arranged specifically to produce an image for public distribution; it was simply part of Caldesi's commission to travel to the Isle of Wight and document the royal children for the queen. The Caldesi image has much in common with Becker's 1854 photograph (pl. 90): it is recognizably located at Osborne; the family is situated outside, grouped around architectural features; and the queen is the central figure. Victoria might easily have said of Caldesi's photograph, as of Becker's,

that it shows how "we are"—that is, it was an accurate representation of the royal family, down to its newest member.

It is noteworthy that the first photographic portrait of the queen shared with the public—the first true likeness seen by her subjects—was an informal picture of the royal family rather than a formal portrait of the queen alone. This was not a patron portrait against which all other portrayals could be measured for accuracy; if anything, it reinforced the existing maternal image. Indeed, when the photograph was included in the Photographic Society's fifth annual exhibition, in 1858, a contemporary reviewer described the image as "well executed and highly interesting, as displaying most vividly the domestic character."[23]

Among the photographs of the queen from the 1850s are a few notable examples of a more imperial image of her. Writing to D. Hastings (a writer at the Morning Herald) in April 1854, Antoine Claudet shared that he had "the honour to be commanded by her Majesty to take my daguerreotype apparatus to Buckingham Palace in order to take her portrait for the stereoscope and this morning h[er] M[ajesty] has given me a sitting and I have succeeded to take four good portraits of her."[24] The 1854 stereoscopic daguerreotype of Victoria is likely one of these images and is among one of the first of the more official-looking portraits of the queen (pl. 73). Her attire is formal; she wears a beautiful dress with lace trim and is draped in jewelry. She appears regal and commanding. When the unique image was viewed in a stereoscopic device, a three-dimensional view of the queen was created. Furthermore, the color applied by hand to the image makes palpable the queen's flesh and the dangling adornments of flowers; together with the creased fabrics of her sash and skirts, these details suggest a tangibility that transcends time.

Another photograph depicting the queen in formal dress also dates from 1854 and was made by Roger Fenton (pl. 74). Victoria, resplendent in a ball gown and headdress with a veil, stands looking lovingly at her husband, who is in formal military regalia. The portrait was made on May 11 at Buckingham Palace, after the conclusion of a Drawing Room—an event at which a select number of people from the upper echelons of society were formally introduced to the monarch—at St. James's Palace. Writing in her journal, the queen recounted: "On coming back was photographed in my Court dress by Mr. Fenton, alone and with Albert—I hope successfully."[25] Fenton's portrait is an interesting composition in that the queen, shown in full-length profile, appears almost subservient to Prince Albert, who stands taller. The scene was staged as if it were a tableau vivant, illustrating an episode from a well-known work of literature. Prince Albert holds his hat in one hand, and with the other seems to be picking a flower from the arrangement at the center. The queen, dressed almost like a bride, looks on, appearing to defer to her husband. It seems that Albert is about to present her with a flower as a token of his affection—and symbolically to choose her as his wife.

The artist Edward Henry Corbould (1815–1905) hand-colored the figures of the queen and prince in Fenton's photograph and sketched an elaborate background over the original scene, then

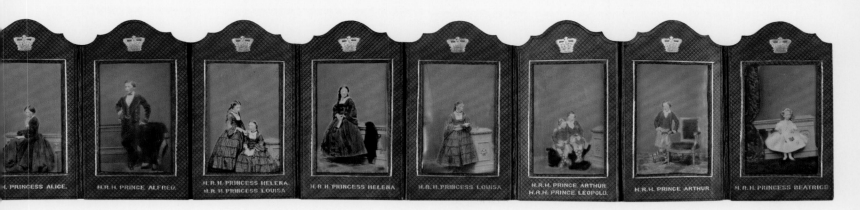

FIGURE 46
John Jabez Edwin Mayall (British, 1813–1901), *The Royal Album*, 1860. Hand-colored albumen silver prints framed
in maroon leather accordion file, 13 × 108 cm (5⅛ × 42½ in.). Bradford, National Media Museum, ST9 C14/S4

transformed the pedestal into a carved font (pl. 75). As a result of this reworking, the couple now
appeared to be standing in a chapel—and the illusion of a royal wedding was created. The painted
photograph was used as a frontispiece in a blue-velvet-covered album containing a selection of
photographs of the royal family. Many of the family portraits were placed in albums, organized with
great care by the queen and Prince Albert, who would spend evenings working together on them.

As the 1850s progressed, a shift was taking place in the photographic market. Rather than
being only a pastime or passion of the amateur, photography was becoming a commercial enter-
prise—and with the introduction of the carte de visite, a lucrative one. Introduced to Britain in
1857 by A. Marion & Co., a London-based French photographic firm, the carte gained widespread
popularity in just a few years. Although the format had been discussed in the early 1850s, and some
early examples in similar formats exist, it was not until 1854 that the carte was patented by the
Frenchman André Adolphe-Eugène Disdéri (1819–1889).[26] Disdéri's carte de visite was a relatively
cheap form of portraiture that involved a single sheet divided into eight frames, yielding multiple
images in the time normally required for one full plate. Once printed, the images were cut into
individual photographs that were trimmed to the size of a calling card (approximately 3½ by 2⅜
inches or 9 × 6 cm). Prices were around sixpence (about £1 or $1.60 in today's currency), making
it reasonably affordable for many people to purchase photographs for the first time. The relative
cheapness of the format was not the only democratizing factor, however; the conventional style of
the card photograph meant that everyone was represented in a similar fashion. The images were
typically made in the studio, using painted screens and/or a number of props, such as drapery, bal-
ustrade, or table and chair—a common backdrop, regardless of the sitter.

The first photographs of the queen made in this new format were by John Jabez Edwin Mayall
(1813–1901) and date from the spring of 1860. Victoria decided to issue her photographic portrait,
and portraits of Prince Albert and the royal children, to the public as a series of fourteen cartes
de visite; the complete set was published as *The Royal Album* (fig. 46). Sales skyrocketed, with mil-
lions of prints selling over the course of just a few years, netting Mayall thirty-five thousand pounds
in royalties.[27] In the first days after the release of Mayall's *Royal Album*, the publisher, A. Marion,
received orders for sixty thousand of the royal portraits—a remarkable figure that surpassed a typ-
ical month's distribution of fifty thousand nonroyal portraits.[28] One retailer, Charles Asprey of 166
Bond Street, advertised *The Royal Album* at the high price of four pounds and four shillings (the
equivalent today of around two hundred pounds or three hundred dollars) and individual photo-
graphs from the set at one shilling and sixpence (three times the cost of a nonroyal card).[29]

The queen issued her portrait at the height of the carte de visite's popularity. However, Victoria
not only acceded to the demand for cartes of the royal family, she also collected the cartes of oth-
ers. Eleanor Stanley, a lady-in-waiting to the queen, wrote in her diary on November 24, 1860: "I
have been writing to all the fine ladies in London for their or their husband's photographs, for the

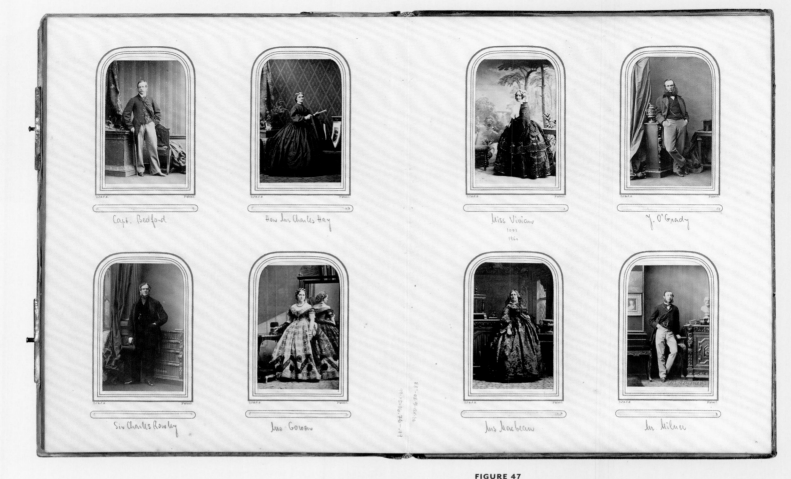

FIGURE 47
Camille Silvy (French, 1834–1910), spread from *Portrait Carte-de-Visite Album of Eminent Victorians*, 1860–62. Double-page spread of eight albumen silver cartes de visite, closed: 31 × 25 × 7 cm (12³⁄₁₆ × 9¹³⁄₁₆ × 2¾ in.). Los Angeles, J. Paul Getty Museum, 99.XD.16

Queen;…I believe Miss Skerrett is right when she says 'she (the Queen) could be bought and sold for a Photograph'!"[30] Victoria's letters and journals give evidence of this exchange of photographs. On June 26, 1861, the Duchess of Sutherland wrote to the queen: "Since I have written this I have received your Majesty's most kind letter—and the precious gift of the photograph so wonderfully like, and rendering exactly that most kind and loving countenance. I shall like much sending one to your Majesty of my dearest husband."[31]

The average person's collection included photographs not only of family members but also of politicians, writers, and actors in addition to royalty. These collectibles were often compiled in albums specifically designed to house the small cards, and depending on the contents, the album could function as a family record or a who's who of mid-nineteenth-century celebrities. Often the albums combined personal photographs with images of more famous sitters, usually beginning with royalty: the pages often opened to Queen Victoria and Prince Albert, followed by other members of the royal family, key political figures or prominent writers, and, finally, the owner's own family and distant relatives (fig. 47). Whether these images shared a page or were simply included in the same volume, there was an allusion of social proximity. A photograph of someone famous in a personal album implied that the album's owner was cultured and learned and perhaps even circulated in the same sphere. Such albums reflected the aspirations of the upwardly mobile and established a family genealogy at a time when relatives might be spread around the world, either doing battle for, or residing in, the farther reaches of the growing British Empire. As the photography historian Anne McCauley has pointed out, the carte-de-visite album was physically reminiscent of the medieval breviary, complete with embossed leather covers and metal latches, and took on some of the breviary's function: "Contemplation of the family, rather than the Holy Family, filled

the leisure hours of the bourgeoisie, for whom the carte album, like the stereoscope, became a faddish parlor amusement as well as the object of personal devotions and heartaches."[32]

From the beginning the carte de visite had performed a practical function in a growing, modernizing society—that of simple identification. This inexpensive photographic portrait was a means to claim and disseminate one's individuality amid an ever-increasing population. As industrialism progressed in the latter half of the nineteenth century, more people flocked to urban centers; between 1851 and 1871 London's population grew by almost a million people. How were the carte-de-visite images of Queen Victoria received in this milieu? Although they are portraits of the queen, they contain no throne, crown, entourage of courtiers, or trappings of royalty. Instead, the viewer is presented with an image of an average middle-class woman of mid-nineteenth-century Britain.

Viscount Esher, writing about Victoria in 1911, stated that the queen "had strong monarchical views and dynastic sympathies, but she had no aristocratic preferences," and she "thoroughly understood the middle-class point of view." He reasoned that the queen's character was based on two essential qualities associated with British middle-class life: common sense and family affection.[33] As oversimplified as this might seem—not to mention offensive to all other classes, who, Esher implies, possess neither quality—Esher's description of the queen suggests that she had no delusions of grandeur and, at least to those around her, seemed attuned to the middle classes—at the same time that she accepted her divine right to rule over them.

Victoria's portrayal in the carte de visite is no different than that of a middle-class woman who had paid for the service of having her photograph made in the photographer's studio. The images employ the same stylistic vocabulary as was employed for all female sitters. The queen is shown in a variety of standard poses against the one-size-fits-all backdrop of the photographic studio; she was more likely to be wearing a bonnet than a crown. Indeed, in the *Times* announcement of Mayall's photographs, it was noted that "the illustrious personages are shown without those stately appurtenances which are usually copied in portraits, and are represented as the members of a private circle, engaged in domestic pursuits alone."[34] Portraits of royal and ordinary persons alike followed the gender conventions of the time, whereby the man was typically presented in the dominant role, and the woman, in a subservient, deferential one. The royal photographs both follow the convention of cartes de visite of the period and are in keeping with the earlier private photographs of Victoria and Albert. Indeed, from the beginning the representation of the monarch alludes to the ambiguity of Victoria as regnant queen and doting wife, subservient to her husband.[35]

As modern scholars have argued, Victoria's photographic image as a middle-class wife reflects the role she was assigned by the culture that produced her.[36] A female monarch was a paradox for a society that defined a woman's place as in the home and power as a male prerogative. Until 2012 the British monarchy was patrilineal and passed to a female heir only when no male heir existed. When Victoria's uncle King William IV died in 1837, the crown passed to her as the only legitimate heir alive. But by the time Victoria assumed the seemingly most powerful position in the country, it had become a symbolic role with diminished power to intervene in the governing of the nation. Nonetheless, people were concerned about Victoria's ability as a woman to rule and worried that her possession of power would influence the cultural perspectives of women in general. Having the queen represented as a loving wife and mother helped calm these concerns.

When Queen Isabella II of Spain wished to exchange photographs with Victoria in November 1861, however, an informal image was apparently not appropriate. The Spanish queen sent the photographer Charles Clifford (1819/1820–1863), who was active in Spain in the 1850s and 1860s, to document Victoria. In Clifford's full-length portrait, she wears a beautiful gown and tiara. Writing in her journal on November 14, 1861, at Windsor Castle, Victoria described how, "dressed in evening dress, with diadem and jewels," she was "photographed for the Queen of Spain by Mr. Clifford. He brought me one of [her portraits], taken by him" (fig. 48 and pl. 99).[37] The image has a regal quality that is rare in photographs of Victoria prior to this date.

Prince Albert died one month later, on December 14, 1861, and the queen, a widow at the age of forty-two, entered a period of deep mourning that would last for the rest of her life. The majority of

FIGURE 48
Charles Clifford (British, 1819/1820–1863,
act. Spain, 1850s–1860s), *Queen Isabella II
of Spain*, 1861. Albumen silver carte de visite,
8.8 × 6.1 cm (3⁷⁄₁₆ × 2⅜ in.). London,
National Portrait Gallery, NPG x74376

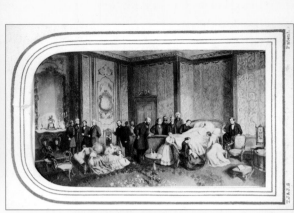

FIGURE 49
Unknown photographer, *Photographic Copy of
Painting Showing Prince Albert on His Death Bed*, 1861–62.
Albumen silver carte de visite, 5.5 × 9 cm (2⅛ × 3½ in.).
Glasgow University Library, Dougan 88

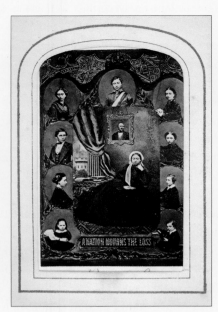

FIGURE 50
A Nation Mourns the Loss, 1862.
Albumen silver carte de visite,
8.5 × 5.5 cm (3⁵⁄₁₆ × 2⅛ in.).
Glasgow University Library, Dougan 89

photographs of her after Albert's death show her dressed in the traditional black weeds. Wanting to record everything with the camera, the queen, known for her sentimentality, commissioned from William Bambridge (1819–1879) a series of photographs of Prince Albert lying on his deathbed, surrounded by flowers (see fig. 32). These postmortem images were strictly confidential.

In the spring of 1862 Victoria sat for a series of intimate photographs, again taken by Bambridge. These images show the queen accompanied by some of her elder children, who express their love for their mother in simple gestures, while no doubt dealing with their own loss (pl. 101). In some of the scenes Victoria is seated next to a bust of her late husband; in most of the images she holds a framed photograph of Albert. Victoria had included framed photographs of Albert in her own photographic portraits as early as 1854, before Albert's death, when she sat for Bryan Edward Duppa (1804–1866) as a surprise birthday gift for the prince (pl. 78). Duppa recorded the queen holding the framed portrait that he had made of Albert just a few months earlier (pl. 79). The photograph within a photograph is an interesting conceit and speaks to both the queen's love of her husband and her love of the photographic medium for recording his likeness. Her propensity for including Albert's portrait in her own portraits intensified after his death. It was as though she could not bear to be photographed without him present in some shape or form, as though her own identity depended upon it.

The nation too was shaken by the loss of the prince consort, and in the first few weeks after his death, sales of Albert's photographic portrait rose sharply as people sought to remember him by his carte de visite. One distributor recorded sales in excess of seventy thousand photographs in just one week.[38] In this way, photography provided a means for people to grieve alongside the queen. Whereas previously the pictures of the prince consort—views of him reading, apparently lost in thought, or engaging with Victoria or their children—provided a somewhat voyeuristic insight into his life, they now functioned as memento mori; collecting such photographs became a way to honor his life and contributions to British culture and politics. Cards representing his last moments as envisioned by artists were also issued (fig. 49). Carte-de-visite scenes of the queen as grieving widow could be full of symbolism. In one photograph of Victoria—dressed in her black weeds and seated, surrounded by her children, beneath a portrait of Albert—the broken column

of the backdrop alludes to his life cut short, and the Round Tower of Windsor Castle is a reminder of where the death occurred (fig. 50).

Queen Victoria stretched the mourning period beyond the customary two years. Her removing herself from society for such a long period ultimately became problematic; as time elapsed, the nation, eager to see its queen once more, grew agitated. Her absence was felt everywhere, from Parliament to court, to events around the country. After the initial surge of photographs of the queen shown in various concocted scenes of grief, there was a dearth of portraits during the 1860s. Any new photographs confirmed that she was still in mourning (pls. 104, 105). Even what should have been a happy occasion—the 1863 marriage of the Prince of Wales to Princess Alexandra of Denmark—yielded a rather sad scene of the bride and groom, together with the queen and other family members, gathered next to the bust of the late Prince Albert (pl. 102).

In the absence from public life of the queen and prince consort, pictures of Victoria and Albert became de facto substitutes for the monarchy. Despite the queen's protestations that she was unable to perform public duties due to her consuming grief, the need for the queen to reenter the public realm only grew stronger.[39] In 1866 Queen Victoria made her first major public appearance since the death of Albert, attending the opening of Parliament. Slowly, and somewhat reluctantly, she increased the frequency of her public appearances.

For the monarchy to remain in place, it was essential that the queen be more visible to her people. Republicanism had been a threat throughout Victoria's reign; indeed, when the Chartists convened in London in 1848 (pls. 11, 12), it was feared that a revolution was imminent, and the royal family was sent away to Osborne, on the Isle of Wight, for their safety. Although peace prevailed and the British monarchy had remained intact, the fate of France was a constant reminder of the political turmoil occurring in Europe. In the 1860s and 1870s, when the queen retreated from public life and seemingly avoided, or delegated, her royal duties, there was another opening for the republican movement. Although people were devoted to the queen, it was difficult to remain faithful to a sovereign who was rarely seen. Furthermore, the photographs of the queen in a continual state of grief evoked not a strong and powerful monarch but a sad and lonely widow.

An 1872 carte de visite showing the queen wrapped in a fur-trimmed coat and a muff was a slight departure from the grieving-widow portraits of the 1860s. The queen was photographed in her winter outfit to commemorate a thanksgiving parade that took place in London on a cold day in February to celebrate the Prince of Wales's recent recovery from typhoid fever (pl. 106). Prince Albert had died from typhoid fever just a decade before, and there was great relief that the heir to the throne had not suffered the same fate.[40] The queen wrote about the day in her journal, amazed at the throngs of people along the route to St. Paul's Cathedral. She may not have realized that the joyous crowds who lined the path of the procession were just as eager to see her as they were to give thanks for the Prince of Wales's restored health.

In the 1870s and 1880s the photographic portraits of Victoria took on a more somber and imposing cast. Widowhood, of course, contributed to this shift in tone, as the queen became resigned to governing the nation and growing empire alone, without Albert by her side (either in life or in photographs). It can be argued, however, that the awarding to Victoria of the title of empress of India was in part responsible for the switch to more regal-looking portraits. Victoria was given the title, an accolade she was eager to receive, by the Conservative prime minister Benjamin Disraeli in 1876. The move strengthened her political power both at home and abroad. Although the photographs continued to reflect her grief—she was nearly sixty years old, yet still clung to mourning clothes—she now appeared stately and duty-bound. Her portraits of the 1870s and 1880s were the most official-looking to date, often showing the monarch wearing a crown and adorned in medals and jewelry alike. Among them is the portrait by Alexander Bassano (1829–1913) taken on the occasion of the Duke of Albany's wedding on April 27, 1882 (pl. 107). Bassano and his team of retouchers altered the original negative to create a more flattering portrait of the monarch (removing a section of her voluminous skirts to create a slimmer silhouette, softening the wrinkles in her face, and reducing her jowls). It is unlikely that these measures were requested by Victoria, who would state in an 1896 letter to her daughter Victoria, Empress Frederick of Germany: "I fear I do not

think…much of artistic arrangements in photographs and God knows there is nothing to admire in my ugly old person."[41]

Yet despite retouching, the later photographs of the queen, taken in a studio setting, reveal an aging woman whose features had softened over time and whose hair had turned gray. The background of the photographs is often as elaborately decorated as the monarch, whose stout frame is regularly festooned in diamonds. Heavily upholstered chairs, brocaded drapes, and painted backdrops are regular components of the scene, in contrast to the haphazard, seemingly spontaneous settings of the earliest photographs. Photographic portraiture had become a formalized, thoroughly commercial genre. In choosing photographers who operated in the commercial arena, Victoria perhaps recognized that a formulaic approach was necessary to promote her role as queen and empress. This standardizing of her identity was essential to reinforce her authority around the world—to make herself an internationally known brand of sorts. Victoria had always been astute in recognizing how her image influenced her political standing. Early in her rule she was keenly aware of her depiction as queen when she favored Hayter's coronation portrait over other paintings and chose to have copies sent to embassies around the world. While Hayter's representation of the eighteen-year-old monarch had been slightly unusual, it had an element of youthful brio, with its message that Victoria was now queen—and had the crown on her head to prove it. But at midcentury, when much of Europe was in revolutionary turmoil, it had been wiser for Victoria to cast herself in the role of the middle-class wife, domestic and loyal, so that she would escape the fate of other European royalty.

Late in the century, Victoria deliberately presented herself in the domain of commercial photography and its studio practices. These portraits have a look of sameness; they lack any distinct sense of authorship, and at times a promotional signature or stamp on the cabinet card is the only sign of a particular photographer's involvement. The result is that the image of the queen is interchangeable from one sitting to the next (pls. 107–109). Her decision to reuse certain portraits can be seen as an acknowledgment that her photographs appeared identical even to her, or at least as a sign of the pragmatism of a septuagenarian. Her 1893 portrait by W. & D. Downey (act. 1860–1920s), taken on the occasion of the Duke of York's wedding, was reused as one of the official portraits for the queen's Diamond Jubilee, in 1897 (fig. 51 and pl. 108).

Downey's official Diamond Jubilee portrait became the image permanently associated with the longest-reigning monarch in British history. Of course, one reason for the long life of the photograph is that, as a late portrait, it stands for the totality of the person and her achievements. Within four years of the queen's issuing of the official portrait, she died. The image was thus one of the last officially sanctioned photographs of the monarch to be released. The image showed her as people remembered her at her last major public appearance (never mind that the photograph had been taken several years earlier), when tens of thousands once more lined the streets of London, this time for the Diamond Jubilee procession. The greatest contribution to the pervasiveness and continuing life of this image, however, was the queen's decision to remove copyright, so that "there should be no restriction on those who might wish to reproduce the photograph."[42] Within days of the queen's selection of the Downey portrait, the photographic firm was inundated with applications for permission to use the image in endless formats—from penny prints to porcelain medallions that cost ten guineas; the products were so numerous that one contemporary account deemed it a "futile task" to attempt to calculate how many prints were in circulation at the time.[43] The removal of copyright was another example of the queen's complicity in the commercial promotion of her image.

Victoria's portrait appeared on everything from tea towels to biscuit tins, endorsing anything from soap to chocolate (fig. 52). As these souvenirs and products permeated homes and saturated popular culture, the patron portrait that had been sought from the earliest days of Victoria's rule was finally set in stone (not to mention in china and linen). The fixed portrait that would correct, or at least provide a counterpoint to, the myriad varying images of Victoria was achieved only at the end of the queen's life. But it lasted throughout the twentieth century and into the twenty-first. That patron portrait is the first image of Victoria we call to mind: the plump, aging queen, swathed in black crinolines and lace, with the small diadem perched on her gray head. The picture

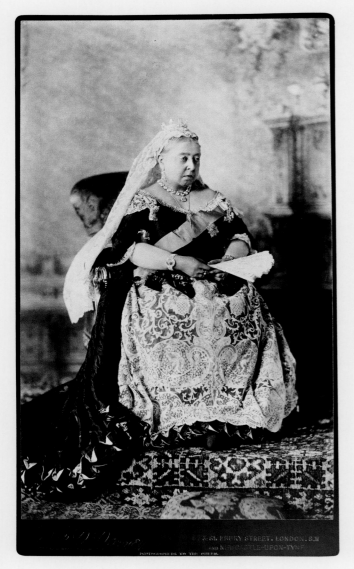

FIGURE 51
W. & D. Downey (British, act. 1867–1908), *Portrait Photograph of Queen Victoria Dressed for the Wedding of the Duke of York*, July 6, 1893. Albumen silver carte de visite, 33.2 × 18.7 cm (13 1/16 × 7 3/8 in.). Windsor, The Royal Collection, RCIN 2105759

FIGURE 52
Advertisement for Fry's Cocoa featuring Queen Victoria, ca. 1897.

of the queen as a young, vital person—a caring mother and an adoring wife—is long lost. It was the image of the stuffy matriarch that came to symbolize an empire, define an age, and epitomize the prudery and conservativeness ascribed to Victoria by later generations.[44]

Like her predecessors, Victoria understood and exploited the power of imagery in asserting her authority, but unlike past monarchs, she had many types of images available to her, and her reach was truly global. The tradition of representing and memorializing British monarchs is centuries old. One of the earliest surviving paintings of a British king is a portrait of Richard II that was created about 1395 and now hangs in Westminster Abbey. There was a limited audience for such a work in the fourteenth century, and the portrait was likely conceived as a historical record rather than an accurate likeness. In contrast, Victoria's portrait was widely circulated around the world through the dissemination of photographs—in the space of two years alone some three million to four million cartes de visite with her image were reportedly sold.[45] Over the course of seven decades, Victoria's depicted image evolved: from the informal mother of the earliest photographs to the middle-class wife of the midcentury pictures, to the sorrowful widow, and, finally, the grand matriarch. By the end of her reign, at the turn of the nineteenth century, her image was also recorded through the new medium of motion pictures. People were now guaranteed not only an accurate likeness but also a moving image of the queen, *as she really was* in life.

1 Beginning in the 1860s, the queen arranged for local photographers to document her collection by photographing the works and creating new carbon copy prints, which were often laid over the original photographs in the queen's albums. The queen's fear that the images were fading seems to have been one motivation for the creation of these copy prints. In many instances, however, the copy prints serve to document works that are no longer in the Royal Collection today.

2 Sophie Gordon, *Roger Fenton, Julia Margaret Cameron: Early British Photographs from the Royal Collection*, exh. cat. (London: Royal Collection Publications, 2010), 5.

3 Victoria, Queen of the United Kingdom, Journal, March 6 and 7, 1842, Windsor, Royal Archives, VIC/MAIN/QVJ. Gordon, *Roger Fenton, Julia Margaret Cameron* (note 2), 5.

4 "Prince Albert's Visit to the Photographic Institution," *Times* (London), March 22, 1842, 5. See also Frances Dimond and Roger Taylor, *Crown and Camera: The Royal Family and Photography, 1842–1910*, exh. cat. (New York: Viking, 1987), 11.

5 There is a list from the mid-1850s of ninety-two daguerreotypes in the Royal Collection, but only a small number of them are in the collection today. List of daguerreotypes belonging to Her Majesty, Windsor, Royal Archives, VIC/ADDC04/2.

6 There are a few photographs from the 1850s in which the queen is pregnant, but inconspicuously so, such as the photograph by Bambridge taken on February 10, 1857, when the queen was around eight months pregnant with Princess Beatrice. The queen is shown seated in a carriage, her frame hidden (Windsor, Royal Collection, RCIN 2900088).

7 Judith Schneid Lewis, *In the Family Way: Childbearing in the British Aristocracy, 1760–1860* (New Brunswick, N.J., 1986), 124.

8 Jack Dewhurst, *Royal Confinements* (London, 1980), 176.

9 Lewis, *In the Family Way* (note 7), 128.

10 *Queen Victoria's Early Letters*, ed. John Raymond (London, 1963), 74, cited in Lewis, *In the Family Way* (note 7), 213.

11 Jennifer Scott, *The Royal Portrait: Image and Impact* (London, 2010), 151.

12 Scott, *Royal Portrait* (note 11), 138.

13 Oliver Millar, *The Victorian Pictures in the Collection of Her Majesty the Queen* (Cambridge, 1992), 1:xix.

14 Victoria, Journal (note 3), January 17, 1852.

15 Margaret Homans, *Royal Representations: Queen Victoria and British Culture, 1837–1876* (Chicago, 1998), 17–33.

16 Queen Victoria to King Leopold, May 30, 1854, Windsor, Royal Archives, VIC/MAIN/Y/99/20. The queen emphatically underscored the phrases "our family group" and "as we are" in the original journal.

17 Millar, *Victorian Pictures* (note 13), 1:294.

18 Scott, *Royal Portrait* (note 11), 145.

19 John Plunkett, *Queen Victoria: First Media Monarch* (Oxford, 2003), 23.

20 "Postscript; the Reginamania," *Spectator*, January 6, 1838, 8, as cited in Plunkett, *Queen Victoria* (note 19), 70.

21 Plunkett, *Queen Victoria* (note 19), 102–5.

22 Richard Hengist-Horne, "Her Majesty's Portraits.—The Great State Secret," *Bentley's Miscellany* 4 (1838): 248.

23 "The London Photographic Society's Fifth Annual Exhibition," *Liverpool and Manchester Photographic Journal*, June 15, 1858, 154.

24 April 6, 1854. Antoine Claudet letters to D. Hastings, 1844–1854. Los Angeles, Getty Research Institute, 86-A89.

25 Victoria, Journal (note 3), May 11, 1854.

26 See Elizabeth Anne McCauley, *A. A. E. Disdéri and the Carte de Visite Portrait Photograph* (New Haven, 1985), 27–52; William C. Darrah, *Cartes de Visite in Nineteenth Century Photography* (Gettysburg, Penn., 1981), 4–11.

27 Darrah, *Cartes de Visite* (note 25), 43.

28 Plunkett, *Queen Victoria* (note 19), 152–53.

29 Charles Asprey, *A New and Enlarged Catalogue of Photographic Portraits of the Royal and Imperial Families of Europe, etc.* (London, 1861), n.p., cited in Plunkett, *Queen Victoria* (note 19), 153.

30 *Twenty Years at Court: From the Correspondence of the Hon. Eleanor Stanley, Maid of Honour to Her Late Majesty Queen Victoria, 1842–1862*, ed. Mrs. Steuart Erskine (London, 1916), 377.

31 Duchess of Sutherland to Queen Victoria, June 26, 1861, in *The Letters of Queen Victoria: A Selection from Her Majesty's Correspondence between the Years 1837 and 1861, Published by Authority of His Majesty, King Edward VII*, ed. Arthur Christopher Benson and Viscount Esher (London, 1911), 3:43.

32 McCauley, *Disdéri and the Carte de Visite* (note 25), 48.

33 *Letters of Queen Victoria* (note 30), 1:20.

34 "The Royal Album," *Times* (London), August 16, 1861, 9.

35 See Homans, *Royal Representations* (note 15), 46–57, for a detailed analysis of the various relationships of Prince Albert and Queen Victoria to each other in the royal portraits.

36 Homans, *Royal Representations* (note 15); Plunkett, *Queen Victoria* (note 19).

37 Victoria, Journal (note 3), November 14, 1861.

38 Andrew Wynter, "Contemporary News: Cartes de Visite," *British Journal of Photography*, March 12, 1869, 35.

39 Letter to the *Times* (London), April 6, 1864: "The Queen heartily appreciates the desire of her subjects to see her, and whatever she *can* do to gratify them in this loyal and affectionate wish she *will* do," cited in Homans, *Royal Representations* (note 15), 63.

40 For most of his adult life, Albert had suffered from gastrointestinal problems. Victoria refused to allow a postmortem examination of her husband. Although his official cause of death was listed as typhoid fever, more recent medical research and examination of private letters between Victoria and Albert, suggest that he may have died from complications of Crohn's disease, an illness unknown to Victorian doctors. Helen Rappaport, *A Magnificent Obsession: Victoria, Albert, and the Death That Changed the British Monarchy* (New York, 2011), 256–260.

41 Queen Victoria to Empress Frederick, August 31, 1896, cited in Dimond and Taylor, *Crown and Camera* (note 4), 69.

42 "The Queen's Jubilee Photograph," *Ludgate Monthly*, n.s. 4 (May–October 1897): 211.

43 "Queen's Jubilee Photograph" (note 41).

44 One demonstration of the power of Victoria's image to characterize the Victorians is the common, but mistaken, belief that she is the source of the phrase "Lie back and think of England." In fact, this piece of advice, often invoked to describe Victorian women's attitude toward sex, came from a Lady Hillingham, not the queen, and first appeared in a private journal from 1912, which was quoted sixty years later. See Lady Hillingham, private journal, cited in Matthew Sweet, *Inventing the Victorians: What We Think about Them and Why We're Wrong* (New York, 2001), 233.

45 Wynter, "Contemporary News" (note 37), 149.

PLATES | *Part 2*

PRIVATE PHOTOGRAPHS OF THE ROYAL FAMILY

Queen Victoria and Prince Albert sat before the camera for many photographers during the 1840s and 1850s. Previously depicted in miniature paintings, now the royal portraits were realized in different mediums—daguerreotype, calotype, and albumen silver print—but had one thing in common: they were private, not for public distribution. In these intimate views we are presented with an image of Victoria as a loving wife and caring mother, and her vitality and youthful appearance are in contrast to the imperial guise of her later portraits. Scenes of domesticity prevail, revealing the life "behind the scenes" of Britain's longest-reigning monarch.

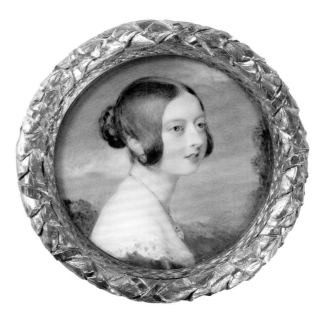

PLATE 66
SIR WILLIAM ROSS
Queen Victoria, 1839

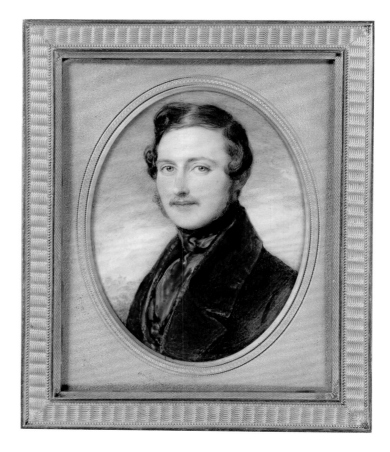

PLATE 67
SIR WILLIAM ROSS
Prince Albert, 1839

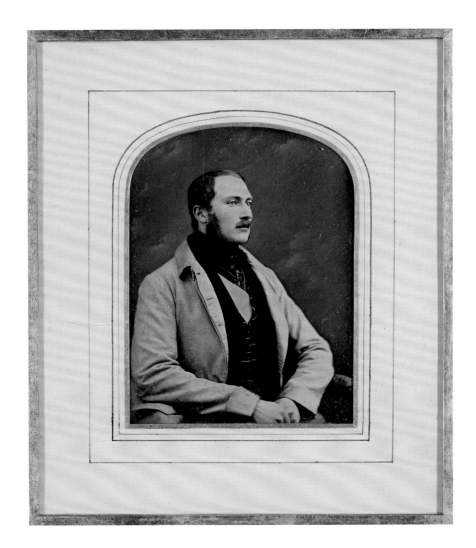

PLATE 68
WILLIAM EDWARD KILBURN
Prince Albert, 1848

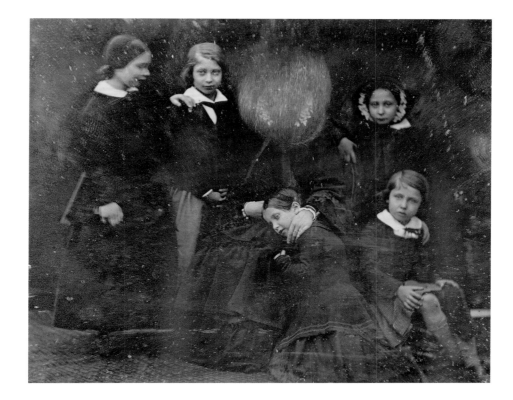

PLATE 69
WILLIAM EDWARD KILBURN
Queen Victoria, the Princess Royal, the Prince of Wales, Princess Alice, Princess Helena, and Prince Alfred, January 17, 1852

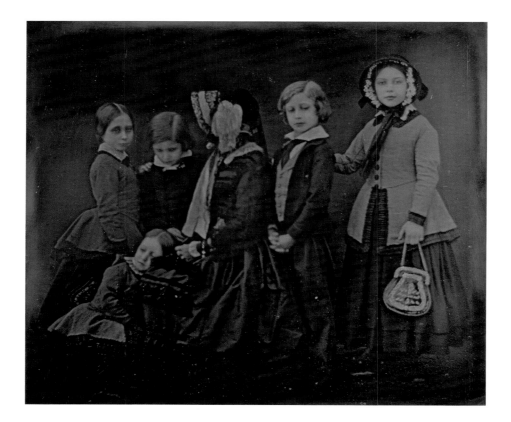

PLATE 70
WILLIAM EDWARD KILBURN

Queen Victoria with Her Children, January 19, 1852

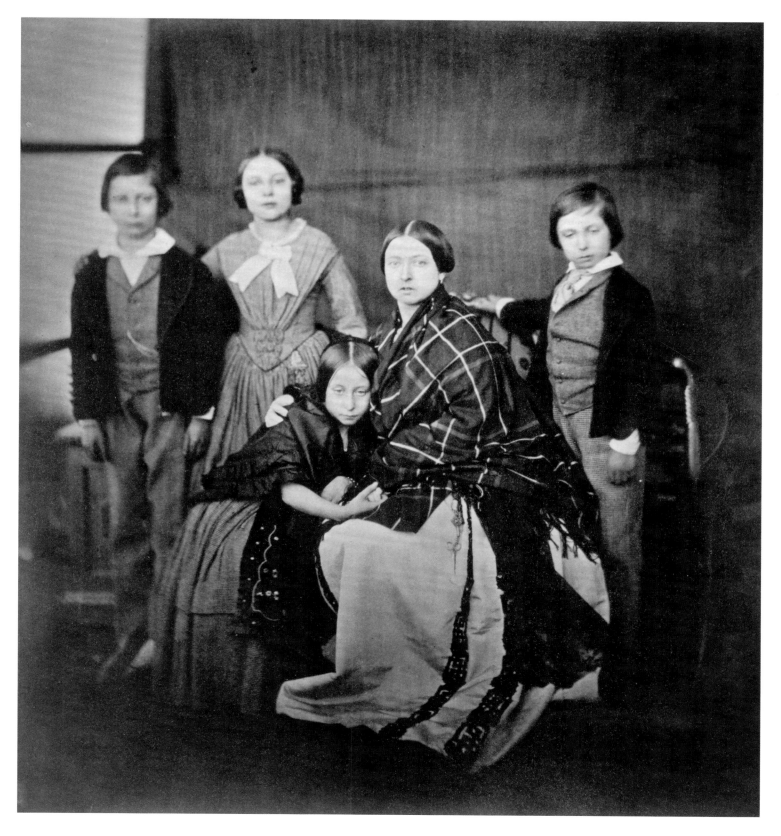

PLATE 71

ROGER FENTON

The Prince of Wales, the Princess Royal, Princess Alice, The Queen, and Prince Alfred, negative, February 8, 1854; print, ca. 1885–90

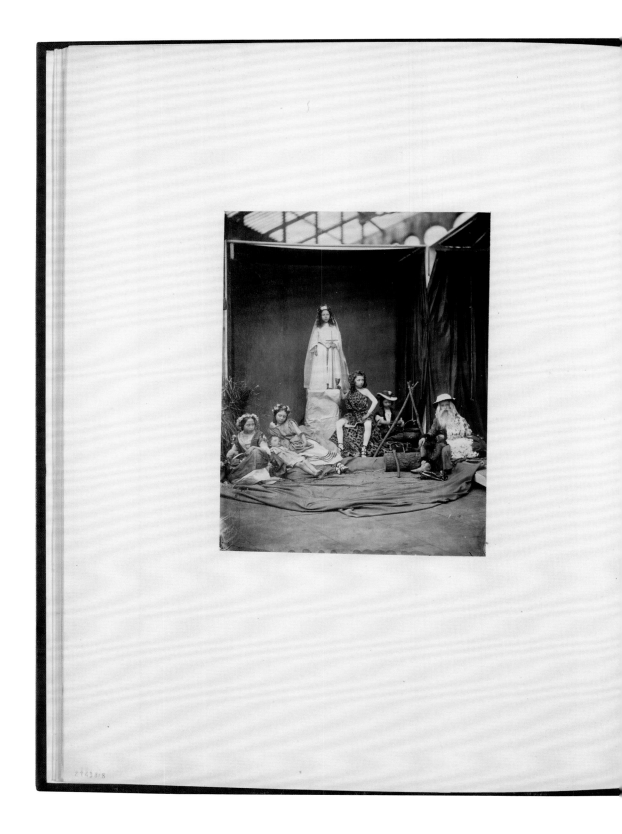

PLATE 72
ROGER FENTON AND CARL HAAG
From the "Royal Children Tableaux" album, 1854

Spirit-Empress, I, before my Queen,
Christ-loving Helena, devoutly stand:
And these fair types that group our symboll'd scene,
Under the Cross, are Guardians of this land.

Frolicsome Spring, with blossom-flowers, and leaves,
Winter, in furs, and snow-wreaths huddl'd up,
Glad Summer, resting on the golden sheaves,
Rich Autumn, holding out his ruby cup.

With plenteous peace on these rejoicing shores,
May God, for England, crown the coming year!
And pour new mercies from his heav'nly Stores,
On thee, and thee,— most honour'd, and most dear.

O Parents! happy in a home so blest
With subjects homage, and with childrens love,
May Earth still shower upon you all it's best,
And more than best be Yours in Heav'n above.

24th May, 1854.

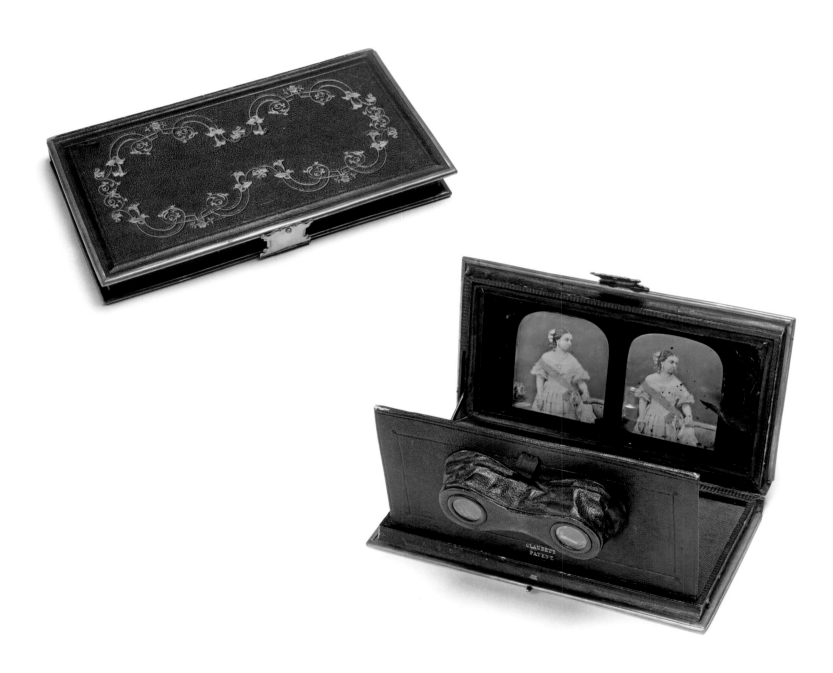

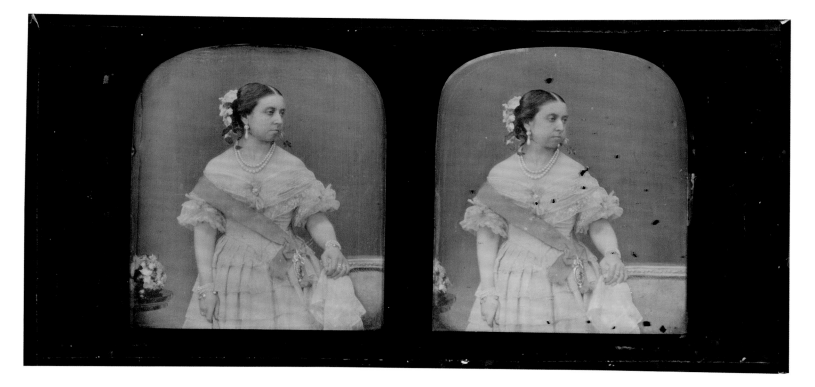

PLATE 73

UNKNOWN PHOTOGRAPHER

Queen Victoria Wearing Blue Dress and Sash, May 1854

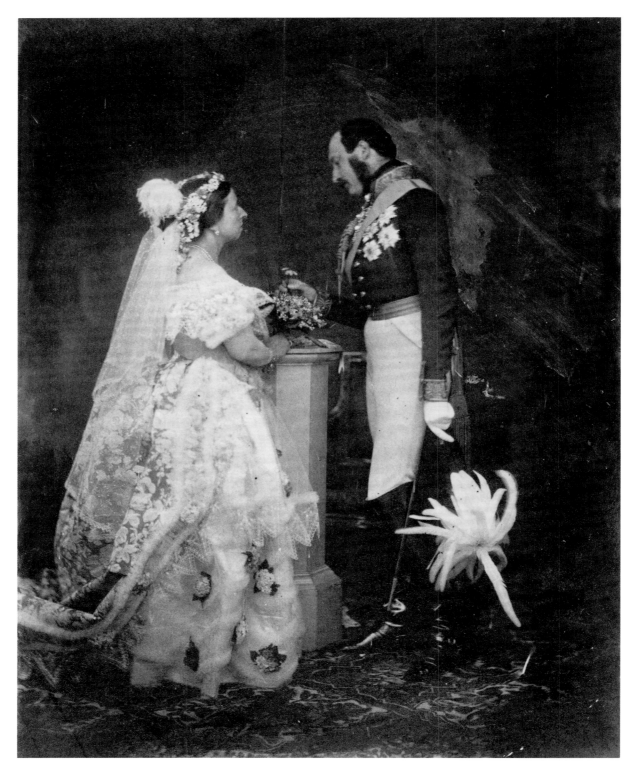

PLATE 74

ROGER FENTON

Queen Victoria and Prince Albert, Buckingham Palace, May 11, 1854

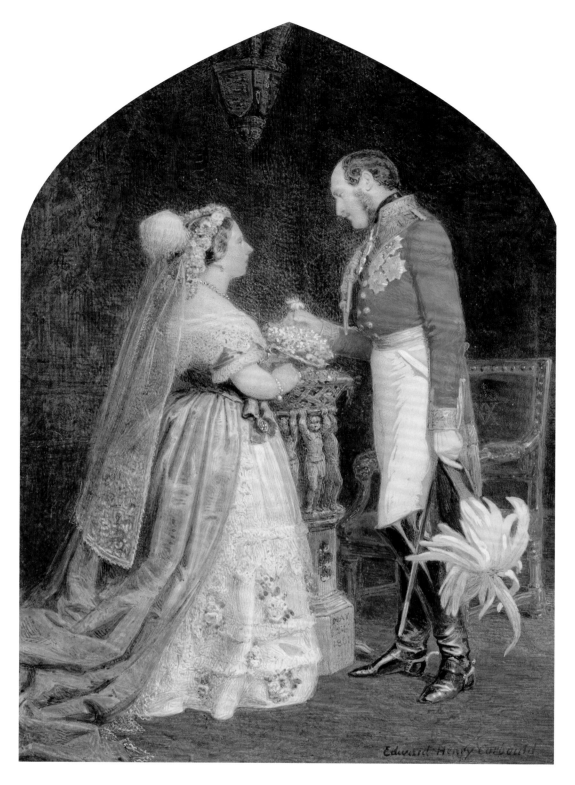

PLATE 75
ROGER FENTON AND EDWARD HENRY CORBOULD
Queen Victoria and Prince Albert, May 11, 1854

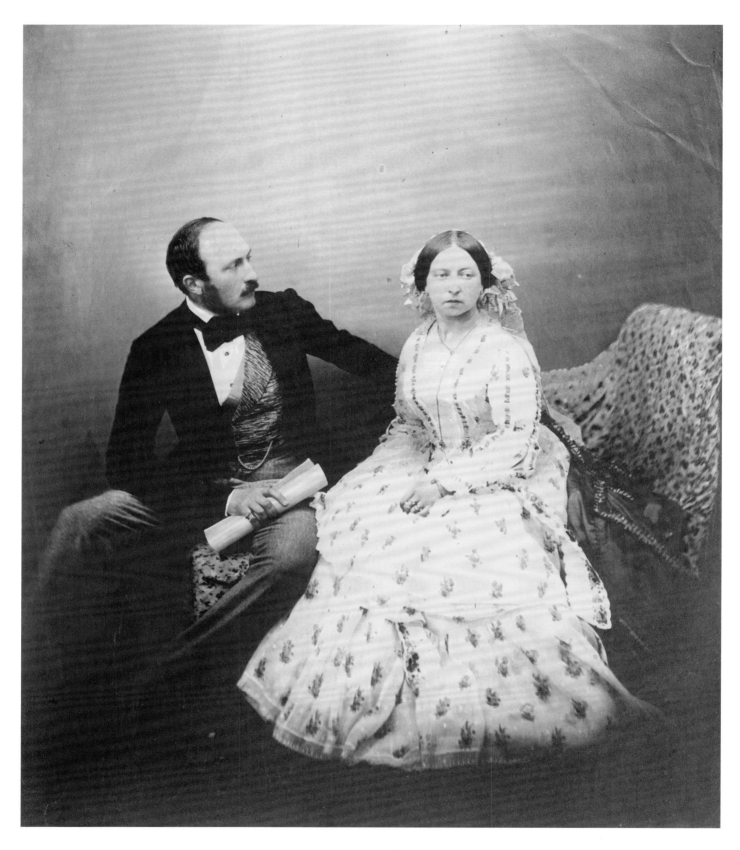

PLATE 76

ROGER FENTON

Queen Victoria and Prince Albert, 1854

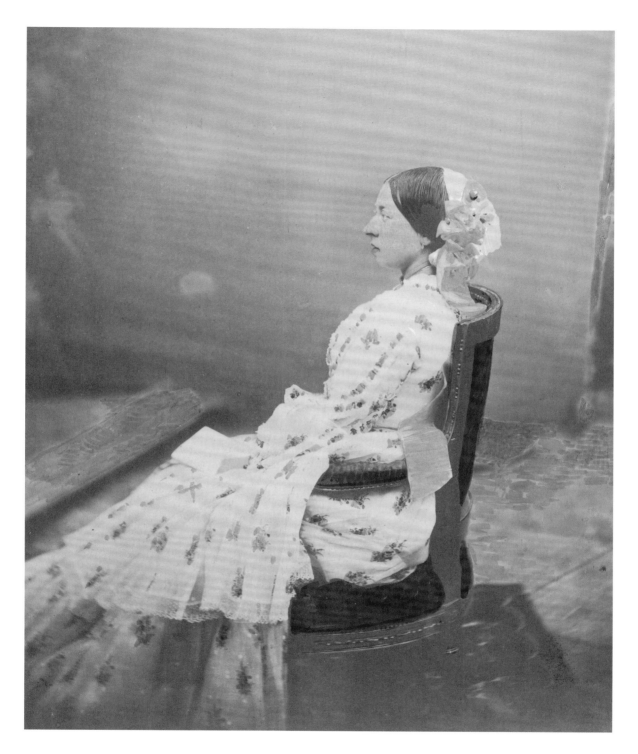

PLATE 77
ROGER FENTON
Queen Victoria, June 30, 1854

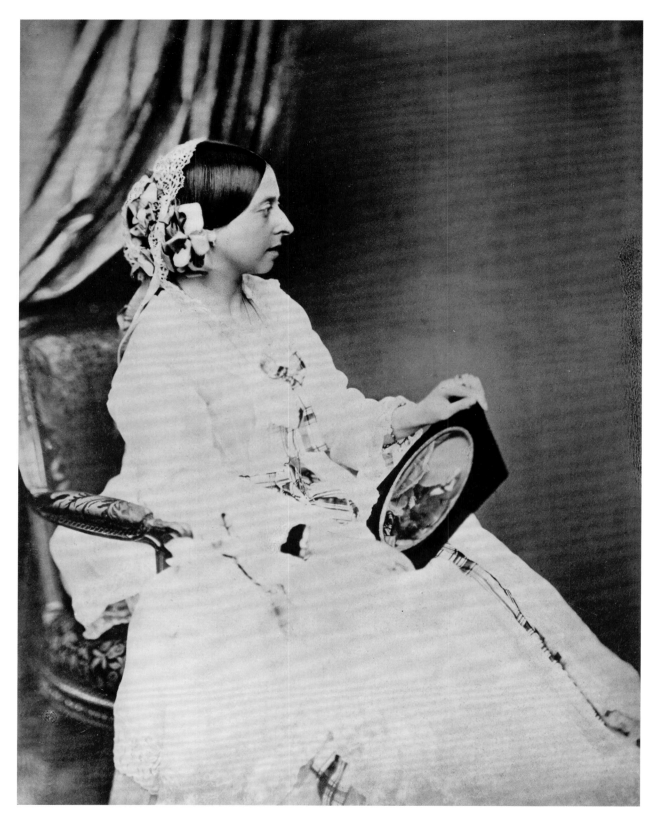

PLATE 78
BRYAN EDWARD DUPPA
Queen Victoria, negative, July 1854; print, 1889

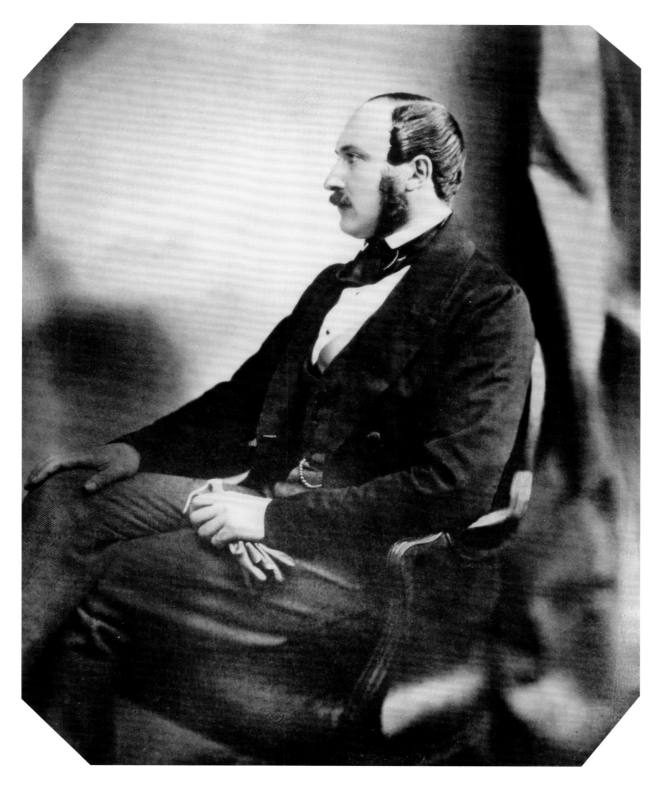

PLATE 79
BRYAN EDWARD DUPPA
Prince Albert, negative, May 1854; print, 1889

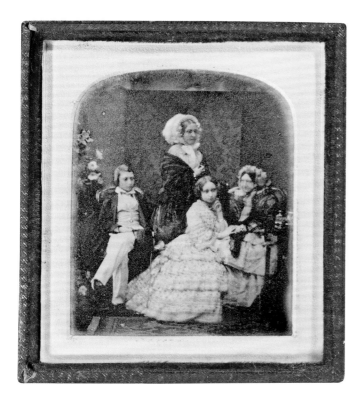

PLATE 80
ANTOINE CLAUDET
Queen Victoria, Princess Mary, Duchess of Gloucester,
the Prince of Wales, Princess Alice, Gloucester House,
June 30, 1856

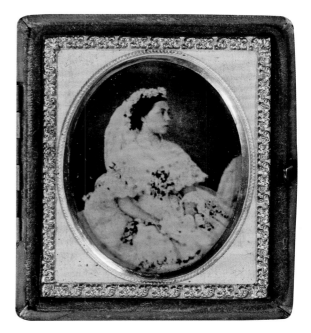

PLATE 81
THOMAS RICHARD WILLIAMS
Victoria, Princess Royal, in Her Wedding Dress,
Buckingham Palace, January 25, 1858

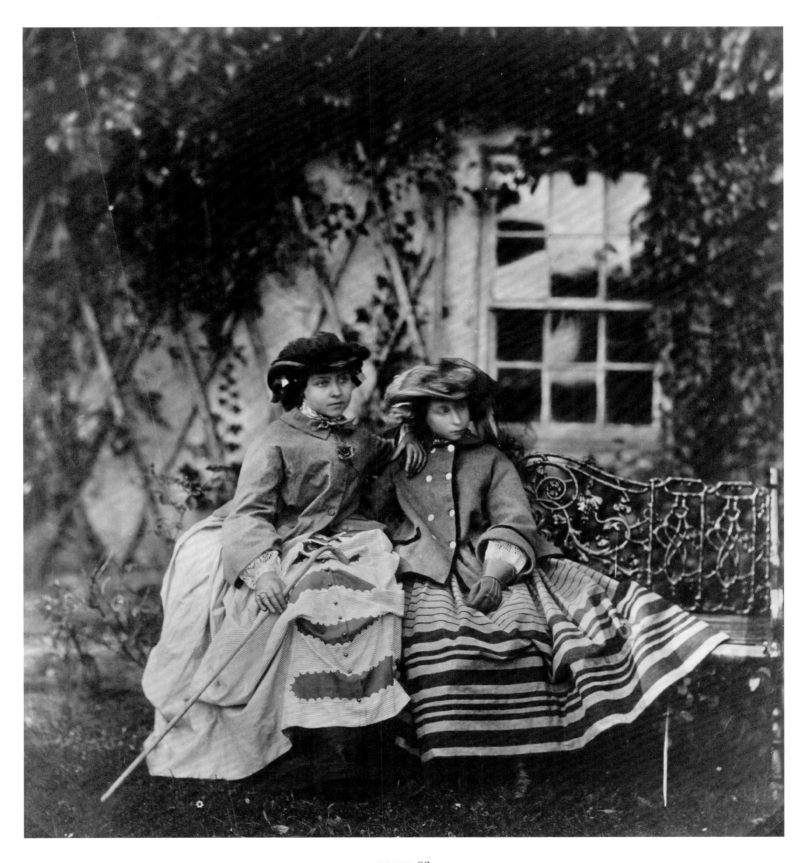

PLATE 82
ROGER FENTON
Princess Royal and Princess Alice, 1857

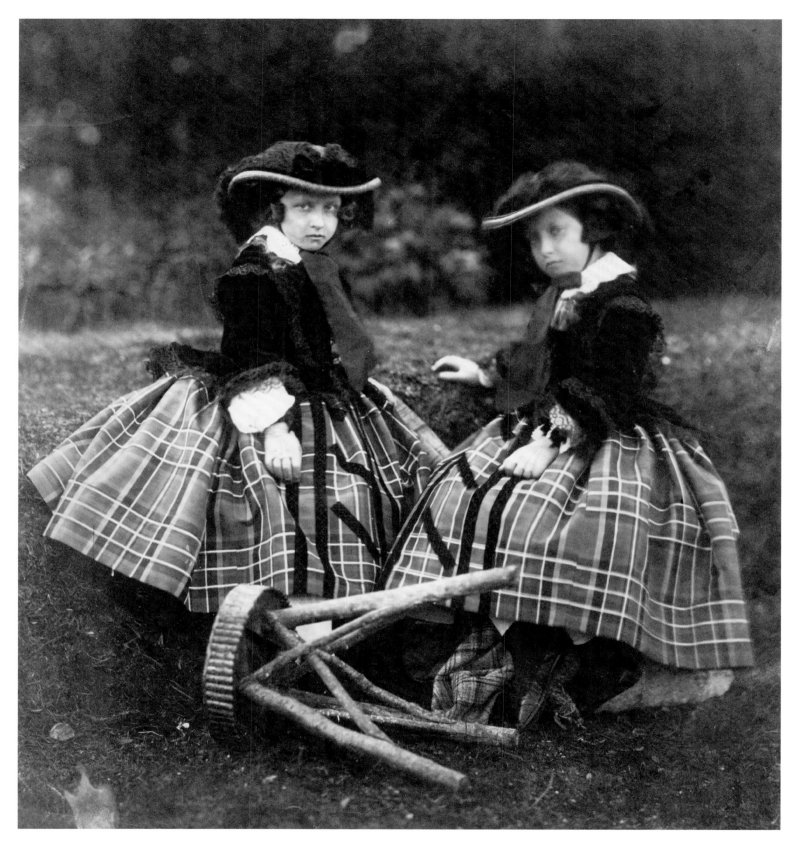

PLATE 83

ROGER FENTON

Princesses Helena and Louise, 1856

PLATE 84
ROGER FENTON
Prince Alfred, 1856

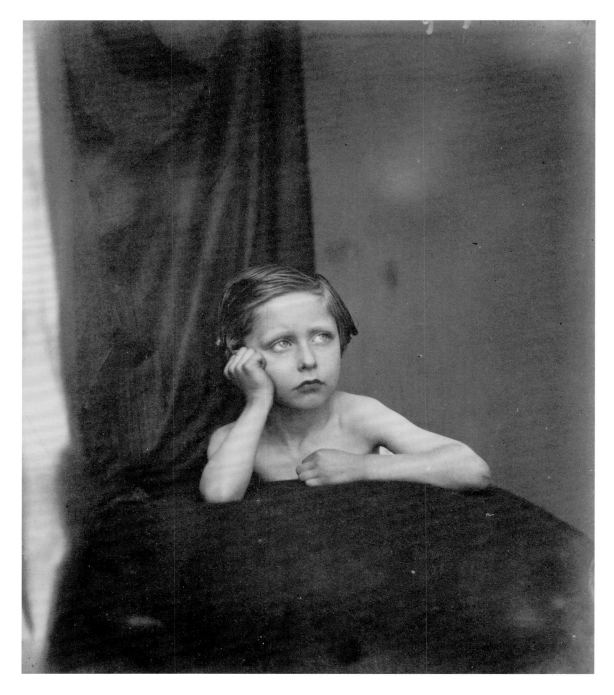

PLATE 85
LEONIDA CALDESI
Prince Arthur, 1857

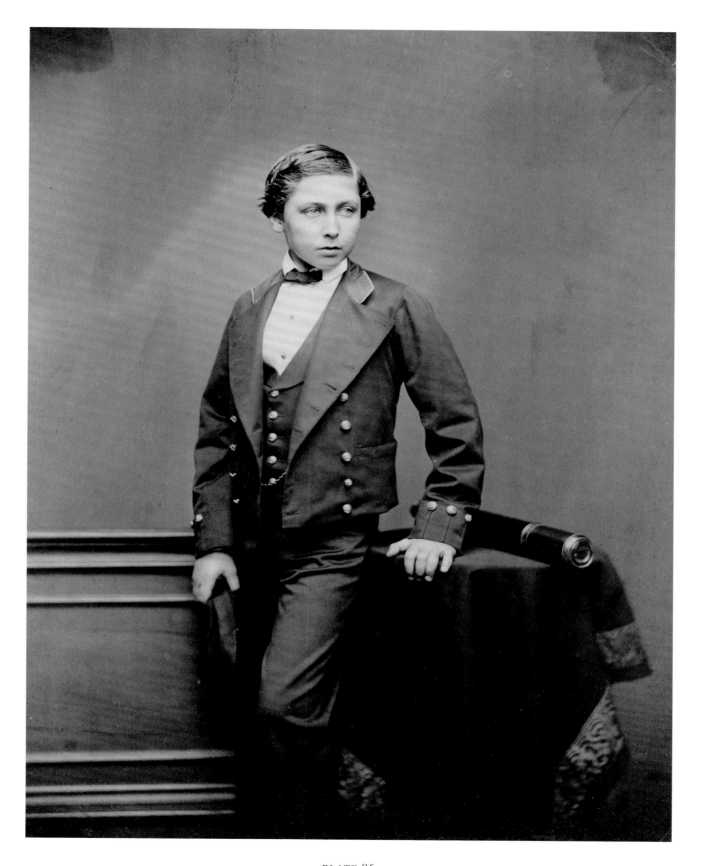

PLATE 86

JOHN JABEZ EDWIN MAYALL

Untitled (The Prince of Wales [Edward VII]), ca. 1856

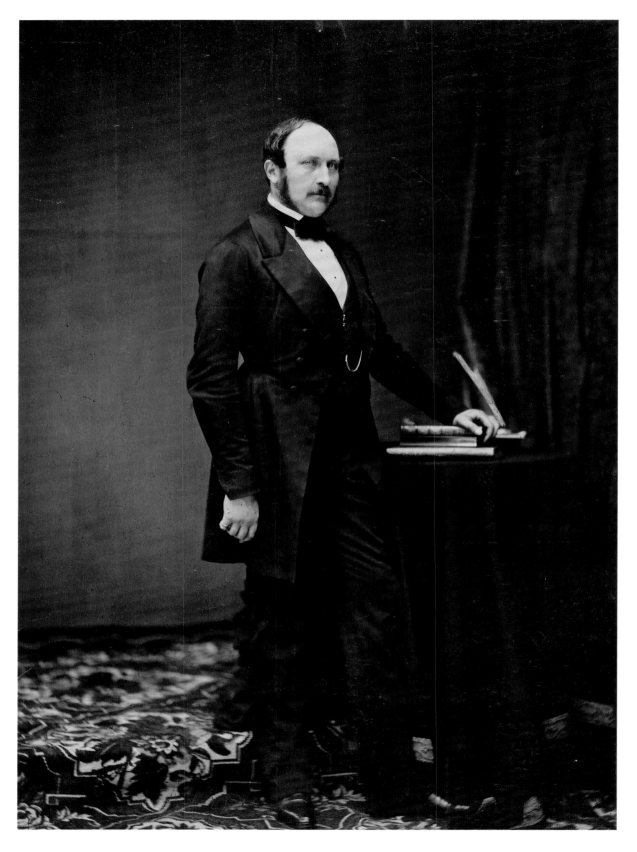

PLATE 87
JOHN JABEZ EDWIN MAYALL
Prince Albert, negative, May 15, 1860; print, ca. 1889–91

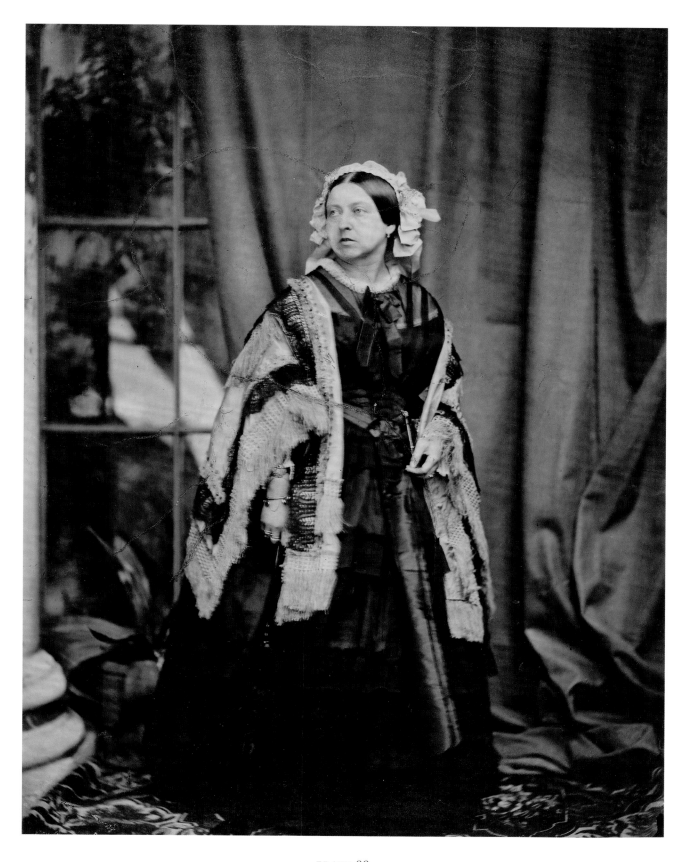

PLATE 88
LEONIDA CALDESI
Queen Victoria, negative, 1857; print, ca. 1889–91

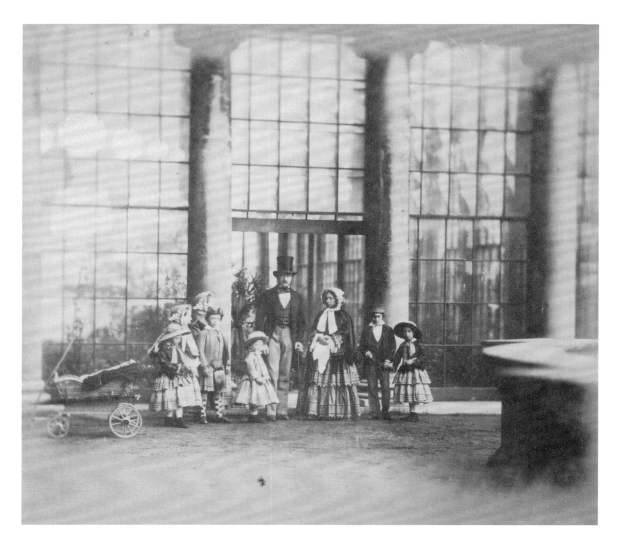

PLATE 89

ROGER FENTON

Queen Victoria and Prince Albert with Seven of Their Children, Buckingham Palace, May 22, 1854

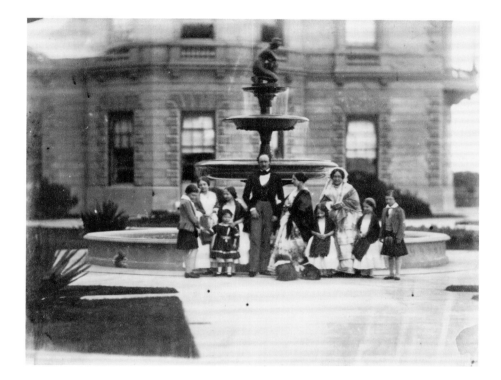

PLATE 90
DR. ERNST BECKER
The Royal Family, Osborne, May 24, 1854

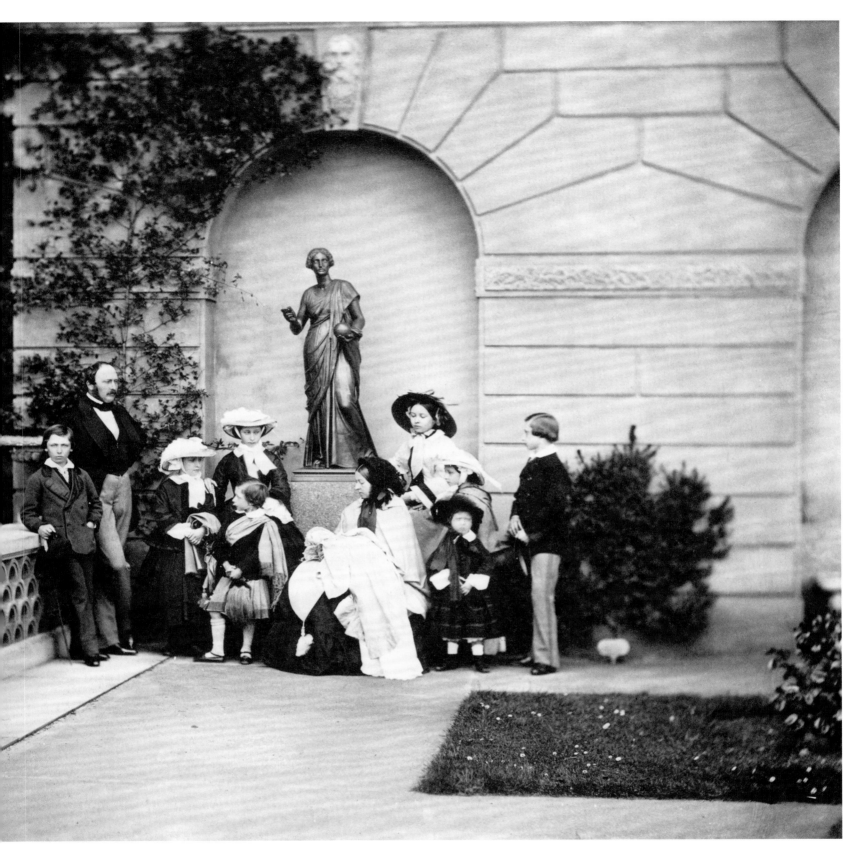

PLATE 91
LEONIDA CALDESI
The Royal Family at Osborne, May 27, 1857

ROYAL RESIDENCES

During their lifetimes, Victoria and Albert occupied four main royal residences: Windsor Castle; Buckingham Palace, in London; Osborne House, on the Isle of Wight; and Balmoral Castle, near Braemar, Scotland. Windsor Castle is the oldest royal residence in Britain to have remained in continuous use. Buckingham Palace, probably the best known of all the royal dwellings, was the least suited to Victoria's needs and those of her growing family. Family life was of central importance to both Victoria and Albert, and their desire to create a warm domestic environment for their nine children motivated the creation of two new residences: Osborne (1845) and Balmoral (1852).

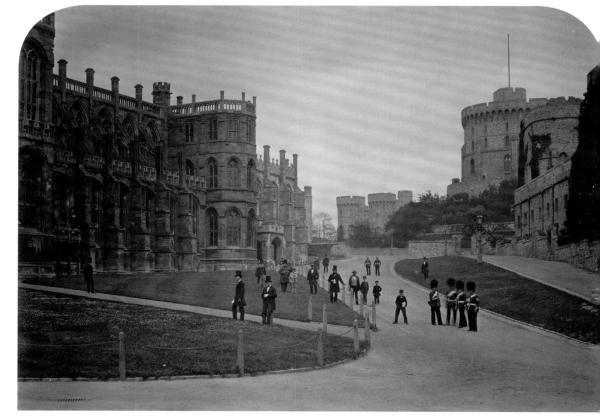

PLATE 92
ROGER FENTON
St. George's Chapel and the Round Tower, Windsor Castle, 1860

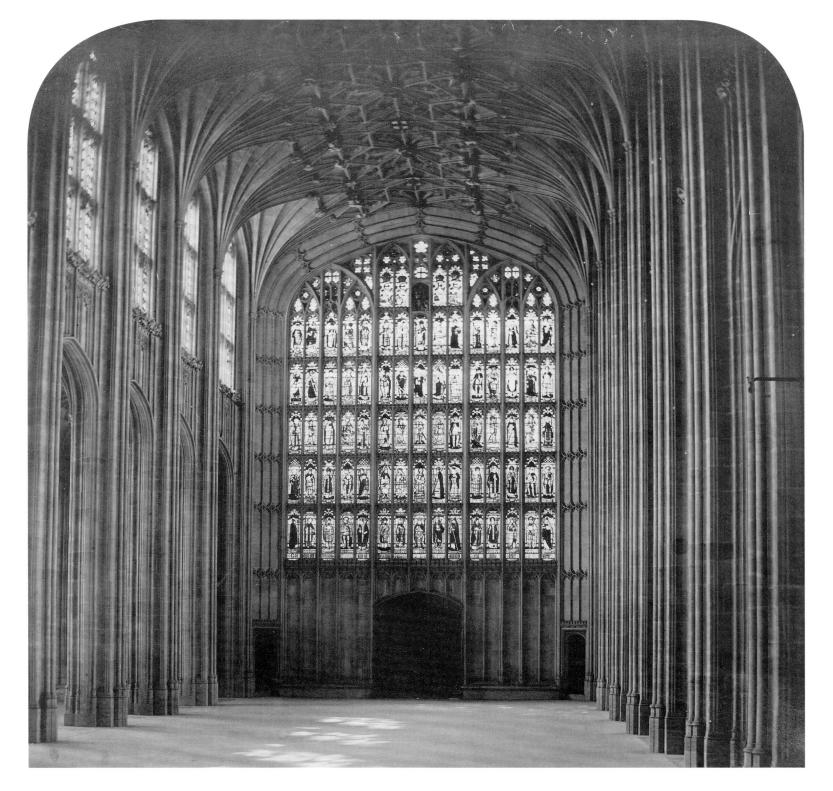

PLATE 93
ROGER FENTON
The West Window, St. George's Chapel, Windsor Castle, 1860

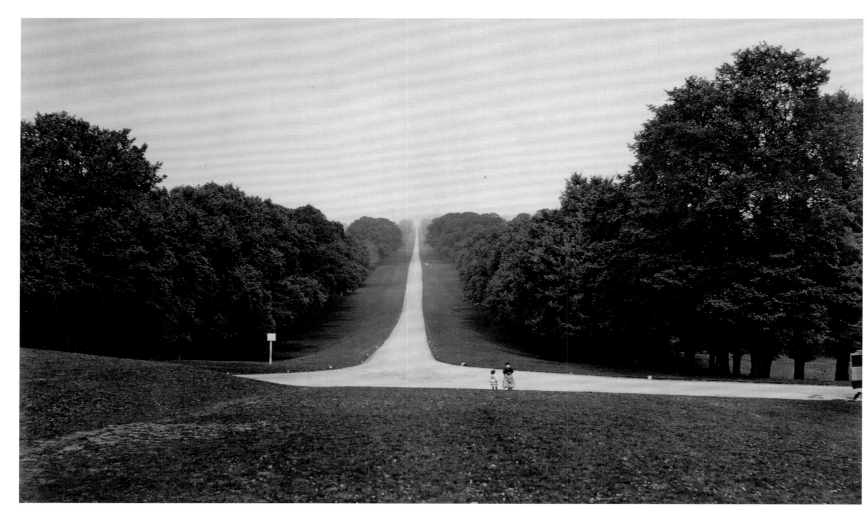

PLATE 94
ROGER FENTON
The Long Walk, Windsor, 1860

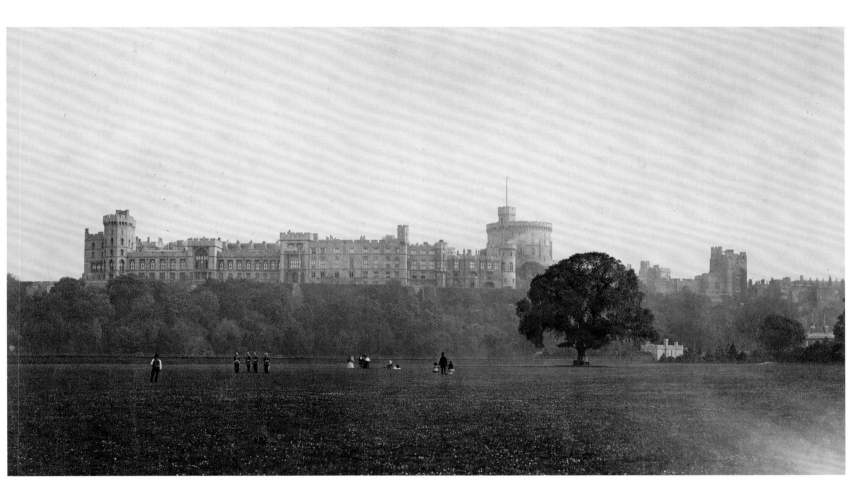

PLATE 95

ROGER FENTON

General View from Town Park, 1860

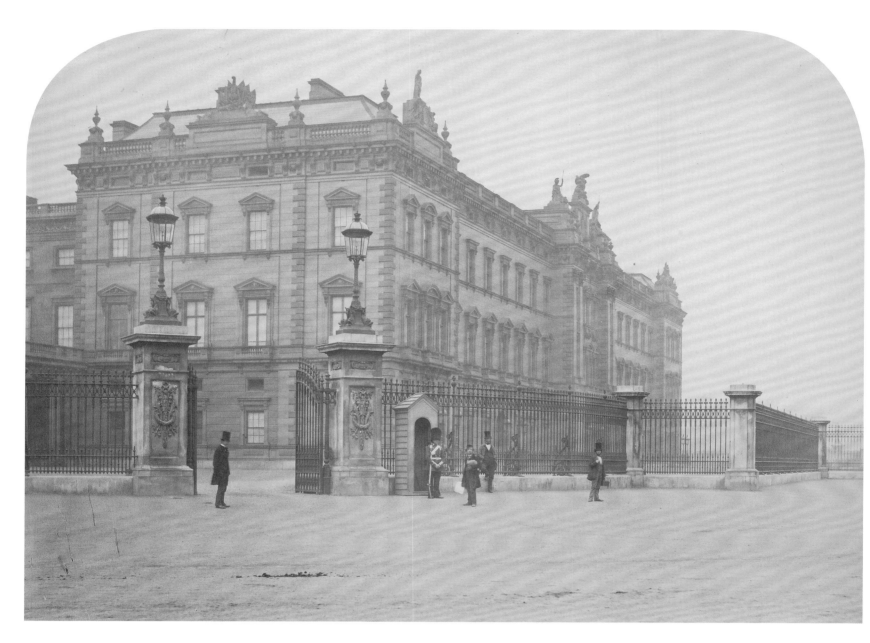

PLATE 96
ROGER FENTON
Buckingham Palace, ca. 1858

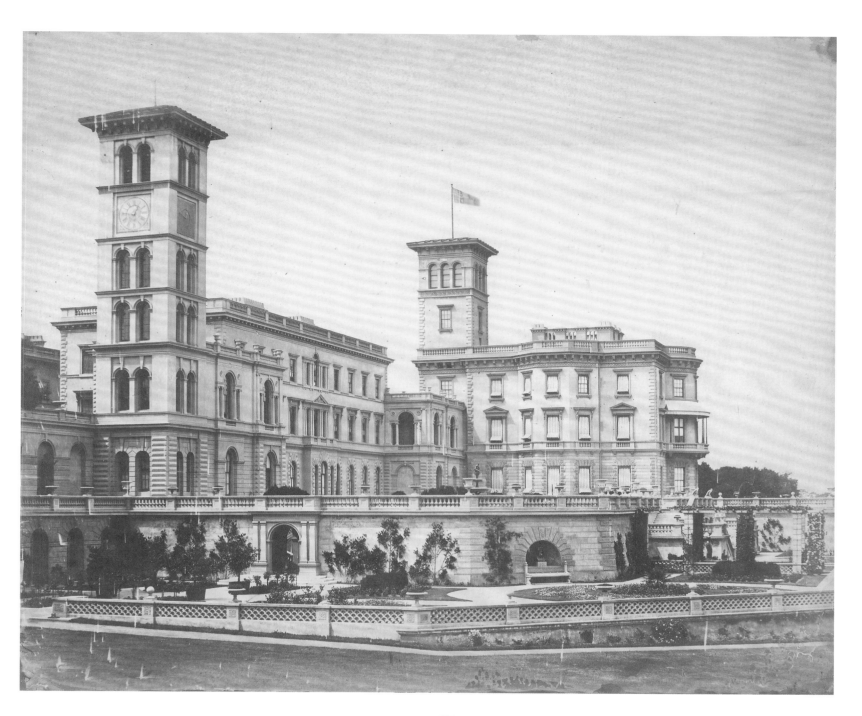

PLATE 97
ROGER FENTON
Osborne House, August 1855

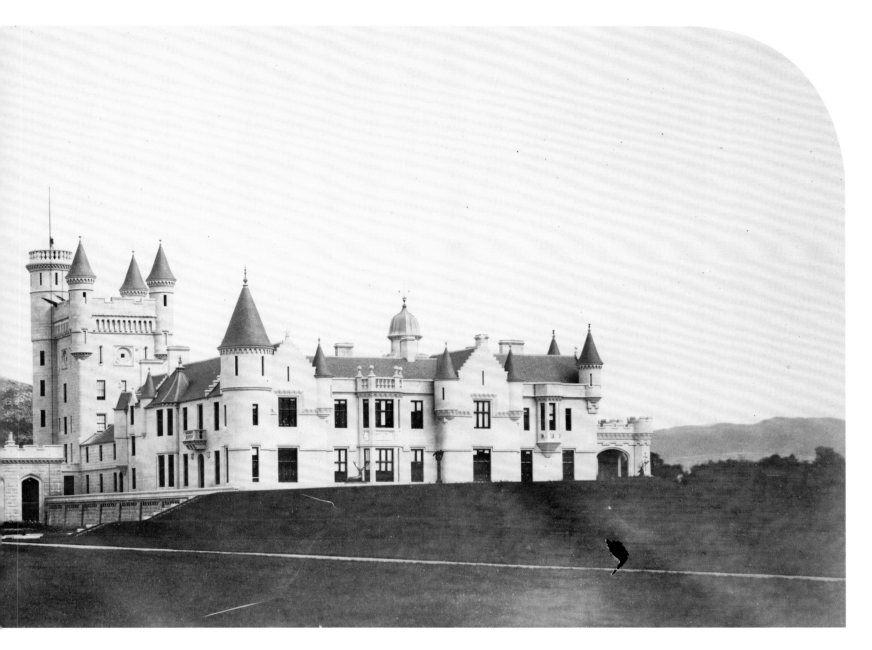

PLATE 98
ROGER FENTON
Balmoral Castle, 1856

PUBLIC PHOTOGRAPHS OF THE ROYAL FAMILY

In 1860 Queen Victoria agreed to have her portrait made by the photographer John Jabez Edwin Mayall and allowed him to issue the image, along with images of the other members of the royal family, as a series of cartes de visite. The format was already fashionable (the queen herself was an avid collector), so it was no surprise that the royal images were enormously popular. Whereas the earlier portraits of the queen and her family had been strictly private, the carte-de-visite images were meant for the public and sold in the tens of thousands. For the first time, people were able to own a photographic portrait of the queen, whose appearance was that of a devoted wife and loving mother.

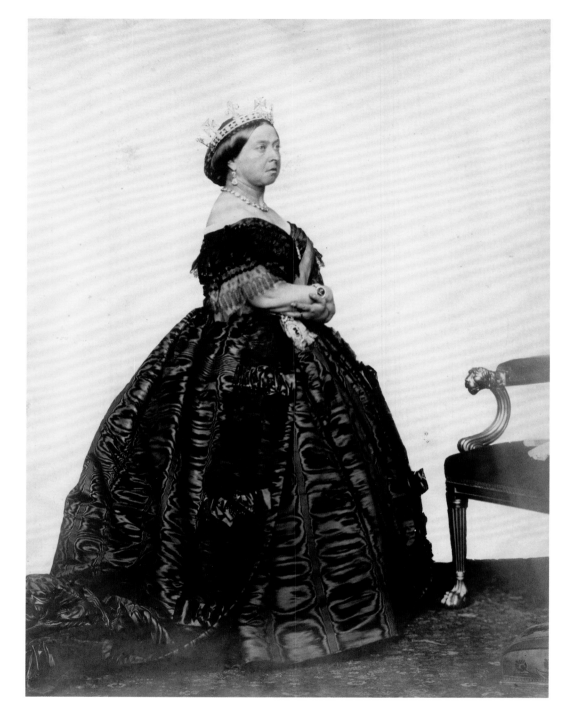

PLATE 99
CHARLES CLIFFORD
Queen Victoria, 1861

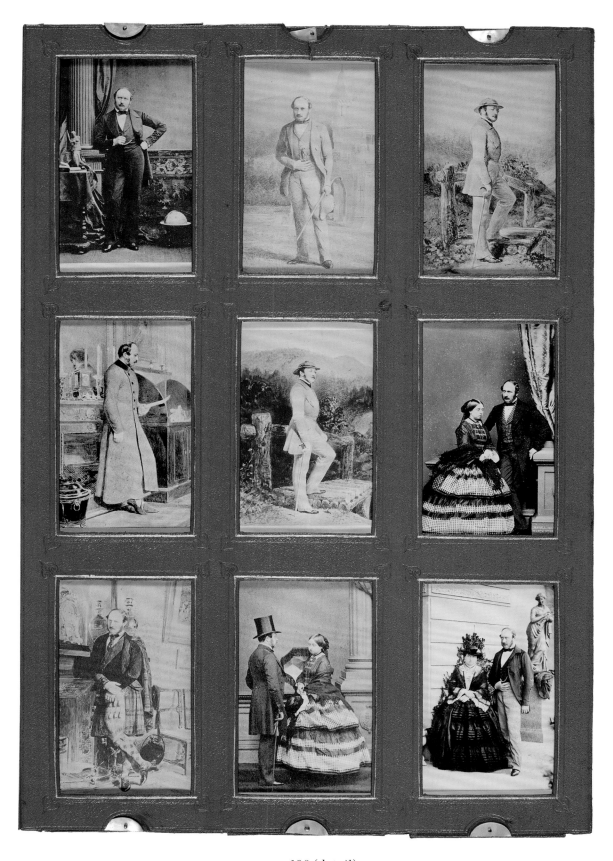

PLATE 100 (detail)

WILLIAM BAMBRIDGE, FRANCES SALLY DAY, JOHN JABEZ EDWIN MAYALL, AND CAMILLE SILVY

Folding Portfolio Containing Portraits of Queen Victoria and Prince Albert, 1859–61

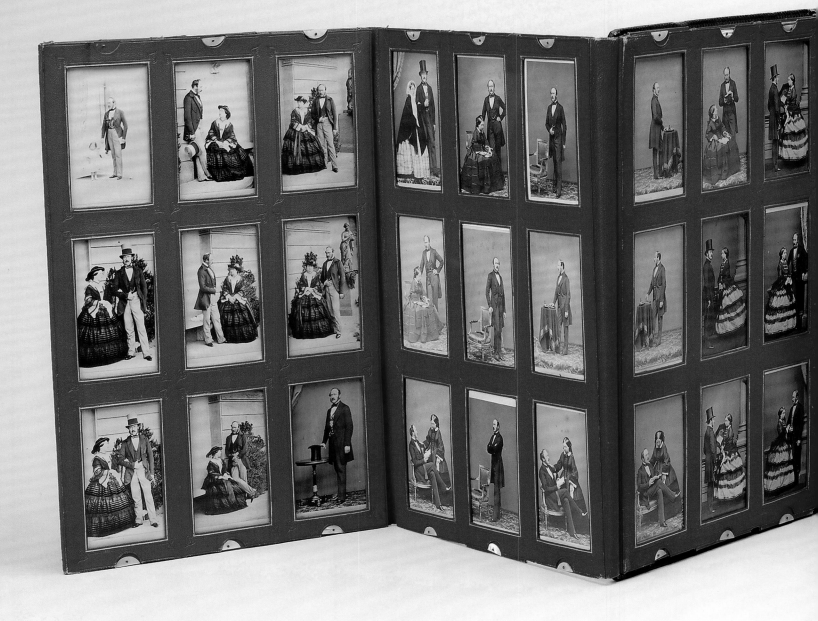

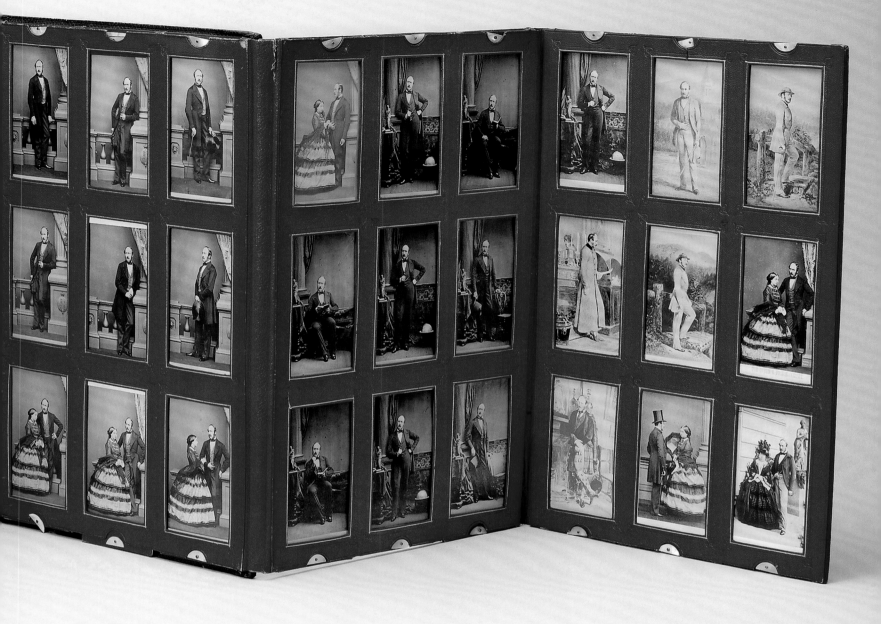

PLATE 100

WILLIAM BAMBRIDGE, FRANCES SALLY DAY, JOHN JABEZ EDWIN MAYALL, AND CAMILLE SILVY

Folding Portfolio Containing Portraits of Queen Victoria and Prince Albert, 1859–61

Public Mourning

On December 14, 1861, Prince Albert died at Windsor Castle. He was forty-two years old. Over the following decade, the queen, having retreated from public life, was photographed as a grieving widow: dressed in black and looking bereft. The public expressed its sorrow by buying photographs of the late prince consort along with those of the widowed Victoria.

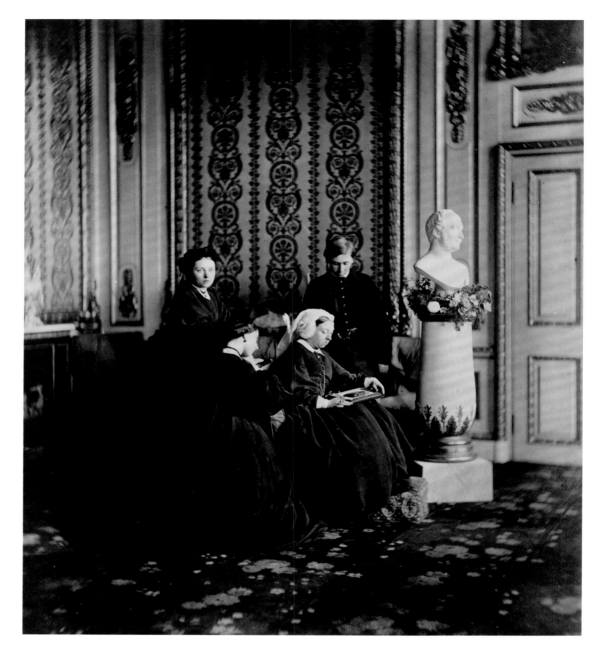

PLATE 101
WILLIAM BAMBRIDGE
Queen Victoria, the Crown Princess of Prussia (Princess Royal of England), the Princess Alice, and Prince Alfred, Windsor Castle, March 28, 1862

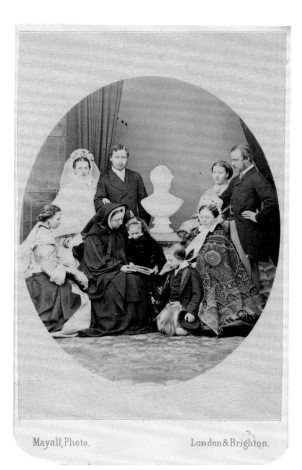

Mayall, Photo. London & Brighton.

Bingham, Phot. 58. rue de Larochefoucauld

PLATE 102

JOHN JABEZ EDWIN MAYALL

Queen Victoria With Her Family,

ca. 1863

PLATE 103

ROBERT JEFFERSON BINGHAM

Queen Victoria, ca. 1862

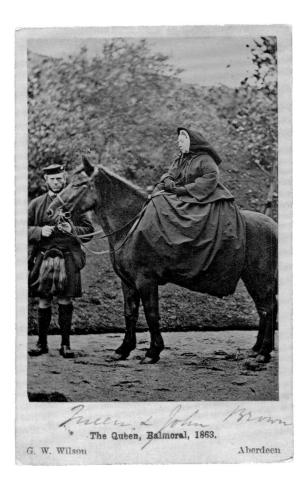

The Queen, Balmoral, 1863.

G. W. Wilson Aberdeen

PLATE 104
GEORGE WASHINGTON WILSON
The Queen, Balmoral, 1863

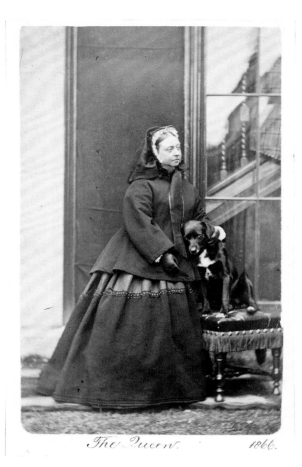

PLATE 105

W. & D. DOWNEY

Queen Victoria and Sharp, 1866

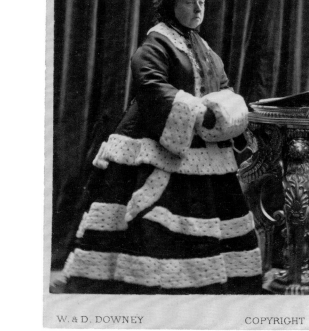

PLATE 106

W. & D. DOWNEY

The Queen, 1872

STATE PORTRAITS

In 1876 Victoria was awarded the title empress of India. The new title, along with the growing reach of the British Empire, gave her a sense of power and responsibility. She astutely recognized that her image was important in defining the empire, and photographic portraits of her assumed an imperial tone. Compared to the earlier, private photographs, the late portraits show Victoria as a commanding queen. Her image from the 1880s and 1890s—the stout, aging sovereign wearing a small crown—has become the lasting image of her and has defined an entire age.

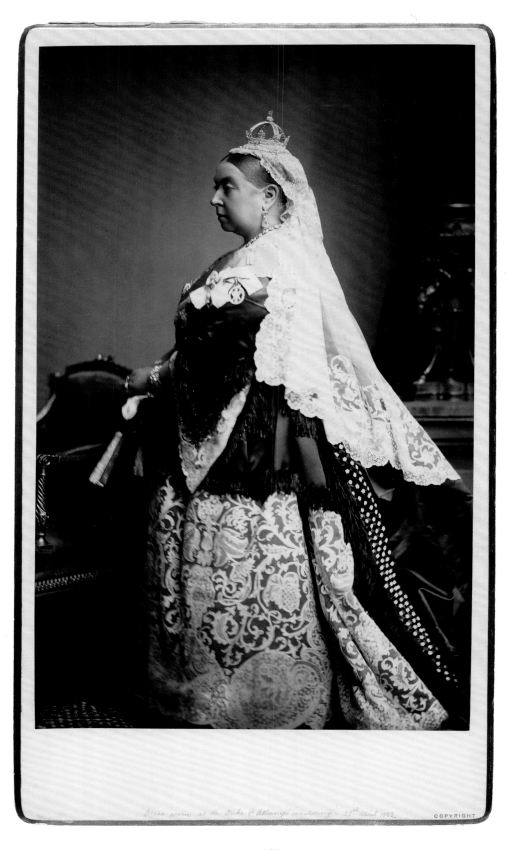

PLATE 107
ALEXANDER BASSANO
Queen Victoria, April 1882

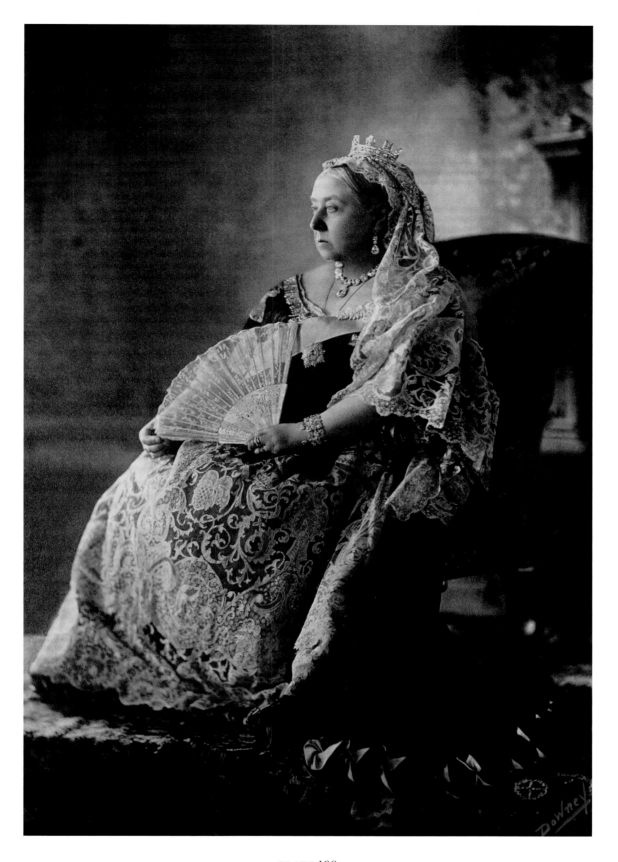

PLATE 108

W. & D. DOWNEY

Queen Victoria: Diamond Jubilee Portrait, July 1893

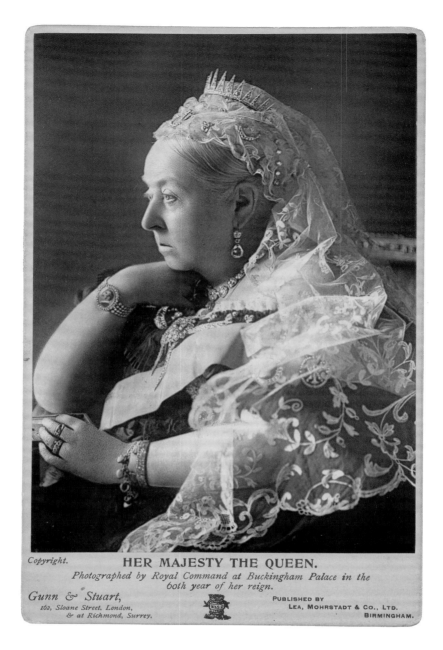

Copyright.

HER MAJESTY THE QUEEN.

Photographed by Royal Command at Buckingham Palace in the 6oth year of her reign.

Gunn & Stuart,
162, Sloane Street, London,
& at Richmond, Surrey.

PUBLISHED BY
LEA, MOHRSTADT & CO., LTD.
BIRMINGHAM.

PLATE 109
GUNN & STUART
Queen Victoria, 1897

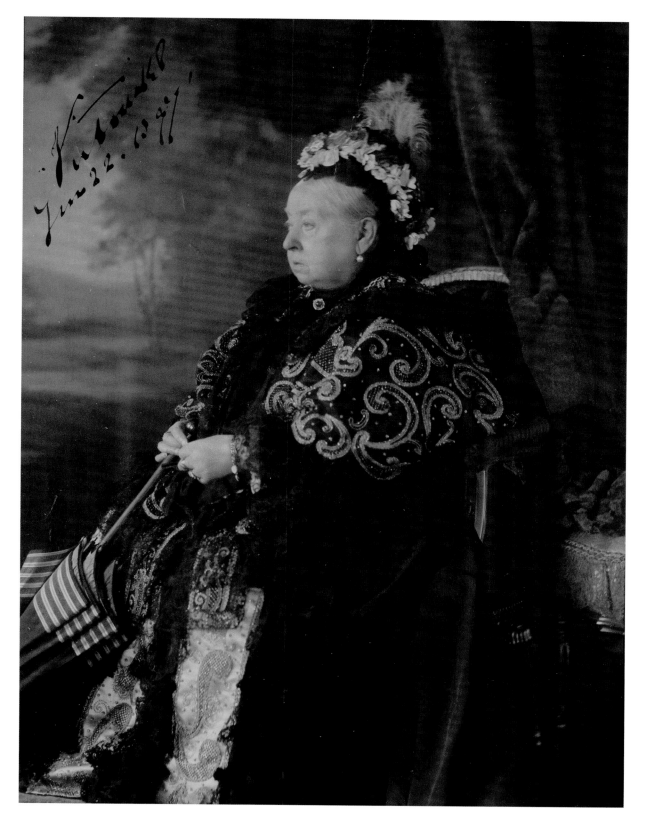

PLATE 110

GUSTAV WILLIAM HENRY MULLINS

Queen Victoria, June 22, 1897

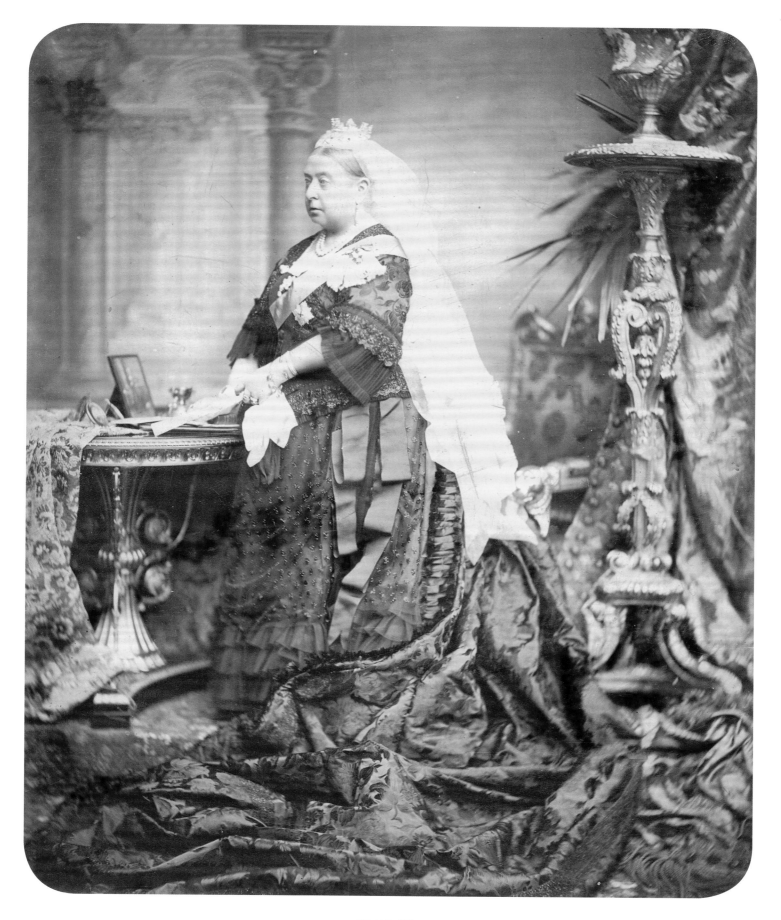

PLATE 111

GUNN & STUART

Portrait of Queen Victoria, ca. 1897

Photography in the Age of Queen Victoria

LIFE OF QUEEN VICTORIA

MAY 24: **Princess Alexandrina Victoria** born (d. 1901)

AUGUST 26: **Albert of Saxe-Coburg-Gotha** born (d. 1861)

PHOTOGRAPHIC HISTORY

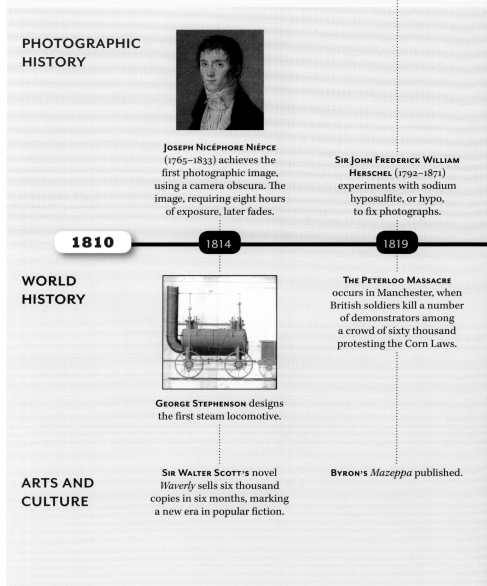

Joseph Nicéphore Niépce (1765–1833) achieves the first photographic image, using a camera obscura. The image, requiring eight hours of exposure, later fades.

Sir John Frederick William Herschel (1792–1871) experiments with sodium hyposulfite, or hypo, to fix photographs.

1810 1814 1819

WORLD HISTORY

George Stephenson designs the first steam locomotive.

The Peterloo Massacre occurs in Manchester, when British soldiers kill a number of demonstrators among a crowd of sixty thousand protesting the Corn Laws.

ARTS AND CULTURE

Sir Walter Scott's novel *Waverly* sells six thousand copies in six months, marking a new era in popular fiction.

Byron's *Mazeppa* published.

KING GEORGE III dies. His son **GEORGE IV** will rule until his death in 1830 and be succeeded by his brother (and Victoria's uncle) **WILLIAM IV**.

At age thirteen, **VICTORIA** begins keeping a journal. She will continue to write in her diary until the end of her life.

NIÉPCE and **LOUIS-JACQUES-MANDÉ DAGUERRE** (1789–1851) begin a collaboration that will last until the former's death in 1833. Daguerre will also continue to experiment on his own.

NIÉPCE takes the first permanent photograph, *View from the Window at Le Gras*, a landscape requiring an eight-hour exposure.

SIR CHARLES WHEATSTONE (1802–1875) invents the stereoscope.

WILLIAM HENRY FOX TALBOT (1800–1877) begins to experiment with a cameraless photographic process and by 1835 succeeds in producing photographs in a camera. He also employs the *cliché verre* process.

1820 **1826** **1829** **1830** **1832** **1834**

STEPHENSON'S steam engine *Rocket* wins competition to run between Manchester and Liverpool.

THE GREAT REFORM ACT effects far-reaching changes in the electoral system of England and Wales. It grants more seats to large cities, taking them away from smaller communities, and enables more people to vote. Separate reform bills are passed for Scotland and Ireland.

AUGUST 1: Slavery abolished in the British Empire.

ROYAL ZOOLOGICAL SOCIETY formed in London.

FRÉDÉRIC CHOPIN debuts in Paris, at the Salle Pleyel.

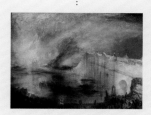
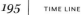

OCTOBER 16: Fire destroys the palace of Westminster. One year later, **J. M. W. TURNER** paints from memory *The Burning of the Houses of Lords and Commons*.

LIFE OF QUEEN VICTORIA

JUNE 20: **KING WILLIAM IV** dies. **PRINCESS VICTORIA** succeeds him as ruler of the United Kingdom of Great Britain and Ireland.

JUNE 28: **VICTORIA'S CORONATION** ceremony held at Westminster Abbey.

APRIL: **VICTORIA** shown samples of Talbot's photogenic drawings by his cousin Theresa Digby, a woman of the bedchamber.

OCTOBER 15: Following royal protocol, **VICTORIA** proposes marriage to **ALBERT**.

PHOTOGRAPHIC HISTORY

JANUARY 7: In Paris, **FRANÇOIS ARAGO** announces **DAGUERRE'S** photographic process.

JANUARY 9: **DAGUERRE** patents the daguerreotype. The French government provides him and Niépce's son with lifetime pensions for the invention, which is presented as a gift from France, "free to the world."

JANUARY 25: **TALBOT** shows his photographs made in 1834, which he calls photogenic drawings, at the Royal Society, London.

MARCH: **HIPPOLYTE BAYARD** (1801–1887) invents the direct-positive process.

HERSCHEL makes the first glass negative.

SEPTEMBER 13: First exhibition of daguerreotypes at 7 Piccadilly Street, London.

OCTOBER: The Frenchman **M. DE ST. CROIX** exhibits daguerreotypes and offers daily demonstrations of the process at the Royal Adelaide Gallery of Practical Science in London.

DAGUERRE'S first daguerreotype requires less than thirty minutes of exposure.

NOVEMBER: **TALBOT** returns to his photographic research, intending to present a paper to the Royal Society, London.

| 1837 | 1838 | 1839 |

WORLD HISTORY

Invention of **MORSE CODE.**

FIRST OPIUM WAR (through 1842) fought by Britain and China after China outlaws the trade of opium and forces domestic and foreign merchants to turn over their supplies.

SAMUEL MORSE invents the telegraph.

ARTS AND CULTURE

THOMAS CARLYLE'S *The French Revolution: A History* published.

LONDON ART UNION established, to promote a popular taste for fine art.

ROYAL POLYTECHNIC INSTITUTION (today the University of Westminster) established in London with the goal of advancing knowledge in engineering and scientific inventions.

CHARLES DICKENS'S *Oliver Twist* published.

Introduction of *Art Union* journal.

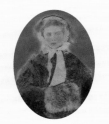

NOVEMBER 21: PRINCESS VICTORIA, the princess royal, born (d. 1901).

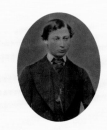

NOVEMBER 9: ALBERT EDWARD, PRINCE OF WALES, born (d. 1910). He is the future King Edward VII.

MARCH 5 AND 7: PRINCE ALBERT sits for daguerreotype portraits at the studio of **WILLIAM CONSTABLE** (1783–1861) in Brighton.

JUNE 13: VICTORIA rides a train for the first time, from Slough Station (closest to Windsor) to London.

VICTORIA and **ALBERT** make their first visit to Scotland.

MARCH 23: RICHARD BEARD (1802–1888) opens the first photographic portrait studio in the British Isles at the Royal Polytechnic Institution, London.

JUNE: ANTOINE CLAUDET (1797–1867) opens the second photographic portrait studio in London on the upper floors of the Royal Adelaide Gallery of Practical Science.

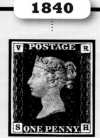

TALBOT invents the talbotype, or calotype—the first negative-positive process—which he patents in 1841.

HERSCHEL invents the cyanotype—a cameraless photographic process based on the light sensitivity of iron salts.

1840　　　1841　　　1842

Introduction in Britain of penny post and postage stamps.

NEW ZEALAND becomes a British colony.

AUGUST 29: Signing of the **TREATY OF NANJING** by the British and the Chinese ends the First Opium War. The treaty reopens China's ports to Britain and cedes Hong Kong to Queen Victoria. Henry Collen (1800–1879) is asked to make a photographic duplicate of the treaty so that the Chinese portion will not be miscopied.

CLAUDE MONET born (d. 1926).

THOMAS CARLYLE's *On Heroes, Hero-Worship, and the Heroic in History* published.

Engraving process adapted for use in periodical press. The *Illustrated London News* and other newly established papers depict current events and scenes in detailed engravings.

ALFRED, LORD TENNYSON, writes second version of "The Lady of Shalott."

FELIX MENDELSSOHN composes his Symphony no. 3.

LIFE OF QUEEN VICTORIA

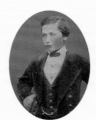

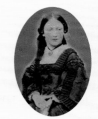

APRIL 25: **PRINCESS ALICE** born (d. 1878).

SEPTEMBER 2–7: **VICTORIA**, with Albert, makes her first international trip, visiting the French king **LOUIS-PHILIPPE** (r. 1830–48). It is the first visit of an English monarch to a French sovereign since 1520.

AUGUST 6: **PRINCE ALFRED** born (d. 1900).

VICTORIA and **ALBERT** purchase Osborne House on the Isle of Wight.

MAY 25: **PRINCESS HELENA** born (d. 1923).

PHOTOGRAPHIC HISTORY

ANNA ATKINS (1799–1871), using Herschel's cyanotype process, publishes the first book illustrated with original photographic images, *Photographs of British Algae*.

1844–46: **TALBOT** publishes *The Pencil of Nature*, the first commercially produced book illustrated with original photographic plates.

TALBOT publishes his second photographically illustrated book, *Sun Pictures in Scotland*.

CARL ZEISS (1816–1888) founds an optical factory in Jena, Germany.

1843 **1844** **1845** **1846**

WORLD HISTORY

ISAMBARD KINGDOM BRUNEL'S SS *Great Britain*, the first propeller-driven ship, is launched.

BRITAIN'S RAIL SYSTEM continues to expand with the issuing of the first prospectus of the London and York Railway.

AUTUMN: **IRISH POTATO FAMINE** begins. The devastating effects will last into the 1850s.

FIRST ANGLO-SIKH WAR (through 1846) results from clashes between the British East India Company and the Sikh Empire.

REPEAL OF THE CORN LAWS, which increases Britain's dependence on cheap imported grain and forces unprecedented numbers of rural and farming people to move to cities for employment or to emigrate.

ARTS AND CULTURE

PRINCE ALBERT invited to become president of the Society of Arts.

JOHN RUSKIN'S *Modern Painters* published.

TURNER paints *Rain, Steam and Speed*.

EDGAR ALLAN POE publishes *The Raven*.

EARLY 1840S: On a visit to Britain, **FREDERICK ENGELS** writes *The Condition of the Working Class in England*.

SMITHSONIAN INSTITUTION founded in America with bequest from James Smithson.

FYODOR DOSTOEVSKY'S *Poor Folk* published.

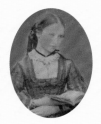

MARCH 18: **Princess Louise** born (d. 1939).

Albert becomes president of the Society for Improving the Condition of the Labouring Classes.

MAY 1: **Prince Arthur** born (d. 1942).

APRIL: **Dr. Ernst Becker** (1826–1888), later a member of the Council of the Photographic Society, appointed Albert's librarian and assistant tutor to the young princes. He purchases photographic equipment and introduces the royal family to picture-making processes.

Victoria and **Albert** purchase Balmoral Castle in Scotland.

William Edward Kilburn (1818–1891) photographs the Chartist meeting at Kennington Common in London, marking the first time a large public demonstration is recorded by the camera.

Sir David Brewster (1781–1868) invents the lenticular stereoscope, an inexpensive device for viewing stereographic images. **Stereographs**, the first mass-produced photographs, become fashionable and popular.

The albumen print is invented by **Louis-Désiré Blanquart-Evrard** (1802–1872). It will be the most widespread type of photographic print for the next four decades.

MARCH: **Frederick Scott Archer** (1813–1857) publishes the wet collodion process, which he had invented in 1848. These images require only two or three seconds of exposure.

The **waxed paper negative** is announced by its inventor, **Gustave Le Gray** (1820–1884).

Talbot gives up his patent on the calotype process at the behest of the nascent Photographic Society of London to encourage the growth of photography in England in step with developments in France and America.

DECEMBER: First exhibition in Great Britain devoted to photography, held at the Society of Arts (of which Albert is president at the time). Nearly eight hundred prints are exhibited.

1848 1850 1851 1852

JANUARY–DECEMBER: A series of **revolutions** occur, most notably in France but also in the Italian and German states, Denmark, Hungary, and other European nations.

California Gold Rush (through 1855).

SEPTEMBER: **Pre-Raphaelite Brotherhood** formed.

William Thackeray's *Vanity Fair* published.

Arundel Society formed by Prince Albert, John Ruskin, and other prominent figures to educate and improve public taste in art.

Karl Marx and **Engels** write *The Communist Manifesto*.

The **Public Libraries Act** passes in Britain.

Tennyson is appointed Britain's poet laureate and publishes *In Memoriam A. H. H.*

MAY 1: **The Great Exhibition of the Works of Industry of All Nations** opens in the Crystal Palace in Hyde Park, London, and features a number of exhibits from countries around the world. Photographs are exhibited; the superior quality of photographs made outside Britain is noted.

Herman Melville's *Moby Dick* published.

DECEMBER 2: Louis-Napoléon Bonaparte becomes **Emperor Napoléon III** of France.

Opening at 28 Leicester Square of the Royal Panopticon of Science and Art, an Institution for Scientific Exhibitions, and for Promoting Discoveries of Arts and Manufactures. Like the Adelaide Gallery and Polytechnic Institution, it has a photographic studio on the roof.

Opening of the **Victoria and Albert Museum** (first called the Museum of Manufacture, then the South Kensington Museum). Its first director, **Henry Cole** (1808–1882), buys and commissions photographs for both teaching and documentary purposes.

LIFE OF QUEEN VICTORIA

APRIL 7: PRINCE LEOPOLD born (d. 1884)

The first camera owned by Victoria and Albert is designed by **SIR WILLIAM SNOW HARRIS** (1791–1867) and mounted to the royal yacht *Victoria and Albert.* The camera can also be detached and used on land.

WILLIAM DUGUID of Westminster furnishes the queen and prince with a portable darkroom, delivered to Buckingham Palace on April 8. Another darkroom, at Windsor Castle, is completed on December 26.

ALBERT urges the **PHOTOGRAPHIC SOCIETY OF LONDON** to set up a committee to investigate the causes of fading in photographs and contributes fifty-five pounds toward the effort.

PHOTOGRAPHIC HISTORY

JANUARY 20: PHOTOGRAPHIC SOCIETY OF LONDON established; Victoria and Albert become patrons in June and will visit every annual exhibition.

The **PHOTOGRAPHIC SOCIETY OF LONDON** hosts its first exhibition. On January 3, **ROGER FENTON** (1819–1869) escorts Victoria and Albert through the exhibition.

ANDRÉ ADOLPHE-EUGÈNE DISDÉRI (1819–1889) introduces the **CARTE DE VISITE**. A camera with multiple lenses reproduces eight individually exposed images on a single negative; the resulting prints are cut apart and glued to calling-card-size mounts.

CARBON PRINTS are patented by **ALPHONSE-LOUIS POITEVIN** (1819–1882) but will not be practicable until **JOSEPH WILSON SWAN** (1828–1914) patents a refined process in 1864. Containing no silver impurities that can degrade over time, the carbon process is lauded for its permanence and produces dense, dark, glossy prints.

FRANCIS FRITH (1822–1898) begins photographing ancient monuments in Egypt and the Middle East. He produces mammoth-plate prints gathered into large folios that are popular and highly acclaimed.

1853 **1854** **1855** **1856**

WORLD HISTORY

CRIMEAN WAR begins and will continue through 1856. French, British, and Ottoman Turkish forces are allied against Russia.

BIG BEN clock tower completed in London.

The Scottish missionary **DAVID LIVINGSTONE** is the first European to see the great waterfall of the Zambezi River (in modern Zimbabwe) and names it **VICTORIA FALLS** in honor of the queen.

Start of the **SECOND OPIUM WAR** (through 1860); Britain and France are allied against China.

ARTS AND CULTURE

MARCH 6: First performance of **GIUSEPPE VERDI'S** *La Traviata,* at La Fenice, Venice.

TENNYSON'S "Charge of the Light Brigade" published.

WALT WHITMAN'S *Leaves of Grass* published.

CHARLES KINGSLEY'S *Westward Ho!* published.

The **SOCIETY OF FEMALE ARTISTS** is formed in London and will hold its first exhibition in 1857.

APRIL 14: PRINCESS BEATRICE born (d. 1944).

Victoria commissions **FRANCIS BEDFORD** (1815–1894) to make photographic views of Coburg, Albert's birthplace.

The queen and prince lend photographs (and other works of art) from the Royal Collection for display in the **MANCHESTER ART TREASURES EXHIBITION.**

JANUARY 25:
Princess Victoria marries **PRINCE FREDERICK WILLIAM** (later King Frederick III) of Prussia (1831–1888). The wedding is photographed by **THOMAS RICHARD WILLIAMS** (1825–1871); daguerreotypes are chosen for their permanence over other processes more common at the time.

NOVEMBER 14: VICTORIA is photographed by **CHARLES CLIFFORD** (1819/1820–1863) at the request of Isabella II of Spain.

DECEMBER 9: ALBERT is diagnosed with typhoid fever. He dies on December 14, at age forty-two.

EDWARD, PRINCE OF WALES, embarks on an educational tour of the Middle East, accompanied by **FRANCIS BEDFORD** as the official photographer.

At the **SOUTH KENSINGTON MUSEUM,** the London Photographic Society organizes the first photographic exhibition to be held in a museum.

TALBOT patents photoglyphic engraving, the first attempt at photomechanical reproduction.

WILLIAM LAKE PRICE (1810–1896) publishes *A Manual of Photographic Manipulation.*

MAY 10: JOHN JABEZ EDWIN MAYALL (1813–1901) makes portraits of Victoria and Albert. These are the first photographs of the royal family to be published and are made available for sale in the summer.

DECEMBER 16: WILLIAM BAMBRIDGE (1820–1879) photographs Albert on his deathbed.

Following Albert's passing, tens of thousands of cartes de visite with Mayall's 1860 portrait of the prince are sold.

Organizers of the **INTERNATIONAL EXHIBITION IN LONDON** attempt to place photography in the machinery section but create a separate space for photography after protests.

The London-based French photographic firm **A. MARION & Co.** introduces cartes de visite to Britain. The process gains widespread popularity by 1860.

1857 — **1858** — **1860** — **1861** — **1862**

British troops are called to suppress the **INDIAN MUTINY** (also called the Sepoy Rebellion), which will conclude in 1858.

ABRAHAM LINCOLN becomes president of the United States.

The **AMERICAN CIVIL WAR** begins and will continue through 1865.

JAPAN is opened to Western trade. To mark the event, the Royal Polytechnic Institution in London displays a nine-thousand-square-foot canvas of Edo (modern Tokyo) painted after photographs made by a Captain Wilson.

Opening of the **MANCHESTER ART TREASURES EXHIBITION,** where photographs are exhibited on an equal footing with traditional fine arts. On view is a portrait by William Lake Price (1810–1896) of Prince Albert, made specifically for the exhibition. This marks the first time a photograph of a member of the royal family is put on public display.

MENDELSSOHN'S "Wedding March" is performed on the occasion of the royal wedding of Princess Victoria, thus beginning a tradition that continues today.

WILKIE COLLINS publishes in book form *The Woman in White.*

GEORGE ELIOT'S *Mill on the Floss* published.

CHARLES DICKENS'S *Great Expectations* published in three volumes.

GEORGE ELIOT'S *Silas Marner* published.

Creation of the **ROYAL FEMALE SCHOOL OF ART** under the patronage of Queen Victoria.

VICTOR HUGO'S *Les misérables* published.

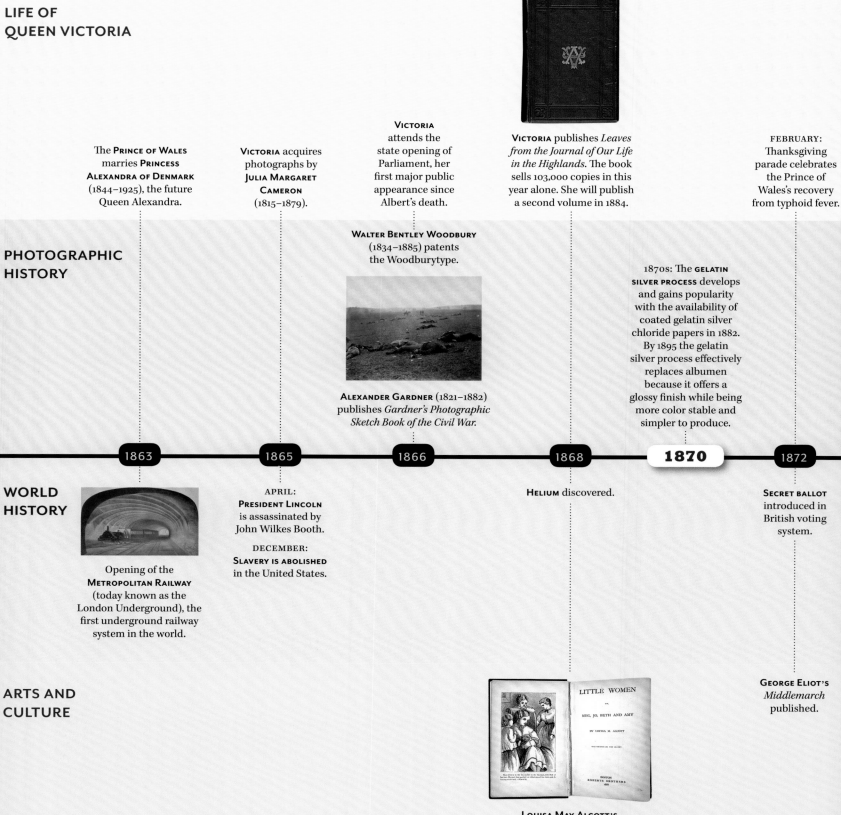

LIFE OF QUEEN VICTORIA

The **Prince of Wales** marries **Princess Alexandra of Denmark** (1844–1925), the future Queen Alexandra.

Victoria acquires photographs by **Julia Margaret Cameron** (1815–1879).

Victoria attends the state opening of Parliament, her first major public appearance since Albert's death.

Victoria publishes *Leaves from the Journal of Our Life in the Highlands*. The book sells 103,000 copies in this year alone. She will publish a second volume in 1884.

FEBRUARY: Thanksgiving parade celebrates the Prince of Wales's recovery from typhoid fever.

PHOTOGRAPHIC HISTORY

Walter Bentley Woodbury (1834–1885) patents the Woodburytype.

Alexander Gardner (1821–1882) publishes *Gardner's Photographic Sketch Book of the Civil War*.

1870s: The **gelatin silver process** develops and gains popularity with the availability of coated gelatin silver chloride papers in 1882. By 1895 the gelatin silver process effectively replaces albumen because it offers a glossy finish while being more color stable and simpler to produce.

1863 — **1865** — **1866** — **1868** — **1870** — **1872**

WORLD HISTORY

Opening of the **Metropolitan Railway** (today known as the London Underground), the first underground railway system in the world.

APRIL: **President Lincoln** is assassinated by John Wilkes Booth.

DECEMBER: **Slavery is abolished** in the United States.

Helium discovered.

Secret ballot introduced in British voting system.

ARTS AND CULTURE

Louisa May Alcott's *Little Women* published.

George Eliot's *Middlemarch* published.

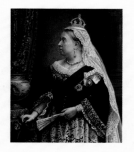

VICTORIA is created empress of India after the British East India Company is dissolved in the wake of the Indian Mutiny, and all Britain's possessions and protectorates are incorporated into her empire.

DECEMBER 14: On the anniversary of Albert's death, Princess Alice dies of diphtheria.

DEVELOPING-OUT PAPERS become available. These papers can be purchased presensitized with chemical emulsion—either silver bromide or silver chloride—which streamlines the chemical development and production of photographic prints from negatives.

PLATINUM PRINTS are invented by **WILLIAM WILLIS** (1841–1923) and are prized for their tonal variation and permanence.

PHOTOGRAVURE— a photomechanical method for reproducing images in large editions—is perfected by the Austrian printer **KAREL KLIČ** (1841–1926). His method is derived from Talbot's photoglyphic engraving process as well as from the traditional printmaking process of etching.

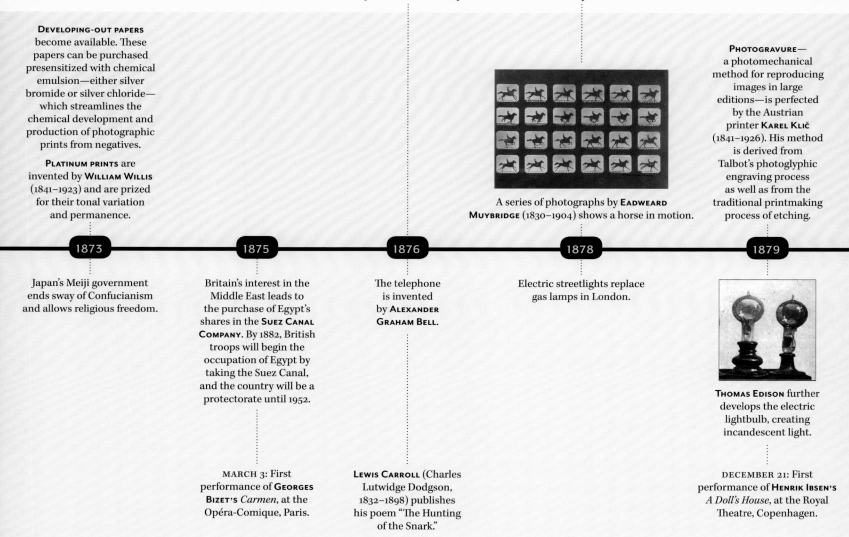

A series of photographs by **EADWEARD MUYBRIDGE** (1830–1904) shows a horse in motion.

| 1873 | 1875 | 1876 | 1878 | 1879 |

Japan's Meiji government ends sway of Confucianism and allows religious freedom.

Britain's interest in the Middle East leads to the purchase of Egypt's shares in the **SUEZ CANAL COMPANY**. By 1882, British troops will begin the occupation of Egypt by taking the Suez Canal, and the country will be a protectorate until 1952.

The telephone is invented by **ALEXANDER GRAHAM BELL**.

Electric streetlights replace gas lamps in London.

THOMAS EDISON further develops the electric lightbulb, creating incandescent light.

MARCH 3: First performance of **GEORGES BIZET'S** *Carmen*, at the Opéra-Comique, Paris.

LEWIS CARROLL (Charles Lutwidge Dodgson, 1832–1898) publishes his poem "The Hunting of the Snark."

DECEMBER 21: First performance of **HENRIK IBSEN'S** *A Doll's House*, at the Royal Theatre, Copenhagen.

LIFE OF
QUEEN VICTORIA

1880s: Alexandra, Princess of Wales, begins to make photographs of the royal family, friends, and places she visits. Her photographs will be displayed in 1897 alongside those of famous photographers of the day such as **Henry Peach Robinson** (1830–1901) and **Frederick Evans** (1853–1943).

June 21: **Golden Jubilee** celebrations mark fifty years of Victoria's rule.

Victoria's grandson **Wilhelm II** becomes emperor of Germany and king of Prussia.

PHOTOGRAPHIC
HISTORY

1880s: Printing-out papers become common, simplifying photographic production. Designed for printing from collodion or gelatin glass negatives, printing-out papers are placed in direct contact with the negative and exposed to light until an image appears.

1880s: The **halftone** printing process, which allows photographs to be reproduced in print alongside text, is introduced.

George Eastman (1854–1932) invents roll film.

Eastman develops the first Kodak camera.

1880 1885 1887 1888 1890

WORLD
HISTORY

December: First Boer War breaks out in South Africa.

Karl Benz invents the first automobile to be powered by internal combustion.

Gottlieb Daimler invents the first gas-engine motorcycle.

The **Yellow River** bursts its banks in China, killing nine hundred thousand people.

Ghastly MURDER IN THE EAST-END. DREADFUL MUTILATION OF A WOMAN.

Jack the Ripper terrorizes London with a series of brutal murders.

ARTS AND
CULTURE

Mark Twain's *Tramp Abroad* published.

First English translation of **Engels's** *Condition of the Working Class in England*.

Oscar Wilde's *Happy Prince* published.

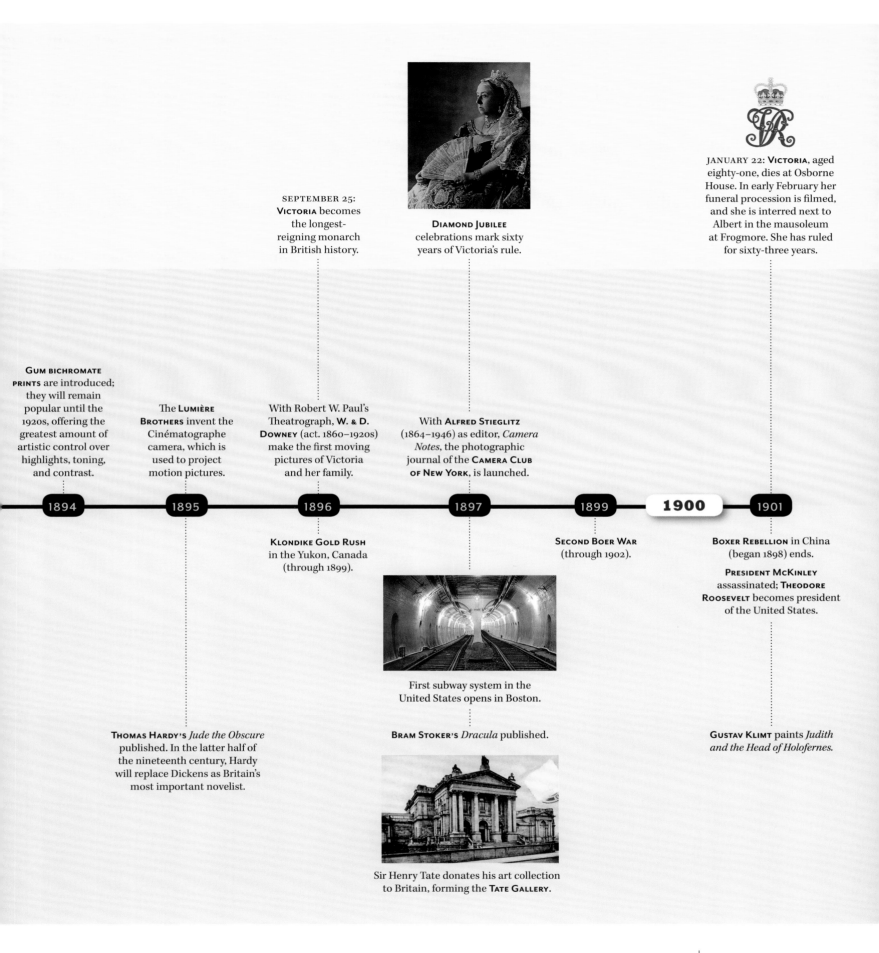

JANUARY 22: **VICTORIA**, aged eighty-one, dies at Osborne House. In early February her funeral procession is filmed, and she is interred next to Albert in the mausoleum at Frogmore. She has ruled for sixty-three years.

SEPTEMBER 25: **VICTORIA** becomes the longest-reigning monarch in British history.

DIAMOND JUBILEE celebrations mark sixty years of Victoria's rule.

GUM BICHROMATE PRINTS are introduced; they will remain popular until the 1920s, offering the greatest amount of artistic control over highlights, toning, and contrast.

The **LUMIÈRE BROTHERS** invent the Cinématographe camera, which is used to project motion pictures.

With Robert W. Paul's Theatrograph, **W. & D. DOWNEY** (act. 1860–1920s) make the first moving pictures of Victoria and her family.

With **ALFRED STIEGLITZ** (1864–1946) as editor, *Camera Notes*, the photographic journal of the **CAMERA CLUB OF NEW YORK**, is launched.

| 1894 | 1895 | 1896 | 1897 | 1899 | **1900** | 1901 |

KLONDIKE GOLD RUSH in the Yukon, Canada (through 1899).

SECOND BOER WAR (through 1902).

BOXER REBELLION in China (began 1898) ends.

PRESIDENT MCKINLEY assassinated; **THEODORE ROOSEVELT** becomes president of the United States.

First subway system in the United States opens in Boston.

THOMAS HARDY'S *Jude the Obscure* published. In the latter half of the nineteenth century, Hardy will replace Dickens as Britain's most important novelist.

BRAM STOKER'S *Dracula* published.

GUSTAV KLIMT paints *Judith and the Head of Holofernes.*

Sir Henry Tate donates his art collection to Britain, forming the **TATE GALLERY**.

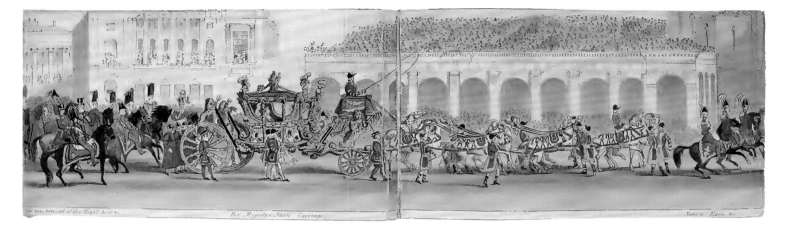

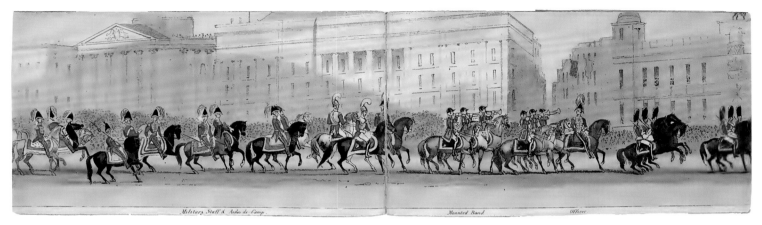

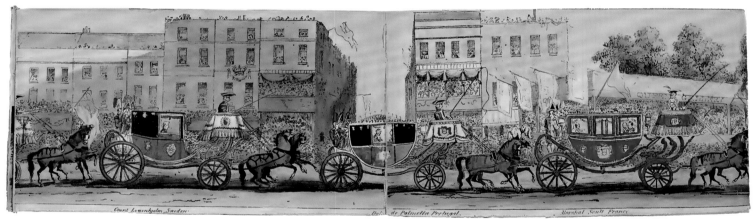

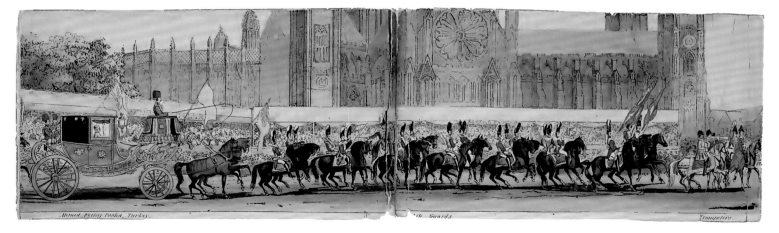

Robert Tyas (British, 1811–1879), *The Tableau of the Procession at the Coronation of Queen Victoria, June 28, 1838*, ca, 1838 (details).
Hand-colored lithograph, 13 × 610 cm unfolded (5⅛ × 20 ft. ⅛ in.). Los Angeles, Getty Research Institute, 94-B10125.

PLATE LIST

PLATE 19
HUGH WELCH DIAMOND
British, 1809–1886
Untitled (Seated Woman with a Bird),
 ca. 1855
Albumen silver print
19.1 × 14.4 cm (7½ × 5¹¹⁄₁₆ in.)
Los Angeles, J. Paul Getty Museum,
 84.XP.927.3

PLATE 20
HUGH WELCH DIAMOND
British, 1809–1886
Untitled (Seated Woman with a
 Purse), ca. 1855
Albumen silver print
19.5 × 14 cm (7¹¹⁄₁₆ × 5½ in.)
Los Angeles, J. Paul Getty Museum,
 84.XP.927.1

PLATE 21
COUNT DE MONTIZON
Spanish, 1822–1887
The Hippopotamus at the Zoological
 Gardens, Regent's Park, 1852
From *The Photographic Album for*
 the Year 1855
Salted paper print from a wet
 collodion negative
11.4 × 12.5 cm (4½ × 4¹⁵⁄₁₆ in.)
Los Angeles, J. Paul Getty Museum,
 84.XA.871.6.9

PLATE 22
ROGER FENTON
British, 1819–1869
Untitled (Aisle of Tintern Abbey), 1854
Salted paper print
18.7 × 22.5 cm (7⅜ × 8⅞ in.)
Los Angeles, J. Paul Getty Museum,
 85.XP.355.9

PLATE 23
WILLIAM EDWARD KILBURN
British, 1818–1891
Untitled (Portrait of a Seated Man
 with Graying Muttonchop Whiskers),
 1852–55
Hand-colored daguerreotype
8.9 × 6.5 cm (3½ × 2⁹⁄₁₆ in.)
Los Angeles, J. Paul Getty Museum,
 84.XT.833.11

PLATE 24
RICHARD BEARD
British, 1801–1885
Portrait of a Young Man Seated at
 Table, ca. 1852
Hand-colored daguerreotype
7.6 × 6.4 cm (3 × 2½ in.)
Los Angeles, J. Paul Getty Museum,
 84.XT.1572.3

PLATE 25
ANTOINE CLAUDET
French, 1797–1867
Portrait of a Girl in Blue Dress, ca. 1854
Hand-colored daguerreotype
6.4 × 5.2 cm (2½ × 2¹⁄₁₆ in.)
Los Angeles, J. Paul Getty Museum,
 84.XT.833.17

PLATE 26
WILLIAM CONSTABLE
British, 1783–1861
Self-Portrait with a Recent
 Invention, ca. 1854
Daguerreotype
9.2 × 6.7 cm (3⅝ × 2⅝ in.)
Los Angeles, J. Paul Getty Museum,
 84.XT.266.13

PLATE 27
ANTOINE CLAUDET
French, 1797–1867
Untitled (Mother Posed with Her
 Young Son and Daughter), ca. 1855
Hand-colored stereoscopic
 daguerreotype
8 × 17.5 cm (3⅛ × 6⅞ in.)
Los Angeles, J. Paul Getty Museum,
 84.XT.924.1

PLATE 28
ANTOINE CLAUDET
French, 1797–1867
Untitled (Portrait of a Middle-Aged
 Woman), ca. 1855
Hand-colored stereoscopic
 daguerreotype
8.4 × 17.5 cm (3⁵⁄₁₆ × 6⅞ in.)
Los Angeles, J. Paul Getty Museum,
 84.XT.924.5

PLATE 29
CAPTAIN LINNAEUS TRIPE
British, 1822–1902
H.M.S. "Duke of Wellington,"
 March 4–5, 1854
Albumen silver print from a waxed
 paper negative
27 × 34.9 cm (10⅝ × 13¾ in.)
Los Angeles, J. Paul Getty Museum,
 85.XM.391

PLATE 30
WILLIAM EDWARD KILBURN
British, 1818–1891
Untitled (Portrait of a Military Man),
 1852–55
Hand-colored daguerreotype
9.1 × 6.5 cm (3⁹⁄₁₆ × 2⁹⁄₁₆ in.)
Los Angeles, J. Paul Getty Museum,
 84.XT.833.14

PLATE 31
WILLIAM EDWARD KILBURN
British, 1818–1891
Portrait of Lt. Robert Horsley Cockerell,
 ca. 1852
Hand-colored daguerreotype
8.9 × 6.5 cm (3½ × 2⁹⁄₁₆ in.)
Los Angeles, J. Paul Getty Museum,
 84.XT.266.3

PLATE 32
ROGER FENTON
British, 1819–1869
Cooking House of the 8th Hussars,
 negative, 1855; print, January 1, 1856
Salted paper print
15.9 × 20.3 cm (6¼ × 8 in.)
Los Angeles, J. Paul Getty Museum,
 84.XM.1028.31

PLATE 33
ROGER FENTON
British, 1819–1869
Valley of the Shadow of Death,
 April 23, 1855
Salted paper print
27.6 × 34.9 cm (10⅞ × 13¾ in.)
Los Angeles, J. Paul Getty Museum,
 84.XM.504.23

PLATE 34
ROGER FENTON
British, 1819–1869
Field Marshal Lord Raglan,
 June 4, 1855
Salted paper print
19.8 × 15.2 cm (7¹³⁄₁₆ × 6 in.)
Los Angeles, J. Paul Getty Museum,
 84.XM.504.12

PLATE 35
ROGER FENTON
British, 1819–1869
Col. Gordon, Royal Engineers, 1855
Albumen silver print
19.1 × 16.8 cm (7½ × 6⅝ in.)
Los Angeles, J. Paul Getty Museum,
 85.XP.355.20

PLATE 36
JOSEPH CUNDALL
British, 1818–1895
ROBERT HOWLETT
British, 1831–1858
Private Jesse Lockhurst, 31st Regiment,
 and Thomas O'Brien, 1st Royals,
 negative, April 16, 1856; print, 1883
Carbon print
21.3 × 17.3 cm (8⅜ × 6¹³⁄₁₆ in.)
Windsor, The Royal Collection,
 RCIN 2500194

PLATE 37
FELICE BEATO
British, born Italy, 1832–1909
Untitled (Group Portrait of Lord
 Clyde, Sir Hope Grant, and
 General Mansfield), ca. 1858
From the album *Lucknow—After*
 the Mutiny
Albumen silver print
19 × 15.1 cm (7½ × 5¹⁵⁄₁₆ in.)
Partial gift from the Wilson Centre
 for Photography
Los Angeles, J. Paul Getty Museum,
 2007.26.208.1

PLATE 38
FELICE BEATO
British, born Italy, 1832–1909
The Great Gateway of the
 Kaiserbagh—3,000 Sepoys Killed
 by the British in One Day in the
 Courtyard by the Light Division
 and Brazier's Sikhs, 1858
From the album *Lucknow—After*
 the Mutiny
Albumen silver print
25.7 × 30.2 cm (10⅛ × 11⅞ in.)
Partial gift from the Wilson Centre
 for Photography
Los Angeles, J. Paul Getty Museum,
 2007.26.208.10

PLATE 39
FELICE BEATO
British, born Italy, 1832–1909
Interior of the Secundra Bagh after
 the Slaughter of 2,000 Rebels,
 Lucknow, 1858
From the album *Lucknow—After*
 the Mutiny
Albumen silver print
26.2 × 29.9 cm (10⁵⁄₁₆ × 11¾ in.)
Partial gift from the Wilson Centre
 for Photography
Los Angeles, J. Paul Getty Museum,
 2007.26.208.7

PLATE 40
ALFRED BROTHERS
British, 1826–1912
Her Majesty's Visit to the Manchester
 Exhibition of Art Treasures of the
 United Kingdom, 1857
Albumen silver print
19.4 × 24.4 cm (7⅝ × 9⅝ in.)
Los Angeles, J. Paul Getty Museum,
 84.XP.728.54

PLATE 41
J. & R. MUDD
British, active 1857–60
Manchester Exhibition of Art Treasures, June 1857
Albumen silver print
26.1 × 37.7 cm (10¼ × 14¹³⁄₁₆ in.)
Windsor, The Royal Collection,
RCIN 2935075

PLATE 42
UNKNOWN PHOTOGRAPHER
Manchester Art Treasures, 1857
Albumen silver print
18.6 × 24.4 cm (7⁵⁄₁₆ × 9⅝ in.)
Los Angeles, J. Paul Getty Museum,
85.XP.355.44

PLATE 43
FRANCIS BEDFORD
British, 1815–1894
The Gateway, Canterbury, ca. 1855
Albumen silver print
20.3 × 16.5 cm (8 × 6½ in.)
Los Angeles, J. Paul Getty Museum,
85.XP.355.93

PLATE 44
GUSTAVE LE GRAY
French, 1820–1884
The Tugboat, 1857
Albumen silver print
30 × 41.3 cm (11¹³⁄₁₆ × 16¼ in.)
Los Angeles, J. Paul Getty Museum,
86.XM.604

PLATE 45
GUSTAVE LE GRAY
French, 1820–1884
The Brig, 1856
Albumen silver print
32.1 × 40.8 cm (12⅝ × 16¹⁄₁₆ in.)
Windsor, The Royal Collection,
RCIN 2934240

PLATE 46
GUSTAVE LE GRAY
French, 1820–1884
The Great Wave, Sète, ca. 1857
Albumen silver print
34.3 × 41.9 cm (13½ × 16½ in.)
Los Angeles, J. Paul Getty Museum,
84.XM.637.1

PLATE 47
OSCAR GUSTAVE REJLANDER
British, born Sweden, 1813–1875
The Two Ways of Life, 1857
Albumen silver print
40 × 77.4 cm (15¾ × 30½ in.)
Bradford, National Media Museum,
2003-5001/3/39373/1

PLATE 48
WILLIAM LAKE PRICE
British, 1810–1896
Don Quixote in His Study, negative, 1856; print, January 1857
Hand-colored photogalvanograph
22.7 × 19.7 cm (8¹⁵⁄₁₆ × 7¾ in.)
Los Angeles, J. Paul Getty Museum,
84.XM.841.2

PLATE 49
ROBERT HOWLETT
British, 1831–1858
I. K. Brunel and Others Observing the "Great Eastern" Launch Attempt, November 1857
Albumen silver print
24.8 × 21.4 cm (9¾ × 8⁷⁄₁₆ in.)
Los Angeles, J. Paul Getty Museum,
89.XM.68.2

PLATE 50
ROBERT HOWLETT
British, 1831–1858
The Steamship "Great Eastern" Being Built in the Docks at Millwall, November 1857
Albumen silver print
20.8 × 26.2 cm (8³⁄₁₆ × 10⁵⁄₁₆ in.)
Los Angeles, J. Paul Getty Museum,
84.XP.675.24

PLATE 51
W. & D. DOWNEY
British, active 1860–1920s
Hartley Colliery after the Accident, January 30, 1862
Albumen silver print
15 × 20.4 cm (5⅞ × 8¹⁄₁₆ in.)
Windsor, The Royal Collection,
RCIN 2935022

PLATE 52
W. & D. DOWNEY
British, active 1860–1920s
W. Coulson, Master Sinker, and Four of His Men, Pit Mouth, Hartley Colliery, January 30, 1862
Albumen silver print
14.6 × 20.1 cm (5¾ × 7⁵⁄₁₆ in.)
Windsor, The Royal Collection,
RCIN 2935021

PLATE 53
GUSTAVE LE GRAY
French, 1820–1884
The English Fleet at Cherbourg, 1858
Albumen silver print
30.4 × 38.4 cm (11¹⁵⁄₁₆ × 15⅛ in.)
Windsor, The Royal Collection,
RCIN 2934238

PLATE 54
FRANCIS FRITH
British, 1822–1898
The Ramesseum of El-Kurneh, Thebes, Second View, 1857
Albumen silver print
36.4 × 48.7 cm (14⁵⁄₁₆ × 19³⁄₁₆ in.)
Los Angeles, J. Paul Getty Museum,
84.XM.633.13

PLATE 55
FRANCIS FRITH
British, 1822–1898
Fallen Colossus from the Ramesseum, Thebes, 1858
From the album *Egypt, Sinai, and Jerusalem*
Albumen silver print
39 × 48 cm (15⅜ × 18⅞ in.)
Los Angeles, J. Paul Getty Museum,
84.XO.434.4

PLATE 56
JOHN CRAMB
Scottish, active 1850s–1860s
Church of the Holy Sepulcher and Christian Street, 1860
From the book *Palestine in 1860: A Series of Photographic Views, Taken Expressly for This Work by John Cramb, Photographer to the Queen*
Albumen silver print
22.2 × 17.2 cm (8¾ × 6¾ in.)
Los Angeles, J. Paul Getty Museum,
84.XB.1336.18

PLATE 57
FRANCIS BEDFORD
British, 1815–1894
Gizeh—The Departure of H.R.H. the Prince of Wales and Suite from the Pyramids, March 5, 1862
From the book *The Holy Land*
Albumen silver print
9.7 × 13 cm (3¹³⁄₁₆ × 5⅛ in.)
Los Angeles, J. Paul Getty Museum,
84.XB.1272.1

PLATE 58
FRANCIS BEDFORD
British, 1815–1894
Bethlehem—The Shepherds' Field, April 3, 1862
Albumen silver print
22.9 × 28.6 cm (9 × 11¼ in.)
Los Angeles, J. Paul Getty Museum,
85.XM.143

PLATE 59
JULIA MARGARET CAMERON
British, born India, 1815–1879
Untitled (Paul and Virginia), 1864
Albumen silver print
26.7 × 21.1 cm (10½ × 8⁵⁄₁₆ in.)
Los Angeles, J. Paul Getty Museum,
84.XM.443.12

PLATE 60
JULIA MARGARET CAMERON
British, born India, 1815–1879
The Whisper of the Muse / Portrait of G. F. Watts, April 1865
From *The Overstone Album*
Albumen silver print
26 × 21.4 cm (10¼ × 8⁷⁄₁₆ in.)
Los Angeles, J. Paul Getty Museum,
84.XZ.186.96

PLATE 61
JULIA MARGARET CAMERON
British, born India, 1815–1879
George Frederic Watts, 1865
Albumen silver print
37 × 29 cm (14⁹⁄₁₆ × 11⁷⁄₁₆ in.)
Windsor, The Royal Collection,
RCIN 2941861

PLATE 62
JULIA MARGARET CAMERON
British, born India, 1815–1879
Thomas Carlyle, 1867
Albumen silver print
31.6 × 24.7 cm (12⁷⁄₁₆ × 9¾ in.)
Windsor, The Royal Collection,
RCIN 2941860

PLATE 63
JULIA MARGARET CAMERON
British, born India, 1815–1879
Thomas Carlyle, 1867
Albumen silver print
36.7 × 25.9 cm (14⁷⁄₁₆ × 10³⁄₁₆ in.)
Los Angeles, J. Paul Getty Museum,
84.XM.443.23

PLATE 64
OSCAR GUSTAVE REJLANDER
British, born Sweden, 1813–1875
Untitled (Portrait of a Young Boy), ca. 1860
Albumen silver print
16 × 11.1 cm (6⁵⁄₁₆ × 4⅜ in.)
Los Angeles, J. Paul Getty Museum,
85.XP.355.142

PLATE 65
OSCAR GUSTAVE REJLANDER
British, born Sweden, 1813–1875
Study of the Head of John the Baptist in a Charger, ca. 1855
Albumen silver print
15.7 × 20.3 cm (6³⁄₁₆ × 8 in.)
Windsor, The Royal Collection,
RCIN 2906274

PLATE 66
SIR WILLIAM ROSS
British, 1794–1860
Queen Victoria, 1839
Watercolor on ivory
Diam. 4.9 cm (1 15/16 in.)
Windsor, The Royal Collection,
 RCIN 420260

PLATE 67
SIR WILLIAM ROSS
British, 1794–1860
Prince Albert, 1839
Watercolor on ivory
9.6 × 7.6 cm (3¾ × 3 in.)
Windsor, The Royal Collection,
 RCIN 420268

PLATE 68
WILLIAM EDWARD KILBURN
British, 1818–1891
Prince Albert, 1848
Hand-colored daguerreotype
8.6 × 6.3 cm (3⅜ × 2½ in.)
Windsor, The Royal Collection,
 RCIN 2932487

PLATE 69
WILLIAM EDWARD KILBURN
British, 1818–1891
Queen Victoria, the Princess Royal,
 the Prince of Wales, Princess Alice,
 Princess Helena, and Prince Alfred,
 January 17, 1852
Daguerreotype
9.1 × 11.5 cm (3 9/16 × 4½ in.)
Windsor, The Royal Collection,
 RCIN 2932491

PLATE 70
WILLIAM EDWARD KILBURN
British, 1818–1891
Queen Victoria with Her Children,
 January 19, 1852
Hand-colored daguerreotype
8.9 × 7 cm (3½ × 2¾ in.)
Collection of Charles Isaacs and
 Carol Nigro

PLATE 71
ROGER FENTON
British, 1819–1869
The Prince of Wales, the Princess
 Royal, Princess Alice, The Queen, and
 Prince Alfred, negative, February 8,
 1854; printed later by an unknown
 photographer, ca. 1885–90
Carbon print
22 × 19.7 cm (8 11/16 × 7¾ in.)
Windsor, The Royal Collection,
 RCIN 2900013

PLATE 72
ROGER FENTON
British, 1819–1869
CARL HAAG
British, born Germany, 1820–1915
Double-page spread from the "Royal
 Children Tableaux" album, 1854
45.5 × 35 cm (17 15/16 × 13 13/16 in.)
 LEFT:
 The Royal Children as the Four
 Seasons and the "Spirit Empress"
 Albumen silver print
 20.7 × 15.8 cm (8⅛ × 6 3/16 in.)
 Windsor, The Royal Collection,
 RCIN 2943818
 RIGHT:
 Royal Children Tableaux: Helena
 Watercolor and gouache over
 pencil, over trimmed albumen
 silver print (with poem inscribed
 in pen and ink)
 15.5 × 28.3 cm (6⅛ × 11⅛ in.)
 Windsor, The Royal Collection,
 RCIN 931943

PLATE 73
Unknown photographer
Queen Victoria Wearing Blue Dress
 and Sash, May 1854
Hand-colored stereoscopic
 daguerreotype
8 × 17.5 cm (3⅛ × 6⅞ in.)
Windsor, The Royal Collection,
 RCIN 72047

PLATE 74
ROGER FENTON
British, 1819–1869
Queen Victoria and Prince Albert,
 Buckingham Palace, May 11, 1854
Albumen silver print
20.4 × 16.2 cm (8 1/16 × 6⅜ in.)
Windsor, The Royal Collection,
 RCIN 2906513

PLATE 75
ROGER FENTON
British, 1819–1869
EDWARD HENRY CORBOULD
British, 1815–1905
Queen Victoria and Prince Albert,
 May 11, 1854
Hand-colored albumen silver print
20.3 × 14.2 cm (8 × 5 9/16 in.)
Windsor, The Royal Collection,
 RCIN 2914323

PLATE 76
ROGER FENTON
British, 1819–1869
Queen Victoria and Prince Albert,
 1854
Hand-colored albumen silver print
21.9 × 18.4 cm (8⅝ × 7¼ in.)
Windsor, The Royal Collection,
 RCIN 2914264

PLATE 77
ROGER FENTON
British, 1819–1869
Queen Victoria, June 30, 1854
Hand-colored salted paper print
19.1 × 15.6 cm (7½ × 6⅛ in.)
Los Angeles, J. Paul Getty Museum,
 98.XM.16.1

PLATE 78
BRYAN EDWARD DUPPA
British, 1804–1866
Queen Victoria, negative, July 5, 1854;
 printed by Gustav William Henry
 Mullins (1854–1921), 1889
Carbon print
21.8 × 16.6 cm (8 9/16 × 6 9/16 in.)
Windsor, The Royal Collection,
 RCIN 2906533

PLATE 79
BRYAN EDWARD DUPPA
British, 1804–1866
Prince Albert, negative, May 1854;
 printed by Gustav William Henry
 Mullins (1854–1921), 1889
Carbon print
20.2 × 16 cm (7 15/16 × 6 5/16 in.)
Windsor, The Royal Collection,
 RCIN 2906522

PLATE 80
ANTOINE CLAUDET
French, 1797–1867
Queen Victoria, Princess Mary, Duchess
 of Gloucester, the Prince of Wales,
 Princess Alice, Gloucester House,
 June 30, 1856
Hand-colored daguerreotype
6.4 × 5.2 cm (2½ × 2 1/16 in.)
Windsor, The Royal Collection,
 RCIN 2932493

PLATE 81
THOMAS RICHARD WILLIAMS
British, 1824–1871
Victoria, Princess Royal, in Her
 Wedding Dress, Buckingham Palace,
 January 25, 1858
Ambrotype
3.4 × 2.8 cm (1 5/16 × 1⅛ in.)
Windsor, The Royal Collection,
 RCIN 2932490

PLATE 82
ROGER FENTON
British, 1819–1869
Princess Royal and Princess Alice, 1857
Salted paper print
33.9 × 30.8 cm (13⅜ × 12⅛ in.)
Bradford, National Media Museum,
 2003-5000/3324/1

PLATE 83
ROGER FENTON
British, 1819–1869
Princesses Helena and Louise, 1856
Salted paper print
33 × 29.2 cm (13 × 11½ in.)
Bradford, National Media Museum,
 2003-5000/3320

PLATE 84
ROGER FENTON
British, 1819–1869
Prince Alfred, 1856
Salted paper print
33.2 × 26 cm (13 1/16 × 10¼ in.)
Bradford, National Media Museum,
 2003-5000/3323/2

PLATE 85
LEONIDA CALDESI
Italian, 1823–1891
Prince Arthur, 1857
Salted paper print
17.7 × 15.1 cm (6 15/16 × 5 15/16 in.)
Windsor, The Royal Collection,
 RCIN 2900255

PLATE 86
JOHN JABEZ EDWIN MAYALL
British, 1813–1901
Untitled (The Prince of Wales
 [Edward VII]), ca. 1856
Albumen silver print
27.1 × 20.8 cm (10 11/16 × 8 3/16 in.)
Los Angeles, J. Paul Getty Museum,
 84.XP.675.4

PLATE 87
JOHN JABEZ EDWIN MAYALL
British, 1813–1901
Prince Albert, negative, May 15, 1860;
 printed by Hughes & Mullins,
 ca. 1889–91
Carbon print
40 × 28.5 cm (15¾ × 11¼ in.)
Windsor, The Royal Collection,
 RCIN 2931343

PLATE 88
LEONIDA CALDESI
Italian, 1823–1891
Queen Victoria, negative, 1857; printed
 by Hughes & Mullins, ca. 1889–91
Carbon print
40.2 × 30.8 cm (15 13/16 × 12⅛ in.)
Windsor, The Royal Collection,
 RCIN 2931295

PLATE 89
ROGER FENTON
British, 1819–1869
Queen Victoria and Prince Albert with Seven of Their Children, Buckingham Palace, May 22, 1854
Albumen silver print
13.7 × 15.2 cm (5⅜ × 6 in.)
Windsor, The Royal Collection,
 RCIN 2906085

PLATE 90
DR. ERNST BECKER
German, 1826–1888
The Royal Family, Osborne, May 24, 1854
Albumen silver print
8.5 × 10.9 cm (3⅜ × 4⁵⁄₁₆ in.)
Windsor, The Royal Collection,
 RCIN 2106402

PLATE 91
LEONIDA CALDESI
Italian, 1823–1891
The Royal Family at Osborne, May 27, 1857
Salted paper print
15.9 × 20.7 cm (6¼ × 8⅛ in.)
Windsor, The Royal Collection,
 RCIN 2906244

PLATE 92
ROGER FENTON
British, 1819–1869
St. George's Chapel and the Round Tower, Windsor Castle, 1860
Albumen silver print
30.7 × 43.4 cm (12¹⁄₁₆ × 17¹⁄₁₆ in.)
Windsor, The Royal Collection,
 RCIN 2100045

PLATE 93
ROGER FENTON
British, 1819–1869
The West Window, St. George's Chapel, Windsor Castle, 1860
Albumen silver print
28.7 × 28.9 cm (11⁵⁄₁₆ × 11⅜ in.)
Windsor, The Royal Collection,
 RCIN 2100041

PLATE 94
ROGER FENTON
British, 1819–1869
The Long Walk, Windsor, 1860
Albumen silver print
32 × 42.4 cm (12⅝ × 16¹¹⁄₁₆ in.)
Windsor, The Royal Collection,
 RCIN 2100070

PLATE 95
ROGER FENTON
British, 1819–1869
General View from Town Park, 1860
Albumen silver print
16.2 × 29 cm (6⅜ × 11⁷⁄₁₆ in.)
Windsor, The Royal Collection,
 RCIN 2100060

PLATE 96
ROGER FENTON
British, 1819–1869
Buckingham Palace, ca. 1858
Albumen silver print
32.2 × 43.3 cm (12¹¹⁄₁₆ × 17¹⁄₁₆ in.)
Windsor, The Royal Collection,
 RCIN 2935164

PLATE 97
ROGER FENTON
British, 1819–1869
Osborne House, August 1855
Albumen silver print
37.7 × 45 cm (14¹³⁄₁₆ × 17¹¹⁄₁₆ in.)
Windsor, The Royal Collection,
 RCIN 2104681

PLATE 98
ROGER FENTON
British, 1819–1869
Balmoral Castle, 1856
Albumen silver print
22.7 × 43 cm (8¹⁵⁄₁₆ × 16¹⁵⁄₁₆ in.)
Bradford, National Media Museum,
 2003-5001/2/20125

PLATE 99
CHARLES CLIFFORD
British, 1819/1820–1863, active Spain, 1850s–1860s
Queen Victoria, November 14, 1861
Albumen silver print
25.5 × 19.4 cm (10¹⁄₁₆ × 7⅝ in.)
Los Angeles, J. Paul Getty Museum,
 84.XA.876.2.27

PLATE 100
WILLIAM BAMBRIDGE
British, 1819–1879
FRANCES SALLY DAY
British, ca. 1816–1892
JOHN JABEZ EDWIN MAYALL
British, 1813–1901
CAMILLE SILVY
French, 1834–1910
Folding Portfolio Containing Portraits of Queen Victoria and Prince Albert, 1859–61
Leather portfolio containing fifty-four albumen silver cartes de visite
33.5 × 141 cm (13³⁄₁₆ × 55½ in.)
Windsor, The Royal Collection,
 RCIN 2914920

PLATE 101
WILLIAM BAMBRIDGE
British, 1819–1879
Queen Victoria, the Crown Princess of Prussia (Princess Royal of England), the Princess Alice, and Prince Alfred, Windsor Castle, March 28, 1862
From the "Portraits of Royal Children" albums, vol. 6 (1862–63)
Albumen silver print
18.5 × 16.3 cm (7⁵⁄₁₆ × 6⁷⁄₁₆ in.)
Windsor, The Royal Collection,
 RCIN 2900545

PLATE 102
JOHN JABEZ EDWIN MAYALL
British, 1813–1901
Queen Victoria With Her Family, 1863
Albumen silver carte de visite
7.2 × 5.9 cm (2¹³⁄₁₆ × 2⁵⁄₁₆ in.)
Los Angeles, J. Paul Getty Museum,
 84.XD.737.2.70

PLATE 103
ROBERT JEFFERSON BINGHAM
British, 1824–1870
Queen Victoria, ca. 1862
Albumen silver carte de visite
7.1 × 5.5 cm (2¹³⁄₁₆ × 2³⁄₁₆ in.)
Los Angeles, J. Paul Getty Museum,
 84.XD.737.2.68

PLATE 104
GEORGE WASHINGTON WILSON
British, 1823–1893
The Queen, Balmoral, 1863
Albumen silver carte de visite
8.5 × 5.7 cm (3⅜ × 2¼ in.)
Los Angeles, J. Paul Getty Museum,
 84.XD.1157.1652

PLATE 105
W. & D. DOWNEY
British, active 1860–1920s
Queen Victoria and Sharp, 1866
Albumen silver print
8.9 × 5.6 cm (3½ × 2³⁄₁₆ in.)
Windsor, The Royal Collection,
 RCIN 2908315

PLATE 106
W. & D. DOWNEY
British, active 1860–1920s
The Queen, 1872
Albumen silver carte de visite
9.2 × 6 cm (3⅝ × 2⅜ in.)
Los Angeles, J. Paul Getty Museum,
 84.XD.1157.1661

PLATE 107
ALEXANDER BASSANO
British, born Italy, 1829–1913
Queen Victoria, April 1882
Albumen silver print
30.9 × 19.1 cm (12³⁄₁₆ × 7½ in.)
Windsor, The Royal Collection,
 RCIN 2105758

PLATE 108
W. & D. DOWNEY
British, active 1860–1920s
Queen Victoria: Diamond Jubilee Portrait, July 1893
Carbon print
37.7 × 25.4 cm (14¹³⁄₁₆ × 10 in.)
Windsor, The Royal Collection,
 RCIN 2912658

PLATE 109
GUNN & STUART
British, active 1894–1905
Queen Victoria, 1897
Gelatin silver print
16.4 × 10.6 cm (6⁷⁄₁₆ × 4³⁄₁₆ in.)
Windsor, The Royal Collection,
 RCIN 2105772

PLATE 110
GUSTAV WILLIAM HENRY MULLINS
British, 1854–1921
Queen Victoria, June 22, 1897
Gelatin silver print
21.7 × 16.1 cm (8⁹⁄₁₆ × 6⁵⁄₁₆ in.)
Windsor, The Royal Collection,
 RCIN 2105789

PLATE 111
GUNN & STUART
British, active 1894–1905
Portrait of Queen Victoria, ca. 1897
From the photograph albums of Mrs. Lewis Percival
Gelatin silver print
28.6 × 23.5 cm (11¼ × 9¼ in.)
Los Angeles, Getty Research Institute,
 96.R.84

Index

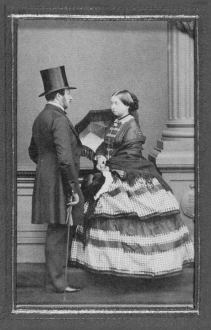 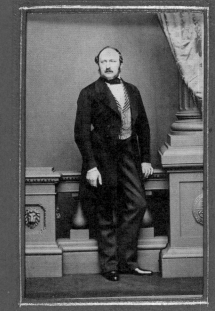 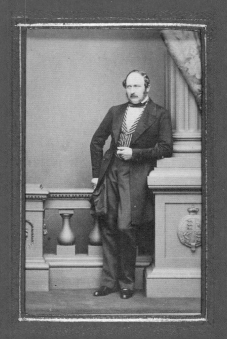 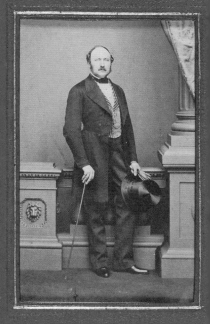

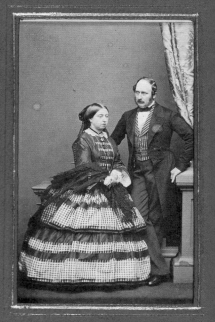 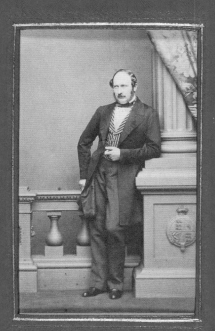 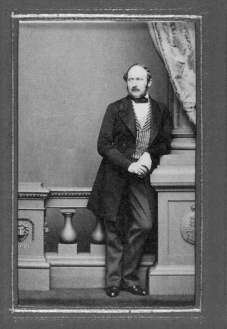 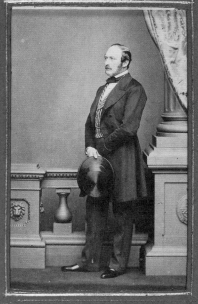

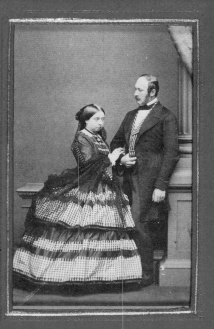 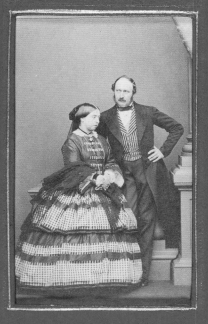 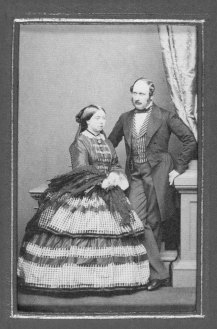 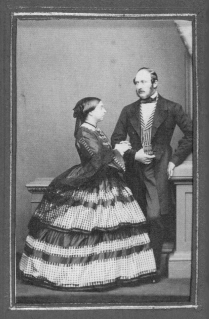